MOVIE COMICS

MOVIE COMICS

Page to Screen/Screen to Page

BLAIR DAVIS

RUTGERS UNIVERSITY PRESS
New Brunswick, New Jersey, and London

Library of Congress Cataloging-in-Publication Data

Names: Davis, Blair, 1975– author.
Title: Movie comics : page to screen/screen to page / Blair Davis.
Description: New Brunswick, New Jersey : Rutgers University Press, [2017] |
 Includes bibliographical references and index.
Identifiers: LCCN 2016008286| ISBN 9780813572260 (hardcover : alk. paper) |
 ISBN 9780813572253 (pbk. : alk. paper) | ISBN 9780813572277 (e-book (epub)) |
 ISBN 9780813572284 (e-book (web pdf))
Subjects: LCSH: Comic strip characters in motion pictures. | Comic strip
 characters on television. | Comic books, strips, etc.—Adaptations. | Celebrities
 in art. | Celebrities in literature.
Classification: LCC PN1995.9.C36 D38 2017 | DDC 791.43/657—dc23
LC record available at https://lccn.loc.gov/2016008286

A British Cataloging-in-Publication record for this book is available from the
British Library.

Visit our website: http://rutgerspress.rutgers.edu

Manufactured in the United States of America

For Audrey and Ewan, and all of the stories to come

CONTENTS

ACKNOWLEDGMENTS

Once again, this book would not have been possible without the love, support, patience, laughter, and sage advice of my wife, Erin. Sorry for spending so much on comic books and making you watch all those serials. To my daughter, Audrey, and my son, Ewan, you are both beyond amazing and I love you immeasurably. May we read many comics and watch many movies together in the years ahead.

My thanks are due to several funding agencies within DePaul University that provided much needed support while writing this book. The University Research Council's Competitive Research Grant and Paid Leave Program along with the College of Communication's Summer Research Grant program allowed me the vital time and resources to conduct this book's research. The College of Communication's Undergraduate Research Assistant Program was also instrumental, and my heartfelt thanks are due to both Kaitlyn Anglum and Shelly Yusko for their hard work in completing numerous tasks that made this a better book.

I am grateful again to Leslie Mitchner, Marilyn Campbell, and Lisa Boyajian at Rutgers University Press for making this such an easy book to write. I am also thankful to Barbara Hall and the staff of the Margaret Herrick Library at the Academy of Motion Picture Arts and Sciences, as well as the UCLA Film and Television Archive, for making my research trip so productive.

My deepest thanks to Susan Ohmer for being a reader on various stages of my manuscript and for providing vital feedback. Dana Polan, Paul Heyer, and Paul Booth also read work in progress and provided much needed suggestions, and I am grateful for their support and encouragement. Brian Cronin and Jake Rossen answered my questions about Superman, Will Brooker helped me solve some puzzles about Batman, and Jef Burnham provided essential information about Captain America, and I thank them all for clarifying numerous details.

I am incredibly fortunate to work with a wonderful group of colleagues in the Media and Cinema Studies Program at DePaul, and would like to thank Michael DeAngelis, Kelly Kessler, Paul Booth, Luisela Alvaray, and Kelli Marshall, along with our College's dean, Salma Ghanem.

I am also appreciative of my co-panelists and the audience members at SCMS, MEA, and PCA, where I presented aspects of this book as conference papers, for their feedback and questions that helped me think through various aspects I was developing. The same is true of my DePaul students in MCS 273, 349, 520, and 521, who were subjected to all manner of film clips in the name of qualitative research.

Many thanks again to my family, especially my father, Steve Davis. This book is also a tribute to the memory of my mum, Wilma Davis, for taking me to my first comic shop (appropriately enough named The Comic Shop in Vancouver, British Columbia) when I was quite young. The trip required us to take three buses there and three back. It has proven to be an inspiring example of how literally to go to great lengths for your kids when they show an interest in something.

MOVIE COMICS

INTRODUCTION

Movies and Comics Adapt Each Other

I like to think that the reason why I remain passionate about comics is because *Superman* (1978) was the first film I ever saw as a child. Some images can prove foundational. Growing up in the 1980s, there was rarely the hope in my schoolyard that our favorite comic book heroes would be coming soon to theaters near us. As the decade progressed we encountered a series of increasingly unsatisfying *Superman* sequels, plus a much-derided 1986 adaptation of the *Howard the Duck* comic book. There were also a few films based on comics that I was too young to have discovered yet (such as 1982's *Swamp Thing* and *Creepshow*, the latter based on the EC horror comics of the 1950s). So when Tim Burton's *Batman* (1989) came along at the end of the decade, it was cause for celebration at my local comic shop—an institution that encouraged our previous schoolyard hopes.

My own children are now growing up in an era in which schoolyard debates about comic book heroes on the big screen have become a question of *when* and not *if.* My younger self would have been utterly gobsmacked by the sheer number of comic book films in recent years, let alone their growing popularity. With such films as *The Avengers* (2012) and *The Dark Knight* (2008) setting box office records, it is tempting to believe that comics imagery has never been more prevalent in cinema than it is now, given how characters like Batman, Wolverine, and Captain America have become the new action movie icons.

The presence of comics characters onscreen actually dates back to the very beginning of American narrative cinema, however. The instinctive desire to see these characters in a new visual form seems to be as old as the medium of cinema itself. Some of the earliest cinematic adaptations of any kind feature comic strip characters, meaning that comics were central to the origins of narrative filmmaking as the twentieth century began.

Live-action versions of newspaper strips were common in the early silent film era, followed by animated shorts and feature-length films in the 1910s and 1920s. The coming of sound brought feature films and serials of such comic strips as *Skippy, Little Orphan Annie, Dick Tracy*, and *Flash Gordon* to theaters in the 1930s, while the rise of the comic book publishing industry saw serials featuring such popular characters as Superman, Batman, Captain Marvel, and Captain America (along with lesser known characters like Congo Bill and The Vigilante) in the 1940s.

At the same time as film audiences were enjoying their favorite comics characters onscreen, films were being regularly adapted into comic books and newspaper strips. The debut of *Movie Comics* in 1939 saw still photos from current films mixed with line art in conjunction with original dialogue, creating a unique hybrid of photorealistic and hand-drawn images. The 1940s and 1950s also saw such titles as *Movie Love* and *Movie Classics* regularly deliver adaptations of current films to newsstands.

Many popular film stars received their own comic book titles in this period, including John Wayne, Gene Autry, Bob Hope, Abbott and Costello, Roy Rogers, Buster Crabbe, Tim Holt, and Dean Martin and Jerry Lewis, among others. Walt Disney Studios became particularly active in adapting both its live-action films and animated characters into comics for younger audiences, with Mickey Mouse and Donald Duck remaining a staple of comic book publishing for many decades.

Adaptation was an integral part of film, television, and comics from very early in the history of each medium. Adapting comics to film and television (as well as vice-versa) demonstrates our collective desire to experience the same stories and characters in more than just one form, be it pen and ink, four-color printing, celluloid, or broadcast signal. Our favorite characters take on a life of their own (a cliché that I explore) and we want to experience them anew—in another medium from that in which they first appeared—so that we may have the pleasure of meeting them again, seemingly for the first time.

Although hundreds of comics characters have been adapted to film and television, few scholarly studies of this phenomenon exist, especially ones focused on the Classical Hollywood era.[1] It has often been pointed out that film and comics share roughly contemporaneous origins, with both the public projection of the Lumière brothers' Cinematograph and the appearance of the first newspaper comic strip *Hogan's Alley* converging in 1895. Despite this chronological parallel in the development of the two media, there has been relatively little scholarship directly comparing the historical interplay between them across multiple eras.

As the twentieth century began, several comic strips had already been adapted as films, including *The Katzenjammer Kids in School* (1898) and *Happy Hooligan Assists the Magician* (1900).[2] Two dozen more films followed between 1901 and 1903 based on Frederic Burr Opper's *Happy Hooligan* and *Alphonse and Gaston* strips. One film in particular, *Hooligan in Jail* (1903), reveals much about the popularity of comics-based films overall. It begins with a medium-long shot of Happy pacing in a jail cell until a guard brings him a bowl of soup. The camera tracks in toward him as he sits and enjoys his meal, ending in a medium close-up with Happy looking directly into the lens as he continues to eat. By this point the makeup effects are quite evident, with the actor wearing a fake nose and rounded cheeks to make him resemble the character as drawn. String can clearly be seen holding his tin-can hat in place.

The film lasts approximately fifty seconds, about half of which is simply footage of Happy eating. In other words, the film is mainly an opportunity for viewers to not only observe the character up close during a private moment, but also scrutinize the process by which he has been brought to the screen: the makeup effects, costuming choices, and the actor's nuances become much more clear in this film's close-up shot than in the long-shot format used in most of the previous entries. The artificial nature of the character's features becomes quite apparent because of the close-up, but it gives the audience a unique perspective into the aesthetic choices made in adapting the comic strip to cinema that most other adaptations of this period lack. The focus of this film is on the character himself, not on his actions or the amusing antics he gets up to. Here then is a film that celebrates the act of transporting a character from the page to the screen, allowing audiences the chance simply to revel in Happy's cinematic presence as he enjoys his meal.

While comic book adaptations have enjoyed spectacular international success in recent years, moviegoers have always craved the chance to scrutinize the presence of their favorite comics characters onscreen, poring over how the drawn image becomes translated into the corporeal form of an actor (who is frequently enhanced by some form of special effects, makeup, or elaborate costuming). Writing about Happy Hooligan's early films, comics scholar Jared Gardner notes, "These earliest partnerships between comics and films remind us that film wasn't born telling stories that follow classical Hollywood rules.... The earliest films were something else entirely, what Tom Gunning has influentially identified as a 'cinema of attractions'— a cinema of display as opposed to narrative, exhibition as opposed to voyeurism."[3] While we typically think of adaptation as the transportation of a narrative from one medium to another, many of the earliest films based on comics function largely as "attractions" rather than as stories. They exist so that we may enjoy seeing a character that we had previously known only as a static, drawn image become a moving, photorealistic image. Even though modern comics-based films involve complex narrative maneuvers, seeing a familiar print-character onscreen for the first time still evokes the same attraction-based pleasures of the earliest comics adaptations.

The silent era saw numerous comic strips adapted into films—first as live-action shorts, and later as animated efforts and feature films. Following the success of *Happy Hooligan*, *Foxy Grandpa* was brought to the screen in 1902 (filmed during a stage performance), while several films based on *Buster Brown* were produced starting in 1904. Edwin S. Porter, known for *Life of an American Fireman* (1903) and *The Great Train Robbery* (1903), directed a series of seven *Buster Brown* films in 1904, including *Buster's Revenge on the Tramp, Buster and the Dude,* and *Buster's Joke on Papa.*[4] Porter also made two *Happy Hooligan* films in 1901, *Happy Hooligan Surprised* and *Happy Hooligan April Fooled*, yet his pioneering efforts in adapting print characters to the screen remain lesser known. Plays, novels, operas, songs, and fairy tales were all regularly adapted to film in the early years of cinema, and comics were equally represented among the vast array of source material brought to the screen.[5]

Porter went on to direct *Dream of the Rarebit Fiend* (1906), based on Winsor McCay's strip of the same name. McCay would himself adapt his own characters to film in animated form, beginning with *Little Nemo* (1911). This was followed by several films based on specific *Rarebit*

Fiend strips: *How a Mosquito Operates* (1912), *The Flying House* (1921), *The Pet* (1921), and *Bug Vaudeville* (1921). Animated shorts flourished in the 1910s, with series based on *Krazy Kat* and *Mutt and Jeff* enjoying success.[6] Live-action shorts also remained popular in this decade, with *Mutt and Jeff* films produced weekly from July to December of 1911 and a series of films based on *The Katzenjammer Kids* appearing between 1912 and 1920.[7] *The Gumps*, one of the most popular strips of the 1920s, saw over three dozen live-action shorts created between 1923 and 1928.

Several of creator George McManus's strips also spawned their own series of short films, including *The Newlyweds, Let George Do It,* and *Bringing Up Father,* the last also seeing a feature-length film in 1928. Other feature films based on newspaper strips from this decade include *Little Annie Rooney* (1925), *Ella Cinders* (1926), *The Kid Stakes* (1927), *Tillie the Toiler* (1927), and *Harold Teen* (1928). This brief overview demonstrates just how prevalent comic strip adaptations were throughout the history of silent filmmaking. Audiences have always craved screen versions of comic characters. What we think of today as the "comic book movie" has a long history that dates back much further than most realize.

Comics themselves have also been a longstanding venue for cinematic content, characters, and stars. Britain was the leader in offering film-related fare to comics readers in the silent era,[8] with Charlie Chaplin appearing weekly in issues of *The Funny Wonder* starting in August of 1915. The first strip announces, "Here he is, readers! Good old Charlie! Absolutely *It!* A scream from start to finish. What's he doing now, eh!"[9] Chaplin's strip lasted until 1944, proving that comics were a popular forum for the comedian's antics. The *Chicago Herald* also ran a strip called *Charlie Chaplin's Comedy Capers* in 1916 and 1917, produced by future *Thimble Theatre* and *Popeye* creator E. C. Segar. Historian Dennis Gifford even notes how Chaplin's success with British comic fans quickly led to several impersonators in other weekly comics: *Dicky Doenut, the Chap to Make You Chuckle* was found in the pages of *Butterfly*; *Charlie Chirrup, the Chap to Make You Cheer Up* ran in *Picture Fun*; while *Carrie the Girl Chaplin and Her Dog Dot* were featured in *Merry and Bright* (with the dog wearing a bowler hat).[10]

Beginning in 1920, the British titles *Film Fun* and *The Kinema Comic* also offered silent film comedians like Buster Keaton, Harry Langdon, Ben Turpin, Fatty Arbuckle, and Harold Lloyd in comic strip form, followed by the comedy teams Laurel and Hardy and Abbott and Costello in the sound

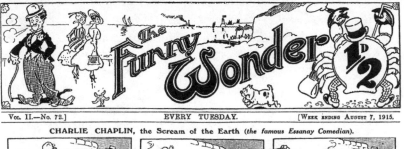

FIGURE 1. Charlie Chaplin's first appearance in *The Funny Wonder*, August 7, 1915.

era. All these American actors were placed within British working-class settings to aid reader-identification while mirroring the daily lives of many *Film Fun* and *Kinema Comic*'s readers.[11] Historian Graham King notes how "movie comedians were aware of *Film Fun*'s value in building their popularity on screen,"[12] something that would also be seen in American comics of the 1930s, 1940s, and 1950s. *Film Fun* ran for over forty years until 1962, transitioning from the silent to sound film era and through television's early years.

Movies and comics have a long history as allies, with their affiliation seen across a range of different forms. The interplay between film and comic books in particular has become a growing area of scholarly interest, fueled by the blockbuster successes of various adaptations of Marvel and DC Comics superhero titles such as *Iron Man* and *Superman*. There have been several terrific works examining how comics have been adapted to cinema, including Ian Gordon, Mark Jancovich, and Matthew P. McAllister's *Film and Comic Books* and Liam Burke's *The Comic Book Film Adaptation: Exploring Modern Hollywood's Leading Genre*.[13] Such texts focus largely on the past few decades of filmmaking, however, and despite this emphasis on

Film Fun 2d

Every Tuesday.

No. 653. Vol. 14. July 23rd. 1932.

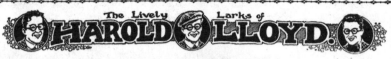

The Lively Larks of **HAROLD LLOYD.**

This Week: SPADES WERE TRUMPS!

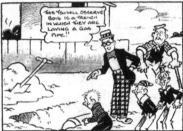

1. Harold and the three lads were out for a walk t'other day, when they came to the trench. So Harold cried: "Halt!" and proceeded to expound. "This hole, gap, or aperture," said he wisely, and with the air of one who knows what he's talking about if he can only remember it, "is not the work of mice. No! 'Tis a trench in which a gaspipe will be laid."

2. And Nippy, Tim, and Clarence were duly impressed. The next moment Harold was also impressed. For up barged the navvy who'd been listening in, and he gave our pal a sharp push in the small of the back. "You put a sock in it!" he barked. "What do you think you know about it? You're talking out of your back collar-stud!" Well, Harold went forward.

3. And it looked odds on his going down that trench so as to get first-hand information about it. But, by a bit of luck, he toppled across it instead, and his flippers came down on the handle of the shovel. Now that useful implement was sticking in a big pile of mortar. Up it shot, and a liberal portion of the stuff whizzed the workman's way and landed right on his map.

4. Then he sort of wished he hadn't interfered. For he was well and truly blotted out, and he felt as empty as he looked. "Ha, ha, ha!" howled the three lads delightedly. "You put it across him that time, Harold, old prune. Good egg for you, boy!" And Harold tootled: "Well, he asked for it. Let's toddle." So away they all went. (Continued on page 24.)

FIGURE 2. July 23, 1932, issue of the British series *Film Fun,* featuring Harold Lloyd.

the modern superhero movie there remains a limited understanding of how comics have historically intersected with other media industries. The relationship between the film and comics industries is more wide-ranging than we might imagine. By reframing how the relationship between comics and cinema can be approached within the field of comics studies, I intend to go beyond the traditional conceptions of the comic book movie, demonstrating the complexities involved in the historical, industrial, and aesthetic relationships between movies and comics (as well as comics and television).

While it is a growing field, comics studies still risks being dominated by a singular focus, given how much of the current scholarly work being done on comics looks at Hollywood adaptations of popular comic book heroes—specifically, modern superhero blockbuster cinema. Such attention is certainly warranted given how comic book properties have become a driving force for major studios seeking to establish film franchises, but the overwhelming amount of recent scholarship in this area threatens to marginalize other vital work being done on comics. As a field of study, comics studies has often relied upon other disciplines for its methodologies. It has borrowed ideas about genre from literary studies, about gender and identity from cultural studies, and about visual storytelling and adaptation from film studies, among other approaches. In turn, comics studies has often taken what has become informally known as a "Comics and . . ." approach, largely framing its object of study within the confines of a more established academic discipline. Writing in the 2011 *Cinema Journal* In Focus section on Comics Studies, Greg M. Smith uses the phrase "Comics and . . ." in describing how studying comics through the framework of film and television "can feel like an attempt to justify the study of comics by linking them to more 'important' media." He worries "that the 'Comics and . . .' approach encourages us to neglect the actual comics themselves and to favor the elements (characters, iconography, storylines) that readily transfer across media," and that "while such works do provide some academic recognition of popular objects such as comics, they also reiterate comics' position as the 'less serious' member of the pair."[14]

Smith calls for an increased focus on studying comics by themselves, without tying them to another medium as a way of justifying the relevance of their study. "Dealing with comics alone is hard enough without compounding the difficulty by studying two different objects," he says. I am generally inclined to agree, and often grow weary of the emphasis on

modern superhero blockbuster cinema in academic work on comics. But there remains a limited understanding of how comics have historically intersected with other media industries. There were a multitude of ways in which the film and comics industries (and later, television and comics) did business with one another beyond simply adapting comics into cinematic form. Film history rarely mentions how audiences regularly experienced film narratives, characters, and actors through the pages and panels of comic books and strips, especially in the studio system era: movies were frequently the basis for the content of comics throughout much of the 1930s, 1940s, and 1950s. If Hollywood was described in its classical era in both trade and fan publications as not just a place "but a mental assumption," "a condition of mind," and "a national obsession,"[15] then the ways in which comics furthered Hollywood imagery beyond the movie theater remains a little-known side of cinematic history.

Movie Comics: Page to Screen/Screen to Page examines the industrial factors surrounding these various adaptations and their source material, the adaptive strategies that emerged, and the contexts of reception in which they were consumed. Trade publications of the period are used extensively (such as *Variety,* the *Hollywood Reporter, Motion Picture Daily, Billboard, Film Daily, Independent Exhibitors Film Bulletin, Photoplay,* and *Box Office*), as well as archival material from the UCLA Film and Television Archives and the Academy of Motion Picture Arts and Sciences' Margaret Herrick Library.

This book presents a historical narrative by which the industrial connections and adaptive processes between comics and film/television may clearly emerge. The formal characteristics and potentials of these media are compared as a way of examining the uniqueness of each individual medium as it adapts the content of another. This narrative also traces the shifts in each medium with regards to the other, examining the ways in which each approached the other both fiscally and creatively as their respective industries evolved.

In drawing upon hundreds of films and comic books/strips, I often apply a "medium theory" approach. This lets us see the particularities of a given medium and the ways in which it formally constructs content, so that we can determine its specific qualities and potentials. I also detail the explicit ways in which both comics and film/television imagery become reconstituted using the formal qualities of the other, along with what elements

prove to be either challenging or successful to the adaptive process. This approach is frequently complemented by an economic analysis of both industries, in order to reveal how the mode of production involved in each respective form of adaptation affected the ways in which the end products were produced, distributed, and consumed. The case studies that I look at throughout are centered on how the individual text constructs meaning for viewers and readers, as well as the larger industrial frameworks of how media texts are developed and circulated.

I primarily cover the 1930s through the 1950s, looking at adaptations of comics through the early sound filmmaking era to the end of television's first full decade. This period saw the rise of the comic book as a new publishing format, the start of B-films in the double-bill era, the birth of new Poverty Row film studios like Republic Pictures (and the entrenchment of chapterplay serials as a product of B-filmmaking), and the beginning of television as domestic entertainment. All of these aspects were instrumental to the variety of ways in which comics were brought to the screen, and how screen imagery was also brought to comic books and strips throughout these three decades. By the start of the 1960s, however, the patterns of the previous three decades changed significantly. There was a major downturn in both films and programs based on comics, and the comics industry experienced an important shift with the rise of Marvel Comics. While the 1966 *Batman* television series certainly became enormously popular, it has been covered elsewhere in great detail.[16]

Although my research turned up examples from numerous countries, I quickly discovered the need to limit my analysis to what are largely American texts. I do not aim to be fully comprehensive and list every film and show adapting a comics character (Roy Kinnard's *The Comics Come Alive* is a valuable checklist in this regard), but my hope is to trace the key patterns involved in as much detail as possible. As a way of further tapering my scope, I also forgo looking at characters who began on radio such as the Lone Ranger and the Green Hornet, even though they went on to have their own comic strips/books, films, and television series. This book follows a largely chronological progression, alternating between chapters covering film and television adaptations and chapters examining how movies/programs were themselves adapted into comics. This format allows us to see the patterns at work in each particular industry more clearly throughout each successive decade. While there is definitely some crossover in my

analysis of the comics, film, and television industries, the emphasis in each chapter is primarily on either page-to-screen or on screen-to-page (in the interests of sustaining both the book's organization and readability).

These comics, films, and programs are valuable examples of how Hollywood interacted with other media in the early to mid-twentieth century. Comics were a vital part of the larger media environment of this period, and the various adaptations examined herein demonstrate the regular interplay between comics and other media throughout these decades. Media history has been enriched by numerous studies examining cinema's relationships with other media. Paul Young's *The Cinema Dreams Its Rivals: Media Fantasy Films from Radio to the Internet* chronicles how rival media are depicted on screen, arguing that what is "fundamentally at stake for Hollywood" is its maintenance "as an institution that is and will remain distinct from competing media institutions."[17] Seminal works such as Michelle Hilmes's *Hollywood and Broadcasting*, Jane Stokes's *On Screen Rivals: Cinema and Television in the United States and Britain*, and Christopher Anderson's *Hollywood TV: The Studio System in the Fifties* have allowed for new insights into the growing interdependence between the film and television industries.[18] As Stokes reminds us, "Each cultural technology defines itself through its relationship with other cultural technologies."[19] The relationships between film, television, and comics, and the ways in which cinema and television defined themselves against comics imagery, are vital processes of study.

You may recognize modern trends throughout that are predated by the examples presented. One Marvel Comics executive recently stated, for instance, how "Marvel is really looking at our films as brands and less as films."[20] Yet this focus on brands existed with the popular comics character Buster Brown as the twentieth century began,[21] and was prevalent in the 1930s and 1940s with Little Orphan Annie, Dick Tracy, Superman, and other comics characters who flourished in print and in various media adaptations. The *Wall Street Journal* described in 1942 how "popular comic characters as Mickey Mouse, Buck Rogers, and Superman, through licenses for reprints, leasing of rights for radio dramas and movies, and for the manufacturing use on numerous toy products, have generated more than $8 billion of financial activity throughout the U.S. economy during the past three years."[22] Film critic Margaret Thorp saw films based on comics (along with the "popular novel" and the "Pulitzer Prize play") as a movie marketer's

dream in the 1930s because they were presold properties "on whose titles some tens of thousands of dollars' worth of advertising has already been done." The same preference holds true among Hollywood executives today.

Thorp also likened the popularity of such adaptations to "the widespread human eagerness to experience the same story in as many media as possible."[23] Comics adaptations were a vital part of how audiences engaged with film and television content offscreen in the film industry's formative decades and in the early years of television's commercial debut. Director John Ford famously described Hollywood as "a place you can't geographically define. We don't really know where it is."[24] Comics extended Hollywood beyond the theater—and television beyond the picture tube— creating a tangible remnant of the cinematic and televisual experience.

This yearning for multiple versions of familiar stories and characters extends across every generation of media consumers. The thrill that young Dick Tracy and Flash Gordon fans felt in the 1930s upon seeing their heroes come alive onscreen surely matches the excitement in my own children's eyes when I introduce them to a new film or television show based on a favorite comics character. The same was true for me and my schoolyard pals when we bought comic book versions of the newest *Star Wars, Indiana Jones*, or James Bond films. They allowed us to anticipate (if we hadn't seen the film yet) or extend (if we had) our viewing pleasure—a function also served by comics adapting films and programs in earlier decades.

The medium of comics has a rich history, one that is certainly older than that of television and equally as longstanding as film. Looking at how comic books and strips historically intersected with movies and television allows for new insights into all three forms—in terms of the unique ways in which each medium constructs its imagery, and in how specific films, programs, and comics are consumed and understood. Growing up, my own exposure to film and television imagery was frequently mediated by comics. While I was delighted by such adaptations as *The Incredible Hulk* television series and the first two *Superman* films, the comics depicting my favorite movies and programs seemed equally important to me as the original material itself. This phenomenon, as it turns out, was not exclusive to a single generation, but instead dates back to the early years of both cinema and television, two media whose relationship with comics has proven to be far-reaching.

1 · 1930s COMICS-TO-FILM ADAPTATIONS

As the 1920s came to a close, Hollywood found itself at a turning point. With the overwhelming success of *The Jazz Singer* in 1927, sound filmmaking captured the public's imagination. Silent pictures suffered in turn, and any hopes that the two could flourish side by side quickly faded. But by the start of the 1930s, Hollywood was still attempting to master sound filmmaking techniques, and many in the industry found these early talking pictures (or talkies, as they were commonly called) less satisfying despite their public appeal. Film scholar Thomas Doherty notes how Universal Pictures head Carl Laemmle was dismayed in 1930 by the "'constant barrage of speaking or music' in the 'chattering dialogue pictures'" of the period, which had lost their emphasis on visual storytelling.[1]

Sound filmmaking suffered a learning curve, and the transition to talkies was not a "gentle grafting, but a brutal, crude transplantation," says historian Scott Eyman.[2] After making several silent features based on comic strips in the late 1920s, Hollywood abandoned them throughout 1929 and 1930 while rethinking the types of films best suited to the new production methods of sound filmmaking. The market for long-running silent short films based on *Mutt and Jeff*, *Krazy Kat*, and their peers also dried up as audiences demanded talkies. If comics characters were to still retain a big-screen presence, they would first have to find their voice.

SKIPPY: COMICS "COME ALIVE" IN THE TALKIES

In 1931, *Skippy* became the first live action feature sound film based on a comic strip. Featuring a mischievous but lovable little boy, Percy Crosby's *Skippy* began in *Life* magazine in 1923 and became a newspaper strip two years later. With its charming depictions of childhood life, it was an influence on both Charles Schulz's *Peanuts* and Hank Ketcham's *Dennis the Menace* strips. The film adaptation and especially its marketing reveal a great deal about how Hollywood saw comics in the early years of sound filmmaking. The film tells the story of ten-year-old Skippy, a successful doctor's son who would rather play with his shantytown friend Sooky than the well-off local kids. Together, they fight to save the shantytown from being demolished and to raise the three dollars needed to buy a dog license for Sooky's impounded dog, who will otherwise be euthanized.

Child actor Jackie Cooper had already appeared in numerous *Our Gang* short films and was loaned to Paramount by Hal Roach Studios to play Skippy.[3] Striking a balance between comedy and melodrama, *Skippy* was produced with more than just youth audiences in mind, with Paramount spending an estimated $295,000 on the film.[4] This makes it among the most expensive films based on comics to be produced in the 1930s and 1940s, when they were more commonly associated with lower budget B-films and serials. Crosby himself wrote the film's initial treatment, something few creators would do as comics became more commonly adapted for the screen in the decades to come. The film even earned Norman Taurog an Academy Award for Best Director, along with nominations for Best Picture, Best Adapted Screenplay, and Best Actor for young Cooper. Though an impressive start for comics adaptations in the sound film era, *Skippy* and its source material remain less well known today than many other comic strips of the period.

Sound filmmaking fundamentally altered the ways in which audiences experienced movies, including how it changed the art of adapting comics. With silent films, comics were brought to the screen through a combination of images (animated or live action) and intertitles. Since comics themselves also were created by combining words and images, the adaptive process prior to 1930 was somewhat less complex given that neither silent cinema nor comics use sound. By 1931, however, some comics fans worried that their beloved characters would now be ruined with the coming of the talkies. As one 1931 article noted, "Many were agonized when they learned

'Skippy' was to be movified. Those who had learned to love Percy Crosby's *Skippy* on the comic page feared what Hollywood would do to him. . . . But *Skippy* is grand. You'll love it—as much for what it isn't as for what it is."[5] This rhetoric concerning advance criticism of the adaptation is especially interesting because it echoes modern sentiments from many comics fans and their fears of how Hollywood might wreck a character that they love (especially upon seeing the first publicity images). Clearly, apprehension over how comics are brought to the cinema did not begin on Internet message boards but is instead a time-honored trend: comics fans are a passionate lot, and they don't take kindly to a screen version of a character that isn't how they envisioned it.

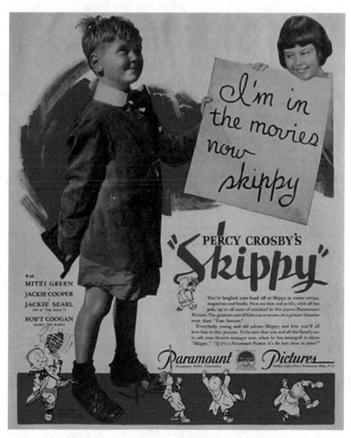

FIGURE 3. Advertisement for *Skippy* (Paramount, 1931).

Doubting fans had little to worry about with *Skippy*. The film was celebrated by critics, with one calling it "a gem of purest ray serene! Though nominally a kid picture designed especially for juvenile audiences, this really possesses the wildest [*sic*] sort of appeal. Every spectator, no matter how far time has removed him from childhood, will see something of his own youth in the joys and sorrows of the golden age we find here. For these children are real in psychology, in speech, in action, and better still, they are not cute— they are poignant."[6] *Skippy* was heralded as comics adaptation done right for creating a human connection with its precise casting, script, and direction.

The film was part of a wave of children's films in the early 1930s, but was sold as being more than just that—as a superior picture that adults would enjoy as well. In a letter to Paramount chief Budd Schulberg, Motion Picture Association of America (MPAA) head Jason S. Joy wrote that he found "nothing objectionable" in *Skippy*'s script, adding: "Incidentally, we enjoyed reading the script very much and believe that it should make a very amusing and popular picture."[7] This was rare praise from the MPAA, the "industry's own self-censorship mechanism" that provided certificates of approval allowing films to be distributed,[8] which seldom took the time to compliment the films that it reviewed. Another MPAA report stated, "It can be highly recommended as suitable for both children and adults because of its sympathetic humor and pathos. It is splendidly produced and merits the highest recommendation on the part of all our committees."[9] *Skippy* seemed to be the ideal film according to the MPAA, not only suitable for family viewing but also well written, acted, and produced.

Such universal appeal was regularly addressed in reviews of the film, with *Billboard* echoing the MPAA's sentiments: "Here is a picture for the whole family. . . . There are laughs galore and a few tears, and a cast that is par excellence. This may sound like superlative, but this is a superlative bit of innocent amusement in this day of racketeering and sex films."[10] Another review calls *Skippy* "probably the greatest youngster picture yet made. It should do a great deal toward bringing them back to the theater and the parents will enjoy it as much as the children. Jackie Cooper in the title role is largely responsible for the success of the picture. He makes the cartoon character a most living and vital youngster and his performance is one of the greatest bits of juvenile characterization in motion pictures, in our opinion."[11]

This idea of the comic strip brought to life (with film here able to make Skippy "living" and "vital") would dominate how adaptations of comics

to both film and television were conceptualized for decades to come. The novelty of moving photographic imagery thrilled motion picture audiences in the medium's initial years. Novelist Leo Tolstoy wrote in 1908 of how movies seemed "closer to life" than novels. "In life, too," he says, "changes and transitions flash before our eyes, and emotions of the soul are like a hurricane. The cinema has divined the mystery of motion. And that is greatness."[12] The ways in which the still images of characters are granted photorealistic movement in cinema remains a large part of the appeal of live-action films based on comics. That which once did not move now does onscreen, and that which was hand-drawn becomes embodied by human actors; these two factors are regularly evoked by film critics and marketers attempting to convey the pleasures of comics adaptations to potential audiences.

Skippy's pressbook reiterated this idea, with one advertisement having Skippy tell us directly that his film would finally allow us to see him "in person": "I've gotten so popular just from folks seein' my picture in the papers it came to me, just like that, I should make a personal appearance. So I'll be seein' ya!" Another ad has two drawn images of Skippy on either side of the photorealistic image of Cooper with the tagline, "In the *Movies* now in person—*Skippy*," while a similar ad declares: "You'll never know Skippy 'til you see him active and alive, in love and out, on the screen." Furthermore, the pressbook provides suggested copy (to be used in other ads, articles, and so forth) that reads, "You've seen his picture in the papers—now meet Skippy himself, in person. Alive and kickin' and talkin' on the screen."[13] If the act of film spectatorship therefore allows us to engage with a character "in person," as this marketing would have us believe, then the film medium is positioned here as creating a more active experience than reading comics. Film audiences would feel they are finally "meeting" a character in the movie theater after having only observed him at a distance on the comics page. The pressbook's rhetoric then takes this notion one step further by implying something fundamentally unsatisfying about reading comics that only cinematic adaptation can resolve:

The greatest kid in the world!
No longer the cold, still, fictional little figure of the printed forms—
 BUT NOW A LIVING, MOVING, BREATHING, TALKING, WHISTLING KID!!

The friend of millions . . . from coast to coast, the nation's host of wherever
 chuckles are in order at the breakfast table.
The acknowledged KING of comic-strip characters.
That's 'SKIPPY'!!![14]

The imagery of the comics medium is certainly "still," but the word
"*cold*" suggests something more. If comics characters are described here
as being "fictional," this implies that they are more factual (i.e., real) enti-
ties onscreen. But if their characters come to life onscreen, does this mean
that comics are a lifeless form? Literally, they are, since the human forms
found on the comics page are not alive, but the metaphor of a corpse seems
to apply when the word "cold" is contrasted with film's living actors. The
stillness of comics' drawn imagery cannot seem to match the vibrancy of
the human subject recorded on film, which lives, moves, breathes, talks
(and occasionally whistles). Still photography was commonly used to take
images of corpses in the Victorian age as a way of preserving the memory
of the deceased. Moving images demonstrate liveliness whereas the inan-
imate form of the still image embodies a condition of stasis. While these
contrasting factors are inherent to each respective medium, the idea that
film embodies life while comics can be equated with death is nonetheless a
loaded concept when it comes to aesthetic analysis. The possibilities inher-
ent in, and pleasures achieved by, comics through its sequential images are
innately different from the medium of film—something true of all media.[15]

What *Skippy*'s pressbook implies, however subtly, is the inferiority of
comics when contrasted with cinema. Comics are seen here as being for-
mally constrictive while movies embody an unbound freedom: one promo-
tional effort reads, "Two famous newspaper comic strip heroes figuratively
reach out over their pen-and-ink boundaries and shake hands in 'Skippy,'
the Paramount talking picturization of Percy Crosby's famous syndicate
feature." As such, many comics characters literally break free from the
comics page in certain movie advertisements. One ad features Cooper's
face appearing to burst through the page of an actual *Skippy* comic strip,
complete with numerous rips and tears. The ad announces that Skippy is
"*Crashing Through* to stardom and high public favor, from the comic sheets
to you in the talkies!"[16]

Once again we find marketing that implies that the presence embodied
by characters in comics is not a true one, and that we can only fully engage

with them when they escape from the limited "pen-and-ink boundaries" of the page. Here it seems that only in the movies do characters truly speak "to you" or appear before "you." The ad emphasizes the film viewer in a way that implies a more active engagement with comics characters than is possible on the page, as if comics characters become more humanized and we can identify with them more closely when they are embodied by actors. Their presence is seemingly stronger in the medium of film than in the cold, distant confines of the comics panel, from which such characters need only to crash through to achieve their full potential.[17]

Skippy was successful enough in 1931 that a sequel was released by the end of the year—*Sooky.* An even bigger budget of $370,000 was given to the follow-up, with both Cooper and Robert Coogan (who played Sooky) given large raises to reprise their roles.[18] The film emphasizes melodrama over comedy this time, with Sooky's mother dying of tuberculosis. The film was still praised for its wholesome values, yet did draw one minor criticism from the MPAA. Jason S. Joy told Schulberg that while there was nothing outright objectionable in *Sooky*, he "might want to consider the possibility of some objections to the scene in which the boys throw tomatoes at the train in order to get a supply of coal," which the engineers throw in retaliation. The boys then sell the coal to buy groceries for Sooky's dying mother. "It is not beyond the bound of possibility that many will consider this as an illustration of a dangerous trick which other children may want to imitate," said Joy. Schulberg cannily replied the following day, "Don't you think that if the picture actually sets the example for children to obtain coal through the same motives and for the same purpose, that we would have a better world, and that, therefore, all those who are rooting for a better world should want to see the scene contained in the picture and hope it will be emulated?" The scene remained unaltered for its American release, but was recommended to be cut for Japanese audiences.[19]

Paramount anticipated an enormous audience for *Sooky*, taking out a three-page trade ad for the film to promote it. Delivered as a "Personal Pledge to Showmen" from the studio's general sales manager, *Sooky* was promised to have "definite outstanding showmanship qualities, down to earth audience appeal, and timeliness. . . . You did *good* business on 'Skippy.' It is my prediction that you will do *Sensational* business with 'Sooky.'"[20] Many exhibitors, however, were concerned at the time that "kid pictures" were "practically washed up."[21] Paramount did not have any further youth

pictures slated for production at this point either, with the fate of the genre cycle resting on poor *Sooky*'s shoulders.

LITTLE ORPHAN ANNIE, THE DISMEMBERED PIG, AND THE TWELVE-YEAR-OLD FILMGOER

Although *Sooky* performed fairly well at the box office, it did not live up to the studio's high hopes. Exhibitors described the film's earnings as "all right but considerably below expectations," "okay but not sensational," and noted that it "failed to create the interest expected." Other exhibitors grumbled that because it was released a week ahead of the Christmas vacation period the film missed out on peak business with kids.[22]

Feature-length youth films in turn began to decline in this period (while "racketeering" and "sex" films thrived with the rise of such stars as James Cagney, Edward G. Robinson, and Barbara Stanwyck). But the following year saw the production of another film based on a popular comic-strip character, and one who was a child at that—Little Orphan Annie. Produced by David O. Selznick for RKO, the 1932 film assumes that viewers are already familiar with how Annie came to live with Daddy Warbucks since it forgoes this part of her story entirely. Instead, *Little Orphan Annie* opens in a train yard with Warbucks down on his luck, having lost his fortune along with so many others during the stock market crash of 1929. He tells Annie that he will regain his riches through gold mining and hops a box car heading out West. Annie is left behind to live by herself, but she soon meets a newly orphaned boy named Mickey who doesn't want to live in an orphanage. After trying unsuccessfully to take care of Mickey at home, Annie finally takes him to the orphanage where she is convinced to stay temporarily until Warbucks returns.[23]

By not having the film chronicle the early history of how Annie met Daddy Warbucks, *Little Orphan Annie* takes a remarkably different approach to its comic source material from the majority of modern adaptations. Rather than tell what amounts to an origin story, the film offers audiences a new chapter in Annie's life. With a popular radio series also serving up new adventures for Annie, RKO probably believed it would be redundant to return to events that have already been covered in other media versions. Hollywood might have felt that its film versions of comics

characters were the superior incarnations, but it did not always see the need to adhere strictly to the original material (while still careful in this case to preserve such familiar catch phrases as "leapin' lizards" and "gee whiskers"). At the same time, the studio sought to retain aspects of what made the character so popular to begin with by having her return to her orphanage roots. This strategy also serves to make her poverty-stricken beginnings modern and relevant to Depression-era audiences by removing her from the comforts of her life with Warbucks.

RKO was cautiously optimistic about the film's chances, calling it "a swell little picture" that "should have wide popularity."[24] The film met with mixed reviews, however, with one critic calling the story "crude" while noting that "listening to little Miss [Mitzi] Green ejaculating 'leaping lizards' or 'leaping' something else, is not conducive to merriment."[25] It also did mediocre business, with one Brooklyn theater reporting that matinee screenings for children were "not working out so well. It seems the kids wanted to see Eddie Cantor."[26] While not offering up the type of song-and-dance routines that Mr. Cantor was known for, and which both stage and film musical versions would popularize decades later, *Little Orphan Annie*

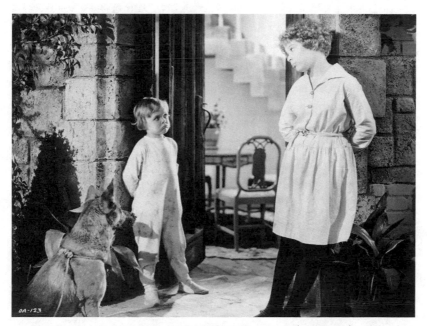

FIGURE 4. Publicity still for *Little Orphan Annie* (RKO, 1932).

contains an animated sequence that surely must have alternately delighted and terrified young viewers. After bringing Mickey home with her, Annie cooks him a lovely dinner of boiled pig's feet, which does not agree with his stomach. That night, he dreams about a pig coming to life out of the painting hanging above his bed. The pig emerges from the painting as if a ghostly apparition and carries crutches because he has no legs. Bones protrude from the stumps, and the pig is none too happy about it. A disembodied voice asks, "Where are you going, pig?" "I'm looking for the little boy who ate my foot," he replies intently.

The pig then finds an apple and takes a bite, prompting the agitated apple to come to life and punch the pig squarely in the face. The pig starts to cry. Meanwhile, two photos of Warbucks hanging above the bed also come alive in animated form, one becoming a police officer who wants to know what's going on, and the other resembling the shop owner from whom Mickey earlier tried to steal an apple. The pig tells the officer that Mickey bit his foot off, while the shop owner mentions how Mickey also bit his apple—and that the apple was going to bite him back. The angry apple then rolls up his sleeves, flexes his muscles, and mutters, "Oh boy oh boy oh boy, and will I bite him, oh boy oh boy oh boy!"

At this, Mickey wakes up and the nightmare ends, but not before leaving many viewers puzzled or disturbed. It is the only use of animation in the film, and seems to have been included to appeal to younger viewers. With its revenge-driven tone and images of dismemberment, it is a peculiarly dark moment in a film that otherwise tries to be both amusing and heart-felt. Its odd insertion actually makes what is an otherwise unremarkable but still pleasant enough film worth seeing for those curious about its mixture of animation and live action. The animation is uncredited, but it generally resembles the style of Fleischer Studios, whose Betty Boop cartoon shorts were flourishing in 1932. Whether a clever imitation or a Fleischer original, the sudden shift in *Little Orphan Annie* to a slightly macabre animated sequence is certainly one of the most interesting moments in all of the 1930s comics-to-film adaptations I have seen, thanks to its vengeful cartoon surrealism.

Press coverage of the film further perpetuated the notion of a comics character coming to life onscreen, occasionally blurring the lines between fantasy and reality. In an article entitled "Writer Busy on Movie for Orphan Annie" (note who is supposedly working for whom), George Schaffer

reported in the *Chicago Tribune* that RKO was "busily at work transferring the adventures of Little Orphan Annie from comic strip to scrip [*sic*] for the movies. Orphan Annie will shortly widen her activities by appearing as a featured actress [personified by Mitzi Green]."[27] The idea that Annie would be starting a new career as an actress in the human form of Mitzi Green continues the trend of Skippy's direct address to audiences in various ads about his "personal appearance" onscreen. Both Annie and Skippy are seemingly not characters to be *adapted to* film; they are somehow wholly *in* the films.

Although it was not as financially successful as they had hoped, RKO pondered whether to make another Annie film in 1934. The studio sought to have an independent producer make the film, however, and would only serve as distributor in addition to giving up the rights to the strip. The project never got past initial negotiations, however, with no cast or director ever assigned.[28] Green would not have been a strong choice to reprise her role as Annie, given some complaints that she was perhaps already too old (i.e., buxom) for the part in 1932 at only twelve years old. Having also starred alongside Cooper in *Skippy*, Green's career as a comic strip starlet was cut short.

Despite those who objected to her "having grown up a little too much" for the role and being "a bit dull" in it,[29] Green's performance and the 1932 film as a whole are laudable in comparison to the thoroughly disastrous version produced a few years later. Originally titled both *Little Orphan Annie, Detective* as well as *Little Orphan Annie and the Champ*, the later film was produced in 1938 by the independent (and short-lived) Colonial Pictures Corporation and released by Paramount as simply *Little Orphan Annie*. This time around, Daddy Warbucks is nowhere to be found, with Annie instead befriended by a former prizefight trainer named Pop. A boxing subplot ensues involving crooked loan sharks who prey on the residents of a tenement building.

The film was problematic from the start, with Paramount executive A. M. Botsford declaring that the first version of the script "was out of the question." Botsford fought to extend the preproduction schedule to allow a stronger script to be written, hoping that a new series of *Annie* B-films might result. With *Little Orphan Annie* ranked as the number-one newspaper strip in a 1938 survey, the timing seemed right to bring Annie back to the screen.[30] But even with a revised script, the best scenario that Botsford

envisioned for the current production was what he called a "perfectly possible *Orphan Annie* picture which will be pretty good."[31]

As it turned out, few thought the new film was any good at all despite the extended production schedule. *Variety* called it "inane," "amateurish," "boresome," "anemic," "unfunny," "useless," "ridiculous," "faulty," "a washout," and "a dud."[32] Another review was no kinder: "A stupid and thoroughly boresome story, combined with mediocre direction, makes this a leading candidate for the poorest picture of the season. Even in 57 minutes it wanders uninterestingly through long passages. Attempts at comedy are well nigh sad. . . . With some semblance of a logical story and proper direction, Ann Gillis would be satisfactory as the 'Little Orphan Annie' screen character; but in this one she fails to register."[33]

It fared no better among nearly all the various social groups from which the studio tried to get support in hopes of drumming up business from parents and their children. The California Congress of Parents and Teachers called it "tense and sordid at times." The National Society of New England Women found the dialogue "halting," the story "weak" and "amateurish," and the comedy "labored" and "overdone." Perhaps the most acerbic response came from a group called the University Women's Club, which declared: "If this film should succeed, no better proof is needed that the average audience has a twelve-year-old mind. Nor is it particularly adapted as entertainment for the actual twelve-year-old."[34] The fact that so many family-oriented social organizations chastised a youth-oriented film like *Little Orphan Annie* at a time when so many decried the "racketeering and sex films" of the 1930s proves just how badly the filmmakers missed the mark with their adaptation.[35] Gray's was among the most popular comic strips of the period, and in 1930 it became one of the first comics to be adapted to radio. With so few feature film adaptations of comics characters in this decade, perhaps audience expectations were higher because of Annie's extraordinary popularity. When presented with a screen version that little resembled the strip, viewers rejected it.

As one review commented, "Even exploitation tie-in with strip will not save [the] picture."[36] It became common in the 1930s to advertise a film based on a comic strip in the newspapers carrying it, with the tie-in between the film and comics versions seemingly benefitting both parties. *Skippy*'s marketing campaign pointed out the advantages of a film based on a comic strip to potential exhibitors: "He reaches 29,000,000 newspaper

subscribers every day . . . even more in the Sunday 'funnies' . . . delights the readers of *Life* . . . an illustrated serial of his adventures ran in *The Ladies Home Journal* . . . three books of Skippy cartoons have been published . . . and *widely read*."[37] As the decade progressed, Republic Pictures would advertise their *Dick Tracy* (1937) serial to exhibitors by pointing out that strip's millions of readers—"Every one of them a pre-sold patron for the picture." Similarly, Universal Pictures sold their 1938 serial *Flash Gordon's Trip to Mars* by telling exhibitors that such newspaper readers constitute the "largest, ready-made audience in the world" for their adaptation.[38] Newspaper strip distribution became translated by movie marketers into potential viewers, echoing the modern corporate need in Hollywood to adapt recognizable properties so that audiences' pre-knowledge of characters will ideally equate to bigger box-office totals. The need for a presold audience dominates what *Variety*'s Peter Bart calls the "classic corporate argument" behind Hollywood's current preference for adapting existing texts and properties instead of developing original stories and characters.[39] The argument has fueled the current boom in comic book movies, but it also regularly helped sell such films in the 1930s.

In the end, tie-ins could not save the 1938 *Little Orphan Annie* film— even a presold audience will stay away from a film with overwhelmingly poor reviews. Annie would not become a regular Hollywood fixture, unlike so many of her peers from the funny pages. The strip excelled in placing Annie in adventurous scenarios that ran for months at a time, and the serialized nature of the radio program saw the character thrive on the air. The reduced narrative scope of feature films might have been a hindrance to making *Annie* work onscreen, and certainly the elimination of a familiar character like Daddy Warbucks didn't help. Perhaps a regular series of films was hopeless given the character's young age. Audiences would either have to accept the character growing older with each film, or be content with the constant recasting of the role.

Gray might not have minded his character's lack of lasting Hollywood presence, given how he portrays the film industry in his strip. In 1935, Gray had Annie go to Hollywood, serving as a stunt double for spoiled child actor Tootsie McSnoots. In turn, Annie exposes the corruption that supposedly permeates Hollywood, allowing Gray to vent his frustrations with the film industry.[40] Overall, Annie's early cinematic efforts remain little known, eclipsed by the success of the 1982 musical version. But the character was

a pop culture phenomenon in the 1930s, with her radio show and fan club (and its famous secret decoder rings) establishing a legacy that outshone what many saw at the time as lackluster cinematic adaptations.

FUNNY PAGES: HOW W. C. FIELDS (ALMOST) MET POPEYE

The years immediately following Annie's 1932 film debut did not see a strong tide of feature films based on comic strip characters. There were a few efforts, but none that led to a sustained number of feature-length releases. Hollywood began to realize that not every comics character could successfully "crash through" into theaters, and that casting the right actor often proved difficult.

Warner Bros. decided to make another *Harold Teen* film in 1934, this time as a musical, and signed Broadway actor Hal Le Roy for his reported "fancy dancing" skills.[41] The film's pressbook offers numerous tie-in suggestions for exhibitors to take advantage of the character's ongoing comic strip presence. Not every newspaper welcomed such plugs for comics-related films, though, especially those that didn't run a particular strip.[42] But Warner Bros. came up with an ingenious effort at securing widespread press coverage for *Harold Teen*. They gathered copies of all the 165 papers that ran the *Harold Teen* strip and took publicity photos of Le Roy reading each one. They figured that since "editors can't resist pictures showing a celeb reading their paper," the move would net them free advertising for the film across the country.[43]

Reviews of the new version were relatively enthusiastic, but still demonstrate a certain awkwardness in their treatment of both youth audiences and comic strips themselves. *Billboard* described how director Murray Roth "does a swell piece of direction, milking every scene for its full entertainment value and playing cannily for the umbilical laughs"[44]—with the word "umbilical" serving to imply both the importance of the film's humor and the youthful nature of its audience. *Variety* wrote, "It appeals to the eye, touches the heart and evokes laughs. . . . In essence, if not in form, it holds to the universal appeal of the comic strip."[45] Film adaptations are therefore capable of effectively capturing the "essence" (a vague term) of comics' "universal appeal" (presumably young and old alike, but in this case meant to

draw largely juvenile filmgoers), but these intangible qualities often proved difficult for Hollywood when dealing with comic strips in the early 1930s.

Harold Teen ultimately did not have much box office appeal and was quickly pulled from some theaters for not performing well.[46] That same year, the film version of Ham Fisher's *Joe Palooka* strip about a boxing champion fared only slightly better in *Palooka* (1934), featuring Jimmy Durante as Joe's manager, William Cagney (the lookalike brother of James Cagney), and *King Kong's* Robert Armstrong. The film's star power, however, could not stave off disappointing returns in many theaters,[47] though the character returned in a series of short films between 1936 and 1937, many featuring Shemp Howard of the Three Stooges in a supporting role. The formats in which comics were adapted by Hollywood were still in flux in the mid-1930s, as feature-length efforts gave way to other types of films.

By far the most popular comics character to appear onscreen in the 1930s was Popeye, who debuted in the *Thimble Theatre* newspaper strip in 1929. Fleischer Studios brought Popeye to film audiences in a series of animated shorts starting with 1933's *Popeye the Sailor*, which costarred fellow Fleischer star Betty Boop as a hula dancer to further ensure the film's popularity.[48] The film continues the trend of having a newspaper image come to life, opening with papers rolling off a press and a headline that reads, "Popeye a Movie Star: The Sailor with the Sock Accepts Movie Contract." Below the headline sits a large picture of Popeye in mid-stride, with an edit soon placing the camera directly within the image. He remains still for a moment but then becomes animated, pausing to adjust himself before launching into a rendition of the now time-honored song "I'm Popeye the Sailor Man." Critics and audiences alike loved the short—one review noted, "*Popeye* is the funniest cartoon in many years. In fact, the audience thought it was the funniest thing they'd ever seen. Whoopee! What a guy!" Another highlighted the short's notion that comic strip characters can somehow sign movie contracts: Popeye "has stepped into a new role. He's a movie star, as the first release proves."[49]

The series of shorts continued through 1957, but the comic strip only became a feature film with Robert Altman's *Popeye* (1980), starring Robin Williams. But instead of a decades-long delay, Popeye's live-action debut almost ended up being less than a year from his animated introduction to theaters. Popeye was just one of many comic strip characters slated to appear in a Paramount film called *Funny Page* that began preproduction in

the spring of 1933. Paramount acquired the rights to six strips, described as a "novelty feature," from King Features Syndicate: *Popeye, Tim Tyler's Luck, Blondie, Boob McNutt, Polly and Her Pals*, and *The Katzenjammer Kids*. Initial plans were to make the film a musical with largely live-action sequences, but possibly using some animation in support.[50] As *Film Daily* noted, "Heretofore when [comics characters] have appeared on the stage or in the films they have been rather broadly burlesqued." Director Edward Sutherland, on the other hand, "plans to handle them more fantastically, with the thought of giving the picture something of an 'Alice in Wonderland' flavor."[51] While Sutherland's intent to avoid mere caricature in favor of a more spectacular approach was ambitious, the *Wonderland* comparison would ultimately be *Funny Page*'s undoing.

The film's concept proved difficult to execute, with the script going through at least seven different versions from numerous writers. This did not stop the studio from exploring casting options, with character actor James Burke apparently ready to remove his front teeth for the role of Popeye. The male roles proved easier to cast; it was many of the female characters for which the studio had difficulty finding suitable actresses. W. C. Fields was chosen to play Popeye's money-troubled, hamburger-crazed friend Wimpy (who "would gladly pay on Tuesday for a hamburger today"), but the actor was hesitant to do it, claiming that he couldn't "*see* himself in the role."[52] The studio was finding out the hard way that casting actors to "suit" comic characters can be notoriously difficult, with audience expectations around whether a certain actor embodies a particular character remaining a problematic force in modern Hollywood.

Only a few weeks before shooting was due to start, Paramount still faced last-minute preproduction difficulties as they pondered the best way to translate comics characters into live action. *Variety* reported: "Paramount will probably resort to using masks on players appearing as cartoon characters in 'Funny Page.' Studio has the masks made up but hasn't decided yet whether to use them or let the make-up men do their stuff. It will be the first time Hollywood employs the false faces in a comedy."[53] The choice between masks or makeup was a significant one—the first approach would completely disguise the actors, while the other would draw attention to the prosthetic alterations. Either way, the artificial nature of these "false faces" would be somewhat at odds with the earlier marketing emphasis on vitality and liveliness in *Skippy* and *Little Orphan Annie*.

The film had already been advertised to exhibitors, with a pressbook on the studio's upcoming films of 1933–34 featuring a two-page spread on *Funny Page* and its stars. Its tagline, "The Stars of This Picture Are Personal Friends with 75,000,000 People," highlighted how the combined readership of the various comic strips would surely translate into increased business.[54] In the end, Paramount called off the production little more than a week before the start of filming (making an unfulfilled pledge to later return to the project). The film had been lining up some significant talent behind the camera, with director Leo McCarey, after his success with the Marx Brothers in *Duck Soup* (1933), set to replace Sutherland, and Duke Ellington providing music.

Instead, Paramount focused on making *Alice in Wonderland* (1933) in time for a Christmas release. The studio apparently decided that because both *Funny Page* and *Wonderland* were "fantasy [films] aimed at kid patronage," it was "too much to expect two pictures so much alike to click simultaneously."[55] Another report instead listed an "actor shortage" as the reason for *Funny Page*'s demise, caused by the "widespread use of all-star casts"—but this conveniently contradicted an earlier wish to cast "a large group of new screen personalities."[56] Curiouser and curiouser, as Alice says, were Paramount's reasons for dumping the film. Fields then moved over to *Wonderland* as Humpty Dumpty (an ironic role, given his hesitation to play Wimpy—Humpty best known for being irreparably broken, while Wimpy is just broke), joining Gary Cooper and Cary Grant (who played a mock turtle, whether it suited him or not).

This would not be the first time that expensive preproduction efforts to adapt comics characters would go unrewarded. From producer Joel Silver's plan to make *Watchmen* in the late 1980s, to director Tim Burton's stalled efforts to make a *Superman* film starring Nicolas Cage and James Cameron's failed attempt at *Spider-Man* in the 1990s, and to Warner Bros.' long road to making a *Justice League* film, bringing comics characters to life onscreen regularly proves difficult. With regard to *Funny Page*, choices between makeup and masks and whether to balance live action with animation showed how film producers could not always offer a more "vital" version of readers' favorite comics characters. Not every character's features closely resemble regular human anatomy, given the possibilities to exaggerate human form in comics, as with Popeye's wildly distorted jaw, forearms, and hands. The need for masks and makeup in the first place proves that not

all comics characters can be easily cast, despite those actors willing to give their two front teeth for a role.

TO BE CONTINUED: THE PILOTS

By the mid-1930s the trend in comic-strip films would shift from feature films to an entirely different cinematic format, one that would appeal to children but not often star them. Serials were typically shown on weekends for children, but not always. Film historian Guy Barefoot notes that in many theaters serials were "a regular part of the programme throughout the week." While serials were made "with children in mind and attracted a sizeable child audience," they were "not limited to screenings marked as exclusively for children, nor were serials only made with children in mind or only watched by children," says Barefoot.[57] Adults liked them too, in other words, and many theaters included them alongside feature films in such action-oriented genres as crime dramas, war movies, and westerns for general consumption.[58]

Tailspin Tommy (1934) was the first comics serial, based on the Hal Forrest newspaper strip that debuted in 1928. Young pilot "Tailspin" Tommy Tompkins solved various mysteries alongside girlfriend Betty Lou Barnes and best friend Skeeter. Adventurous characters such as pilots and spies became increasingly common in 1930s newspaper strips, spurred by the rise of what *Variety* described as "slashing blood and thunder"—that is, adventure-oriented—radio programs.[59] Universal had initially planned to make a serial in the musical genre (which would itself have been a first), but instead saw an opening in the marketplace for an adventure film due to the current "flood of musicals" being released.[60] The aviation serial was indeed seen as having broad appeal—Barefoot quotes a *Motion Picture Herald* review of *Tailspin Tommy* declaring, "All patrons from 6 to 60 should like this."[61]

The trailer for *Tailspin Tommy* begins with copies of the newspaper strip scrolling across the screen, until a headline rips through the pages: *"Here's Big News!"* It then cuts to a silhouetted image of airplanes, with the tagline "Your favorite *Cartoon* hero now comes to life on the screen!" The opening credits further the notion of cinema's ability to embody comics: "Universal presents Hal Forest's Cartoon Strip 'Tailspin Tommy,'" with the cast and producer listed beneath. Hence, the serial does not announce that it is an

adaptation of the strip—it seemingly *is* the strip. Later serials would regularly describe how they were "based on" a particular comic book or strip; the credits of the 1935 follow-up serial *Tailspin Tommy in the Great Air Mystery* was listed as "Based on Hal Forrest's Cartoon Strip," for instance. The first *Flash Gordon* (1936) serial uses strategic punctuation in its credits: "Universal presents Flash Gordon [Alex Raymond's Cartoon Strip]." The 1936 serial *Ace Drummond* goes even further, announcing that it is "based on the newspaper feature entitled Ace Drummond owned and copyrighted by King Features Syndicate / created by Captain Eddie Rickenbacker / America's Beloved Ace of Aces / The Inspiration of Youthful Airmen the World Over."

As such, comics began to be positioned rather differently for film audiences by the mid-1930s—as source material with authors and copyright owners rather than a direct extension of a comic strip in which characters somehow have a say in how they arrive onscreen (what with Annie hiring herself a writer and Popeye signing a movie contract). In turn, film journalists began incorporating news about a comic strip's creator into some reports about their adaptations. With *Tailspin Tommy in the Great Air Mystery*, for instance, Hal Forest is described as being "an interested spectator and advisor on the picture."[62]

Movie marketers may have frequently sold the public on how much more satisfying it was to see their favorite characters move and breathe, but Hollywood still wanted 1930s audiences to know that these were nevertheless the same characters. The idea of authenticity has been seen as central to how audiences traditionally approach adaptations of literary sources. Audiences often compare the cinematic versions of literary characters to what becomes envisioned as the "authentic" or "essential" version from the novel.[63] Given that comics are a visual form as well as containing written elements, audience preconceptions become potentially even more complex regarding how a character would be cast and how settings, costumes, and so on might authentically appear onscreen. Comics readers already have a visual referent to which they can compare cinematic adaptations, making Hollywood's job to convince audiences about the vitality of their new version possibly more demanding (although this authenticity argument clearly did not apply to other adaptive strategies in many serials, as we will see).

Furthermore, with flying planes as the central narrative element of the strip and the film, *Tailspin Tommy* introduces a new difference between how action is portrayed in comics and cinema. While *Skippy* and *Little Orphan*

FIGURE 5. July 13, 1930, *Tailspin Tommy* strip by Hal Forrest.

Annie are more character-driven, and their narrative conflicts largely person to person, serials like *Tailspin Tommy* frequently offer film audiences action sequences relying on motion—high-flying planes, speedy car chases, rousing fistfights, and other such excitements. Action scenes in comics are naturally presented through still images, while such action is put into motion in films through photographic means. In *The System of Comics*, Thierry

Groensteen describes the difference between how comics readers engage with panels versus how film viewers engage with shots: "At the perceptive and cognitive levels the panel exists longer for the comics reader than the shot exists for a film spectator."[64] Comics readers experience a totality of images on a page rather than being shown each one separately in succession. Once a shot leaves the screen, film viewers cannot return to it, unlike the ability to refer back to earlier comics panels as one scans the page.

In this way, the reader controls the pace of reading a comic while the editor controls the pace of film spectatorship. Film is therefore a time-based medium while comics are not (films have a set running time while comics can be read at any pace). But is one process particularly more satisfying than the other? With comics, you have the ability to study the image of a plane, while onscreen such images are more fleeting. Film offers viewers the pleasure of vicariously experiencing motion in ways that are unique to most people (I have never flown a fighter plane or pursued another car at top speed, but I usually find images of these in films quite exciting).

Serials were invariably filmed as B-unit productions in the 1930s and 1940s, meaning that they were given smaller budgets, shorter shooting schedules, and little rehearsal time. They weren't typically shown in major first-run theaters, so they didn't receive the same marketing efforts as larger budget films like *Skippy*. In turn, serial producers were not as concerned with issues like narrative fidelity and successfully capturing the "essence" of source material as much as they were with delivering a fast-paced film on time and within budget. One example comes in how Universal wasn't overly concerned with who played the lead role in the 1935 sequel *Tailspin Tommy and the Great Air Mystery*. With three weeks to go before the start of production, the studio announced that they had yet to cast Tommy. Producer Henry MacCrae was set to resume casting efforts once he returned to Hollywood from the Arizona set of the western *Stormy* (1935), so the studio was clearly in no rush.[65]

Casting proved highly important to *Skippy* and the failed effort at making *Funny Page*, but both were major studio films with relatively large budgets. Most serials were made by either the smaller majors (Universal and Columbia) or independent companies such as Mascot and Republic. The latter two were informally known in the industry as Poverty Row studios, named such for their bargain budgets and because the majority of these small, often failing studios were located in the Gower Gulch region of

Hollywood where the locals weren't always the most upstanding citizens. Republic, for example, once moved a screenwriter into a building that had been previously occupied by a bookie. The writer was frequently interrupted by knocks on the door from people looking to place racing bets.[66]

With an emphasis on action rather than acting skills, most producers making comics-based serials were less concerned with casting a recognizable face. This was particularly true of *Tailspin Tommy*, with its star wearing a leather flying cap and aviator goggles for large parts of the film. Universal followed their two *Tommy* serials with one starring fellow comic strip pilot *Ace Drummond*. While Forrest's strip built up a following in newspapers for several years before it was brought to movie audiences, *Ace Drummond* debuted as a Sunday strip only a year before Universal adapted it. Clearly, comics did not need to be long-running favorites to be optioned for a movie deal by the mid-1930s, particularly as certain film genre cycles gained

FIGURE 6. Introductory image from chapter 2 of *Ace Drummond* (Universal, 1936). Like other Universal serials from the 1930s based on comic strips, *Ace Drummond* recaps prior chapters in panel form.

popularity. But while the *Ace Drummond* film was outright in announcing itself as an adaptation in the opening credits, the start of its second chapter returns to the direct use of the newspaper strip in an innovative way.

The second part of a serial (as well as each remaining chapter thereafter) always recounts the major events of the previous chapter for those who missed it, and to remind returning viewers of last week's cliff-hanger ending. The first shot immediately following the credits in chapter two of *Ace Drummond* is of a pair of hands opening a newspaper to the middle of the funny pages, where we find Rickenbacker's actual *Ace Drummond* strip, among others. The camera begins to move in toward the page, past the pair of hands. The shot then dissolves into a full panel of the comic strip—or at least a replica of one—which serves to announce the title of chapter 2, "The Invisible Enemy." A small section of the next panel awaits at the right edge of the frame, with the camera soon panning over to the next panel.[67] Here we find a drawn image of our villain, with accompanying text below that reads, "The Dragon, a mysterious criminal, is trying to prevent International Airways from establishing an airfield in Mongolia."

By now we can see the edges of the surrounding panels (all hand drawn) to both the left and the right, mimicking how peripheral vision functions as the human eye reads comics. The third panel introduces our hero Drummond and his objectives, while a fourth shows us how heroine Peggy Trainer's father has been kidnapped by The Dragon. A fifth and final panel shows us Ace and Peggy in a two-seater plane, the caption below stating that "Ace sees some natives pursuing Peggy and helps her make a quick getaway in Bauer's plane." The panel then dissolves to a live-action match-cut of Ace and Peggy (now personified by actors John "Dusty" King and Jean Rogers) flying through the sky in full motion.

This opening recap evokes the notion of cinema's liveliness by transitioning from drawn image to live action, but it still pays tribute to the act of reading a comic strip by using a point-of-view shot from a reader's perspective. In turn, what started off as a purely cinematic experience (opening credits and a moving image of a newspaper being opened) becomes an act of reading comics (still, drawn images accompanied by text read in succession). The film viewer is made to engage with another medium directly, but rather than actively scan a full page with their eyes from panel to panel, the panels move for the viewer.[68] Classical Hollywood did not always offer audiences the chance to experience other media in this way, and certainly not

for as long—the five panels take up approximately thirty seconds of screen time. While newspaper headlines were commonly used as expository plot devices in movies to conveniently further things along, viewers were rarely given the opportunity to read an entire article or scan the full page. Most shots of characters listening to the radio are still cinematic experiences given the centrality of the actor (unless the radio is playing in a pitch-black room, we are still watching someone who is listening, as opposed to taking on the reader's perspective with *Ace Drummond*).

The remaining chapters of the serial continue the use of comics panels to recap each previous cliffhanger, with match-shots used to transition into a live-action version of the scene depicted in the final panel. Whereas some studios had previously used a hard-sell marketing approach to convince audiences of the pleasures of seeing their favorite characters come to life, Universal approached comics differently by directly integrating comics form into the required structure of the serial's opening summary of previous events.

In using camera movement to lead the viewer into the comics page, and then using editing to transition from drawn image to actors in motion, audiences are shown the compatibility between the two media. The similarities in how each tells stories and frames their characters emerge by having each chapter's narrative begin in comics form and then continue in cinematic form—as opposed to earlier approaches in which the two forms were positioned on opposite ends of a spectrum in which one is cold and distant while the other is living and vital.

TO BE CONTINUED: FLASH GORDON AND BUCK ROGERS

In addition to its high-flying action, *Ace Drummond* also features some science-fiction elements—futuristic electrical devices and weaponry along with the ubiquitous laboratory equipment full of flashing lights and giant metal coils (probably borrowed straight from the set of *Bride of Frankenstein* [1935]). While *Ace Drummond* is not remembered by most as a full-fledged sci-fi film, another comic-strip serial from 1936 became a pioneering part of the science-fiction genre. European cinema had already seen sci-fi concepts in Russia with Yakov Protazanov's *Aelita: Queen of Mars* (1924), as well as

in Germany with Fritz Lang's *Metropolis* (1927) and *Woman in the Moon* (1929). Science fiction would not become established as a Hollywood genre until the mid-1930s, and then only for a few years at the level of the serial until a cycle of feature films took hold in the early 1950s.[69] Beginning as a newspaper strip by artist Alex Raymond (along with uncredited writer Don Moore) in 1934,[70] *Flash Gordon* saw numerous adaptations in the decades that followed: a radio series, three film serials, live-action television series in 1954 and 2007 plus animated series in 1979 and 1996, and a 1980 feature film (with its forever-catchy theme song by Queen).

Universal took their time producing the *Flash Gordon* serial. The rights to the strip were secured in January 1935, and the serial began production in January 1936 for an April release. Casting proved difficult, with *Variety* reporting that producers required "a number of giants. There are about three or four seven footers around town. None can act." The film still lacked a star with little more than two weeks before the start of shooting. The apparent requirements were that the "Lad who gets it must be a Tarzan."[71] Time was short, but Universal got their wish. Having starred as Tarzan a few years earlier in the 1933 serial *Tarzan the Fearless* for Sol Lessor Productions, Buster Crabbe had both the necessary physique and the benefit of serial acting experience for the role of Flash Gordon.

With a budget of $360,000, it was the most expensive serial ever produced.[72] While not the first sci-fi serial—Gene Autry battled death rays and futuristic soldiers in an underground city the previous year in *The Phantom Empire* (1935)—it was by far the most popular. Posters and lobby cards heralded *Flash Gordon* as "The First Great Serial Spectacle!" with chapters screened at evening performances in first-run theaters, something that few serials would do with regularity.[73] Barefoot recounts that during "opening night at the RKO Majestic Theatre in Columbus, Ohio ('a big first-run house'), the serial apparently created so much enthusiasm among the adults as well as children that it was shown at every performance during the week."[74]

The film's success soon led to a sequel, *Flash Gordon's Trip to Mars* (1938), but the studio only spent approximately half of what they did on the first serial. At $182,000, the sequel was in line with Universal's typical serial budget in the 1930s of $200,000.[75] Still, the serial was critical praised: "It stirs the imagination and is far more novel than serials usually," wrote *Variety*.[76]

Trip to Mars even uses a variation on *Ace Drummond*'s comic panel recaps, with one of Ming the Merciless's guards operating a view screen to

move between images as the previous chapter is recounted at the start of chapter 2 onward. The final panel of these recaps once again transitions into a live-action version of the drawn scene via a dissolve edit, but the effect is not quite as engaging as it was with *Drummond* given that we are looking at a screen over an actor's shoulder rather than becoming fully immersed in the panels through a point-of-view shot. The recaps would be eliminated from the shorter, feature-length version of the serial—*Mars Attacks the World*—which was edited for release later that year, given that there were no longer any chapter breaks.

Universal had been waiting until the serial itself had finished its full domestic run, but the studio rushed the feature version into theaters in early November 1938 to cash in on the publicity surrounding Orson Welles's notorious radio adaptation of H. G. Wells's *War of the Worlds*. On October 30, Welles and his Mercury Theatre company convinced millions of listeners that an actual Martian invasion of Earth was underway. *Mars Attacks the World* was already finalized and sitting on the studio's shelf before the radio program aired. Universal rushed the negative and work print to New York the

FIGURE 7. A previous chapter of *Flash Gordon's Trip to Mars* (Universal, 1938) is recapped in panel form as a soldier turns a dial on a view screen.

following day, and by November 1 the film was playing in seventy-five the-aters (with more to be added as soon as additional prints could be struck).[77]

The serendipity between the two Martian invasion stories is one thing, but the speed with which Universal was able to pull off the move is truly impressive. The thought that Flash Gordon had been standing by all along to save America from a Martian invasion even proved so inspiring to *Variety* columnist George E. Phair that he devised a poem:

When Martians swoop from yonder skies,
Creating wide alarm,
The hosts of Hollywood arise
To free the world from harm.
Flash Gordon hastens to the spot
And slays them with a process shot.

Phair then continued (now in journalistic fashion): "And if Flash Gordon can't lick those Martians, we can sic Buck Rogers on them and toss them into the 25th century. And if that ain't enough, we can scare 'em to death with Boris Karloff."[78]

A third Flash Gordon serial, *Flash Gordon Conquers the Universe*, was released in 1940. The bravado title caught many a journalist's eye, with one gossip columnist quipping, "Indicative of the lengths to which Universal is going in living up to its title promise in making what it modestly announces as 'Flash Gordon Conquers the Universe.' . . . [Crabbe], when queried on what he'd been up to, cracked: 'Oh, I've been all over hell today!'"[79] The title even prompted Phair to write another poem about the global implications of Flash's new cinematic venture as it applied to the start of World War II:

Dictators over there will peter out
And all their warring armies will disperse
In sheer frustration when they hear about
'Flash Gordon Conquering the Universe.'[80]

Buck Rogers may have been seen as worthy substitute for Flash Gordon in the case of a Martian invasion, but Rogers was actually the first sci-fi adventurer to make his comics debut, five years before Raymond's strip. Created by Philip Francis Nowlan, Buck Rogers first appeared in a story

for the pulp magazine *Amazing Stories* in 1928, in which the character's first name was Anthony. Chicago newspaper syndicate head John Flint Dille liked the story enough to have Nowlan turn it into a comic strip debuting in January 1929, but suggested that Rogers's first name be changed to the "livelier" Buck (after western film star Buck Jones).[81]

A radio show followed in 1932, which became so popular that children would reportedly do just about anything to hear it: "Permission to hear the Buck Rogers' adventures had been made the reward for the practicing of music lessons, washing behind the ears, eating all the supper. Buck Rogers may almost be said to be responsible for a new era in child training if a composite of numerous New York mothers is a criterion."[82] That same year, MGM briefly considered making a Buck Rogers film. Warren E. Groat, a reader in the story department, called the comic strip "a well developed and interesting imaginative story. Much better material than 'Just Imagine' produced by Fox. Treatment necessary but the Reader suggests consideration."[83]

Buck Rogers's cinematic debut was put on hold, but the following year Dille commissioned a short film adaptation of the strip for the 1933–34 Chicago World's Fair, with the cumbersome title *Buck Rogers in the 25th Century: An Interplanetary Battle with the Tiger Men of Mars*. Debuting in 1934, the film was clearly intended as a publicity effort for the comic, with the opening text, "Adapted from the Great Newspaper Feature," appearing overtop scrolling images of various *Buck Rogers* strips. This is soon followed by a shot of artist Richard Calkins at a drawing board, touching up a drawing of Buck before turning to the camera and smiling. The emphasis on the strip is self-promoting, but shows again how the adaptive process involved in bringing characters to the screen becomes more forthright in the opening credits of films based on comics as the decade progressed.

The short film is thoroughly amateurish, starting with the nepotistic casting of Dille's son as Buck—he wears a nifty space helmet, but that's about the extent of his acting abilities. Dr. Harlan Tarbell (a famous magician and acquaintance of Harry Houdini) directed the film and also starred as scientist Dr. Huer. The film's aesthetics are far below those of most Poverty Row entries, resembling something that might have been shot in Ed Wood's basement except with nicer backdrop curtains. But with props such as a "cosmic radio television" and a space battle featuring model rocket ships (with effects that easily surpass the flying saucers of 1959's *Plan 9 from*

Outer Space), the film is enough of a novelty given the lack of sci-fi cinema in America at the time to have surely delighted the World's Fair goers who saw it.

As Hollywood began its initial foray into science-fiction serials in 1935, MGM returned to their preproduction efforts on a Buck Rogers film that year soon after Universal acquired the rights to *Flash Gordon*. MGM executive W. D. Kelly sent Nathalie Bucknall, head of the studio's research department, a list of "pseudo scientific fiction" books to consider. Among them were such H. G. Wells novels as *The Island of Dr. Moreau, The Invisible Man, The Time Machine, War of the Worlds, First Men in the Moon, The Food of the Gods,* and *In the Days of the Comet*. The first two novels had already been adapted as horror films, but many of the rest would become films in the 1950s, 1960s, and 1970s. Rather than take the genre in this literary direction, however, MGM was more intrigued with another title Kelly sent—a pop-up Buck Rogers children's book published in 1934.[84] Kelly was dismayed by the choice, finding it "very inadequate." He did confess, however: "Occasionally I have listened to this radio program, when I have been too lazy to get up and turn it off and some of it has considerable imagination in it."[85]

MGM negotiated for the rights to the strip, and a treatment was written by Jules Furthman. Yet rather than turn to the strip, Furthman largely based his treatment on the pop-up book that Bucknall sent him, with much of the plot and even dialogue borrowed directly.[86] While this effort went unproduced at MGM, the science-fiction cycle might have moved beyond serials and established the genre more permanently in 1930s Hollywood had Furthman's treatment been developed. With the success of *Flash Gordon*, however, a short-lived cycle of science-fiction serials led to a Buck Rogers chapterplay in 1939. Having by then acquired the rights to the strip, Universal followed up their first two *Flash* efforts with *Buck Rogers* (1939), once again casting Buster Crabbe in the lead role. The serial was announced at the same time as plans for *Flash Gordon Conquers the Universe*, a move that confused some: *Variety* mixed up the two characters in one report of Universal's production schedule, then later described *Buck Rogers* as a sequel.[87] *Buck Rogers* also used much of the same music from the *Flash* serials (itself borrowed from *Bride of Frankenstein*), as well as many of the same props and set designs. One Mexican distributor even retitled the film and sold it as a new Flash Gordon adventure.[88] Perhaps to distinguish the film further, Universal sent Calkins on a personal tour in Chicago to promote

the serial for the Balaban & Katz theater chain, with the artist offering view-ers some "chalk talk" about the strip.[89]

Ultimately, *Buck Rogers* tends to divide fans of the character—sci-fi writer and historian Ron Goulart calls it "not exactly a gem in the chap-ter play genre."[90] Regardless, the fact that science-fiction serials of the 1930s regularly stemmed from comic strips demonstrates how the origins of the sci-fi film genre in America come from the comics medium. Sci-fi imagery in 1930s Hollywood originated as comics imagery, with illustrations of ray guns and rocket ships capturing the public's imagination in comics form before Buster Crabbe regularly embodied sci-fi heroism onscreen. There had been many kids' films before *Skippy*, numerous aviation films before *Tailspin Tommy*, and plenty of boxing films before *Joe Palooka*. The begin-ning of the science-fiction genre in America is explicitly tied to comics in film history, however, with comic strips stimulating public demand for a new kind of cinematic storytelling thanks to creators like Alex Raymond, Philip Francis Nowlan, and Richard Calkins.

TO BE CONTINUED: FROM JUNGLE JIM TO DICK TRACY

While Alex Raymond is best known for *Flash Gordon*, it was not his only comic strip in the 1930s. *Flash* was intended by King Features Syndicate as a rival strip for *Buck Rogers*, but they also wanted something that would compete with United Feature Syndicate's *Tarzan*. In turn, Raymond and his ghost writer Moore created *Jungle Jim*, with both strips launching together on January 7, 1934. Following their success with *Flash Gordon* in 1936, Universal readied a *Jungle Jim* serial for release the following year. Once again, the chapter recaps put the viewer in a newspaper reader's perspective—the same reader we saw in *Ace Drummond*, in fact, with the same white shirt and rolled-up sleeves. Even the newspaper remains the same, featuring a *Jungle Jim* strip on the top half and *Ace Drummond* on the bottom, with the camera moving in toward the middle of the page. The previous chapter is again summed up in five drawn panels, before dissolv-ing into a live-action version of the final image.

The same recap strategy is found in another 1937 Universal jungle serial, *Tim Tyler's Luck*, based on the comic strip by Lyman Young. Universal did

not follow up either serial with a sequel, perhaps because of the difficulties encountered while working with wild animals in each. While shooting *Tim Tyler's Luck*, a fire destroyed part of the set on the Universal back lot, causing ten thousand dollars' worth of damage and delaying filming because the animals were terror stricken. On the set of *Jungle Jim*, animal trainer Albert Allcorn was severely mauled by a leopard while lying in front of the camera. Shooting resumed only a few minutes after the attack, with a dummy replacing Allcorn beneath the camera to facilitate a close-up of the animal attacking. The leopard shredded the dummy, too.[91]

Despite not having an enduring cinematic presence, *Tim Tyler's Luck* would serve as a major literary influence decades later. In 2004, Umberto Eco's novel *The Mysterious Flame of Queen Loana* told the story of an aging Italian book dealer named Yambo who turns to the books of his childhood after suffering memory loss. Eco borrowed the novel's title from that of a 1935 Italian edition of the comic strip, *La misteriosa fiamma della Regina Loana*, and used an image from it in the novel's climax.[92] Eco interspersed images of numerous 1930s comic strips throughout, leading him to subtitle the book "An Illustrated Novel." *Queen Loana* serves not only as a nostalgic reflection on early comic strips, but also as a critical assessment of the power of their imagery. Following an image of Dick Tracy, for instance, Yambo wonders: "Later, having grown older and wiser, was I drawn to Picasso thanks to a nudge from Dick Tracy?"[93]

Chester Gould's *Dick Tracy* comic strip began in October 1931, after initially being called "Plain Clothes Tracy." Writer Tom De Haven suggests that Gould was strongly influenced by the Warner Bros. gangster film *Little Caesar* (1931) starring Edward G. Robinson, given how it was released in January of that year: not only did the film "feature a gang leader called Big Boy, as did Gould's unsolicited submission, but Thomas E. Jackson, the rail-thin actor who played the detective hero Sergeant Flaherty, had the identical physique and Roman-nosed profile, the same mien, as the primordial Tracy."[94] Max Allan Collins, who wrote the strip from 1977 to 1993 after Gould retired, points out that Gould often drew inspiration from the movies for his characters in the 1930s: "Mad scientist Doc Hump clearly reflects the impact of Universal's successful horror films; and screen sex goddess Claudette Colbert is the obvious inspiration for the sexy, sometimes irresponsible author, Jean Penfield."[95]

Hollywood wanted a piece of Tracy as well. In 1935, MGM arranged a tie-in promotion with the strip for their crime film *Public Hero No. 1*, hoping

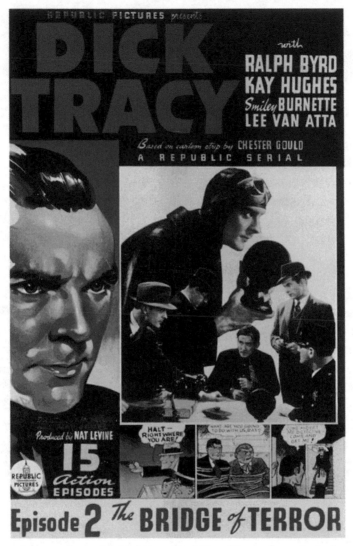

FIGURE 8. A poster for the first *Dick Tracy* serial (Republic, 1937) uses both photorealistic images of the actors and Chester Gould's original line art.

to bring readers into theaters.[96] The following year, after producing the sci-fi serial *Undersea Kingdom* (1936) in an effort to compete with Universal and *Flash Gordon*, Republic Pictures sought their own comic strip property, paying a handsome ten thousand dollars for the *Dick Tracy* film rights to the Chicago Tribune–New York News Syndicate.[97] The resulting 1937 serial

Dick Tracy stars Ralph Byrd in the title role, a part that he would return to many times both onscreen and for television. Yet he was not Republic's first choice to play the jut-jawed detective. When they first purchased the rights to the strip in 1936, the studio wanted Melvin Purvis as their star—who was not an actor, but an actual G-man famous for bringing down notorious bank robber John Dillinger.[98] The casting choice explains why the script changes Tracy from a police detective to an FBI agent—when Purvis couldn't be signed, the career change stuck so as to avoid rewrites.

Had it been Purvis rather than an experienced actor who had taken on the role, the casting might have been problematic given the accelerated nature of serial filmmaking, with little time for rehearsal or extensive retakes. Yet perhaps acting experience was not as essential with Tracy as it might have been with other characters. De Haven describes Tracy as having "qualities (competence, doggedness, coolness under pressure), but no character to speak of, no personality quirks, nothing to particularize him, humanize him: he had no catch phrases, no hobbies, no reader-endearing preferences . . . he became a symbol. He was Pursuit, he was Vengeance. Either way he wasn't your best friend. You couldn't warm to Dick Tracy."[99]

Despite these traits, the strip achieved lasting success with newspaper readers because of its relentless action, colorful violence, and bizarre villains. All these aspects also made the strip ideal material for the serial market as well. With the three sequels that followed—*Dick Tracy Returns* (1938), *Dick Tracy's G-Men* (1939), and *Dick Tracy vs. Crime Inc.* (1941)— Dick Tracy was the most frequently adapted comic character to serials in the Classical Hollywood era. Comic strips seemed to be a natural fit for film serials, given how many strips featured an ongoing (or serialized) narrative. The way that film serials structure their stories is much closer to comic strips than are feature films, which do not require theatergoers to consume a story in multiple parts, over numerous sessions. Comic strips can be continuously open-ended, and despite certain story breaks can go years or decades without a finite ending. Newspaper readers understand that they must regularly come back to serialized comic strips, and that the need for conclusion—something found in most novels, plays, and feature films— must be denied when reading comics. So too must this need for conclusion be denied, or at least postponed for twelve to fifteen weeks, with film serials.

Such denial is inherently part of the pleasures of serialized narratives. As with most pleasure in life, the anticipation is almost as sweet as the moment

itself, if not more so. Consider the following review by veteran *New York Times* critic Frank S. Nugent, in which he set out to review the Paramount film *The Crime Nobody Saw* (1937) but couldn't stop wondering what would happen next after walking into the Central theater in the middle of a *Dick Tracy* chapter:

> We found a seat at the Central yesterday just as Dick Tracy, the comic-strip detective hero, stepped into a looped line fastened to the stern of a submarine, was dragged off the dock where he had been fighting six or seven plug-uglies in the pay of a foreign power and was towed under—firmly roped at the ankle—as the U-boat started to submerge. The Central then calmly advised us to wait till next week for the seventh chapter of Mr. Tracy's adventures and impudently began screening—as though nothing had happened—a Paramount picture called "The Crime Nobody Saw."
>
> This one was based on a play hardly anybody saw, "Danger—Men Working," which Lowell Brentano and Ellery Queen wrote last season for a couple of one-night stands in Baltimore and Philadelphia. While we kept worrying about Mr. Tracy, wondering whether he was any good at untying knots or whether he had a scout knife in his pocket, Lew Ayres, Eugene Pallette and Benny Baker were imitating three playwrights in search of a mystery play. . . .
>
> . . . Candidly we doubted very much that they had a play, either before or after swallowing the strange case of Madame Duval. And, anyway, we couldn't keep our mind on it. Maybe the submarine had changed its mind about submerging. Or maybe the United States Navy was just under the horizon. Or maybe a grateful swordfish that Tracy once had saved from Zane Grey was slicing up from the depths. Guess we'll have to bite our fingernails until next Sunday when Chapter Seven rolls around.[100]

The 1937 *Dick Tracy* serial begins with a full-page image of the Sunday strip (but in black and white), which then rips open via a wipe-edit effect to reveal the film's opening titles. While Universal gave full credit in their serials to each strip's author and to copyright holder King Features Syndicate, Republic includes a more perfunctory title card, "Based on Cartoon Strip by Chester Gould." The credits of chapter one introduce each main character and the actor playing them in a brief moment of action (such as a smile or a menacing glare). After a list of each of the supporting players' names, the title of the first chapter—"The Spider Strikes"—appears overtop the

earlier image of the comic strip. As such, while the film seemingly breaks through the page, denying its "pen-and-ink boundaries" to reach the viewer in the opening pre-credit moments, moving from still imagery to live action, the exact same comic strip page seen previously (now no longer torn open) is briefly revisited in each chapter before the film's narrative begins. Even though they didn't use comics form as actively as Universal to set up each chapter, Republic still wanted *Dick Tracy* at least briefly grounded in the strip's imagery given its enormous popularity.

At the same time, Republic did not feel the need for strict fidelity to the strip in their adaptive choices. In addition to making Tracy a G-man, his adopted son, Junior, is absent in the final two serials. Even more glaring is the absence of Tracy's love interest, Tess Trueheart, and his partner, Pat Patton, from each of the four films, replaced with lab assistant Gwen Andrews and FBI agent Steve Lockhart (who are themselves gone from the final serial). On top of all that, Tracy is given a brother named Gordon who falls under the villainous Spider's evil influence. The changes didn't seem to matter much to audiences or exhibitors—one review describes the film as having "double quick" action, "mighty fine looking" villains, and "punchy" direction.[101] Gould apparently didn't mind the changes, either, since he had "insisted on a contract requirement that the screenplay be submitted for his approval."[102]

While the issue of narrative fidelity is often raised by critics with adaptations of novels,[103] the serialized nature of comic strips worked to 1930s cinema's advantage in this regard. Most newspaper readers experienced comics only a few panels at a time, with only the distant memory of prior plot points and dialogue given the relative scarcity of reprinted strips in book-length form at this time. Costumes, sets, and character designs could be easily critiqued with a quick glance at the day's funny pages, but without an extended text in hand for comparison many comics-based adaptations did not need to be true to the letter (only the "essence") of their source material to please audiences by appearing to be authentic. Charles Schulz noted that when we think about our favorite comic strips, we envision the main character and not the strip's ongoing plot: "We rarely recall any particular episode, but we recall instead the visual characteristics and unique personality traits that the character has had."[104] Readers might recall a character's catch phrases, but rarely the specifics of strips that were months or years past. So long as the actor resembled the character closely enough and the plot satisfied them, film audiences could forgive the absence of other details (which

might have faded from memory anyway). This was particularly the case by the mid-1930s as such adaptations moved toward serials, given their emphasis on nonstop action. If a serial was punchy enough, filmgoers were happy.

One fan of the *Tracy* serials was Orson Welles, who drew inspiration for one of *Citizen Kane*'s most memorable features from *Dick Tracy Returns*. The latter features a fake newsreel summarizing villain Pa Stark's criminal activities, which led Welles to create the "News on the March" scene in which Charles Foster Kane's life is recounted via similar mock footage. Welles was an avid comics reader throughout his life, and told Michael H. Price and George E. Turner in 1971: "I loved the Tracy chapter-plays, and the 'true crime' newsreel sequence in that one serial was enough to make me feel as though the story was unfolding in life. The actual Hollywood-studio newsreels, after all, were what kept a matinee at the Bijou anchored in a real-world sensibility. And how better to acquaint the audience with ol' Charlie Kane, than with a convincing newsreel segment?"[105]

While Dick Tracy was the most popular serial detective (or G-man), many other comic strip crime fighters got their own chapterplays in the 1930s. Following their work together on *Ace Drummond* and *Jungle Jim*, directors Ford Beebe and Clifford Smith directed serials in 1937 based on the strips *Radio Patrol* and *Secret Agent X-9*. The latter came about when King Features Syndicate asked Alex Raymond to join writer Dashiell Hammett on a new title to compete with *Dick Tracy* following the success of *Flash Gordon* and *Jungle Jim*. Hammett was the preeminent detective author of the time, having already written *Red Harvest*, *The Maltese Falcon*, *The Glass Key*, and *The Thin Man*, among other stories. While Hammett gave up writing prose fiction in 1934, he was wooed with a large salary by King Features (given how owner William Randolph Hearst was a fan of his work) to create the adventures of agent X-9.

Hammett left the strip after four story arcs, but its ongoing popularity led to the Universal serial. Once again, comics panels are used in the film's chapter recaps, but instead of showing the usual hands of the presumably working-class man (with his rolled-up sleeves) opening a newspaper, *Secret Agent X-9* features the arms of a man in a dark blazer wearing leather gloves (perhaps so as to leave no fingerprints?). Even more mysterious is how the gloves are gone by chapter 5, not to return in subsequent chapters. The move from rolled sleeves to buttoned cuffs is reflective of the growing earning power of comics-based film serials in this era, as well as the

strip's notable literary pedigree—in addition to Hammett, novelist Leslie Charteris (creator of Simon Templar, a.k.a. *The Saint*) wrote *Secret Agent X-9* for a time in the 1930s. Another film serial followed in 1945, starring Lloyd Bridges in an early leading role.

As part of King Features Syndicate's deluge of new titles in 1934, *Red Barry* by Will Gould (no relation to Chester) debuted in March of that year in a further effort to compete with *Dick Tracy*. Universal turned the strip into a 1938 serial starring Buster Crabbe as the title undercover cop. Oddly enough, the film costars an actor named William Gould—no relation to the strip's creator—as a police commissioner. King Features would sell one more strip for serial production in the late 1930s, this time to Columbia Pictures. Having entered the chapterplay market in 1937 after seeing Universal's recent successes, Columbia made their first comics-based film with 1939's *Mandrake the Magician* (from the strip of the same name). While the serial remains Mandrake's only cinematic effort to date, the magician nearly returned for a 1970s film by Federico Fellini. A childhood fan of the strip, Fellini wanted

FIGURE 9. A chapter of the *Secret Agent X-9* serial (Universal, 1937) begins with a pair of hands opening up a newspaper to the strip itself, positioning the film viewer as a comics reader.

Marcello Mastroianni as the lead, but the two men differed on who should play love interest Princess Narda (Claudia Cardinale or Catherine Deneuve). Although Fellini discussed the film project numerous times with the strip's creator, Lee Falk, a new Mandrake film was not in the cards.[106]

FEATURE FILM SERIES IN THE LATE 1930s: TOMMY RETURNS, BLONDIE BLOOMS

While King Features had initially intended to sell the screen rights to *Secret Agent X-9* in 1935 for the production of a feature film, it would be a few more years before a studio would move away from serials into features based on comics.[107] This would change by 1938, when Poverty Row studio Monogram Pictures acquired the rights to *Tailspin Tommy* for the production of six feature-length B-films, although only four would emerge. The films were made quickly, given the low-budget methods at work; *Sky Patrol* (1939) began production on July 21 and was released to theaters on August 21. Regardless, the films were well received by critics, who praised the "action melodrama" and leading man John Trent as Tommy.[108] Trent was a former TWA pilot himself before turning to acting, leading Monogram to plan a unique publicity stunt—one that played up a seemingly realistic aspect of the series, a benefit given their low budgets and colorful source material. Along with costar Marjorie Reynolds, Trent would "fly into towns day before [the film's] opening, showing theatergoers [that the] actor can handle [a] plane and needs no double."[109]

An even more unique strategy to keep audiences coming back to theaters for the next installment came in how the endings of the first three entries announced the subsequent film's title. While many James Bond films would go on to use this strategy, Monogram took it even further. As *Variety* reported: "Monogram has put tag ending on first of Tailspin Tommy series, entitled 'Sky Pirate,' bringing cast principals back on screen after final shot to tell theater patrons of next feature involving the adventures of the flyer and his pals."[110] The second film, *Stunt Pilot* (1939), ends with Tommy and his friends being asked by the government to assist in border patrol efforts. They heartily agree, and the group turns toward the camera as Tommy speaks directly to the audience: "Well, that's the next one!" Then, before the final fade-out, the actors all announce the next film's title in unison: "Tailspin

Tommy in Sky Patrol!" In turn, *Sky Patrol* ends with Tommy and pals discussing the possible formation of an aviation club for boys. "They have boy scouts, why can't they have scouts of the air?" asks Tommy. The film's final image is of a man speaking into a microphone—"Calling all theaters! Calling all theaters!" This is followed by a pair of title cards announcing the next film in the series: "Watch for the next Tailspin Tommy / Scouts of the Air."

Building such showmanship directly into a film itself to sell an upcoming release to audiences and exhibitors is a unique strategy that few producers attempt. The only problem was that the next film's title was changed during production to *Danger Flight* (1939), despite the air scouts premise remaining. Still, the effort to turn a series of feature films into a serialized narrative by setting up the next entry's plot in the final minutes was a calculated effort to avoid closure and keep audiences coming back for more in the same tradition of the original *Tailspin Tommy* serials.

While other studios would attempt to turn comic strip characters into ongoing film series in the late 1930s, not every effort was successful. Warner Bros. acquired the rights to the strip *Jane Arden*, intending 1939's *The Adventures of Jane Arden* as the first of several films about the crime-fighting reporter—but further entries were not to follow. More eventful was Columbia's *Blondie* (1938), which spawned one of the most prolific film series ever. Based on the Chic Young strip of the same name that began in 1930, *Blondie* was followed by twenty-seven sequels through 1950, something few characters have achieved onscreen.

Penny Singleton and Arthur Lake portrayed Blondie and Dagwood Bumstead throughout the entire series. Lake, of course, had previously starred as Harold Teen in 1928, and would return to the role of Dagwood for the 1957 *Blondie* television series.[111] The strip takes place largely in the Bumstead home and Dagwood's office at the J. C. Dithers Construction Company, making it ideally suited to B-film production and its regular reuse of indoor sets. Unlike such characters as Flash Gordon or Buck Rogers, who would eventually need to find new planets to defend in a long-running series of films, the regular routine of work and family life depicted in *Blondie* meant that the constant need for elaborate (i.e., costly) sets and props could be avoided.

The first *Blondie* film was enormously successful, with *Variety* correctly predicting that it would lead to a series of films in a review that described it as "a comedy gem" that "should drag heavy coin into box offices."[112] With three sequels following in 1939 alone (*Blondie Meets the Boss, Blondie Takes*

a Vacation, and *Blondie Brings Up Baby*—the latter title a play on the previous year's *Bringing Up Baby* starring Katharine Hepburn and Cary Grant), Columbia began to actively court the newspapers carrying the strip to ensure the continued use of tie-in marketing. Lou Smith, head of publicity for the studio, sent a weekly newsletter to these papers, covering "progress of Blondie series pix from start to completion of production."[113] But not everyone was pleased with the strip's newfound media presence. One review of the *Blondie* radio show (which began in 1939 and also starred Singleton and Lake) saw it as having "every chance of becoming radio's most stupidly puerile show," calling it an "epic of infantile inconsequentiality." The critic goes on to describe the *Blondie* film series as "tolerated (not universally, however) as a filler between the first and last reels" of more high-minded A-films. In the end, the review reveals its bias: "Nothing literate or brilliant is expected from a comic strip."[114]

Despite (or perhaps because of) their growing popularity in the 1930s, some high-minded critics still saw comics as a sub-literate and aesthetically inferior medium. By May 1939, however, comics had actually become the biggest form of source material for Hollywood adaptations so far that year. *Variety* reported: "Newspaper strips momentarily have opened up as largest single source, numerically speaking, of picture material. With five of them already established as basis for series and serial films, and a sixth serving as foundation for series of animated cartoons, two more are under negotiation by major plants." These adaptations were also vital to those owning the rights to the strips: "In some cases income from picture biz on strips has meant difference between profit and loss for syndicates because of tightening newspaper markets due to economic conditions."[115]

While such adaptations may not have always been "brilliant" (though many are excellent, especially *Skippy* and *Flash Gordon*), they were regularly profitable and positively reviewed. The reciprocal benefit to both film studios and newspaper syndicates shows how the vitality of comic adaptations was not just in how characters came to life onscreen, but also in their earning power. Major and minor studios alike sought to establish ongoing series based on comics characters throughout the decade. From the enormous popularity of such serials as *Flash Gordon* and *Dick Tracy* and feature film series like *Blondie*, comics became an increasingly significant force in 1930s Hollywood as the decade progressed.

2 · 1930s CINEMA AND COMICS

Screen to Page

While numerous comic strips were adapted to film in the 1930s, movies and comics also regularly came together in print form throughout the decade. The history of cinema rarely mentions how audiences experienced film narratives, characters, and actors through the pages and panels of comic books and strips. Movies were often the basis for the content of comics in the 1930s, particularly with the rise of the comic book format as the decade progressed. Just as comic strip characters were frequently adapted to feature films, serials, and animated shorts, comics themselves began to incorporate cinematic imagery on an increasingly regular basis in this decade.

The comic book began to take shape in the form that we now know it by the mid-1930s, having gone through different iterations until then. The newspaper comic strip, of course, was already well ingrained in American popular culture by the start of the decade. Despite some critics who saw nothing brilliant (or even literate) in them, comics were one of the most popular forms of mass entertainment in this era. A Gallup poll early in the decade "revealed that more people read 'the best comic strip in a newspaper, on an average day'" than they did the front page's headline story.[1]

Most comic strips were distributed through newspaper syndicates like King Features and United Feature to papers across the country. King Features

Syndicate was formed in 1914, and featured such popular strips throughout the 1920s as *Bringing Up Father, The Katzenjammer Kids,* and *Tillie the Toiler.* By 1930, however, the rise of the adventure strip began to dominate newspaper comics (and would for decades to come). With the success of the *Tarzan* and *Buck Rogers* strips launched in 1929, the funny pages were reinvigorated. Comics historians Pierre Couperie and Maurice C. Horn describe comic strips in the 1920s as a "rather dull interlude" in comics' development, seeing the 1930s as instead representing a "surge of creativity" in the medium.[2]

As seen in the numerous film versions already examined, the funny pages offered many different types of comic strips in the 1930s: the heroic adventures of *Jungle Jim* and *Tailspin Tommy*; the futuristic exploits of *Flash Gordon*; the youthful mishaps of *Skippy* and *Little Orphan Annie;* the criminal intrigue offered in *Dick Tracy* and *Secret Agent X-9*; the domestic foibles of *Blondie.* Comics scholar Robert C. Harvey notes how "individual strips have acquired their reputations of excellence on the basis of the creator's ability to excel in one or more of several components of the art form: the gag, the suspenseful ending, the story itself, characterization, art work, or dialogue."[3] As comic books emerged, most of these same genres and storytelling devices continued into the new format (although not every book used gags, and most didn't use cliffhanger endings until the 1960s).

When films are adapted to comics, and when movie stars appear in panels rather than onscreen, readers engage with cinematic imagery through the unique formal qualities of the comics medium. In *Comics and Sequential Art*, legendary artist Will Eisner wrote:

> The format of comics presents a montage of both word and image, and the reader is thus required to exercise both visual and verbal interpretive skills. The regimens of art (e.g., perspective, symmetry, line) and the regimens of literature (e.g., grammar, plot, syntax) become superimposed upon each other. [Reading comics] is an act of both aesthetic perception and intellectual pursuit. . . . In its most economical state, comics employ a series of repetitive images and recognizable symbols. When these are used again and again to convey similar ideas, they become a distinct language—a literary form, if you will. And it is this disciplined application that creates the 'grammar' of sequential art.[4]

When film content is transported to the medium of comics, creators must consider how best to apply the formal conventions through which

comics combine words and images in their adaptations. When the content of one medium is adapted to another, that content is invariably altered—this is an obvious but crucial point, reminding us that there is a creative process involved in making the content of one medium adhere to the formal demands of another. While I see films and comics as natural allies throughout much of their history, comics are not necessarily a simpler or less sophisticated medium, nor are they inherently capable of fewer aesthetic innovations and pleasures than other media. Comics which use cinematic imagery are not merely bastardized versions of their source material (although some will be inevitably better than others, depending on the talents of the artist or author). Rather, comics offer a way to create new forms of storytelling using film characters and narratives, sometimes telling a familiar story in a new way, or perhaps extending a story or a character beyond its cinematic iteration. In any case, the cinematic imagery presented in comics regularly proves complementary, offering film viewers another means by which to enjoy their favorite films and actors—and in a way that is more tangible and permanent than the fleeting, flickering images projected on movie screens.

While movies and comics both originated at the end of the nineteenth century, comics were relatively slow to adapt movies in the United States when compared to British titles like *Film Fun* and *The Kinema Komic* of the 1920s. Yet once American comics began adapting films and showcasing Hollywood stars and characters in the 1930s, regular interaction arose between the two media that saw a wide range of films and actors appear in comics panels for decades to come. Cultural theorist Arthur Asa Berger notes how "comic strips and comic books (and all forms of the high arts and popular arts) reflect the society from which they spring,"[5] and in this sense we may say too that the ways in which Hollywood became part of various comics were vital reflections of the film industry in this period.

"INTRODUCING THE WORLD FAMOUS MOVIE CHARACTER MICKEY MOUSE"

The first American film star to cross over to comics in the 1930s was not a man but a mouse. Mickey Mouse quickly became a cinematic sensation, but his popularity extended to other media in this decade as well. While

Walt Disney is best known for his animated films, his comic strips played a key role in the early success of his studio. Created in 1928 by Disney and animator Ub Iwerks, the first Mickey Mouse cartoon they produced was a silent short called *Plane Crazy*. In it, Mickey builds his own airplane as homage to aviator Charles Lindbergh (whose nonstop solo flight the previous year across the Atlantic Ocean from New York to Paris made him world famous). The film was shown publicly on May 15, 1928, but failed to gain a distributor.[6] Following Disney's success with the sound cartoon short *Steamboat Willie* later that year (which many describe as Mickey's film debut because it was the first to receive theatrical distribution), sound was added to *Plane Crazy* for its release in 1929.

Despite the initial rejection, Mickey soon became a cinematic sensation. Both Disney and Iwerks were approached separately by King Features Syndicate in 1929 about the possibility of creating a Mickey Mouse comic strip. Disney had already been contemplating Mickey's merchandizing potential, and he saw the character's regular presence in newspapers as a key promotional strategy for his cinematic efforts. A representative at Disney's first film distributor agreed that "it certainly would be good publicity" to have Mickey reach potential filmgoers on a regular basis.[7]

Advertisements for the strip stressed the fact that Mickey's fans could now see him on a daily basis. One of the ads used by King Features to promote the strip reads: "Mickey Mouse / You've seen him in the *'Talkies'*— Now you can see him *Every Day*." Another ad for the *New York Daily Mirror* states, "You've got a real treat coming to you every day when the greatest laughing sensation in a blue moon starts doing his antics in the newspaper!"[8] To Disney and his distributors, of course, the comic strip was seen as building anticipation for Mickey's next film installments as readers got a steady dose of their favorite film character six days a week.

The strip launched on January 13, 1930, with its first story arc adapting *Plane Crazy*. While much of the basic story remains, the numerous differences between how the strip and the film structure their content is quite revealing about the possibilities for depicting the same character and narrative in each medium. The strip opens with Mickey resting on a bale of hay while reading a book about aviation. "Gee!!—But I'd like to fly and become a great aviator like Col. Lindbergh!!" he says. The next two panels show Mickey daydreaming about meeting Lindbergh in a thought balloon, prompting an idea to "build an aeroplane and learn to fly like Lindy!!"

The first panel demonstrates a high degree of narrative economy by encapsulating the story's forthcoming plot in a single line of dialogue. This strategy is necessitated by the formal brevity of daily comic strips, which must convey the story's information as efficiently as possible for readers who must reorient themselves each day with the strip's prior events. The film, on the other hand, opens with an approximately twenty-second shot of numerous animals building the plane alongside Mickey. This is followed by an iris shot of Mickey (depicting him in a circle against the black frame and thereby setting him apart as our protagonist, a common silent-film editing technique). While the film allows ample time to establish the setting and action for viewers before we are properly introduced to our hero, the strip must introduce its setting and main character quickly in order to interest the reader enough to come back the next day.

Once Mickey decides to build the plane, the strip emphasizes his efforts in launching and flying it over several daily installments. The construction process is skipped here, as are the array of supporting characters, given the need to economize action into a few panels at a time while still leaving room for a punch line. The flurry of moving parts in the film would lose their effectiveness if rendered as still images, given how many panels would be required to convey the cacophony of construction going on. At the same time, the strip emphasizes dialogue through word balloons, turning what is largely visual humor in the film (music and sound effects are present, but no dialogue other than the onomatopoeic "Ha Ha") into an equal combination of sight gags and punch lines. Yet some things seem to work well in both media, as each uses the same gags in which a tightly wound wiener dog is used to activate the propeller, a turkey's tail is used as the plane's tail fin, and Minnie falls out of the plane but is saved by using her underpants as a parachute. While narrative elements from other early Disney cartoons like *Jungle Rhythm* (1929) and *Hells Bells* (1929) were also borrowed in the strip's early months, David Gerstein points out that a gag from the comic involving a crocodile swallowing a lion was reused in the 1931 cartoon *The Castaway.*[9]

The film's moving imagery of Minnie falling through the sky is simulated in the strip by the use of vertical speed lines indicating her rapid downward progression. While such lines are used to create the appearance of motion in a static image, the aesthetic possibilities of comics go beyond the simulation of cinematic movement. Comics can use point of view in ways that

films rarely did in this era, such as breaking the fourth wall and address-
ing the reader directly.[10] As filmgoers we are only observers of Mickey's
escapades in *Plane Crazy*, but the strip sets us up from the beginning as a
more active participant. Mickey regularly addresses the reader in the strip,
facing and speaking to us directly as if we were his confidant. Two of the
first four installments' punch lines are of Mickey waving at the reader while
exclaiming "Yoo Hoo!!!"—once when he flies through the air, and again
after he lands inside a pair of long underwear on a clothesline. Mickey evi-
dently didn't want to lose the reader in the strip's first week, making sure
that we are still following his early adventures. He often talked to the reader
in the weeks that followed, especially in the final panel. When a mysterious
character named The Fox leaves a note warning of things to come, Mickey
shows us the note while nervously asking "Who-o-o-o-o Who is The
Fox??" When he falls into a barrel of water attempting to rescue Minnie,
Mickey assures the reader that he will still prevail: "I may be all wet—but
I'll save Minnie yet!!"

Two months after the strip's debut, King Features approached Disney
and asked for the storylines to be more adventurous. With *Tarzan* and
Buck Rogers captivating readers with their heroic exploits, the syndicate
wanted more than just cute animal antics and playful punch lines from
the *Mickey Mouse* strip. The first installment of the new story arc (Mickey
Mouse in Death Valley) provides a grand entrance for Mickey, who has
pasted a large poster of himself on a fence. It reads: "Introducing the World
Famous Movie Character Mickey Mouse Who Will Appear on the Comic
Page of This Paper Daily." The poster also introduces Minnie Mouse as
Mickey's "Fickle Frivolous Flapper," and a cat named Terrible Tom as "The
Vile Villain." Leaning against the fence with a bucket of paste and a brush,
Mickey directly addresses the reader: "I don't like to talk about myself, but
honest I've made more people laugh in the movies than any other guy my
size in the world—Look me up, I'm going to be in this paper every day."
The first strip of this new storyline is therefore entirely self-promotional,
and not narrative-based, in keeping with Disney's entrepreneurial intent for
the strip.

Disney initially wrote the strip himself from January to March 1930,
joined by Iwerks as artist, but by April he began providing plots to Floyd
Gottfredson (who took over the strip in May). Gottfredson was initially an
animator for the Disney studio, working as an "inbetweener" by finishing

backgrounds and incomplete details on work done by others. He was given the job on the strip once Disney's cinematic commitments demanded his full attention.[11] Hence, Disney saw the skills of a film animator as readily translating to comics, since Iwerks had already made the transition between the two media. Drawing moving imagery one sketch at a time (with others finishing various details) as an animator is certainly a different process from writing comic strip narratives; in the latter, meaning is conveyed through a single static image per panel rather than via numerous frames per second to create movement. In the case of the "Mickey Mouse" strip, however, the creative transition of an artist from one medium to another worked quite seamlessly given the strip's longevity and acclaim. With Disney describing the "medium" of animation as "so young and so unexplored and so fascinating" in a 1938 *Lux Radio Theatre* interview,[12] it was only natural for him to test out his animators on the comic strip given his innovative approaches to various media throughout his life.

While Gottfredson had been working with Disney's "Death Valley" storyline throughout the summer of 1930, he was subsequently free to take the strip in a new direction. Disney occasionally made story suggestions to Gottfredson, one of which was a doozy: when Mickey mistakenly thinks that Minnie is in love with someone else, he repeatedly tries to kill himself (with what Disney believed would be hilarious results as each attempt fails). Having seen the premise in the 1920 Harold Lloyd short film *Haunted Spooks*, Disney thought it would work well given how both Mickey and Lloyd had relatable "everyman" qualities.[13] Gottfredson hesitated at the idea: "I said, 'Walt, you're kidding!' He replied, 'No, I'm not kidding. I think you could get a lot of funny stuff out of that,'" recalls Gottfredson. "Gee whiz, Walt, I don't know. What do you think the Syndicate will think of it? What do you think the editors will think of it? And the readers?" asked Gottfredson. "I think it will be funny. Go ahead and do it," said Disney.[14]

As such, the strip took a decidedly darker turn in October 1930. Mickey observes Minnie with another mouse through a window, believing that he saw them kiss. October 17's strip ends with an image of Mickey walking away down a dark street while crying: "Sniff!! Sniff!" The melancholy of this strip's final image is surpassed the next day, with Mickey reaching for a shotgun on the wall in the last panel after declaring, "Oh, what's the use? She doesn't care for me anymore—what is there to live for! Without Minnie I might as well end it all!"

FIGURE 10. In a strip from October 18, 1931, Mickey Mouse reaches for a shotgun after mistakenly believing that Minnie has fallen in love with someone else.

The next installment shows Mickey setting up the shotgun on two chairs with a string attached to the trigger. "It's no use!" cries Mickey, who tells us that without Minnie he "might as well drift in to the hereafter!" As he begins to count to three, he is stopped from ending it all when a cuckoo clock on the wall goes off, which Mickey takes as a sign that he would indeed be cuckoo for taking his own life. The next day's strip sees him back at it, however, as he stands on the ledge of a bridge: "It's no use! I can't get Minnie off my mind! I just can't go on without her!—It's the river for me!" He jumps off the bridge, shouting, "Good-bye Minnie! Good-bye cruel world!" but is saved when he lands on the deck of a passing boat (which Lloyd also did in *Haunted Spooks*). Determined to kill himself, subsequent strips see him

tampering with the gas line at home so that he will die in his sleep, tying a rope around his neck with the other end wrapped around an anvil so that he can drown himself, and hanging himself from a tree branch.

All in all, Mickey attempts suicide five times over the course of a week, but is thwarted at every step. While there are punch lines in most cases to offset the grim content, the initial moment of Mickey removing the shotgun from the wall is to my mind one of the darkest images ever created in the history of popular culture given how it serves as a cliffhanger for fans of the beloved children's icon. The next strip didn't appear until October 20, leaving readers to ponder poor Mickey's fate for two days. Watching Lloyd's efforts to kill himself onscreen is one thing given how viewers can immediately see that he survives. Having readers wait two days to find out whether Mickey would pull the trigger is another thing entirely.

Disney has said that Mickey's sole purpose is to inspire laughter. "We didn't burden him with any social symbolism; we made him no mouthpiece for frustration or harsh satire. Mickey was simply a little personality assigned to the purposes of laughter," he explained.[15] Are Mickey Mouse's repeated suicide attempts truly funny? Disney sure thought so. As it turned out, there were no objections from the strip's readers, editors, or anyone at King Features. "See, it was funny; I told you it would be," Gottfredson recalls Disney telling him afterward.[16]

Perhaps Disney's insistence on Mickey's suicidal tendencies was a reflection of his own personal anxieties suffered that year. Disney recalled how in 1931, "I had a hell of a breakdown. I went all to pieces." Feeling the pressure of his growing animation studio, Disney admitted: "As we got going along, I kept expecting more from the artists and when they let me down and things, I got worried. Just pound, pound, pound. Costs were going up, and I was always way over what they figured the pictures would bring in. . . . I just got very irritable. I got to a point that I couldn't talk on a telephone. I'd begin to cry."[17]

While the film studio may have caused him anxiety, the comic strip's success should have given Disney some encouragement. After only a few months, the strip was featured in forty different newspapers and in twenty-two countries. It proved so successful that when twelve papers offered readers a photo of Mickey as a promotional effort, "they received twenty thousand requests."[18] December 1931 saw King Features strike a deal for the *Mickey Mouse* strip to run in every Hearst newspaper by the following

month.[19] This was immediately followed by the creation of a *Silly Symphonies* strip based on the Oscar-winning animated series. Debuting on January 10, 1932, the strip was conceived largely as a publicity effort for the short films, given that *Silly Symphonies* typically did not use ongoing characters.

Disney's career, of course, flourished as the decade progressed. In 1939, Margaret Thorp stressed in *America at the Movies* how Disney's characters "have become part of America's folklore."[20] Given its enormous popularity (and daily presence in the home among newspaper readers), the strip serves as a key factor in shaping Mickey Mouse's cultural importance in the 1930s. While Disney is best known for his films, comic strips also proved to be an important part of his studio's early success.

THE EVOLUTION OF FILM AND COMICS IN THE EARLY TO MID-1930s

Just as movies went through numerous formal changes, the formats through which comics could be read also fluctuated in the late 1920s and early 1930s. Dell published *The Funnies* from 1929 to 1930, a sixteen-page tabloid-sized weekly comic with new characters rather than reprints. Available at newsstands on Saturdays at a cost of ten cents, the format was meant to resemble the color funnies section but it failed to catch on with readers, who saw better value in their Sunday papers (the same fate previously occurred with the similar effort *Comic Monthly* in 1922).

Hardcover collections of newspaper strips did better in this period, with the Cupples & Leon Corporation publishing compilations of *Harold Teen, The Gumps, Little Orphan Annie,* and *Dick Tracy,* among others. Various publishers had offered collections of reprinted comic strips dating back to 1897 with *Yellow Kid Magazine,* and there were "over five hundred books of comics" published between that year and 1932.[21] The history of cinema saw films shift from the one-minute actualities of Edison and the Lumière brothers to one-reel short films, feature-length films, and eventually talkies. So too were comics offered in a variety of formats in the medium's initial decades. Both media then settled in to a long-running format by the 1930s that remains largely the same today—sound feature films and the comic book.

Not everyone could afford the hardcover collections, however, especially as the Depression took hold in the early 1930s. One response came from the

Whitman Publishing Company and their series of Big Little Books. While *The Funnies* cost ten cents for sixteen pages, Big Little Books cost the same price for what was often more than three hundred pages (but in a smaller package typically measuring 3⅝ by 4½ by 1½ inches).[22] The books regularly adapted storylines from comic strips and used their images directly. The first Big Little Book—*The Adventures of Dick Tracy, Detective*—was released in 1932, followed by editions in 1933 featuring *Little Orphan Annie*, *Buck Rogers*, and *Mickey Mouse*, among other strips.

The format of each book saw a page of prose text side by side with an enlarged panel from the original comic strip on the adjoining page. James A. Findlay of the Bienes Museum of the Modern Book describes how "children were enthralled by the 'comic book' nature of the publications since each book generally had a text page and an accompanying facing illustration."[23] While this format is more in line with picture books rather than comic books (given how the use of sequential imagery on the same page is lacking here), Big Little Books nevertheless demonstrate the strong parallels between film and comics in this era.

These books did not just adapt comic strips—they regularly featured movie adaptations as well. As such, Big Little Books were a forum in which comics and film imagery collide, with the same audience targeted for adaptations of both media. The format treats both films and comics the same way, given the same adaptive strategy at work in combining prose text with images—be it with comics panels or movie stills. While there were occasional Big Little Books based on popular radio series, these required an artist to create new images, whereas those based on either comics or films repurposed parts of the same content from the original versions (whether a panel from a comic strip, or photorealistic imagery from a movie). The two media were quite interchangeable to Big Little readers, especially when compared to the extra steps needed to adapt stories from any other medium to the format in the 1930s.[24]

The first Big Little movie adaptations arrived in 1934, with books based on Columbia's Buck Jones western *The Fighting Code* (1933), the Universal western *Gun Justice* (1933) starring Ken Maynard, and Universal's *The Big Cage* (1933) starring Clyde Beatty (the book's title was changed to *Lions and Tigers*). The covers often attempt to re-create the look of film posters, with the last reading, "Carl Laemmle presents Lions and Tigers with the Sensational Dare-Devil Clyde Beatty." *Gun Justice* lists the film's four main

actors along with the tagline "A Universal Picture." The bottom of the cover proclaims, "Read the story—then see the Picture," creating a twofold meaning: Big Little Books alternate story and pictures with each successive page, and readers should rush out to see the film after finishing the book.

Studios both large and small saw the promotional value in letting Whitman give their films the Big Little treatment, with the books often appearing within mere weeks or months of the theatrical release. The adaptation of RKO's *The Lost Patrol* (1934) presented on its cover a list of the film's six main stars, while the book based on Poverty Row studio Mascot Pictures' *Little Men* (1934) similarly engaged in cross-promotion, the words "Read the Story See the Picture" stretched across the front. There were also adaptations in 1934 of MGM's *Treasure Island* (1934), Paramount's *Alice in Wonderland* (1933), RKO's *Little Women* (1933), Sol Lessor Productions' *Tarzan the Fearless* (1933), and the Universal Tom Mix western *Terror Trail* (1933). In 1935 there were Big Little Books based on Twentieth Century–Fox's *This Is the Life* (1935) with child-star Jane Withers, the Buck Jones western *The Roaring West* (1935), the serial *The New Adventures of Tarzan* (1935), and MGM's animal drama *Sequoia* (1935).

But it was not only youth-oriented films and adventurous B-movies being adapted. In 1934, a version of *David Copperfield* (1935) was published in advance of that film's release, along with an adaptation of the 1926 Warner Bros. silent film *The Sea Beast* (published as *Moby Dick*). In 1936, the series adapted Paramount's *The Plainsman* starring Gary Cooper and directed by Cecil B. DeMille. The popularity of Big Little Books spawned numerous competitors, including Fawcett Publishing Co.'s Dime Action Books, and Saalfield Publishing Company's Little Big Books (undoubtedly an underhanded attempt to benefit from association with Big Little Books).[25] The latter also produced movie adaptations, with books featuring Laurel and Hardy, Shirley Temple, and Our Gang, along with such films as *Peck's Bad Boy* (1934) and *Gulliver's Travels* (1939) and serials like *Burn 'Em Up Barnes* (1934) and *Chandu the Magician* (1932). Most notably, Frank Capra's 1934 Oscar-winning *It Happened One Night* was turned into a Little Big Book in 1935, proving that the format was not just intended for comic strips and kids' films, but could adapt award-winning, adult-oriented cinema.

Big Little Books thrived for decades to come, with Disney continuing to offer the *Mickey Mouse* strip for adaptation, along with feature films like *Snow White* (1938) and *Bambi* (1942).[26] As such, Big Little Books offered

readers an array of comic strip characters alongside film stars from both the silent era and the talkies in the publisher's vast catalogue of titles. With titles adapted from both media sitting side-by-side on store shelves, the choice to purchase stories based on either films or comics created a close link between the two for Big Little readers.

THE RISE OF THE COMIC BOOK

In 1934, Whitman branched out into another publication format—the comic book. Their first effort was *Tim McCoy, Police Car 17*, an adaptation of Columbia's *Police Car 17* starring McCoy (the published title incorporates the actor's headline billing from the film's poster). It was the first comic book based on a film in a period that saw the format only just beginning to take shape as we commonly know it today. At 14¾ by 11 inches, *Tim McCoy, Police Car 17* is larger than the later 6⅝-by-10¼-inch standard. Its cover has also been described as "stiff," perhaps placing *McCoy* closer to the earlier hardcover reprints of comic strips than with the modern comic book format. Regardless, the fact that it was an original adaptation of a current film and not a reprint of existing material makes it historically important, as we will see.[27]

The smaller format was first used in 1933 by the Eastern Color Printing Company, which published a collection of reprinted comic strips called *Funnies on Parade*. Used as a promotional giveaway with Proctor & Gamble (P&G) products, the title collected many popular strips in color. Salesman Max C. Gaines sold ten thousand copies of *Funnies on Parade* to P&G, and in only a few weeks they had given away every copy. Two more promotional books were created in 1933, *Famous Funnies: A Carnival of Comics* and *Century of Comics*. The enormous success of these books led Gaines to propose a new title to be sold on newsstands for ten cents, called simply *Famous Funnies*. It has been credited as the first modern comic book by historians given how its size and softcover format became the standard in the decades that followed.[28]

Famous Funnies' arrival in 1934 even gained the attention of *Variety*, although they were somewhat skeptical about its chances: "Another attempt to put across a mag comprised solely of cartoon strips is to be made by the Eastern Color Printing Co. That outfit is getting out a monthly bearing the title Famous Funnies utilizing the second publication rights of

[established strips]. Will sell for a dime. Previously a similar mag was tried by the Dell chain. Lasted but a couple of issues."[29] *Famous Funnies* would last for more than just a couple of issues, remaining on newsstands until 1955. The book reprinted numerous strips, including *Buck Rogers*, and generated a monthly profit of thirty thousand dollars.[30] It also featured a strip entitled *Screen Oddities* by Captain Roscoe Fawcett, which had previously been syndicated as a newspaper strip.[31] It featured profiles of famous actors like Warner Baxter, Katharine Hepburn, and Margaret Sullavan, along with line-art drawings. Baxter, we are told, "actually served as the chief of a fire department" while still an actor, but "lost his job when he failed to respond to a minor blaze." We also learn that movie stars "may discuss for publication their preferences in wines but are forbidden to mention their tastes in distilled liquors."[32] It might not have been substantial, but there was movie-related content in the first issue of the title that launched the modern comic book—a trend that would be built upon in the years that followed.

Famous Funnies quickly led to such competitors as 1935's *New Fun Comics*, which offered new strips rather than reprints, but they sold poorly. Readers wanted recognizable characters, not new ones.[33] The struggle to find success with anything other than reprints of newspaper strips makes *Tim McCoy, Police Car 17*'s arrival in 1934 all the more significant. As a full-length adaptation of a feature film, *McCoy* tells an extended story with a single protagonist, rather than offering a variety of different strips, characters, and storylines as *Famous Funnies* and its peers did. *McCoy* was not an ongoing, serialized title but instead tells a self-contained story (making it closer to the modern conception of the graphic novel), which might exclude it from many historical accounts as one of the first comic books if using the size and ongoing release schedule of *Famous Funnies* as a standard. Yet *McCoy* is central to the origins of extended storytelling in comic book form, given how it was newly created and presented more than a single page of panels (as per the Sunday newspaper strip reprints).

In *McCoy*, Dell turned to a film that remains little known and wasn't particularly well received in its day. *Photoplay* described it upon release as a "stock melodrama" and "woodenly acted,"[34] yet it proved vital to the early history of comic books by demonstrating the narrative possibilities for a full-length story in comics form. Telling a serialized story in a few panels per day requires a different approach from a full-length tale given the constant need for recapping previous events in a daily strip. Since *McCoy*

is an adaptation, the narrative pace of this early feature-length comic book approximates the narrative pace of a 1930s Hollywood film. This cinematic influence would persist as comic books evolved.

In 1936, Dell joined the reprint market with *Popular Comics*, which proved highly successful. It included such popular strips as *Tailspin Tommy, Dick Tracy, Little Orphan Annie, The Gumps, Terry and the Pirates,* and *Skippy,* proving that familiar characters outsold unknown properties. Other reprint titles followed, including *The Funnies, Ace Comics,* and *Feature Funnies.* In addition to such strips as *Jane Arden, Joe Palooka,* and *Lala Palooza, Feature Funnies* contained a section called *Star Snapshots* (later changed to *Screen Snapshots*) by Bernard Bailey, chronicling the careers of famous movie stars much as *Screen Oddities* had offered interesting trivia. Nonfiction items chronicling famous or historical figures (or real-life oddities) were common in early comic books. *Popular Comics* included a *Ripley's Believe It or Not* feature, while *Feature Funnies* ran a similar effort called *Strange As It Seems.* Bailey's *Star Snapshots* was a full-page feature drawn in a relatively photo-realistic style, containing a large head shot followed by several panels outlining the actor's early life and rise to fame in Hollywood.[35] For an entry on Myrna Loy, for instance, we are told that "in a recent pole [*sic*] conducted by hundreds of newspapers—and in which 39,000,000 people voted—Myrna Loy was selected as the undisputed queen of the female stars of Hollywood for the year of 1937."[36] Other actors featured include Norma Shearer, Charles Laughton, Katharine Hepburn, and Lionel Barrymore.

The same format was used in numerous titles. Bailey did a similar feature under the alias Glenda Carol called *Movie Memos* for both *Wonder Comics* and *Wonderworld Comics* (the former title changing its name to the latter after two issues) in 1939, profiling such actors as Deanna Durbin, Laurel and Hardy, Joe E. Brown, Harpo Marx, and Cary Grant. Bailey first began this format in 1936's *Wow, What a Magazine,* which lasted only four issues despite its proud title. *Wow* featured various one-page comic strips along with journalistic columns such as *How They Got in the Movies* profiling the rise of stars like Bela Lugosi. Bailey's *The Stars on Parade* profiled Fred Astaire and Shirley Temple in the first issue, describing how Astaire "once sat in a booth during a benefit given in London and danced with anyone who would pay two shillings to dance with him."[37]

Jumbo Comics also ran a feature called *Stars on Parade,* with one 1939 issue profiling Katharine Hepburn's hat collection ("So far she has collected two

hundred of them!") and describing how Jean Muir, "one of Hollywood's loveliest girls, wears the biggest shoe in the movie colony."[38] Such trivia was essential to the Hollywood publicity machine. "Every aspect of life, trivial and important, should be bathed in the purple glow of luxury," notes Margaret Thorp, so that "the aura of glamour can follow a star even beyond life's bounds."[39] While fan magazines such as *Photoplay* and *Screenland* were the more predominant form through which this luxury was promoted in print, comics played their part as well in the 1930s.

The second issue of *Jumbo Comics* also featured Edgar Bergen and his ventriloquist dummy Charlie McCarthy, the cover boasting "Scoop! Complete cartoon preview of Charlie McCarthy in 'A Letter of Introduction' / The New Universal Picture Laff-Riot." The feature film is treated to a three-page adaptation, focusing on a select few scenes while also condensing entire subplots into single captions. With movies permeating these early comic books, the mid- to late 1930s saw readers regularly offered film-oriented content alongside (mostly reprints of) various comic strips. Comic book publishers felt no need for antagonism toward the film industry as a way of distinguishing their product as a better purchasing choice; instead they welcomed movie-related content as a way of drawing in more readers. While the film and radio industries were often at odds with one another as the 1930s progressed[40]—despite such high-profile collaborations as *Lux Radio Theatre*—the comic book industry was too new and unstable (given how many early titles quickly folded) to see itself as a serious rival to the movies. As a result, early comic books frequently offered a broad range of pop-culture material in addition to the action heroes and funny animals that would eventually dominate the medium.

Even *Action Comics* #1 featured movie-related content. In addition to containing Superman's debut in 1938, the book also included a one-page feature by Bernard Bailey called *Stardust* in yet another variation of *Stars on Parade*. With profiles of Fred Astaire (reusing the same image and anecdote from *Wow, What a Magazine*), Wheeler and Woolsey, Charles Boyer, and Constance Bennett, *Stardust* once again offered readers a glimpse into the private lives of some of Hollywood's most popular stars. Hence, even what is arguably the most famous comic ever published relied in part on movie imagery, given how dominant the trend in Hollywood-related features was in this era.

FIGURE 11. *Stardust* page from the first issue of *Action Comics* (June 1938).

PROMOTIONAL COMICS AND THE BIRTH OF MARVEL

By 1939, the success of *Action Comics* led to a surge of new competitors. As historian Gerard Jones describes, "The word was spreading through the printing and pulp business: There was money to be made in comics." At the same time as a new group of publishers entered the market, some also saw the potential to make even more money by using comics as a promotional vehicle for movie exhibitors to attract more patrons. Among those who joined the comics business that year was Martin Goodman, publisher of

such pulp magazines as *All Star Adventure Fiction, Mystery Tales*, and *Marvel Science Stories*. In 1939 he formed Timely Publications, borrowing the title of the magazine for his first comic book, *Marvel Comics*. While *Action Comics* used movie imagery in the same way as other anthology titles of the period, the origins of the company that would eventually become Marvel Comics are tied to a more unique form of cinematic publicity.

The first issue of *Marvel Comics* debuted two enduring characters, the Human Torch and the Sub-Mariner. But the Sub-Mariner also appeared in another comic that same year produced by Funnies Inc. (one of several new companies to emerge in the late 1930s that printed comics for upstart publishers), which was intended to be sold to theaters as a promotional comic. Comic book giveaways at movie theaters were sporadic, but the growing affinity between the two industries saw the trend recur every few years. In 1933, *Mickey Mouse Magazine* was sponsored by various dairy companies and available at theaters and department stores. Only nine issues were published before the magazine was relaunched through new distribution channels. Several attempts at creating promotional comics for movie theaters followed in the 1930s and 1940s, including *Motion Picture Funnies Weekly* (*MPFW*) in 1939. The first issue features an eight-page story in black and white with the Sub-Mariner (an Atlantian prince), along with shorter installments of such forgotten (and forgettable) characters as American Ace, Kar Toon and his Copy Cat, and Jolly the Newsie.

Only one issue was ever created, although covers were produced for the next three issues. The series was intended as a weekly effort, with the final panel of the Sub-Mariner story proclaiming, "Continued Next Week." Just as film serials used their cliffhanger format to draw viewers back to the theater week after week, *MPFW* was created with the same intent in mind. The back cover of the first issue sums up the comic book's promotional intent with a drawn image of two men standing outside a movie theater. A line of children rushes to the ticket window: "What's the attraction? A Double 5-Star Bill or a $1000 Jack-pot?" asks the first man. "Neither! He just signed up *Motion Picture Funnies Weekly* and the kids are simply flocking in! Wish I'd signed too!" replies the second man, apparently a fellow exhibitor.

The "jackpot" reference alludes to the practice of offering theatergoers the chance to win money through quizzes, contests, and similar efforts, a common strategy by 1930s' exhibitors to lure in Depression-era audiences with the promise of a cash windfall.[41] The ad's suggestion that kids would prefer a free comic book over the chance to win some money (or see a

double bill of two "5-star" A-pictures) plays upon the rapidly growing pop-
ularity of the comic book format in the late 1930s; exhibitors failing to take
advantage of this new trend as a way of attracting more children to their
theater will apparently be left wishing they had, much like the ad's rueful
theater owner. The comic book publishing industry was still new enough in
1939 to carry with it a sense of pervasive opportunism. Many comics pub-
lishers sought to make a quick buck by not only following the emerging
superhero trend, but by also convincing theater owners of the potential for
their comics to increase box office sales.

The ad's headline proclaims "1000% Drawing Power," with *MPFW*
described as "The *first* Box-office attendance builder created exclusively for
the Motion Picture Theatre business. Fully copyrighted and protected." The
ad then breaks down the book's merits: "It's First! It's Cheap! It Repeats!
Its [*sic*] Proven! It's Just Out! It's All Yours!" The book's weekly schedule is
compared to a chapterplay ("Continues to pull like a super serial!"), and its
exclusivity is highlighted ("Public gets it *only* by paid admission to your Box
Office"). It also claims to appeal to more than just youth audiences: "Works
100% on young and old, because it uses proven popular drawing power of
Comics." The promotional potential of comic books was key to the format's
1933 debut with *Funnies on Parade*, but the sustainable use of comics as a
box office draw for film exhibitors was not yet fully proven. The growing
affinity between the two media by the end of the decade, however, made a
venture like *MPFW* seem like it had the potential to succeed.

Samples were sent out to numerous exhibitors, but the response did
not warrant a full print run so the concept was abandoned. The promise
of a weekly comic is the book's major selling point given the intent to draw
young audience members back to the theater on a regular basis. It is also
one of the drawbacks that likely prevented enough exhibitors from adopt-
ing the idea: if left with too much overstock at the end of the week (despite
the ad's explicit promise of "no leftovers"), the cost of the book would can-
cel out the extra ticket sales.

In the wake of *Motion Picture Funnies Weekly*'s failure, Funnies Inc. worked
with Goodman to produce *Marvel Comics* #1, in which the same Sub-Mariner
story from *MPFW* #1 by Bill Everett appears (now with four added pages, and
in color). There are differing accounts, however, as to whether Everett initially
created the story for *Marvel Comics* or *MPFW*—Roy Thomas notes how
"nobody to date has nailed down precisely how the one led to the other—or
even been able to prove with 100% certainty which one came first."[42]

Complicating things further is an account of Columbia Pictures' involvement in *MPFW*'s origins. Writer Ronin Ro claims that Everett originally created Sub-Mariner in conjunction with the studio's planned Technicolor serial *The Lost Atlantis* (and a proposed sequel, *Prince of Atlantis*). Ro states that Columbia asked Funnies Inc. "to create a black-and-white comic book for free distribution in movie theaters. The magazine's covers would have advertised both Atlantis films. When Columbia canceled the films, the comic [*MPFW*] was also canceled." He adds that when Everett approached Goodman with his creation, Goodman then "acquired the rights from Columbia" for the character.[43]

Ro's is the only account I have found of this version of the story. *Variety*'s coverage of the preproduction of *The Lost Atlantis* lists a budget of one million dollars, with the film purportedly offering "fantasy [which] will be done on the order and magnitude of 'The Lost World' thriller of the silent era." The film is not described as a serial as Ro suggests, but rather was to be shot in Technicolor with a six-month shooting schedule to incorporate some sophisticated effects work with miniature models. This extended schedule was unheard of for a serial, as was the high budget and color cinematography, making it unlikely that *The Lost Atlantis* was intended as a chapterplay. *Variety* also described how the recent success of *Snow White*'s animation style had "unquestionably exercised a stimulating effect on the proposed production of plastic animations in 'The Lost Atlantis' and other scheduled fantasies."[44] Ro notes that when the scale of the film's effects proved too expensive, the production was cancelled, as was the studio's involvement with Funnies Inc.[45]

Supposedly, then, Columbia wanted a comic book tie-in starring an Atlantian hero as a promotional giveaway to advertise both *The Lost Atlantis* and its planned sequel. Why they wanted an original character for the comic rather than the film's protagonist is unaccounted for. Still, if this story is true, it shows how some in Hollywood were looking closely at the potential of comics beyond just as source material for adaptation.

MOVIE COMICS: "A FULL MOVIE SHOW FOR 10¢"

The late 1930s saw further attempts to merge cinema and comics, to varying degrees of success. Centaur Comics published two issues of *Little Giant Movie Funnies* in 1938, which consisted of uncredited reprints of Ed

Wheelan's *Minute Movies* strip.[46] The book also featured what the cover promised were "Animated Movies" via a flip book effect—small drawings at the corner of each page created a seemingly moving image when the pages were flipped quickly. It was an amusing novelty, but with no real cinematic content the book failed to satisfy comics fans seeking their favorite films and actors.

A more direct treatment of movie content came with 1939's *Movie Comics* from publisher Maxwell Charles Gaines. After his success in gaining newsstand distribution for the *Famous Funnies* reprint comics, Gaines formed All-American Publications in 1938. The move would prove significant not only to how movies were handled in comic books, but also to the development of superhero comics. The first issue of his debut title *All-American Comics* arrived in early 1939, and was partially a reprint book featuring such strips as *Skippy, Reg'lar Fellers*, and *Mutt & Jeff*, among others. All-American Publications was formed with the help of Harry Donenfeld, owner of National Allied Publications and Detective Comics Inc.; Gaines had brought *Superman* to Donenfeld after creators Jerry Siegel and Joseph Shuster tried unsuccessfully to sell it as a newspaper strip, and the success of *Action Comics* led to a surge of new companies. All-American became a sister company to the latter two, with all three merging by 1946 to form what would become DC Comics.[47]

In the same month that *All-American Comics* began, Gaines launched another venture: under the company name of Picture Comics Inc., he published six issues of *Movie Comics*. The cover of each issue promises "A Full Movie Show for 10¢," which was the same price as what most kids paid for a movie ticket (while adults frequently paid between twenty and thirty-five cents).[48] The first issue featured condensed adaptations of four feature films from 1939—*Son of Frankenstein, Gunga Din, The Great Man Votes*, and *Fisherman's Wharf.* The cover also promised several additional categories of films—"Shorts—News Reels—Comedies"—endeavoring to replicate the full experience of a night at the movies for the reader, with its various forms of programming (both feature-length and short films, fictional and nonfiction films, various genres, etc.).

Movie Comics attempted to offer more added value for the reader's money than even a ticket to a double bill could provide, with adaptations of four features, plus a wide array of extras. The first issue also adapts the 1939 Universal serial *Scouts to the Rescue.* In true cliffhanger fashion, the

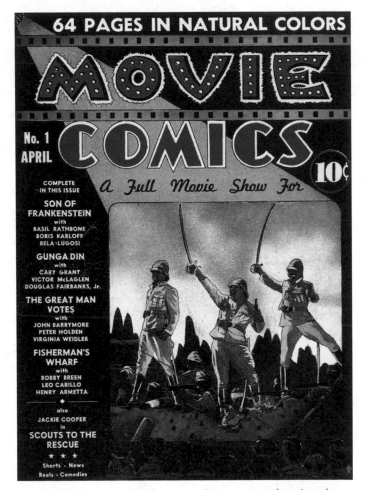

FIGURE 12. Cover of the first issue of *Movie Comics* (April 1939).

adaptation continues into issue #2. Further added value was offered in the cover headline "64 Pages in Natural Colors," playing up the fact that the movies featured are black and white. The film images presented in *Movie Comics* are all colorized, but the color quality is often far from natural.

Even more in keeping with double-bill distribution is the way in which *Movie Comics* regularly mixed adaptations of both A- and B-films. Major studio A-films like *Gunga Din, Four Feathers,* and *The Great Man Votes* are featured alongside such B-films as *The Saint Strikes Back,* and westerns like *Blue Montana Skies* and *Mexicali Rose.* The series featured a mixture of major studios (RKO and Universal), Poverty Row studios (Monogram,

Republic), and independent producers (like Sol Lesser Productions, Walter Wanger Productions) who often used United Artists as their distributor.

The first issue introduces the book's concept to readers in a title page labeled "Now Showing" (featuring replicas of the opening credits' title card for each film). The book's editor tells us that *Movie Comics* is "the newest idea in Comics and Movie Books—a combination of both, which we believe you will like very much." "Movie Books'" refers to the use of film imagery in many Big Little Books, with *Movie Comics* positioned as a hybrid publication format—not your usual hand-drawn comic book, and not your typical movie-related book with its prose narrative and individual images.

FIGURE 13. Editorial page from *Movie Comics* #1 describing how the series offers readers a "permanent record" of various films.

The editorial continues: "Movie Comics will present each month, an idea of the outstanding pictures to be shown in your neighborhood theatre so that you will better enjoy them when you see them on the screen." The book is therefore intended in one sense as a promotional tie-in for upcoming films, drawing in curious film fans looking for a sneak peek at the story and images from movies coming soon to their local theaters. Later issues began suggesting different ways to enjoy *Movie Comics*: the third issue states, "We hope you will enjoy reading it before you see these pictures and again, after you see them in your neighborhood theatre," while the fifth suggests, "We hope you will read Movie Comics, *before* and *after* you see the pictures, so you can get triple the enjoyment out of them!"[49]

This evolving rhetoric over various issues indicates a hedging of bets as to when readers will pick up the book, especially with many comics being passed along or traded to successive readers. Fawcett Publications noted the power of comic books' "secondary readership," with an "average comics magazine life of 90 days" as any given copy passes through the hands of various readers, whether shared, traded, discarded, and so on.[50] With films distributed in different parts of the country (and regions of larger cities) at different times in this era,[51] some readers might have seen a film come and go before they picked up a given issue of *Movie Comics*, while others might still be waiting for the film to open in their neighborhood.

The editorial announcement that the series will attempt to convey *the idea* of certain movies reflects a key issue in cross-media adaptation. Ideas are mental representations, with the standard definition of communication seeing an idea transferred from one mind to another via a medium, be it speech, the written word, or an image.[52] When ideas are poorly communicated, they are typically not received well or with much clarity. Such miscommunication may be the fault of the sender, possibly even a dim-witted recipient, but often the fault lies in a medium's ability to fully convey a particular idea. Media theorist Edmund Carpenter famously noted how the various differences between media "means that it's not simply a question of communicating a single idea in different ways but that a given idea or insight belongs primarily, though not exclusively, to a single medium, and can be gained or communicated best through that medium." Each medium "codifies reality differently; each conceals a unique metaphysics," says Carpenter.[53]

Movies and comics both tell stories through a series of images, but—as we saw with the earlier discussion of *Tailspin Tommy*—the temporal quality

involved with each is different. Movies use editing to maintain or disrupt a feeling of time as it unfolds directly, be it through cross-cutting, a montage sequence, or following one scene with another taking place later the same day. This temporal quality is not the same with comics, since the reader controls how fast—and in what order—they experience the story and its imagery. Editing allows filmmakers to surprise audiences by revealing certain images in specific moments, a strategy that is difficult to achieve effectively in comics with anything but the first image of a page with multiple panels (since readers can see the entirety of the page, and any surprises that may lie ahead). The use of panels separated by a blank space called the gutter means that comics are dominated more so by concerns of space rather than time, along with what Thierry Groensteen calls "the general architecture of the page" and how the "graphic treatment" conveys meaning therein (i.e., how panels are designed and how many are used per page, how gutters are used to separate the panels, where word balloons are placed, etc.).[54]

With these theoretical principles in mind, the editorial concern for how *Movie Comics* conveys "the idea" of movies suggests that whatever meanings and pleasures the series might offer stems in large part from how it allows the reader a simulated cinematic experience through a different medium. Reading *Movie Comics* is certainly not the same process as viewing a film, but the book still conveys the "idea" of watching a movie—as readers, the series' covers frequently place us in a darkened theater, sitting behind other spectators as we follow the light from the projector to the towering screen in front of us. As such, many readers no doubt imagined what the film would be like as they flipped through the pages. This was exactly the intent of the book's publishers, who sought to reach eager filmgoers looking for a way to extend their love of the movies beyond the act of filmgoing.

Just as part of the pleasure involved in looking at a drawn image of an airplane in mid-flight in a *Tailspin Tommy* strip comes in knowing that we have a privileged perspective of an action that ordinarily involves movement (with the plane's soaring motion captured for a split-second), so too is the temporal nature of the cinematic image removed when re-created in comics form. This allows us to scrutinize each image in the narrative for as long as we like, and control both the pace and the order of the book's sequential imagery. We don't get the entire film's narrative as we would in a theater, but we do get an idea of the story and its images, in turn creating an experience that draws upon our memories and knowledge of being a moviegoer.

When the book's readers then go on to see the film, their experience with the comic's version of the narrative informs how they watch it onscreen— with the comic book treatment becoming part of the viewer's overall cinematic experience. You certainly might not always find it as satisfying to read the comic adaptation as to see the film (since Carpenter tells us that each medium does some things better than others, we might prefer for instance to see the fight scene in *Gunga Din* in full motion onscreen rather than a single, static image in the comic); nevertheless, there are still certain pleasures to be had in the unique way that a comic book presents its combination of visual imagery and the written word.

On a formal level, however, whatever simulated cinematic experience a reader might have with *Movie Comics* is not achieved by reproductions of actual frames from the film. Instead, publicity photos are used (as was the case with Big Little Books). One issue describes how the adaptations use "photographs from the actual movie."[55] When films are produced in Hollywood, numerous publicity photos are taken on the set throughout production. These photos are of course not the "actual movie" itself, but they have a close affiliation with the films they chronicle. Publicity stills are distributed to exhibitors, journalists, and other outlets for promotional purposes prior to a film's release.[56] With the comic book's story and art needing to be completed weeks, if not months, in advance in order to move through the various editorial, printing and distribution phases, the publisher would have acquired all the various publicity materials (still photos, press kit, story synopsis, etc.) well in advance of the film's release in order to produce the distinctive art style of the series.

The series was "originally intended to be published by Emil Strauss's Photochrome, the engraver who had been producing color separations for early comics."[57] When All-American Publications secured the title, they contracted out the work to Photochrome rather than use their own staff. Comics colorist Jack Adler described how because *Movie Comics* "used photographs to tell the stories . . . they had to do a lot of retouching to make the pictures fit the stories. The retouching required airbrushing." Indicative of just how young the comic book industry was at the time, Adler confessed that he knew nothing about airbrushing and learned on the job (ruining an airbrush in the process) while working on the series.[58]

Indeed, what is clearly unique about the *Movie Comics* issues is their use of a fumetti cartoon style, creating a unique hybrid of photorealistic images with hand-drawn cartoons. Fumetti (sometimes called photonovels after the Italian term *fotoromanzi*) is a style of producing comic art using

photographic images as the basis of the imagery, typically adding captions or word balloons. *Movie Comics* uses fumetti as the overall basis of its artwork, but often uses just the actors' faces or bodies. The rest of the panel is frequently hand-drawn (things like the background imagery, props, and sometimes even the actor's bodies). As a result, there is often a noticeable difference in the amount of photographic content in any given panel versus that which is not photorealistic. Colorist Sol Harrison described how, "in most cases, we did not have the photographs that fit the story. We had to piece heads, hats, uniforms together, flop faces and fit the various pieces together."[59] The reader therefore gets cinematic imagery, but the images themselves become highly mediated (e.g., colorized, airbrushed, manipulated in size or scale).

Given that each page contains multiple panels, this regular juxtaposition between photorealism and the more abstracted nature of the hand-drawn image creates an overall style that is certainly unique—perhaps too unique for most readers. In *Cartooning: Philosophy and Practice*, Ivan Brunetti notes that the use of photographic images in creating comics "opens up a quagmire of theoretical questions about 'what is comics,'" and that the uniqueness of this formal style often diverts readers' "attention away from the actual content of the story." The combination of realistic and abstracted images within a single panel is akin to the cinematic combination of live-action footage and animation in a single shot—a technique that the viewer generally accepts in a film like *Who Framed Roger Rabbit?* (1988) because it clearly establishes the rules of its diegesis so as to make the presence of animated figures entirely natural to the human characters and in turn the audience.

But because *Movie Comics* is directly based upon still images that are already entirely photorealistic, the use of abstracted hand-drawn imagery becomes all the more complicated for the reader because of the inconsistencies in the formal methods used to construct the various panels—sometimes the actors are seen in full, sometimes their heads are placed on cartoon bodies. Brunetti sees the juxtaposition of photography and comics form as being odd and ultimately inappropriate: "In the context of comics," he says, "photographs usually have a lurid, oily (one might say pornographic) verisimilitude that feels incongruous and wrong, like when you see an eleven-year-old girl walking down the street wearing leather pants."[60]

I can see how this might be true when it comes to a character found only (thank goodness) in *Movie Comics*—Phoozy. The story of a young boy heading for Hollywood to become a star upon seeing a photo of Carole

Lombard and Jimmy Stewart in *Made for Each Other* (1939), Phoozy does indeed feel oily, incongruous, and wrong. Clad in white footie pajamas, his buttocks precariously peeking out from the unbuttoned rear panel, Phoozy was no doubt intended as an amusing film-related diversion from the book's various adaptations (or, more likely, as filler to meet a certain page count). It could have been amusing had it been hand-drawn, as other humorous strips in the book were (Action Camera; Movietown). But the use of a fumetti style for an original character creates an odd dynamic for the reader as we observe this young boy's misadventures (the punchline involves a hitchhiking Phoozy raging as a car passes him by).

FIGURE 14. *The Adventures of Phoozy* from *Movie Comics* #1.

Whereas we might accept the use of photographic images as we read film adaptations because they use recognizable actors, the use of photos to depict a little boy who (1) dreams that Carole Lombard was kissing him instead of Jimmy Stewart; (2) decides to hitchhike three thousand miles to Hollywood; and (3) does so in his aforementioned pajamas comes off as alarming rather than endearing because of the images' relative lack of abstraction compared to a hand-drawn representation. Photographs denote realism whereas drawings allow for exaggeration. A drawing of a saucer-eyed childlike Annie or Skippy hitchhiking may make us smile at the folly of youth, but a photograph of a real child doing the same might remind us of how inappropriate and dangerous this action really is.

By comparison, the fumetti treatment of films like *Son of Frankenstein* (1939) or *Stagecoach* (1939) is far more enjoyable since the use of photorealism is applied to familiar film genre tropes and famous actors, allowing for processes like the suspension of disbelief and escapism to occur more readily. In *The History of the Comic Strip: The Nineteenth Century*, David Kunzle argues that the ability to achieve an immersive physiological sensation is found in both the origins of comics and cinema. He describes how artist George du Maurier created "a remarkable superimposition of three phases of a horse jumping a gate" in 1868, a decade before Eadweard Muybridge's photographic experiment of a horse in motion. The latter demonstrated the principle of persistence of vision, which became the basis of cinematography. With du Maurier's horse appearing to leap off the page, Kunzle notes: "We have here the *sensation*, rather than the mere impression, of the horse charging at and over us . . . [and this reaction] was to be the aim of the earliest cinema, which, to the delight and terror of the spectators, filmed the head-on rush of the express train."[61]

If *Movie Comics* therefore seeks to offer readers the "idea" of filmgoing, it is not a stretch to believe that many readers felt relatively similar sensations (excitement, trepidation, etc.) while reading about Basil Rathbone's efforts to revive Frankenstein's monster, or John Wayne's shootout with a group of Apaches, as they would while seeing these same images unfold onscreen. While a movie in comic book form is not the same experience as it is on celluloid, all adaptations seek to retain some elements of what made the original text successful, and create similar positive reactions for the viewer (or reader, listener, etc.) through the distinct formal means of the new medium.

More specifically, if the sensation of film spectatorship (or at least the idea, or impression of watching cinematic imagery) can be achieved in

comics, the ways in which readers are positioned at the start of each adaptation becomes key to how *Movie Comics* replicates films. The *Stagecoach* adaptation begins with introductory panels for each of the nine major characters, listing the actors who play them. The credits "A Walter Wanger Production / United Artists" are placed above the film's title. Similarly, the

FIGURE 15. Adaptation of *Stagecoach* from *Movie Comics* #2 (May 1939).

Son of Frankenstein adaptation lists actors Basil Rathbone, Boris Karloff, and Bela Lugosi above the title in the same manner as the film's posters and lobby cards. The comic also lists the film's screenplay, producer, and director credits, along with the fact that this is "A *New* Universal Picture," complete with a small drawing of the studio logo.

FIGURE 16. Adaptation of *Son of Frankenstein* from *Movie Comics* #1.

Few if any films attempt to make you feel like you are reading a book (lacking, for instance, an author's dedication, detailed publishing information, or table of contents). *Movie Comics*, on the other hand, hopes that readers will feel at some level like they are "at the movies" by simulating how movies begin—with a studio logo and opening credits. The comics do not list the writers and artists from All-American and Photochrome who worked on each adaptation, just the films' screenwriters, directors, and other Hollywood talent. The immersive aim of allowing readers to imagine themselves in a movie theater is key to the book's creators, beginning with the cover image of a darkened theater in mid-screening, continuing with the use of actual fonts and logos from the film's posters, and on to the insistence on cast lists and company credits for each adaptation.

Whether you find the adaptive process involved in *Movie Comics* successful or not, and whether it achieved or failed to create the sensation of filmgoing for readers in 1939, the series' attempt to merge movies with comics is an important cross-media experiment. It was not the only attempt in 1939 to transport cinematic imagery to a new medium. *Gunga Din*, the lead story in the first issue, was also part of an experimental NBC television broadcast in 1939. RKO prepared a condensed twenty-minute version of the film, which *Variety* reported was "virtually the full Gunga Din footage edited down to two reels, with close-ups covering the story for the most part." The reliance on close-ups was necessitated by how unclear long shots appeared on the small screens of sets at the time, which ranged from five to twelve inches.[62] This abridged version of the film demonstrated to television viewers in 1939 both the benefits (private consumption outside of the theater) and limitations (some formal cinematic elements don't translate as well as others) of shifting cinematic content to a new medium. These same pros and cons are also true of the *Movie Comics* adaptation of *Gunga Din*, making the book a similarly relevant part of the early history of film's cross-media extensions.

Finally, the most significant value of *Movie Comics* was in how it sought to offer a lasting version of the films it presented. In the decades before television and home video, films were not commonly seen again after their theatrical release, unless reissued again in subsequent years. Only the memory of a film's images and story remained once it left theaters in this era.[63] *Movie Comics* offered readers a tangible record of their favorite films from 1939, something that could be referenced for future reference and enjoyment. If the memories and "ideas" of certain films grew increasingly faint once they

were no longer in theaters, then *Movie Comics* allowed those ideas to live on in the mind. The first issue announces to readers that the book will "serve as a permanent record of the pictures you have enjoyed, which you can refer to again and again with pleasure and entertainment." Similarly, the second issue's introduction states, "We want to make Movie Comics a permanent record of the outstanding pictures you have seen or will see in your neighborhood theatre, so you can enjoy them over and over again."[64] Eventually filmgoers would be able to buy video tapes, laser discs, DVDs, and Blu-Ray discs of their favorite films to enjoy again and again after a film had left theaters, but for a brief time in 1939 this function was fulfilled by a short-lived comic book series.

In the end, *Movie Comics* lasted only six issues, with no explanation apparent for its demise. The final issue contained no opening editorial, nor any concluding page (although readers are encouraged to enter a contest related to the 1939 serial *The Phantom Creeps*; entrants would never know if a winner was selected, given the promise of an announcement in a future issue). We might speculate that readers found its hybrid film/comics approach too awkward and unappealing, and this is quite likely given how many later series adapting films to comics did not use this fumetti approach, favoring strictly drawn images (but often with wholly photorealistic covers of the film's stars). The late 1930s was a highly turbulent period in comic book publishing that saw numerous companies emerge, each attempting to imitate the success of Superman and *Action Comics*. Publisher Max Gaines had launched *Movie Comics* in the same month as his *All-American Comics* title, which one advertisement in the final issue of *Movie Comics* describes as "America's fastest growing comic monthly for all American Boys and Girls!"[65]

It is likely, then, that the overwhelming success of the superhero comics market led Gaines to divert more of his creative and financial resources to creating new heroes rather than testing the market for film adaptations any further. By the end of the year, Gaines would publish *Flash Comics* #1, starring The Flash under his All-American Publications line, soon followed by the debut of Green Lantern in *All-American Comics* and the creation of Wonder Woman the following year (along with other popular characters such as Hawkman, Hawkgirl, and The Atom). The rest, as they say, is comic book history.

As comic books developed throughout the 1930s, it seemed increasingly likely that films and comics could become natural allies, though

FIGURE 17. *Snow White* newspaper strip from March 13, 1938.

perhaps without the same rapport as between film and radio. The comic strip characters who thrived in feature films and serials also appeared in top-selling books like *Feature Funnies* and *Popular Comics*, while numerous comic books included biographical sections about Hollywood actors. Efforts like *Tim McCoy, Police Car 17, Motion Picture Funnies Weekly,* and *Movie Comics* may have met with varying degrees of success, but they were early experiments in adapting and promoting films at a time when the comic book was emerging as a new format and itself testing out different types of content.

Disney's newspaper strips enjoyed continued popularity throughout the decade, with the studio taking advantage of their high regard to promote its first feature-length release in 1937. *Snow White* was serialized as a Sunday comic strip beginning on December 12 of that year. Since the film's Los Angeles premiere was on December 21, and didn't reach other cities until the early months of 1938, many filmgoers came to the film with the comic strip images of Snow White and the film's early characters as their point of visual comparison. The same was later true of *Pinocchio* (1940), which began as a Sunday strip in December 1939 several weeks before the film premiered.[66] The visual appeal of comics held significant promotional value for Disney—comics were not a competing medium but a way of drawing readers to the theater.

The success of such newly created comic book characters as Superman and Batman was not lost on Hollywood as the decade wound down. As the 1940s began, several film studios jockeyed to be the first to bring a superhero to the screen. With help from the men who brought Betty Boop and Popeye to theaters, filmgoers would soon see a man leap tall buildings in a single bound and earn an Academy Award nomination in the process.

3 · 1940s COMICS-TO-FILM ADAPTATIONS

The wealth of comic strip adaptations in the late 1930s continued strong over the next decade. They were joined onscreen in the 1940s by the numerous comic book action heroes who came crashing through into theaters. The overwhelming success of Superman's monthly adventures in *Action Comics* quickly gained Hollywood's attention. The possibilities for adapting comic books and their superheroes seemed vast, as multiple studios fought for the rights to popular characters. Within just a few short years of the format's debut, comic books had fast become a medium whose characters were sought after by producers in other media.

In turn, the version of Superman that audiences experienced in the character's early cinematic adventures is different in many ways from that found in the comic book, as are the radio and newspaper strip versions. By 1941, just three years after he first appeared in the pages of *Action Comics*, there were multiple iterations of the character in concurrent media forms (which was also true of Batman two years later). The notion to create any kind of continuity among these different versions was not a common concern at the time, however. While audiences are typically thought to crave a certain degree of faithfulness from the screen versions of their favorite comics characters (something that was not always delivered upon), narrative fidelity to source material was not a pressing factor in how comic books were adapted to films throughout the decade.

Fidelity was a central concern of early film adaptation theorists, with George Bluestone's 1957 study *Novels into Film* becoming the dominant scholarly approach to the relationship between cinema and literature for decades thereafter. Bluestone stressed the need to account for the different aesthetic possibilities inherent in both literature and film: "The film becomes a different *thing*" altogether from the novel, and in turn the specific strengths and limitations of each medium should be taken into account when approaching adaptations, he argues.[1] Still, many film scholars have subsequently pointed out the problematic nature of such early criticism. James Naremore writes, for instance, of how Bluestone's approach "tends[s] to confirm the intellectual priority and formal superiority of canonical novels . . . [as] a standard of value against which their success or failure is measured."[2]

Despite this, many of Bluestone's ideas about the relationship between movies and novels can tell us a lot about how adaptations of comics from this period were envisioned, albeit indirectly given that he does not explicitly analyze such films himself. Bluestone notes that Hollywood adaptations of novels from the 1930s through the 1950s "persistently rate among top quality productions," as evidenced by their regular contention for Academy Awards.[3] He also argues that there had been certain assumptions among film audiences in recent decades regarding literary adaptations: "that the novel is a norm and the film deviates at its peril; that deviations are permissible for vaguely defined reasons—exigencies of length or of visualization, perhaps—but that the extent of the deviation will vary directly with the 'respect' one has for the original; that taking liberties does not necessarily impair the quality of the film, whatever one may think of the novel, but that such liberties are somehow a trick which must be concealed from the public."[4]

The films based on comic books and strips in the 1940s were rarely "top quality productions"; they were usually chapterplay serials from the smaller Hollywood majors like Columbia and Universal, or else B-films and serials from such Poverty Row studios as Republic and Monogram. With comics not garnering as much critical respect as novels and plays, the ways in which "deviations" and "liberties" function in adaptations of comics are quite different from films based on other literary sources, especially given the economic limitations under which B-films operated as compared to larger-budgeted Hollywood productions adapting novels.

Fidelity analysis often becomes a kind of shell game in media studies, in which the revolving search for authenticity between the adaptation and its source material is played out. In describing how Batman has gone through multiple incarnations in film and television adaptations spanning numerous decades, film scholar Will Brooker rightly notes that the character "has proved himself infinitely adaptable, retaining only minimal identifying traits of appearance and personality through every incarnation as he transforms according to the needs and moods of each period."[5] Under such circumstances, fidelity criticism alone is not enough to understand how cinematic iterations of comics characters functioned, especially when we consider how many characters in this period were consumed by audiences in multiple media forms simultaneously (i.e., comic books, comic strips, film, and radio). Some adaptations were decidedly more faithful than others in this decade, but their popularity was not contingent upon sticking closely to the source material. Comics were adapted into animation, serials, and feature films in the 1940s, with varying results. Just as a narrative is presented differently in each medium based on particular formal constraints and aesthetic possibilities, so too did the different cinematic forms through which comics characters appeared onscreen in the 1940s place limits and/or offer unique potentials to how a comic was adapted.

IT'S SUPERMAN!

In 1941, Superman took flight across theater screens for the first time. Max Fleischer Studios, creator of the *Betty Boop* and *Popeye* series, produced the first of several animated shorts distributed by Paramount. The first effort, *Superman,* was nominated for an Academy Award for Best Short Subject, Animated (losing out to Disney's *Lend a Paw,* in which Mickey Mouse's dog Pluto rescues a kitten).

The animated shorts were not the first efforts intended to bring Superman to theaters, however. By 1940, several film studios wanted to feature the comic book hero in a live-action serial. Negotiating for the rights to the character alongside Universal and Columbia, Republic Pictures believed they had reached a deal "in principle" with Harry Donenfeld of Superman Inc. (a subsidiary corporation of National Allied set up to handle licensing Superman).[6] Boosted by the success of their *Dick Tracy*

films, Republic even went so far as to announce a Superman serial for their 1940–41 season, but without a formal contract in place Donenfeld seemed to have kept his options open.[7] The tentative deal would have placed significant limitations on Republic—a "representative of Superman Inc. [would] have the right to be present on the Republic lot and to okay script and production," and the whole deal could be cancelled if "it is found that the serial detracts from the popularity of the Superman radio program or the Superman comic."[8]

The studio began working on a script before the deal was finalized, but encountered difficulties in getting it approved; *Variety* noted that Republic began seeking ways to have their contract with Superman Inc. "liberalized" so as to speed up preproduction efforts.[9] Such disputes led to the parting of ways in mid-August of 1940, but when Donenfeld quickly turned to Paramount and Fleischer Studios by month's end, Republic still sued for breach of contract, unhappy with the better treatment received by these new players.[10] In the meantime, Republic salvaged the unused script by creating its own heroic character, The Copperhead, for the serial *The Mysterious Dr. Satan* (1940). The film kept much of the original plot and characters, even using the name Lois for the hero's love interest. This, then, was a phantom version of a Superman serial, lacking the title character himself but retaining the narrative framework through which the studio would have presented him.

When the deal between Paramount, Fleischer Studios, and Donenfeld was reported in September 1940, the animated shorts were described as "capitalizing on the popularity of the radio and syndicated newspaper character" (note how the comic books are not mentioned).[11] The first Superman short was to be initially completed in time for the upcoming Christmas season, but was ultimately not released until September 1941.[12] The Fleischers felt that more time and money should be spent on the series, in order to set it apart from the other animated efforts in the marketplace. Dave Fleischer notes that while most animated shorts cost between nine and fifteen thousand dollars to make at the time, he felt that it would take much more than that to do justice to the superhero: "I couldn't figure out how to make Superman look right without spending a lot of money. I told [Paramount] they'd have to spend $90,000 on each one."[13]

Remarkably, Paramount agreed to the larger budget (which other sources state as being closer to fifty thousand dollars in the end), which was

"more than three times as much as the typical Popeye" short.[14] While comics characters had settled in to a pattern of serials and B-films in the 1930s (after a few larger budget efforts like *Skippy* as the decade began), the 1940s began with Superman receiving the big-budget treatment—relative to other animated efforts of the period. While further feature-length A-films starring comics characters were still more than a decade away, the first cinematic effort to bring a comic book superhero to the screen was a lavish one for its respective cinematic form.

As Fleischer Studios completed their first animated Superman film, Paramount began preparing a major marketing campaign to ensure that the larger budget shorts were well received by exhibitors and audiences. *Action Comics* had a circulation of 840,000 copies in 1940, while the *Superman* comic had a circulation of one million and the newspaper strip was featured in 182 "big city" papers.[15] Paramount hoped that this substantial readership would mean bigger box-office returns, using an "asses-in-seats" marketing angle in one of the studio's more bizarre trade ads. A broken-down theater chair addresses the reader: "I was about to fold up under a load of dust and cobwebs. But then the boss booked Superman and I've been holding up my end ever since. Superman makes a terrific impression on me—and there's a ticket sold for every one of my impressions!"[16]

Aiding in this marketing push was the creation of multiple trailers, a rare occurrence for short films in this era. One such trailer showcased the "Supermen of America Club," a Superman fan club that began courting members as early as the third issue of *Action Comics* in 1938. Members could purchase such merchandise as emblems, badges, and rings, with the trailer's profile of this devoted comic book fan base apparently seen as a key strategy to boosting theater attendance for the animated shorts.[17]

The first Superman short opens with a brief origin of the character, chronicling the demise of the planet Krypton, the arrival of baby Kal-El on Earth in a rocket ship, and the duality of Clark Kent and Superman. It is interesting to note which version of this original story is used, however, as there were already multiple iterations in the comic books by this point. 1938's *Action Comics* #1 describes how "a passing motorist, discovering the sleeping babe within [the rocket], turned the child over to an orphanage." The Kents are not involved as adoptive parents in this original account, with the child instead raised by the orphanage to "maturity."[18] This serves as the basis for the Fleischers' cartoon, which uses a still image of an orphanage as

FIGURE 18. Trade advertisement for the first animated *Superman* short film (*Film Daily*, June 10, 1942).

Clark's childhood is quickly surmised for viewers. A syndicated Superman newspaper comic strip began in January 1939, in which the Kents are again absent. Yet this account was built upon later that year with the release of *Superman* #1, in which the Kents find the baby, turn it over to the orphanage, but then soon seek to adopt him. "The love and guidance of his kindly foster parents was to become an important factor in the shaping of the boy's future," we are told, with his mother telling a young Clark that he must use his powers "to assist humanity."[19]

The Kents would be featured in future adaptations containing Superman's origins, such as the 1940s radio series, 1948 film serial, and 1950s television series, with the tensions between Clark's earthly upbringing and his Kryptonian heritage becoming increasingly prominent in such films as *Superman* (1978), *Superman Returns* (2006), *Man of Steel* (2013), and the *Smallville* (2001–2011) television series. When a character is adapted into different media forms over multiple decades there are usually many versions of (and continuities for) that character, with alterations in narrative or characterization that can be subtle or overt. Superman is a key example of how a character traverses multiple media given the many variations present in such a short time across four different forms.

Between 1938 and 1941 there were the comic books, newspaper strip, radio program, and animated film series, all of which offered a slightly different version of the hero regarding his origins and characterization. These versions competed with one another in the overall media marketplace of the 1940s, with audiences able to choose one or more versions of the character to consume (and producers able to draw upon different elements in subsequent adaptations). Under such circumstances, the issue of fidelity became largely beside the point. Films based on comic books and strips didn't always hold true to the characterization of the source material in the 1940s, but critics and audiences admired them nonetheless.

To modern animation historians, however, the *Superman* shorts were a failed attempt. In *One Hundred Years of Cinema Animation*, Giannalberto Bendazzi calls the Fleischers' Superman films an "insignificant rendition" of the character.[20] Noell K. Wolfgram Evans laments that the Superman films "are not cartoony" because of the resultant "artificiality" in attempting to re-create the realistic movements of human beings (as opposed to the physically impossible contortions of Mickey Mouse using a dachshund for a propeller in *Plane Crazy*, for instance) and in turn the films "lack some of the benefits that come along with the medium" of animation.[21]

Whatever aesthetic detriments might be found in the series (although many fans—myself included—would disagree that they are "insignificant"), these *Superman* films are a vital example of cross-media interplay in this era. The radio actors who portrayed Clark Kent, Lois Lane, and Perry White also voiced the characters in the films, while the films' music was later used in the Superman radio program.[22] The interplay between the different adaptations of Superman continued throughout the decade, with

producers often referencing versions from other studios and other media. The lines between the various media adaptations often became blurred for Superman fans in the 1940s (especially with the comic book Clark Kent watching his cinematic alter ego onscreen, for instance, as the next chapter demonstrates), with the variety of different versions readily embraced by fans despite any incongruities.

SERIAL HEROES: CAPTAIN MARVEL, BATMAN, CAPTAIN AMERICA

While the animated shorts regularly offered comic book fans a cinematic version of the Man of Steel, the desire for a live-action Superman film still loomed. This would come later in the decade, but not before several other heroes appeared onscreen in various serials. *Variety* reported in 1940 that serials ranked among Hollywood's most profitable products, despite having "long been regarded more or less as stepchildren even on the lots where they've been the bread and butter of the annual output." Serials, they noted, "have a fixed market, which assures grosses ranging anywhere from 100 to 300% over and above the lensing outlay." The 1937 *Dick Tracy* serial, for instance, cost $300,000 to produce and had earned $700,000 by 1940.

Much of this success is credited to how most serials from this period were adaptations: "At least 80% of the material used nowadays for the chapterites [*sic*] is backgrounded against characters that have been widely built up via newspaper comic strips or radio serials. Producers have discovered that these figures have pre-sold audiences for the film versions."[23] Comic books had fast become another bankable source of presold audience members by the early 1940s, with the success of *Action Comics* leading to a boom in comic book publishing as the decade began. Comics historian Colton Waugh noted in 1947 that there were 60 titles published between 1939 and 1940, while in 1941 it was up to 168.[24]

One of National's main competitors was Fawcett Publications, whose most popular character was Captain Marvel in *Whiz Comics*. After Republic's failed attempt to produce a live-action Superman serial, Fawcett approached the studio directly and offered up Captain Marvel as an alternative. After an active bidding war between Republic, Universal, and Columbia for Superman's screen rights in which National sought to retain as much control

as possible, here was a publisher that just wanted a film based on their character and which practically gave away the screen rights for free.

Republic wasted little time after their tentative Superman deal fell apart in August 1940. Whereas the rise of the comic strip adventure serials in the mid-1930s saw movie producers looking at what were frequently long-running newspaper strips dating back to the 1920s (such as *Buck Rogers* and *Tailspin Tommy*), the sudden rise in popularity of comic book heroes saw film studios react more quickly. Having already lost out on Superman, Republic wasn't about to miss out again on the chance to offer eager comic book fans the first live-action adaptation.

By early October the studio had signed a deal with Fawcett to produce a film based on Captain Marvel, with production beginning in the last week of December.[25] Fawcett granted an extremely agreeable deal to Republic, which had only to purchase advertising in four of the publisher's magazines, use the Captain Marvel name in the film's title, and give proper screen credit to the publisher. In return, Republic could take any liberties they wanted with the source material.[26]

The studio worked closely with Fawcett on publicity efforts for the serial. While films based on comic strips in the 1930s often saw tie-in efforts with various regional newspapers, the comic book format presented new possibilities for cross-promotion. Comic books offered a new type of product with which to advertise film adaptations, with characters clearly branded on a book's cover rather than appearing within a newspaper's interior. Newsstand dealers were given publicity items like posters and banners in the hopes of selling more copies of *Whiz Comics* while advertising the film. Thousands of copies of *Whiz* were given out to theatergoers on the serial's opening day in numerous cities, with some exhibitors describing how their normal ticket sales doubled as a result.[27]

Exhibitors had balked at a weekly promotional comic like *Motion Picture Funnies Weekly* that wasn't tied to a specific release, but many were happy to use comic books to market a particular film. The same promotional campaign was used for Republic's 1942 serial *Spy Smasher*, based on another Fawcett character acquired by the studio. Fawcett provided free full-page ads for the film in their line of comic books and worked closely with any interested exhibitor to promote the release. Such efforts again vastly improved normal serial attendance numbers for the film as well as increased circulation for *Whiz Comics*.[28]

Being the first live-action adaptation of a comic book character, the same marketing strategies seen a decade earlier with *Skippy* resurfaced again with *Adventures of Captain Marvel*. One advertisement shows the hero crashing through the cover of *Whiz Comics* with the caption, "Right out of these pages onto the screen zooms the most thrilling serial ever filmed by Republic Studios!" Another announces: "The same familiar Captain Marvel that has thrilled you so much in the comic books comes to life on the screen in twelve smashing episodes, and you can't afford to miss a single one of them!"[29] Vitality is once again used to market the adaptation, with a comic book hero coming to life as he bursts forth from the page. At the same time, any possible fears about the screen treatment are assuaged by the promise that this is the "same familiar" character that readers know and love.[30]

But this seeming need for familiarity did not equate to audience demands for narrative fidelity, which is why the superhero serials of the 1940s are a vital case study in cinematic adaptation given the wide range of approaches taken toward their source material and its characters. *Adventures of Captain Marvel* is faithful to the hero's origin story in some regards but not others, shifting the setting from America to Siam. The biggest challenge for the filmmakers in adapting the superhero from the page to the screen would be in re-creating Captain Marvel's spectacular powers, especially flight. While 1930s serial heroes like Flash Gordon, Buck Rogers, Jungle Jim, and Tailspin Tommy were ordinary men facing incredible situations, 1940s comic book serials introduced the problem of re-creating superpowers onscreen using human actors. Animation afforded Superman the full range of abilities from his comic book adventures since both are hand drawn, but live-action filmmaking requires the simulation of super-strength, the ability to fly, and other such physical impossibilities.

These special effects were even more difficult on a low budget at a minor studio such as Republic, which lacked both the time and money that a Hollywood A-film unit might be able to put into developing a superior re-creation of super-heroic abilities. As a form, low-budget serials were poorly equipped to depict superheroes, but the industry saw the chapterplays as the way to reach a target audience. Hollywood generally saw comics as juvenile fodder in this era, with superhero movies left to the serial factories to be produced for presumably youthful viewers. Children were a large portion of serial audiences, but adults regularly watched them too.[31] Kids

weren't the only ones reading comic books, either—a 1944 study of reading habits found that 41 percent of adult males and 28 percent of women read an average of six comic books per month.[32] These statistics seemed to warrant a big-budget Hollywood superhero film, but fans would have to wait until the rise of blockbuster cinema in the late 1970s, when *Superman* (1978) was but one of many genre efforts predominantly inhabiting the domain of B-filmmaking in past decades to be retooled for mass audiences.

The special effects of superhero serials test what is aesthetically possible in low-budget filmmaking along with what is possible in their narrative scope. *Captain Marvel's* flying effects were achieved through a combination of a dummy on a wire-pulley system and rear-projection footage. The seven-foot papier-mâché dummy was typically shown in an extreme long shot and was occasionally intercut with shots of actor Tom Tyler against rear-projected footage of fast-moving clouds to give the impression of rapid flight.[33] The dummy remained in the same pose throughout the film—both arms outstretched before it. Such shots were then followed by Tyler or stuntman Dave Sharpe leaping to the ground or on top of Marvel's opponents, creating a sometimes awkward juxtaposition between these movements and the prone, rigid dummy. The same is true of Tyler's movements while suspended in a harness in the rear-projected shots when used next to shots of the stiff dummy. Both types of flying shots were used in the opening credits of each chapter as the main titles began, allowing viewers ample time to study the effects before experiencing then within a narrative context. As the dummy approaches the camera in the opening shot, we can more clearly make out how artificial the face and general anatomy are. On the whole, though, the film's special effects are admirable given Republic's production methods and budgetary constraints.

Much like some modern CGI, the flying scenes using the dummy appear more convincing during night scenes given how the cover of darkness masks the technical limitations of the special effects. But despite the obvious artificiality of the flying effect, reviews of the serial were highly favorable and praised the film's action sequences. *Showmen's Trade Review* noted how "few children, in their wildest imagination, have dreamed of such situations as one sees in this film. . . . There are many technical details which have been smoothly handled, so that every 'trick' seems to be genuine."[34] "Excellent effects are obtained for scenes showing Tyler flying through the air," wrote *Motion Picture Daily.*[35]

FIGURE 19. A dummy is used in the *Captain Marvel* serial (Republic, 1941) during flying scenes.

With the success of *Captain Marvel* and the animated *Superman* shorts proving marketplace demand, National took out a trade ad in 1942 celebrating the Man of Steel's cinematic success in which they also touted the potential of the company's other characters as well. The ad features Batman and Robin proclaiming how Superman "is currently making box-office history," while editorial material adds the following:

> And congratulations to you too, Batman and Robin! You're Superman's only rivals in popularity polls across the country . . . and you're due to make your bow in movies before the snow flies again!
>
> And while we're on the subject . . . Hop Harrigan, The Three Aces, and many other heroes of juvenile popularity are just waiting their chance to meet their fans on screen . . . and millions of their fans are waiting for them![36]

Columbia began production on a Batman serial in 1943 after beating out two other studios for the screen rights to the character.[37] Will Brooker notes

how the serial was explicitly marketed using the comic book's imagery, with newspaper ads that "used Bob Kane artwork, while the film poster incorporated drawings of Batman and Robin rather than photographs of the actors in costume."[38] One ad simply announces, "Look! Batman and Robin are in the Movies!"[39] Another forgoes the soft sell and boasts that Batman is "A Hundred Times More Thrilling On The Screen!" (although a few years later, comic books had apparently gained some esteem in the eyes of Hollywood marketers, as the ad for the 1948 serial *Batman and Robin* bragged of being only ten times more thrilling).[40]

A *Batman* newspaper strip was developed shortly after the serial's release in 1943, which overtly used certain elements from the film. Whereas the interplay between the *Superman* short films and radio series involved voice actors and musical elements, with *Batman* we find shared narrative aspects between the film, comic strip, and comic books. The serial's first chapter opens with voiceover narration describing the Bat Cave, which is where we first find Batman and Robin. Both the comic book and strip would soon refer to the hero's headquarters by this name, with the strip's Bat Cave closely resembling the Columbia set with its large bat hanging above a desk and chairs, complete with candles on the wall.[41] The comic books also altered the character design of Bruce Wayne's butler Alfred Pennyworth to more closely resemble actor William Austin, notes Brooker, as the character shifted "from a short, bumbling figure to the tall and more sophisticated butler familiar from the mid-1940s onwards."[42]

Both Batman and Captain Marvel also draw from cinematic influences in their character design: artist Clarence C. Beck (who had previously been an artist on one of Fawcett's movie magazines) admits basing Marvel on actor Fred MacMurray,[43] while Bob Kane acknowledges that he was inspired by *The Bat Whispers* (1930) and *The Mark of Zorro* (1920) in creating Batman. So too did some of Batman's most popular villains stem from cinematic origins—the Joker was based on Conrad Veidt in *The Man Who Laughs* (1928), while Two-Face was inspired by *Dr. Jekyll and Mr. Hyde* (1941), with the image of a split face in the film's poster nearly identical to the way Two Face was drawn the following year. Comic books were regularly influenced by Hollywood in their early years, using cinematic imagery to develop its own.[44]

As an adaptation, the 1943 *Batman* serial is often decried by fans. Batman's costume is thought by many to look ill-fitting on actor Lewis Wilson, with

FIGURE 20. The Bat Cave is featured in the first *Batman* serial (Columbia, 1943). The film was the first to name the cave, with the comics soon also referring to it as the Bat Cave.

Kane even describing him as "an overweight chap . . . who should have been forced to go on a diet before accepting the role" (though one 1943 review actually calls Lewis "a handsome and personable Batman").[45] While some see it as lacking, Brooker describes how *Batman* is essentially faithful to the comic book despite the liberties necessitated by the production methods of B-unit filmmaking.[46] The film does omit the comics' colorful villains, centered instead around Japanese saboteur Dr. Daka as a way of grounding the story within the World War II spy elements that were so common in serials of this era. In perhaps the most apparent change, the Batmobile is a humble Cadillac lacking any bat-inspired flourishes. What remains the same, however, is the comics' basic character traits (Batman as a crusader of justice), settings (Gotham City, Wayne Manor), costumes (Adam West wore a Batman costume using very similar design elements in the 1960s television series), and crime-oriented subject matter.

The same degree of faithfulness cannot be said of Republic's 1944 *Captain America* serial. Making his debut in 1940's *Captain America Comics* #1

from Timely Publications, the character's origin story here sees the frail Steve Rogers transformed by an experimental serum into a super-soldier with enhanced "mental and physical abilities," gaining "the strength and the will to safeguard our shores!"[47] In the comic, Rogers serves as a U.S. Army private, changing into Captain America whenever needed, and is aided by his youthful sidekick Bucky Barnes. In the serial, Captain America's alter ego is District Attorney Grant Gardner, whose secretary Gail Richards replaces Bucky as the sidekick who knows the Captain's true identity. His private's uniform is replaced by a business suit, the army base by an office. Here, the character is not the product of a powerful serum, and Captain America possesses no enhanced abilities. In place of his iconic star-spangled shield, the hero carries a gun while battling crime. The character's costume even fails to include several elements featured in the artwork from the film's posters and lobby cards—a chainmail tunic and winged headpiece.

Timely publisher Martin Goodman gave the screen rights to Republic for free, believing that the publicity created by the character's screen presence would lead to increased sales of the comic book. Just as they had arranged with Fawcett, their contract with Timely allowed Republic free rein with the character,[48] but this time the studio exercised this option without restraint. An army base would have necessitated more sets, props, and so on, and placed limitations on the film's narrative scope. The new approach made use of existing Republic sets and materials while allowing for an urban adventure tale (i.e., one that could make full use of the studio's back lot). Despite the cost-cutting script decisions, the film was actually the most expensive serial ever produced by Republic, with a final cost of $222,906.[49]

Goodman objected to the changes upon seeing the finished product, asking for all references to Grant Gardner in the film to be changed to Steve Rogers through the use of retakes. Republic rejected the costly suggestion, implying that the changes were really Timely's fault because the sample material provided to the studio did not refer to Captain America as Rogers, nor did they state that he was even a soldier or that he didn't use a gun in the comics.[50] The source material was obviously researched in haste, reflecting a different adaptive strategy from most other superhero serials. Unlike *Adventures of Captain Marvel*, there is no origin provided in *Captain America*, nor do we get anything similar to *Batman*'s narration explaining the character's motivations. While the costume remains somewhat similar

to that in the comics, *Captain America* lacks *Batman's* faithfulness in setting, characterization, and narrative tone (given the former comic book's consistent war-themed plots).

There were starkly different approaches in Hollywood to the issue of fidelity—be it to narrative elements, characterization, or visual design—in adapting comic book source material throughout 1940s comic book serials. Republic did what was best for the studio rather than fans of *Captain America Comics*, although historian Richard Hurst contends that the changes were not problematic for audiences: "As an adaptation of the original comic book character, the adaptation was admittedly less than successful and relatively dishonest. However, this was not a great drawback in the overview since many in the serial audience were not that familiar with the comic book, and most of those who were Captain America readers were able to accept even the unnecessary changes readily."[51] Comics fans were presumably just happy to have a film—any film—made from their favorite characters, in the same way that Fawcett and Timely gladly gave away the screen rights to their books in the hopes of increasing newsstand sales.

NEWSPAPER STRIP SERIALS: *TERRY AND THE PIRATES*, DON WINSLOW, AND RED RYDER

At the same time as comic book adaptations were taking flight onscreen in the early 1940s, serials based on newspaper comic strips remained strong in this period as well, continuing the popularity they had enjoyed throughout the late 1930s. Whereas comic book heroes posed new problems for producers in re-creating such powers as flight and super strength onscreen, the newspaper strips that were adapted as serials at the beginning of the decade relied on the tested genre elements of western and jungle-adventure films. Columbia released *Terry and the Pirates* in 1940, while Republic offered *Adventures of Red Ryder.* While each serial had a presold fan base from the comic strip, both could also be marketed solely on their familiar genres, should any exhibitors have been wary of their audiences growing tired of such adaptations.

Comic strips were gaining critical attention by the 1940s, recognized for their cinematic qualities and as a medium capable of formal complexity rather than just providing "illiterate" fodder for juveniles and

unsophisticated adults, as the 1939 reviewer of *Blondie* implied. In a 1944 article for the *New Republic*, art critic (and future film critic) Manny Farber wrote: "Comic strips are not what they used to be. Those in the *New York Post*, which are the ones I read, are getting increasingly genteel, naturalistic and like the movies, moving away from the broad comedy of their beginnings. . . . The technique and behavior in comic strips have been increasingly refined." Farber went on to describe how strips like *Terry and the Pirates* "have taken over the close-up, the angle shot and dramatic lighting, and have learned the advantage of variegated views of a subject and scenes packed with décor, people and shadows to simulate liveliness."[52]

Similarly, in a 1951 article for *The Nation*, Farber heralded *Terry and the Pirates* creator Milton Caniff as one of "the last in the great tradition of linear composers that started with Giotto and continued unbroken through Ingres." Farber notes how the "funnies turned into pseudo-movies" by the 1930s, "taking over close-ups, tricky lighting and the rest." He goes on to draw more cinematic parallels with Caniff's work: "There have been some miraculous cinematic inkers like Caniff (*Terry* [*and the Pirates*], [*Steve*] *Canyon*), who draws incredibly sharp and delicate faces with a crowquill pen and exciting clothing with a shadownicking brush; yet even Caniff fondles his troubled adventurers like a cosmetic man making up a glamour girl."[53]

The serial format seemed like a natural fit for *Terry and the Pirates* given the cinematic parallels that Farber describes, the adventurous nature of the strip, and the success of the radio series that had begun in 1937. Caniff hated the film, however. Biographer Robert C. Harvey describes how Caniff was "excited by the prospect of turning *Terry* into a movie," but that as the serial's preproduction got underway "it quickly became apparent that his role in the making of the movie would be that of an interested bystander." While he would receive a portion of the film's profits as the strip's creator, Caniff cared more about how his creation would be adapted and how the new version would affect the original:

> As *Terry*'s creator, he was more than casually concerned about how the movie people might portray his characters. He wanted the contract to protect his characters, to prohibit the moviemakers from changing them in any way inconsistent with the manner in which the strip presented them. Columbia was unwilling to surrender creative control to Caniff, but Caniff didn't want

artistic approval: he wanted only reasonable assurance that his creation would not be irrevocably altered. Columbia, however, was reluctant to commit to any contractual provision that might interfere with the process of adaptation.[54]

Caniff has told of how he "ran out of the theater screaming" after watching the serial's first chapter, and that he refused to watch the remaining install-ments. "It was a terrible, miserable show . . . Almost a disgrace. After seeing just one episode, I wanted to hide. And it rankled. During the long, dark hours of the night, you grind your teeth down to the gums. . . . It's one thing if you're a producer or a multifaceted person with lots of irons in the fire, but the *Terry* characters were all I had."[55]

Caniff's lament raises the question of whether an adaptation in another medium affects the way that fans consume and enjoy the original text. The characters might be all that the creator has, but once an adaptation is produced, the fans suddenly have different versions—sometimes compli-mentary, sometimes competing. Caniff's fear that his creation would be "irrevocably altered" by the film version has more merit than we might think at first. We might desire to experience the same story and its charac-ters in multiple media forms, but a new version inevitably affects the origi-nal version upon return to it. Just as we bring preconceptions about how a familiar story will be adapted when we go to the movie theater, so too do we return to that story again with the images and alterations of the new ver-sion as a frame of reference.

This process is perhaps not so problematic with novels, but since com-ics are an ongoing form their fans soon return back to the books and strips after seeing the cinematic versions. It might be years before a novel is read a second time, but comic strips are returned to daily and comic books read monthly, meaning that a film's photorealistic images (and their human embodiment of drawn characters) affect how viewers return back to the comics on a more immediate level than with novels. The faces on the page are now tempered by the images of the actors who played them onscreen, and the characters exist in two separate narrative continuities that the reader must now differentiate between.

In the case of *Terry and the Pirates*, the differences were substantial. "The strip's celebrated realism was nowhere in the serial plot," writes Harvey. "Littered with lost civilizations, ancient idols of fabulous worth, a band of

villains dressed as tigers, a murderous gorilla, and erupting volcanoes, the only things the writers took from the strip were the names of the principal characters," he notes.[56] In the strip, Terry was an orphan but in the film his father lives, as does the father of another character who had died. The strip's central villain, the Dragon Lady, is changed from a pirate to the high priest-ess of a lost civilization (which had never figured in the strip). The character Big Stoop, a nine-foot-tall mute whose tongue was cut out by the Dragon Lady, now spoke in the serial because producer Larry Darmour felt they "could get so much more out of the character if he speaks." Attempting to preserve the continuity between the film and the comic strip, he rational-ized: "In this connection, I believe you can assume that the action of this serial dates prior to the time the Dragon Lady cut out his tongue."[57]

Darmour and other serial producers likely felt that the fidelity wasn't a pressing concern with serials based on comics, given the presumed juvenile audiences for both the source material and the adaptations. Perhaps they felt that children weren't as sophisticated at distinguishing the differences between the two versions, or that they wouldn't care so long as the action was constant and the cliffhangers enthralling. But while serial producers always had to keep younger viewers in mind, some began looking to adult audiences as well in the early 1940s as a way of expanding their market. In turn, a somewhat different approach to the material was required in order to convince older viewers that the cliffhanger format could offer more than just juvenile thrills when adapting comics characters.

With their 1942 serial *Don Winslow of the Navy*, Universal sought to make the dialogue "more adult than usual" as part of an overall trend by both that studio and Columbia to "create an adult following for their serials." In order to do this, such films would have "more mature plots" in addition to featur-ing "topical stories covering current world conditions." "Where originally framed primarily to whet the interest of juvenile patrons, shorts produc-ers claim they are now gearing their 'chapter plays' to fit the adult mind," reported *Variety*.[58]

The effort was a success, with one review noting that the serial was more convincing than most: "Producers have given it a first rate cast and produc-tion values. First chapter concerning a submarine captain who's ordered by the Scorpion to blast a boat carrying workers for a U.S. naval base hints more plausibility than usual in this serial. Opening shots of big battlewag-ons in battle maneuvers are authentic."[59] Similarly, *Showmen's Trade Review*

told potential exhibitors that *Don Winslow* "had none of the earmarks of the customary ground-out serial play" and featured "real production values. If they did a lot of faking you and your audience will never know it."[60] This desire for authenticity functions on several levels—with creators like Caniff seeking to prevent inconsistencies with his strip, to critics praising the realism presented within a cliffhanger format more commonly associated with obvious artifice, to producers hoping to please both young and older fans alike with their treatment of the source material.

In effort of achieving such authenticity, *Don Winslow* was partially filmed at the San Diego Naval Base, but it also reused sets from Abbott and Costello film *In the Navy* (1941) for which a replica ship deck was built.[61] The U.S. Navy Department cooperated with the serial, even sending uniformed navy men to the premiere (while setting up recruiting stations in the lobby) to add an official touch to the film.[62] The same drive toward narrative credibility was found in Columbia's *The Phantom* (1943), based on Lee Falk's popular newspaper strip. "The action has been directed so that it appears more plausible than most serials, yet the element of mystery is there to attract the kids and give the proper amount of excitement," noted one review.[63]

The attempt at creating authenticity, or the audience's perception thereof, is also seen in the design work for the credits of the 1940 *Adventures of Red Ryder* serial from Republic. As seen throughout many 1930s serials, producers invoke the source material directly by using actual newspaper pages to showcase comics imagery before transitioning into their cinematic equivalent. The same strategy used by Universal is employed to a different end by Republic in *The Adventures of Red Ryder*. The opening credits of each chapter begin with a shot of a *Red Ryder* comic strip. In the middle of various drawn images is a panel containing the photographic image of star Don Berry as the main character. The camera tracks into this panel, and once fully entrenched within the borders of the panel, the still image begins to move, as Berry rides his horse. The film's title is then superimposed over top of the image, with the lettering replicating the font style of the comic strip's title. The font is also used for the title of each chapter, invoking the viewer's experience with the strip and linking live action with hand-drawn art as a way of assuring audiences that the cinematic depiction of the cowboy hero was a true one.

This approach was continued in the film's advertisements, featuring drawn images of Red Ryder, along with the strip's font for both the title and

the credit "By Fred Harman," just as the creator's name appears in the newspaper strip. Much like *Skippy*'s ads did at the start of the 1930s, these drawn images are positioned within the middle of a series of photorealistic images of scenes and actors from the film.[64] Republic might not have always actually delivered on viewers' hopes for an accurate rendition of their favorite comics stars (as demonstrated by the significant character changes, deletions, and additions in their *Dick Tracy* and *Captain America* serials, for instance), but they framed their adaptations in such a way as to offer at least the promise of an authentic version. While Caniff feared that the film version could alter how readers approached his comic strip, film producers were less concerned about the impact that their adaptations might have on the source material and more interested in having audiences accept that whatever variations the cinematic versions offered were made with their viewing pleasure in mind—even if they were typically motivated by economic constraints instead.

FROM THE PAGES OF ACTION COMICS: KATZMAN VS. SUPERMAN

Serials based on newspaper strips continued as the decade progressed, with Don Winslow returning in 1942 with *Don Winslow of the Coast Guard*. That year also saw *King of the Mounties* as a chapterplay, followed by 1943's *Adventures of Smilin' Jack* and 1945's *Brenda Starr, Reporter*, but the pace of such adaptations slowed by mid-decade. The same was true of films stemming from comic books—be it animated shorts or live-action serials. The final *Superman* short was released in 1943, with the series' demise a result of both relatively high production costs and declining exhibitor interest. After *Captain America*, it would be several years before another high-profile comic book hero appeared onscreen. A few of National's characters were adapted for serials, but none was the star of his own book. Hop Harrigan had been a supporting player in *All-American Comics* since its debut in 1939, but the title is better known for featuring the original incarnation of Green Lantern. Hop, a young aviator, got his own radio show in 1942 and a serial from Columbia in 1946, but by 1948 both his radio and comic book appearances ended and the character was forgotten.

Two other supporting characters also received their own serials from Columbia, *The Vigilante* in 1947 and *Congo Bill* in 1948. Both were back-up players in *Action Comics*. None of these serials required prior knowledge of the characters given their clearly defined genre elements—*Hop Harrigan* could be enjoyed as an aviation-adventure film, *The Vigilante* as a western, and *Congo Bill* as a jungle-adventure entry. There were also serial adaptations of such newspaper comic strips as *Brick Bradford* (1947), *Tex Granger* (1948), and *Bruce Gentry* (1949) in this period as well, with films based on comics enjoying a relatively steady presence in the late 1940s despite a temporary turn away from adaptations overall in the film industry. In 1948, Hollywood saw the need for less adapted works in favor of original scripts, given how "fresh material is needed to lure a carefully shopping public in to theatres." *Variety* reported that 73 percent of all "story buys" purchased in the first half of the year were "original stories" rather than the rights to source material stemming from magazines, comic books, novels, or radio plays.[65] Still, some of National's biggest characters returned in 1948, with serials starring both Superman and Batman.

But a serial wasn't National's first choice as Superman's initial live-action foray. In 1946, Superman Inc. expressed interest in having another cinematic take on the character. The company hoped for more than just another B-film serial—instead they envisioned a feature-length film to be produced in color. In an even bolder move, they sought a satirical rendition starring either Bob Hope or Danny Kaye. Hope had played the hero on radio that year for the Armed Forces Radio Service series *Command Performance* (in which he jokes, for instance, that he should stop by the YWCA to test out his X-ray vision).[66] While some fans might have questioned the use of Hope or Kaye as the Man of Steel, a comedic take on Superman starring either actor would have resulted in something that Hollywood had yet to offer comic book readers—an A-film treatment of a character with high-end production values and special effects.

When their hopes were dashed, Superman Inc. granted the screen rights to B-film producer Sam Katzman, who approached several studios about making a serial. Universal Pictures declined, having ceased making serials in 1946. Republic Pictures was naturally hesitant to work with Superman Inc. again, given the legal action taken over their failed attempt in 1940, along with being named as a defendant in the case against Fawcett Comics over the similarities between Superman and Captain Marvel. The studio even

issued a statement decrying the possibility of realistically portraying a fly-ing superhero in a live-action film (although they would reuse the same fly-ing dummy in such sci-fi serials as *King of the Rocket Men* [1949] and *Radar Men from the Moon* [1952], to simulate flight via jet-pack).[67]

Katzman indeed struggled in the preliminary special effects work used to make Superman fly. A full day of shooting was spent with star Kirk Alyn in a harness suspended by wires, but the result looked entirely unconvinc-ing when the test footage was played back. The wires were clearly visible, a concession that even Katzman (renowned for his frugal filmmaking) wasn't willing to make.[68] Heeding Republic's forewarning, he settled on a more unconventional approach to make Superman fly—animation. When we first see the hero take flight in the film's second chapter, it is to rescue a woman from a burning building. "This looks like a job for Superman!" proclaims Alyn as Clark Kent via voiceover, borrowing the line from the radio program just as the Paramount shorts did. In so doing, the audiences' experiences with the character in other media forms are invoked at a key moment in which the film attempts to solidify its own interpretation of Superman's incredible abilities.

Alyn ducks behind a parked car, emerging in his Superman costume before pausing to look up at the blaze. As he leans forward on bended knee as if to propel himself into the air, an animated cloud of smoke begins to envelop the actor's lower half, with his full body then replaced by an ani-mated approximation which leaps skyward and flies into a window of the burning building. The smoke cloud trails his initial propulsion, both sig-nifying the speed and power of Superman but also slightly masking the technical nature of the transition for audiences as Alyn is replaced by his animated counterpart.

The actual drawn images used to animate Superman here are not overly detailed, with little attention paid to anatomical accuracy (his individual fingers disappear as the shot progresses, he lacks a distinct mouth, eyes, ear canal, etc.). The film's director, Spencer Bennet, lamented that Katzman gave Columbia's animation department limited funds with which to achieve such special effects, and that the animated scenes might have looked more convincing had the producer doubled their "$32 per foot of film" budget.[69] If the Fleischer films have been criticized for not being "cartoony" enough, Katzman's film suffers from animation that is too loose and unrealistic.

Prior to this scene, audiences enjoyed Superman's first appearance in the serial in which he bends a broken train track just in time to prevent a locomotive from derailing. The shift to a hand-drawn Superman for his second appearance only a few minutes later is jarring given that we have just seen Alyn perform simulated super-heroic efforts in the flesh.

As the animated Superman flies inside the window, the scene cuts to a crowd of onlookers at street level. "Something flew in the window!" says one man. "It was a bird!" shouts a woman, once again invoking the radio program and its opening narration ("Up in the sky! Look! It's a bird! It's a plane! It's Superman!"). Inside the building, Alyn—now live-action—scoops up the trapped woman in his arms and rushes back to the window through the flames. The scene cuts back to the crowd, with one man shouting, "Look, there he is again!" The animated Alyn then flies back to the ground carrying the woman, landing behind the same car.

To complete the landing, a medium shot through the car window shows the actor finishing his descent and placing the unconscious woman on the ground. The use of animation is each case is brief—two seconds for the takeoff and three for the landing. Whereas Katzman felt that the visible wires in his test footage would be detrimental in convincing audiences of the character's ability to fly, the obvious artificiality inherent in replacing an actor with an animated semblance invokes the same problem. In each case, the specific formal qualities used to create the special effect are obvious. Unless Katzman believed that his viewers would be unable to tell the difference between Alyn and his animated counterpart, audiences would still recognize the same cinematic sleight-of-hand at work that the visible wires would have betrayed.

As was the case with the dummy in *Adventures of Captain Marvel*, the combination of animation and live-action footage raises the problem of achieving verisimilitude in a film's special effects on a reduced budget. Since human beings cannot fly unassisted, movies will always have to depict a hero's ability to fly through artificial means. The trick, much like any magic act, is to never let audiences figure out how an effect is done as they are experiencing it. When a particular technique (be it digital, animated, or papier-mâché) is used only sporadically and briefly, the audience has less time to ponder how it works and is ideally too caught up in the excitement of the action to scrutinize it closely. The 1950 follow-up serial *Atom Man*

vs. Superman also uses animation for its flying sequences, but often inter-cuts live-action footage of Alyn in a harness, usually in medium shots (with Katzman likely having salvaged the usable footage from his 1948 test foot-age in which the wires were less prominent).

The effects are even more intriguing given how the film's producers tried to convince audiences that Superman was not a mere actor in the film—but that he was real, despite appearing in both live-action and animated form. "'I wasn't allowed to tell anyone I was Superman,' recalls Alyn . . . so the illu-sion of Superman actually being from Krypton wouldn't be broken for the kids. I could say that I was Clark Kent—but not Superman.'"[70] Superman received top billing in the films' credits, while Alyn's name was absent. *Variety* explained how Columbia "doesn't want to insult the cliffhanger's moppet audience with the advice that anyone but the great man himself could play the role." The trade magazine toasted Alyn in an article entitled "Hail the Forgotten Man!" calling him "Hollywood's unknown actor." "Most thesps are embittered over one thing or another," it notes, but "the one with the most reason to hate the world" is Alyn, thanks to the serial's sly billing.[71]

A similar strategy was used in 1931's *Frankenstein*, in which a question mark appears instead of Boris Karloff's name in the opening credits, creat-ing the impression that the monster might be real. *Frankenstein*'s intended audience was not children but adults, proving that the approach can be used with all ages as a way of building intrigue around a larger-than-life character who is seemingly real. *Superman*'s print ads echoed this: "For the First Time! The One and Only Superman . . . Rocketing to Real Life in a Mighty Super-Serial!"; "The one and only Superman—Your Favorite Hero of Comics Magazines, Radio and Newspapers Comes to Dynamic *Real Life* in Columbia's Thrilling Movie Serial!" The constant emphasis on reality is ironic, not only given the film's use of animation but also since the posters use drawn imagery rather than photorealistic images.

Animation was also used for other action sequences, such as when Superman bursts through a cave wall to rescue a group of miners after an explosion. Once again Alyn is replaced in mid-motion via a dissolve as he makes contact with the rocky wall, with less than a second of animation used to show Superman in action (the brevity again aiding the effect; lingering onscreen, however, is the hole in wall, also animated,

FIGURE 21. Kirk Alyn is replaced by his animated counterpart in the *Superman* serial (Columbia, 1948) to create the effect of Superman breaking through a rock wall.

left by his body). The explosion of Krypton and the rocket ship's escape are also animated, but the effect is less jarring given how it is the film's first instance of animation and is used to depict outer space rather than the human form.

The film's script follows the radio show closely in portraying the demise of Krypton. Both the serial and the first episode of the program feature Superman's father, Jor-El, addressing Krypton's council about the cataclysmic events to come, with the character delivering the line "Krypton is doomed!" in both versions. As opposed to the narrative economy necessitated in the origin from cinematic debut in 1941, the serialized nature of both the radio program and Katzman's film allowed for a prolonged opening in which the events by which Superman arrived upon Earth could be told in depth. Much like the program's first episode, the serial's initial chapter also recounts the planet's explosion, the sad farewell to their infant son Kal-El by parents Jor-El and Lara, and the infant's journey in a rocket ship to Earth. The serial's credits list it as not only being "Based on" the comic books but also "Adapted from" the program, demonstrating the close connection between the cinematic and radio versions of the character.

Ultimately, the radio series, animated shorts, and live-action serial all offer Superman fans a range of interpretations of the character in different media forms, each with its own limitations (flight being reduced to a

sound effect on the radio, and difficult to achieve in a believable way with live-action). In many ways, the various superhero serials of the 1940s are much less successful than their comic book counterparts. What works well in the pages of *Whiz Comics* or *Action Comics* doesn't necessarily translate as effectively onscreen, particularly when low-budget production methods are involved. The pleasure we take in a static image of Captain Marvel flying or punching through a wall stems in part from our ability to imagine the scene set in motion, since comics are a participatory medium requiring readers to make connections between panels. If Superman is flying in two consecutive panels, the reader imagines a prolonged period of flight. Speed lines are often used to create the impression of movement so that we don't imagine our hero merely floating in the air.

When cinematic special effects are compromised by either fiscal or technological limitations, the equivalent imagery of a superhero soaring through the air looks artificial in a way that is not the case on the page. A person flying or running at super-speed usually appears no less natural on the page than do images of someone walking or standing, because the same brush strokes are used to depict each action. Cinematic special effects involve not just the recording of reality but its inherent alteration, so the success with which Hollywood can re-create what our heroes can do on the page is dependent on a producer's bankroll, a technician's skill, and other complex factors.

The same issues are present in modern Hollywood as well, despite the prevalence of digital special effects. Comics scholar Scott Bukatman notes that "the superhero film feels, for the most part, like something less than the sum of its parts" and "generally feels like an impoverished version of superhero comics." "There is nothing at stake," he argues, when computer-generated figures do battle with one another, since the removal of the human body gives us "corporeality without *corpus*." The special effects of 1940s superhero serials demonstrate the same "rupture" that Bukatman describes with modern films between "human space and plasmatic space" as characters shift between their CGI and human forms,[72] albeit that such ruptures are more overt when Katzman's animated Superman or the flying Captain Marvel dummy zooms behind a large rock and emerges again as a costumed actor. In turn, films like *Adventures of Captain Marvel* and *Superman* are fascinating case studies to do with the limitations of special effects in the Classical Hollywood era.

FEATURE FILMS: TRACY TRIUMPHS, TILLIE KEEPS TOILING, PALOOKA PERSEVERES

While film serials were often aimed at youthful audiences, feature films based on comics regularly appealed to a wider age range. In contrast with the afternoon matinees in which many serials played, feature films in this era were programmed as part of a double bill, with largely adult audiences attending evening screenings. As such, feature films could not typically get away with the same approaches to plot and characterization found in the serials, in which action scenes took precedence. It also meant the need to include more well-known actors and/or recognizable character actors, such as the casting of Mike Mazurki and Boris Karloff as villains in the *Dick Tracy* series of the mid-1940s.

There were no American feature films based on comic books in this decade, only comic strips. But the feature film was more structurally akin to comic books than strips in the 1940s, because unlike most comic strips the stories told in comic books were not typically serialized across multiple issues in their early years. Their storylines were most often self-contained rather than ongoing, and comic book readers didn't need to devote themselves to regular installments of an adventurous story told in small segments over a prolonged period of weeks or months. Comic book fans could miss any number of issues and still enjoy the start of a new adventure, since the narratives followed more traditional story structures containing a beginning, middle, and an end, building toward a climax with a clear resolution at the end of each issue.

Adapting an ongoing comic strip, in which stories usually took several months to reach a break in the action (there were no true conclusions, however, unless a strip was cancelled), posed a unique challenge for feature films. While serials allowed for stories to play out over numerous chapters, the average running time for a feature length B-film was around one hour. The long-running subplots of comic strips cannot be accommodated in such a brief running time, so feature film adaptations usually presented new tales about the main characters. If a series of films developed, subsequent narratives were often centered on a supporting character, such as how each *Dick Tracy* film focused on a particular villain or how certain *Blondie* films played up Dagwood's boss Mr. Dithers or the family dog, Daisy.

Numerous feature versions of comic strips appeared in the early 1940s, from a wide range of studios. RKO distributed *L'il Abner* (1940), based on Al Capp's comic strip and produced by the independent company Vogue Productions. Producers Releasing Corporation offered *Reg'lar Fellars* (1941) based on the strip of the same name, while Monogram Pictures produced *Private Snuffy Smith* (1942) and *Hillbilly Blitzkrieg* (1942) based on Billy DeBeck's strip *Barney Google and Snuffy Smith*. With both Poverty Row and major Hollywood studios distributing such adaptations, comics characters starring in feature films appeared in a wide range of theaters, often reaching metropolitan, neighborhood, and rural viewers alike in a way that not all serials did.

In 1941, Columbia produced a new version of *Tillie the Toiler*, hoping to re-create the success of their ongoing *Blondie* films. Penny Singleton, who played Blondie, even apparently chose the actress who would embody Tillie onscreen herself. According to one fan magazine, Singleton and her husband, Robert Sparks (producer of the *Blondie* series), were doing radio interviews while on their honeymoon. Singleton spied secretary Kay Harris working on her typewriter at a Cincinnati station and suggested her to Sparks. While such serials as *Terry and the Pirates* and *Captain America* took little care in preserving the authenticity of the original comics, Columbia apparently felt the need to closely duplicate Tillie with their casting choice. "Dozens of established Hollywood actresses tried out" but "were rejected because they failed to live up to the physical requirements of the comic strip *Tillie*," reported Gloria Brent of *Hollywood* magazine: "*Tillie the Toiler*, you must remember, is more than a cartoon character to millions of newspaper readers. She is practically human, and her fans don't want her tampered with when she goes Hollywood. The movie *Tillie* must closely resemble the pen-and-ink *Tillie*. She must be tall, brunette, flip, fresh, flirtatious, and pert-nosed. These rules were as inflexible as the tiny waist and southern accent on Scarlett O'Hara."[73]

Much as Skippy's fans worried that the character would be unfavorably re-created onscreen in the early 1930s, the same concerns were evident as the following decade began. Casting an unknown actor as a comics character is a recurring strategy in Hollywood because the audience doesn't bring the same preconceptions to the theater as they would for an actor associated with other characters. If Tillie is "practically human," then Columbia hoped that by casting Harris in the role audiences wouldn't see her as an already-famous human but as the genuine

article, much as Katzman chose Kirk Alyn as Superman, the better to convince young fans that the character was real rather than a familiar actor merely playing a role.

One poster for Tillie the Toiler featured an image of Harris with a word balloon above her head: "Hello Folks! At Last I'm in the Movies!" While this approach conveniently overlooks the 1927 version of the strip starring Marion Davies, a new generation of film fans had grown up since the silent era who would not have remembered the first film. The same cannot be said of RKO's marketing efforts for the first *Dick Tracy* feature in 1945, in which the company positioned its version of the character as if it were the first cinematic iteration. "He's in the Movies Now! See Him on the Screen!" declared one poster, while another boasts, "Dick . . . in the Flesh!" An advertisement for the film's New York debut announces, "Now He's Alive and On the Screen!"[74] With the final Republic serial *Dick Tracy vs. Crime Inc.* having been released in 1941 (and, like many serials, staying in circulation for over a year), the Ralph Byrd chapterplays would have likely been fresh in most viewers minds as RKO began selling them on the cinematic vitality of their version of the character.

FIGURE 22. Lobby card for the first *Dick Tracy* feature film (RKO, 1945).

Byrd was initially unavailable to play Tracy for RKO, having joined the marines in 1943. Morgan Conway appeared as Tracy in two films, *Dick Tracy* (1945) and *Dick Tracy vs. Cueball* (1946). He was replaced with Byrd for the final two entries, *Dick Tracy's Dilemma* (1947) and *Dick Tracy Meets Gruesome* (1947), yet both actors were well received by critics in the role. Whereas *Tillie the Toiler* was cast with the character's physicality in mind, the same requirement was not necessary with *Dick Tracy* given Chester Gould's exaggerated approach to his characters' anatomy. What mattered more was the tone through which the material was presented.

In 1946, Bing Crosby lent his voice to Tracy in a satirical turn for the radio series *Command Performance,* joined by Dinah Shore as Tess Trueheart, Bob Hope as Flat Top, Frank Sinatra as Shakey, Jimmy Durante as The Mole, and Judy Garland as Snowflake (*Variety* jokingly gave an article about the show the headline "Amateur Night").[75] The material was played strictly for laughs, while the films were played straight. The RKO series might even be described as film noir given their lurid content and shadowy visuals, although the films have not benefited from the critical legacy of film noir like other crime-oriented B-films of the period—perhaps because of their comic strip origins.

Several reviews noted that the films strike a fine balance in how the material is handled, with *Dick Tracy Meets Gruesome* described as being played with a "straight face," and that audiences will react the same, enjoying rather than laughing at any perceived silliness.[76] "No one expects this comic strip fellow to ring true, and he is given an engagingly preposterous touch," wrote the *Hollywood Reporter* of the first *Tracy* film, adding that it "fairly well materializes the character as the followers of the comic strip by Chester Gould would have him" with a supporting cast lending "supplementary characterizations that match [Gould's] conceptions."[77] Another review praises *Dick Tracy Meets Cueball* for its "skillful charting of their course between ingenuousness and ingenuity," adding: "Whether you like your Dick Tracy straight or adulterated Dogpatch Style, you will find [the film] right up your alley. . . . This little budgeter spoofs itself with a granitic deadpan that rivals the Gould original. The kids (what was that about childish tastes for blood and gore?) will love the two-dimensional police-blotter nightmare presented herein, while their 'grownups' will savor the sharp, implicit byplay of self-satire."[78]

Inherent in these reviews is the idea that a film based on a comic strip shouldn't take itself too seriously, nor should audiences. The *Tracy* feature films are positioned as retaining the strip's authenticity by respecting how Gould's characters are portrayed in print—unlike the Republic serials, which did away with most of his characters altogether. At the same time, the RKO series is also seen as possessing an at times gently satirical tone, one that acknowledges the more spirited qualities of the source material (breakneck action and sensational scenarios; vile villainy and ham-fisted rogues; exaggerated or malformed anatomy) while attempting to replicate them in cinematic form.

Gould wrote a similarly playful review of the first film for the *Chicago Tribune*, in which he joked of worrying about Tracy's fate in the final fight scene, lest his demise spell the end of the strip: "Gosh I don't want to lose that fellow Tracy. Turning to serious farming for a living is not in my present program. My frolics with Diet Smith, B.O. Plenty, etc., may not be great moments in history, but they're a darn sight more lucrative than tilling the soil." Gould even included a sketch of himself watching the film in a theater: "Shut up, Gould," Tracy tells him from the screen.

Unlike Milton Caniff, who ran screaming from the theater upon seeing his characters on the screen in *Terry and the Pirates*, Gould seemed pleased enough with how RKO adapted his creations. "Yes, Morgan Conway, Anne Jeffries and Mike Mazurki make a pretty neat Tracy cast. They've done it, and we're glad," he wrote.[79] Few comic strips were turned into feature films after previously having been made as serials, but those that did reached new audiences, saw different approaches to narrative and characterization, and often achieved improved production values. Another example was *Red Ryder.* Following the success of their *Adventures of Red Ryder* serial, Republic began a series of feature-length B-westerns based on the strip, which rivaled *Blondie* in sheer number. The studio produced twenty-three *Red Ryder* films between 1944 and 1947, releasing up to eight per year. Republic's contract with Fred Harmon had an option for yearly renewal, but despite the films' success the studio dropped the series in 1947 "because the price was getting too high." Harmon in turn put the film rights "on the open market," where they were picked up by Eagle Lion Studios, which produced four more films in 1949.[80]

With twenty-seven *Red Ryder* features in total, the series fell one film short of the twenty-eight *Blondie* films produced between 1938 and 1950; yet

the way in which the market embraced the rapidity of *Red Ryder* features proved that such adaptations were well received. The films even reached more people than the strip itself, proving that the character was popular with non-comics-fans as well. An advertisement for the radio program tells of how *Red Ryder* is "an American institution! 45,000,000 men, women and children read this popular comic-strip feature in 750 daily and Sunday newspapers. 65,000,000 people see *Red Ryder* in the 8 feature motion pictures shown annually in more than 8,000 theatres."[81] Many seeing the films were clearly "presold" audiences but a significant percentage were not, showing how compatible the comic strip was to series filmmaking.

Comics fans seeking film versions of their favorite characters had a lot of choice throughout the 1940s, particularly by mid-decade. In 1945, audiences could choose from films based on *Brenda Starr, Reporter, Secret Agent X-9, Red Ryder, Dick Tracy,* and *Blondie.* The following year saw films based on the latter three strips, as well as *Bringing Up Father, Joe Palooka, Hop Harrigan,* and *Little Iodine.* In 1948 alone, comic book fans could see serials starring Superman, Batman and Robin, Congo Bill, and Tex Granger. The marketplace supported a wide range of comics adaptations, in animated, feature-length, and serial form.

Comic books had become fully entrenched in American popular culture by end of the 1940s, just as comic strips were by the 1930s. One sign of their success was the extent to which their characters were parodied. In addition to the *Command Performance* spoofs of Superman and Dick Tracy, numerous send-ups of these two comics icons were seen in *Merry Melodies, Looney Tunes, Terrytoons,* and other animated films series. Bugs Bunny donned a Superman costume for the 1943 short *Super-Rabbit,* while a box of Superguy Soap Chips is featured in the 1941 short *Goofy Groceries.* The 1942 short *The Mouse of Tomorrow* featured a character known as Super Mouse, who would later become the long-running animated hero Mighty Mouse. Superman was also spoofed in the 1944 Popeye short *She-Sick Sailors* and the 1947 Little Lulu short *Super Lulu,* among others. Dick Tracy was parodied in the 1942 short *Dumb Hounded,* in which Droopy the dog learns how to be a detective by reading a Dick Tracy comic book. In 1946, Daffy Duck imagined himself as Duck Twacy in the Looney Tunes short *The Great Piggy Bank Robbery.*

These animated parodies further show how there were numerous different versions of comics characters in multiple media throughout the 1940s,

some serious and others satirical. Many were relatively faithful adaptations, while many more were not. Yet audiences didn't use fidelity to the source material as a criterion for judging their success in a way that many modern fans do. Film audiences were largely happy to see their favorite characters "come to life" onscreen, and Hollywood still regularly marketed the novelty of familiar comics stars crashing through the page into theaters.

In many ways when it came to screen adaptations, comics fans in this decade were like Gandy Goose and Sourpuss the cat in the 1949 *Terrytoons* animated short *Comic Book Land*. After falling asleep while reading comic books, the pair are transported through the air in their bunk beds to a magical land high up in the clouds. There they meet numerous colorful figures who emerge from the panels of the massive comic books towering high above them—the books serving as part of the land's architecture. So too did comics fans dream of meeting their illustrated heroes in physical form, or at least the celluloid semblance of such. While the serials, animated shorts, and feature films based on comic books and strips didn't always present versions of their favorite characters that fully lived up to reader's expectations, given how often characters were radically altered or eliminated altogether in these Hollywood versions, such adaptations were nonetheless generally well received by film audiences since fidelity to source material was not generally a measure of success or failure.

Comic Book Land serves as a metaphor for the relationship between the physical and psychological spaces involved in reading comics and watching movies. The two are often positioned as similar visual experiences, despite the fact that one is print-based and the other photorealistic. Seymour Chatman notes in his influential 1978 study *Story and Discourse: Narrative Structure in Fiction and Film* how both comics and movies "can move from close to long shot and return with no effort," as if both use cameras capable of achieving the same focal lengths.[82] The two media use different tools to achieve their effects, but we often see them as achieving similar aesthetic ends. As we read a comic, we might imagine the action unfolding before us as if we are an observer or participant to the events, much as audiences seek to lose themselves in the diegesis of a film. The modern notion of a comic book movie similarly implies a cinematic experience that in some ways replicates either the striking formal flourishes or the exuberant content of comic books and strips. Be it through a tongue-in-cheek approach to direction and acting, or a more abstract approach to sets, props, the use

of color, and other aspects of filmic mise-en-scène, attempting to transfer the unique qualities of the comic medium to film is still the same challenging prospect today that it was in decades past. But even more difficult is how the vastly different running times of serials, shorts, and feature films demanded disparate adaptive strategies while each still sought to replicate what is pleasurable about comics. The term "comic book movie" conjures up visual and tonal preconceptions that are just as applicable in the cinematic marketplace of the 1940s as they are today. While Hollywood studios didn't always respect what they were adapting, they courted the same presold audiences then as they do now, and viewers were generally pleased with the results despite the often altered origins and continuities as well as the impoverished production values through which comic characters appeared onscreen.

4 · 1940s CINEMA AND COMICS

Screen to Page

Comic book readers experienced a wide range of movie-related content in the 1940s. Much of it was in the form of adaptations or extensions of popular films. Some books featured popular actors in new adventures. Other instances were decidedly more unique. The various film-oriented comic books, strips, and ephemera of this period hoped to capitalize on readers' fascination with Hollywood as an industry, with its stars and perceived glamour, along with the pleasures of moviegoing. Some tried to replicate the act of being a film spectator using well-known stars and characters. Others created simulated filmgoing experiences using non-cinematic content. In some cases, comics readers were pitched an array of curious movie-related products in advertisements, with comics fans generally assumed to also be film fans.

Film-related advertising quickly became a regular aspect of comic books. As seen with films based on such heroes as Superman, Batman, and Captain Marvel, comic book publishers habitually advertised the adapted adventures of their characters within the pages of *Detective Comics, Whiz Comics, Action Comics*, and other titles. But these were not the only type of movie-related ads found within the pages of such books in the 1940s. Numerous film-inspired products were pitched to readers. Some came from

well-known companies while others were from fly-by-night outfits. "*Kids!
Play Movies!*" announces one ad for Kellogg's cereal, with the boxes offer-
ing "everything you need to build a Hollywood stage set at home." "Movie
stars and their costumes!" says a young girl holding a cut-out of Jane Greer
from *The Big Steal* (1949). "Stage Crews and Movie Equipment," a boy
proclaims, holding a miniature cardboard camera crane. The ad tells read-
ers how they can get "Models of Hollywood crews and stage equipment to
cut out and place on your own Hollywood set. Cameramen, klieg lights,
wind machines, microphones—16 other models, plus a plan of a typical
Hollywood set to guide you in setting up your own Hollywood show!" The
Kellogg's Variety pack offers "Life-like dolls of famous movie stars like Jane
Greer and Glenn Ford to cut out and dress up! Authentic costumes with
each actor and actress, plus props they use when acting!"[1] Here movie fans
are offered the chance to replicate both on- and offscreen movie imagery in
a new visual form, much as comics allowed readers to extend their engage-
ment with popular film stars and characters beyond the theater.

Another ad promised to actually turn your comic books into movies
via the "Comic-Scope," which readers are assured is "Not a Toy But a *Real
Projector!*" The device is essentially a magic lantern (a type of projector dat-
ing back to the seventeenth century) allowing for the enlargement of com-
ics imagery, but is sold here as "A New Amazing Invention!!!" The images
remained static, but the ad suggests that through their enlargement they
have become cinematic in nature. Readers had only to mail in coupons from
three comic books published by Fox Publications Inc. (*Wonderworld Comics,
Fantastic Comics, Mystery Men Comics, Science Comics*, or *Weird Comics*),
along with fifteen cents for handling. The Comic-Scope apparently paid for
itself, however: "Show your own films at home—charge admission—run
real movie parties. Now for the first time you can use comic strips in the
Comic-Scope and screen them in any size and in full color."[2]

Film spectatorship was also invoked by numerous comics that simulated
being in a movie theater, often using fake films rather than actual ones. In
1940, one of several new anthologies called *Target Comics* began, featur-
ing the blend of genre-based characters (e.g., western, aviation, superhero)
that made *Action Comics* a success. One of the book's regular offerings
was *Fantastic Feature Films*, which gave readers a supposedly new film in
every issue. The movies were entirely made up, however, but presented as
if real. The first issue offers a panel simulating a title card on a film screen

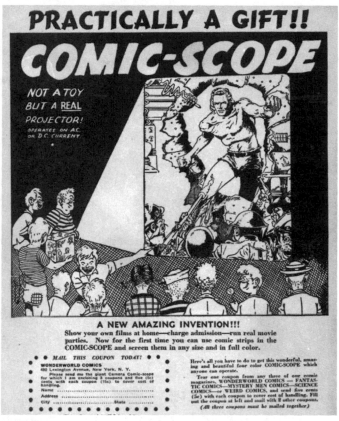

FIGURE 23. Advertisement for the Comic-Scope projector from *Wonderworld Comics* #12 (April 1940).

that reads: "Presenting the Maskless Axeman / A Fantastic Feature Film in Technicolor / Starring Orson Black / Karen Drake / Bruce Brian." This is followed by a panel depicting movie patrons in a theater looking up at the screen, in which another title card informs us of how the film features "an excellent supporting cast." The remaining panels tell the axeman's tale using the form of traditional comic book storytelling, but the cinematic opening is invoked in the last panel with a caption reading, "On this screen next issue, Target Comics will show another 'Fantastic Feature Film!'" The second issue follows the same format, but refers to fake actor Orson Black as "The Man of a Thousand Faces" while casting him in the role of a deformed hunchback much like the one portrayed by the real thousand-faced Lon Chaney a generation earlier.

FIGURE 24. A faux film is presented in *Fantastic Feature Films* from *Target Comics* #1 (February 1940).

From ads selling Hollywood cereal box cutouts of film stars and equipment, to those inviting entrepreneurial children to profit from comics-based magic lantern shows, to fake films with fake actors using panels that simulate theater screens, the ways in which films and comics were intertwined in print grew increasingly diverse as the decade progressed. Comics offered numerous representations of the film medium in their pages and panels. Questions surrounding representation are typically approached by film scholars in terms of

individuals (often with marginalized identities), but the ways in which other media are used to represent cinema itself raise larger ideas about how an *entire medium* might be represented, replicated, and repurposed. The Kellogg's cereal ad targets a desire among some film fans to replicate Hollywood imagery in concrete terms (e.g., cardboard cut-outs). The Comic-Scope projector demonstrates how comics imagery might be repurposed as (what is purported to be) cinematic imagery for home consumption, using comics as a way of re-creating the pleasures of film spectatorship outside the movie theater. *Fantastic Feature Films* seeks to represent the act of filmgoing in comics form by simulating some of the cinema's formal codes (such as the opening credits sequence) through the use of panels and line art. These patterns are regularly seen throughout the decade in a wide range of movie-related comics, with the relationships between the film and comics industries taking on new, often increasingly versatile dimensions as the 1940s progressed.

SUPERMAN: THE MATINEE IDOL MEETS ORSON WELLES

One of the cleverest instances of cross-media interplay involving film and comics came in 1942 on the heels of Superman's animated efforts for Paramount. The nineteenth issue of the *Superman* comic book saw Clark Kent and Lois Lane attend a matinee screening of the latest short film starring the Man of Steel, with Clark attempting to distract Lois during the scenes in which his secret identity is revealed. The story is full of intertextual references designed to produce knowing smiles from those who have seen the films, while serving as a promotional vehicle for the Fleischer series.

It begins with editorial narration setting up the story: "Talk of the talkie industry—the favorite entertainment of millions . . . that's the Superman movie cartoon! But tho the films in this stirring series thrill a nation, they can be a source of acute embarrassment to Clark Kent, particularly if Lois Lane happens to accompany him to one of them! Why? Read the adventure of . . . 'Superman, Matinee Idol.'" When Clark asks Lois to a movie, she chooses a theater showing the latest Superman short, having "missed seeing the first few in the series." Clark begrudgingly agrees, worried that "Lois is liable to see something that gives away my true identity," but still muses, "I hear that Paramount Pictures did an outstanding job" on the films.

FIGURE 25. Clark Kent and Lois Lane watch themselves on screen in "Superman Matinee Idol" from *Superman* #10 (November-December 1942).

Such dialogue is entirely ingratiating but attempts to establish a narrative continuity between the animated shorts and the comics.

As the film begins for the two reporters, the credits show a title card stating, "Copyright 1942 / *Action Comics* and *Superman* Magazines / Based on the famous comic strip created by Jerome Siegel and Joe Shuster." "I don't believe I've ever seen those magazines!" says Lois. Clark thinks to himself: "How they know so much about me is a puzzle. Perhaps they're clairvoyant!" The continuity is obviously problematic, since there is no viable way for the publisher or filmmakers in the story to actually know that Kent is

Superman, while Metropolis's film audiences and comics readers would already know the secret identity that he is trying to protect in the story. The entire tale is little more than an inside joke by DC Comics serving to promote the adaptation of their most famous character, but the result is clever fun despite its impractical qualities.

The story visually differentiates the fake film footage with large black borders containing vertical white lines so as to resemble strips of celluloid with sprocket holes. Even though film audiences don't actually see these perforations, the design style is a commonly used visual signifier by comics artists to suggest cinematic content. The faux footage takes up the majority of the thirteen-page story, often punctuated with panels of Clark and Lois in the audience reacting. At one point a giant robot grabs the onscreen Lois, while the real Lois in the audience gasps, "I—I can't look!" Clark reassures her, "You should know by this time that Superman always saves you in the nick of time!" When her celluloid counterpart is nearly trampled by the robot only to be rescued by her Kryptonian hero, the real Lois stands up and cheers, "Yea, Superman" at the screen. "Sit down, Lois!" chides Clark. "You're a grown woman, and besides, it's unseemly to cheer for yourself."

Aiding in the verisimilitude is the choice to use the mad scientist from the first Paramount short as the fake film's villain. "In the first cartoon release, Superman sent a mad scientist to prison—but he first had to battle a heat ray and smash the savant's laboratory," Clark explains to Lois, recapping the film's plot. The story's final panel finds Clark exchanging a wink with his heroic onscreen double. "Well, pal, our secret is still a secret from Lois!" thinks Clark as he escorts her out of the theater.[3] The self-referential nature of the story serves to draw equivalences between the act of reading a story in the pages of a comic book and watching it in a movie theater. The images on the very screen that a film audience watches on the story's first page soon become our only visual point of reference. As the story begins, we are positioned as moviegoers ourselves, sitting two rows behind Clark and Lois as the steady beam of light from the projector shines overhead— much like the covers of *Movie Comics* did in 1939. This perspective is recreated in three subsequent panels once the pair arrives at the theater, but from then on the reader largely experiences the fake film directly, with the screen filling the entirety of each panel.

The way in which the reader experiences cinema here relates closely to the notion of "immersion" raised by Jan Holmberg in his article "Ideals

FIGURE 26. Paramount's Superman short films receive some clever publicity in the pages of "Superman Matinee Idol" from *Superman* #10.

of Immersion in Early Cinema." Analyzing the ways in which early twentieth-century audiences experienced cinema, he argues that the interplay of cognitive and physiological engagement made possible by being a film spectator is dependent on the "illusions" presented onscreen being

experienced as if they were real phenomena. "I think it could be productive to view almost all of film history as a sort of striving for this illusion of presence, or immersion," says Holmberg, who sees such subsequent technological advancements as widescreen cinema and 3-D films as further attempts at achieving this immersive quality.[4] "Superman, Matinee Idol" presents a simulated Superman film to readers by positioning them as one of the story's moviegoers who see the fake film footage from the same perspective as Clark and Lois. Similarly, we might ask whether the process of reading a comic about filmgoing in any way changes the reader's cognitive or physiological engagement with the printed text, and whether the simulation of a cinematic experience can achieve any degree of the same immersive state that actual movies strive to achieve in their audiences.

When we experience one medium through another, in other words, does anything change? If a film shows us a program on a television set, the content of one medium becomes moderated through the form of a different medium. If that TV set is shown in a close-up, for instance, film viewers become positioned as a de facto television viewer even though the principles of cinematic spectatorship remain in place. The film's director in this case seeks to draw upon viewers' experience as television audiences and re-create it through the cinematic medium. Even if the program shown is newly created by the filmmakers rather than preexisting, there is still an attempt to re-create the act of television spectatorship so as to give film viewers the feeling, albeit a simulated one, of experiencing a different medium. In *Videodrome* (1983), David Cronenberg uses extended close-ups of television sets as a way of commenting on the medium's more ominous potentials, and making film viewers identify with—and become immersed in—these television images is crucial to the director's intent. Similarly, when comics present simulated cinematic content, they attempt to create an impression of watching a movie and of experiencing a different medium (albeit for what are usually less alarming purposes than Cronenberg's), such as *Superman*'s intent to attract those readers who have not yet seen the animated films, and to reaffirm the viewing pleasures of those who have.

The ersatz animated short in "Superman, Matinee Idol" uses several tricks in addition to the black borders and sprocket holes to create a pseudo-cinematic experience for readers. Various establishing shots of buildings (the *Daily Planet* building, a prison) are shown, a technique rarely practiced in the comics themselves in this period given their preference to

include characters in most panels. A shot/reverse-shot structure is played out multiple times over successive panels during moments of intense action (the scientist activates his robot; Lois is shot at), also not widely used in most *Superman* comics at this time. A common 1940s montage technique is invoked in one panel depicting a radio announcer declaring, "The mad scientist has escaped!" while surrounded by newspapers with similar headlines filling the edges of the panel. Readers are presumably meant to envision the newspaper headlines being revealed one at a time, thereby turning a single comics panel into the semblance of a film sequence containing multiple shots (or composited images).[5]

"Superman, Matinee Idol" offers a compelling case study of two famous characters encountering themselves in another medium. Clark Kent doesn't seem fully comfortable watching himself onscreen, perplexed by "how they know so much" about his personal life. Lois Lane seems oddly at ease with watching herself, although she does turn away at one point when faced with near death at the hands of a giant robot. The illogical nature of the central premise—that Kent must try to prevent Lois from finding out his identity, but not any of the theater's other audience members—suggests a sort of anxious nightmare on Clark's part, although the tale is not revealed to be a dream, hoax, or imaginary story. Going to the movies is often likened to being in a dream state. The viewer engages both in an enveloped darkness, eyes rapidly following the movement of images that unfold before them. We often identify with the characters onscreen, projecting ourselves into the film so that we may live vicariously through them. Lois and Clark instead watch *themselves* onscreen, or at least what are meant to be animated versions of themselves. The fact that Clark reassures Lois of how "Superman always saves you" when she is unable to watch herself being attacked by the robot creates a unique dynamic for Lois as a film spectator: she has indeed already faced situations remarkably similar to the amazing spectacle being witnessed onscreen, with Clark attempting to temper her expectations about the fictional scene by reminding her of the (diegetically) factual outcomes of the many perilous situations she has faced in real life.

The story becomes a metanarrative about the ways in which public figures view themselves onscreen, and about the act of filmgoing itself. As comic book readers, we view Lois and Clark while they in turn view themselves, yet Joe Shuster's art renders each of the two versions of the characters the exact same way. The supposedly animated cinematic footage

becomes a mirror image of the comic book's human characters, and in turn the line between film form and real life is blurred for the reader. When we experience representations of filmgoing through media other than cinema, it allows the opportunity to reflect on the act of film spectatorship in a way that we are typically unable to do while immersed in a movie in the dreamlike darkness of the theater. The static imagery of the comics medium allows us a privileged perspective on the act of being a film viewer, show-ing us only a single moment at a time of people watching motion pictures that inherently imply movement. Comics about filmgoing allow us to step outside of ourselves as filmgoers and contemplate how we consume films. This is why the story cross-cuts between the images onscreen and Lois and Clark's reactions to them. While the simulated actions depicted onscreen are thrilling, so too is seeing Lois and Clark as film spectators an engaging act for readers.

Clark Kent met other film stars besides himself within the pages of *Superman* in the 1940s, including singer Perry Como in 1949. That year also saw the sixty-second issue of *Superman* serve as a promotional vehicle for the release of *Black Magic*, with its star Orson Welles joining Superman on an adventure that not only depicted the film's production but also invoked the infamous "War of the Worlds" radio broadcast. Ironically, journalist Hedda Hopper negatively equated Welles with Superman in the pages of *Modern Screen* magazine only a few months before the crossover: "Orson Welles, once the boy wonder of show business, might again do great things if he'd stop believing he's wrapped in a cosmic mantle. After his martian invasion broadcast some years ago, he saw himself as a superman and has always tried hard to live up to it." She adds, "But ever since he handed American the screaming-meemies, Orson has been playing Superman and his own Olympian myth has clouded his once shining future with a fog of foolishness."[6]

Despite this harsh critique of Welles's career, the story casts Welles as a heroic figure, who saves Earth from a real Martian invasion. The tale begins with a rooftop duel featuring a sword-wielding Welles, who falls to his supposed death after meeting with "a fatal thrust" of his opponent's blade. As Welles "lies immobile on the ground, abruptly a voice shouts the command—'cut!'" We learn that this violent scene was merely a part of the production of the new "historical picture" *Black Magic*, "starring Orson Welles as the sinister magician, Cagliostro." Welles and his costar Nancy

Guild soon discover a rocket ship, which a "curious" Welles investigates. Unbeknownst to him, it is due to be launched by the "International Rocket Society" on a course toward Mars. Looking out of a porthole toward the Earth as the rocket leaves the atmosphere, Welles laments: "When I fooled the world with my Martian invasion broadcast—I never dreamed *I* would invade Mars myself!"[7] The reader is led from the production of a Hollywood to an outer-space adventure, using Welles's "War of the Worlds" broadcast as a narrative bridge to involve him in the story.

In *Swift Viewing: The Popular Life of Subliminal Influence*, Charles Acland notes how "the first panels are vaguely documentary by design. They mirror other behind-the-scenes promotional texts, like on-set shorts, presenting the work of movie making. But whatever naturalism had been developed to this point evaporates" once the rocket ship is introduced, says Acland.[8] "This crazy little fantasy, light in tone, relies upon background knowledge of Welles' notorious career and of the character he plays in the upcoming film. The comic character is an amalgam of movie star illusionist and movie character mesmerist," he argues.[9] Welles uses several magic tricks throughout the story to defend himself against the Martians (involving smoke, flames, and a rabbit up his sleeve). He also stages a broadcast in which he vocally imitates the Martian leader, declaring an end to the war on Earth.

Acland also notes that at one point Superman is "strangely drawn to appear smaller than Welles" as the hero blocks a ray gun blast meant for Welles, although the size difference is subtle.[10] Even stranger is the story's final panel featuring Welles and Superman together, in which the Man of Steel appears to be only half the size of the movie star. But this too is an illusion. The distortion occurs only in a single panel, with the distinctions between the panel's foreground, middle ground, and background not clearly demarcated. Numerous piles of stacked boxes fill the panel, and it is unclear whether Welles is meant to be standing in front of, or behind, one of the boxes. In turn, we can either see Welles as standing in the middle ground and Superman in the background (a Martian inhabits the foreground) with Welles appearing larger, or we can see the image as placing a miniature Superman in the middle ground while Welles inexplicably towers over him in the background. As with a drawing in which both a rabbit and a duck appear to be alternately present in the same image, my own eye keeps shifting the positions of Welles and Superman in the panel, with neither figure appearing to inhabit the space naturally.

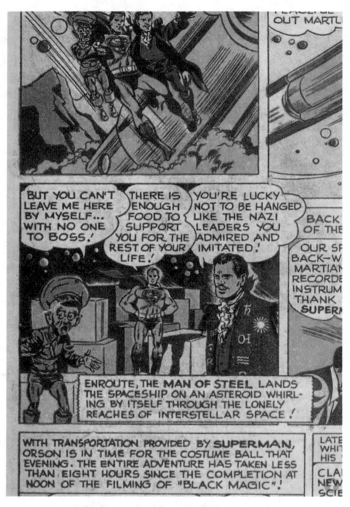

FIGURE 27. Superman meets Orson Welles in "Black Magic on Mars" from *Superman* #62 (January–February 1950). In a story about illusions, one of the final images plays with perspective through the positioning of Welles, Superman, and the Martian leader.

While this could be dismissed as a simple error, a case can be made for artist Wayne Boring's work being deliberate rather than accidental. Acland describes how "the narrative of the comic 'Black Magic on Mars' plays with media manipulation and illusion by alternatively concealing and revealing it to the reader at several points."[11] In addition to Welles's phony broadcast to the inhabitants of Mars, the story features several rocket ships that

turn out to be mirages, fooling even Superman's X-ray vision. This use of "manipulation" and "illusion" extends to the ways in which Superman is drawn as well, with Boring seemingly engaging in an illusion of his own, perhaps inspired by the trickery at work in the story and in Welles's career. *Citizen Kane* (1941) has many such moments that play with character size and perspective, from an aging Charles Foster Kane reflected endlessly within opposing mirrors, to his being set against the engulfing hearth of an oversized fireplace, to a younger Kane pacing an office only to reveal that the windowsill is much higher than it first appears when he was in the shot's foreground. In turn, a story about the manipulation of imagery can be seen as ending with one final illusion for eagle-eyed readers.

Both "Black Magic on Mars" and "Superman, Matinee Idol" offer readers a specific side of the film industry—production in the former, exhibition in the latter. Each story rewards the reader's background knowledge of Hollywood, offering playful intertextual references as the driving force of each narrative. Each story is gimmicky and implausible, but they show their creators having fun with movie imagery in a forum where the financial stakes are relatively low. If a film fails at the box office, a studio can lose thousands or millions of dollars, jeopardizing the production of future releases. If a particular issue of a long-running comic book like *Superman* is deemed unsatisfactory by readers, another issue will replace it on newsstands within a month or two, offering a new adventure unrelated to the prior issue (in this era of largely non-serialized titles). In this way, many comics of the 1940s offered lighthearted depictions of Hollywood, often with famous characters interacting with well-known industry figures. Such instances largely went against concerns for narrative continuity, but as we will see the results foreshadowed some modern media storytelling approaches that are acclaimed for their intricacy and ambition.

WALT DISNEY COMICS AND STORIES

Superman's popularity as one of the top-selling comic book characters of the 1940s was rivaled by that of several talking animals. While there were newspaper strips based on Walt Disney characters throughout the 1930s (Mickey Mouse, Donald Duck in *Silly Symphonies*, and the adaptations of *Snow White and the Seven Dwarfs* and *Pinocchio*), an ongoing Disney comic book did not arrive until 1940 with *Walt Disney's Comics and Stories*. Earlier that year, the Dell Publishing series *Four Color* put out an issue starring

Donald Duck comprising only newspaper strip reprints. *Mickey Mouse Magazine* had featured reprints of Mickey's comic strip in the 1930s, but they were never a major focus of the publication. The success of Donald's solo issue led to the monthly title *Walt Disney's Comics and Stories*, which re-offered numerous *Silly Symphonies* strips starring Donald along with Floyd Gottfredson's *Mickey Mouse* strip. Both had the added bonus of now being color instead of their original black and white.

The cover to the first issue of *Comics and Stories* shows Donald winking at the reader while bending back the bottom corner as if to reveal what's inside. This is bookended by another surprise revelation on the final page, which concludes a story in which Mickey meets Robinson Crusoe. As he prepares to return home after rescuing Crusoe from a tribe of cannibals, a caption tells us of how "the final scene of 'Robinson Crusoe' has been shot and the company prepares to leave the island location." A large camera and light are unloaded from a ship, while the cigar-chomping, beret-wearing director barks, "Make it snappy, boys! Let's get goin'!" It turns out that Mickey had actually been starring in a movie about Robinson Crusoe in Gottfredson's adventure (which originally ran in newspapers in between 1938 and 1939). We didn't see the film crew or the cameras as the action unfolded throughout the previous pages, leaving the reader immersed in what had seemed to be yet another of Mickey's wild adventures. Regarding his performance, Mickey asks the director, "How'd I do, Mac?" "Y'did all right, son!" replies the director. "It shows that a classy director can get results out of anybody."

By making Mickey a movie star in this adventure, Gottfredsen draws a direct parallel between his strip and Disney's theatrical films. If Mickey is an actor, then his films might be considered his day job while the strip chronicles his life offscreen. Mickey is actually quite different in these two media, says comics scholar Thomas Andrae:

> We forget that audiences growing up in the thirties—and into the fifties— knew two radically different Mickeys, the mouse of the animated cartoons and that of the newspaper comic strips. As comics historian Bill Blackbeard puts it, the comic strip Mickey "was a death-defying, tough, steel-gutted mouse quite unlike the mild, blandly benign mouse of contemporary Studio usage, who kept the kids of [this era] rapt with his adventures on pirate dirigibles, cannibal islands, and bullet-tattered fighter planes." Whereas the screen Mickey was famed with romantic idylls and musical hijinx with

Minnie, the comic strip mouse had little time for romance: he was involved in life-and-death struggles which could not be won through tricks of animation magic.[12]

The two versions may have been dissimilar, but Gottfredson attempts to unite them with a metatextual moment that readers of this first issue of *Walt Disney's Comics and Stories* don't actually get. The issue only reprints the latter part of the story, and doesn't include the beginning as it originally appeared in newspapers in which Mickey receives a phone call from Walt Disney himself, asking whether he would be willing to star in Disney's latest film. "Hello, Walt—this is Mickey! I hear you've got a new picture for me!" he says. "Yes—we're going to make 'Robinson Crusoe!' Think you'd like to work in it?" asks Disney.

The fact that this is a "new" picture implies that Mickey has worked for Walt before, which is confirmed when he arrives at the studio: "Mornin' Mickey! Glad to see you on the lot again!" says the security guard. After Mickey picks up his script, he sits and reads it as set construction goes on around him. The director later walks him past various lights and cameras while telling Mickey that the film will be shot on location, as someone behind them exits a cutting room with two reels of film. They board the studio's yacht for Abalone Island—"Where all the desert island pictures are made!"—and Mickey rereads his script while final preparations are made for the shoot. The director tells the crew to "watch those reflectors! Don't lose any light!" The cameras are set up on a floating barge as Mickey and Crusoe set out on their raft. "Camera ready?" someone asks. "Sound okay?" asks another. Once everything is set, the director yells, "Action! Camera! Roll 'em!" Over the course of a week's worth of strips, readers have been guided through the film's various preproduction stages and are given a backstage look at what is supposedly Walt Disney's studio.

The narrative involving Crusoe that follows is therefore set up as clearly being cinematic content, but readers then go months before seeing the cameras again once production has wrapped. As the cameras begin to roll, Mickey and Crusoe are in the exact same position in two successive panels. In the first, we see them in the distance with the camera barge in the foreground. In the second panel, we see only Mickey and Crusoe in a long shot, presumably from the camera's viewpoint. Since we never see the camera crew again, we might presume that the entire story is presented to us from

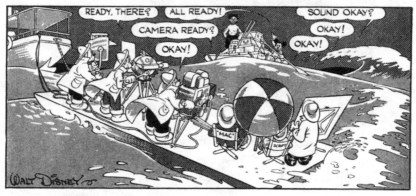

FIGURE 28. Mickey Mouse begins work as the star of a new Robinson Crusoe film (December 21, 1938).

the camera's perspective. In turn, comic book storytelling becomes equated here with that of the cinema, using comparable approaches to camera perspective and mise-en-scène. This belief in the commonalities between how these two media told stories was growing throughout the Classical Hollywood era, demonstrated by Manny Farber's subsequent articles on the cinematic qualities of Milton Caniff's work.

The emphasis on reprinting existing newspaper strips continued throughout early issues of *Comics and Stories*, with a few minor cinematic supplements. The first two issues feature ads for a package of films billed as "The Great Walt Disney Festival of Hits!" in which *Snow White and the Seven Dwarfs* was combined with four Disney short films for theaters. There are also ads for "Walt Disney's Pinocchio Hankies" (which are touted as dual-purpose: "For Blow—For Show").

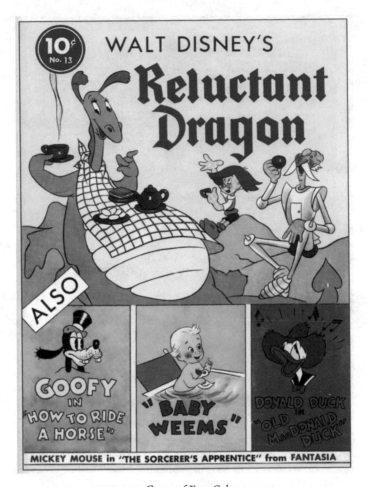

FIGURE 29. Cover of *Four Color* #13, 1941.

A more substantial film tie-in came with 1941's *Four Color* #13, which consisted entirely of adaptations of both feature-length and short films produced by Disney between 1940 and 1941. The lead story adapts part of *The Reluctant Dragon* (1941), a lesser-known film in which actor Robert Benchley tours the Disney studio's production facilities while attempting to pitch an idea to Walt Disney himself. Along the way, Benchley is treated to several animated shorts, including *Baby Weems* about a super-intelligent infant and *How to Ride a Horse* starring Goofy. The final short is *The Reluctant Dragon*, which Benchley had in fact been hoping to suggest as the studio's next film.

But before the reader arrives at the adaptation of this animated short, they are met by a different type of content from the film. The inside pages of both the front and back covers contain black-and-white images from *The Reluctant Dragon*'s live-action footage. The six stills are accompanied by textual passages explaining the plot and selling readers on the film's merits. "Walt Disney's feature picture, 'The Reluctant Dragon,' combines live-action photography with animated cartoons," the first passage informs us. "It tells the story of Robert Benchley's enthusiasm for Kenneth Grahame's delightful tale about the dragon who wrote poetry. He sets off for the Disney Studios to convince Walt Disney that he should make a moving picture based on the dragon story." The comic book attempts to re-create as much of the film as possible, bookending the animated adaptations with material that approximates the movie's live-action framework. Also included in the comic are an eleven-page version of *Baby Weems* and a six-page version of *How to Ride a Horse.*

As an added bonus, the book also features an adaptation of the 1941 Donald Duck short *Old MacDonald Duck,* as well as a textual account of Mickey Mouse's antics as "The Sorcerer's Apprentice" in *Fantasia* (1940). The eight pages of text are accompanied by numerous drawings of Mickey, and are preceded by a two-page foreword by conductor Leopold Stokowski discussing the role of music in collaboration with the film's animation. He informs us that *Fantasia*'s music has been synchronized with "an art of color and form in motion," with Walt Disney having "brought to life a new phase of art" in his various animated efforts—"painting in motion. For centuries, painters of all countries of Europe, as well as of China, India, Japan, and Java, have tried to suggest motion in painting. The imagination of Disney, combined with his ever-widening knowledge of recently discovered technical possibilities, has unfolded a new and freely flowing way of painting with color, light, form and motion."[13] Much like how *The Reluctant Dragon* shows viewers how Disney's films are made, this passage is highly self-promotional; what it offers, however, are insights into how readers and viewers might think further about the formal qualities of Disney's work, how it combines sound and image, and how it connects to older artistic traditions.

Four Color #13 offers readers a variety of cinematic-related content, some adapted and some behind-the-scenes. The issue's cover resembles the movie posters advertising "The Great Walt Disney Festival of Hits!" with small boxes depicting the title of each short film so as to sell readers on the

1. Walt Disney's feature picture, "The Reluctant Dragon," combines live-action photography with animated cartoons. It tells the story of Robert Benchley's enthusiasm for Kenneth Grahame's delightful tale about the dragon who wrote poetry. He sets off for the Disney Studios to convince Walt Disney that he should make a moving picture based on the dragon story.

2. On his way to Walt Disney's office, Benchley gets lost in the many buildings on the Disney lot. With the help of Frances Gifford, he makes a tour of the unusual departments connected with the making of Disney pictures. Here they are in the model department, where figures of the many Disney characters are sculptured.

3. Ward Kimball, one of Walt Disney's top animators, shows Robert Benchley what makes Disney characters move.

WALT DISNEY'S RELUCTANT DRAGON, No. 13—PUBLISHED BY
DELL PUBLISHING COMPANY, INC.
149 Madison Ave., New York, N. Y.
Copyright, 1941, by Walt Disney Productions. World Rights Reserved. Printed in U. S. A.

FIGURE 30. Inside front cover to *Four Color* #13, featuring production stills from *The Reluctant Dragon* (1941) along with text summarizing the film's narrative. *Four Color* would often use this approach for future film adaptations.

variety of content within. Much like how *Movie Comics* did two years prior, this issue of *Four Color* offered Disney fans a souvenir of the film through which they could reexperience the stories and images in print form.

Disney characters appeared off and on in *Four Color* throughout the decade. In addition to numerous issues starring Donald and Mickey, there were also tie-ins with the release of such films as *Dumbo* (1941), *Bambi* (1942), *The Three Caballeros* (1945), and *Song of the South* (1946). When *Snow White* was re-released by Disney in 1944, a similar tie-in was released

using the Sunday newspaper strip (which ran for twenty weeks between 1937 and 1938) as its basis. The *Four Color* version required some formal alterations to accommodate the strip to the new format since the strip's panels formed a horizontal rectangle while the book's pages were vertical. The shift necessitated the reorganization—and occasional removal—of several panels. In turn, the narrative was a somewhat different one for the book's readers, with some events occurring in a slightly different order than in the original strip.[14] Both versions, however, gave readers extra scenes with the Prince that were cut from the finished version of the film.

In one sequence, Snow White creates a scarecrow-like figure out of a bucket and old rags. She paints a face on the bucket and dubs her creation "Prince Buckethead," imagining him to be the one who will take her away from her life of toil. Little does she know that she is about to be paid a visit by the real Prince: "But from a far country, comes an adventurous Prince who has heard of Snow White's beauty!" we are told. The Prince watches Snow White as she pretends that the bucket is courting her. "I'm sorry I'm not more beautiful, Prince Buckethead! I hope you're not disappointed!" she says. "Disappointed? Why—I'm enchanted!" replies the Prince while hiding in Buckethead's attire.

Snow White runs away in embarrassment to her room and the Prince stands beneath her balcony and woos her: "Stay in your window! I shall tell you why I am here! . . . I came from a far country, seeking the most beautiful woman in the world!" The evil Queen overhears this and smiles: "A man of rare taste, for one so young!" she says vainly. The Prince continues: "The fairest flower that man ever beheld—Snow White!" The Queen reacts in shock: "Snow White! Fairest in the land! How dare he!? I am the Queen of beauty! My mirror never lies!" She then consults her magic mirror, which tells her, "Beauty and love go hand in hand! Snow White is now the fairest in the land!" since she has met her beloved Prince. The Queen calls for her guards to capture the Prince, and he is locked in the palace dungeon. "Fear not, my princess! No power on earth can keep us apart!" he cries as he is dragged away.

The film was originally meant to include the Prince Buckethead sequence, but it was cut from the final version.[15] The comic strip was adapted from an earlier version of the film's script, which contained several plot points that ultimately went unused in the film. Given how the Sunday strip ran for weeks before the film's debut in 1937, readers would have been surprised to see the film's beginning unfold quite differently from the print

FIGURE 31. The 1937 *Snow White* comic strip, reformatted as a comic book in *Four Color* #49, 1944.

version they had been following. What appears to be a random encounter in the film is explained more fully in the comic, with tales of Snow White's legendary beauty having spread far and wide enough for the Prince to have come to seek her out. While the film begins with the Queen being told that Snow White is fairer than she by her magic mirror, in the comic it is only once Snow White has met her true love that her beauty then eclipses that of the evil Queen.

The comic often provides readers with more dialogue between characters as well. In the film, for instance, the Queen merely threatens the hesitant huntsman by telling him, "You know the penalty if you fail." In the

comic strip she warns him, "The lives of your own children are forfeit, if you fail!" The comic strip serves as what we would today call a director's cut of the film, with the cinematic version having trimmed certain sequences in order to tighten up the pace. Comics serve as a space in which film narratives can be expanded upon, with serialized comic strips requiring an entirely different type of pacing from motion pictures.

The comic also contains a sequence in which the Prince has been captured by the Queen and locked in the dungeon. When the Queen transforms herself into an old hag, she taunts the Prince in his cell with her plan to poison Snow White. The Prince later steals a set of keys from a sleeping guard, as we are told that he "tries desperately to escape in time to save Snow White from the poisoned apple!" He flees the palace while being chased by sword-wielding guards, finds his horse, and "speeds for the forest."

In the film, the Prince is only seen briefly at the beginning and the end, with a title card telling viewers that he "had searched far and wide" for Snow White and found her after having "heard of the maiden who slept in the glass coffin." The Prince was apparently one of the more difficult figures for the film's animators, so his role in the story was downgraded. The lack of motion in the comic negates the problems of making his animated movements appear convincing, so his expanded role in the strip is less problematic than it might have been in the film. While Michael Barrier compares the Prince's escape from the dungeon and his race to save Snow White to an overly melodramatic scene in a D. W. Griffith movie, the Prince's sudden arrival at the end of the film is a *deus ex machina* ending that might have benefited from the inclusion of some of the material seen only in the comic.[16]

In 1944, *Walt Disney's Comics and Stories* #43 offered a more unusual tie-in to that year's re-release of *Snow White*: a three-page story called "Donald Duck and the Seven Dwarfs." Much like Walt's phone call to Mickey, this story is also highly metatextual: "What an idea of Walt's! Sending me into the woods as a talent scout . . . there's nothing but trees," grumbles Donald. "A-ha, a house! Maybe the home of a future movie star!!" he exclaims upon finding the dwarfs' cottage. "Open up! Opportunity is knocking at your door!!" says Donald, who is met with an accidental door in the face by Grumpy (who believes him to be "the ol' witch" in disguise with whom the dwarfs did battle in the film). "Everybody's crazy around here. . . ," says Donald. "Well, they need crazy people in the movies. I'll try once more!"

FIGURE 32. Donald Duck meets the Seven Dwarfs in *Walt Disney's Comics and Stories* #43, 1944.

As the dwarfs attempt to drive him away, Donald tells them: "What's all this nonsense about me being a witch? I'm Donald Duck, the famous actor!!" Just as Mickey was revealed to be an actor working for Disney, so too is Donald positioned here as one of Walt's star performers (who apparently also serves as a talent scout on occasion). The story ends with a direct plug for the film as Donald and the dwarfs sit around the dinner table. "Imagine me offering you a screen test . . . why you're almost as famous as me . . . say, I hear *Snow White* is coming back soon!" says Donald. "That's

right—it'll be theatred in all the plays!" replies Doc. "I mean, played in all the theatres, opening everywhere . . . Hi ho, hi ho hi ho!"[17]

The story is little more than a playful promotion for the film, but it creates a pattern in which Disney's characters are revealed to be performers playing a role onscreen. The comics would therefore seem to show us their private lives offscreen when they aren't performing for the camera. In the Donald Duck short film *Old MacDonald Duck* adapted for *Four Color*, we see him playing a farmer. It is a job that he doesn't typically perform and one he clearly isn't very good at, but he is cast as a frustrated farmer for the comedic potential provided by the situation. In contrast, the comic strip (which was frequently reprinted in the comic books) shows him doing more domestic duties such as walking his St. Bernard, looking after his nephews, washing dishes, cooking a meal, getting his car serviced, and repairing a driveway. He is equally frustrated by these everyday events in the comics, but they are decidedly less exciting than his work as a trapper in Antarctica (*Polar Trappers* [1938]) or a fireman (*Fire Chief* [1940]), and owning a sailboat (*Sea Scouts* [1939]) or a gold mine (*Donald's Gold Mine* [1942]).

Even Goofy is a movie star in Gottfredson's strip. As Mickey arrives at the studio to pick up his Robinson Crusoe script, he runs into Goofy who complains about the new film he is starring in. "Well, they got me in a pitcher where I'm co-starred with a grasshopper—and the durn critter's stealin' all thuh laffs, gawrsh-ding it!" he says with a scowl. The comics frequently show us not only the backstage aspects of how characters like Mickey, Donald, and Goofy create their films, but also their complaints about their Hollywood careers and how they go through aspects of their day-to-day routines.

This encounter with Donald was not the only time that the Seven Dwarfs met up with a Disney character from another film. In addition to the adaptation of *Snow White*, *Four Color* #49 also featured the back-up story "The Seven Dwarfs and Dumbo," in which the dwarfs lament how lonely they have been since Snow White went to live with the Prince. They are startled by a knock on the door and are greeted by a familiar face to *Snow White* fans: "I was once the Queen's huntsman! But now I am a messenger for Snow White and her Prince!" he announces. He presents a gift to the dwarfs from Snow White, "with her gratitude and love!" Inside the box is a lamp and a note, which informs the dwarfs that if they light the lamp and make a wish then it will come true. They ask for a "playmate," chanting in

FIGURE 33. Dumbo befriends the Seven Dwarfs in 1944's *Four Color* #49.

unison: "We wish for someone to take Snow White's place so we won't be lonely!!!" A sudden storm then leads to gale-force winds that send Dumbo flying through the window. The dwarfs decide to "adopt Dumbo as one of the family," and he takes Dopey for a ride on his back through the air while the others work in the mine.

During their flight, Dopey and Dumbo find the former huntsman trapped on a cliff ledge, having been "attacked by the wicked prince, the brother of the bad queen! He is ruling the land, now that she is dead!" The wicked prince soon captures Dopey and locks him in the prison tower,

which leads to a rescue mission by Dumbo and Doc. On their return flight, Dumbo says, "We'll be home soon!" "Yes! And I hope it will be your home always, Dumbo!!" replies Doc. The next day the group sets out to visit Snow White, singing, "Hi ho, hi ho! To see Snow White we go! To tell her that we thank her so for our new playmate, brave Dumbo!!"[18]

The story serves as sequel to *Snow White* in which many of the film's characters and premises are expanded upon—the dwarfs are lonely in Snow White's absence, the evil queen's brother rules the land, the huntsman now works for Snow White and the Prince, and the dwarfs are still in contact with her. Another such continuation comes in the story "The Seven Dwarfs and the Pirate" from 1949's *Four Color* #227, in which one more familiar character returns: "Suppose we look in on a certain old witch, who lives in the forest nearby," the narrator tells us. In the 1937 film, the wicked queen transforms herself into an old hag in order to poison Snow White, but he falls off a cliff to her apparent death during a storm. In the Dell comics, however, she apparently did not die and instead remains in her hag-like form. We might speculate whether she is the same character, a new character, or whether readers are meant to conveniently forget that the film's hag was actually the Queen in disguise. In the film, the Queen actually transforms into an old "peddler," yet she is commonly seen as changing herself into a witch. In this new story she has the same magic mirror, but now lusts for riches rather than obsessing over beauty: "Every night she asks here magic mirror the same question . . ." / "Mirror mirror on the wall, am I not the richest of them all?"

These Dell comics offer several elements that partially conform to Henry Jenkins's definition of transmedia storytelling, even though they are not the purest example of this phenomenon given that he is analyzing modern media industries rather than those of decades past. "Transmedia storytelling is the art of world making," says Jenkins.[19]

A transmedia story unfolds across multiple media platforms, with each new text making a distinctive and valuable contribution to the whole. In the ideal form of transmedia storytelling, each medium does what it does best—so that a story might be introduced in a film, expanded through television, novels, and comics . . .

. . . Reading across the media sustains a depth of experience that motivates more consumption. Redundancy burns up fan interest and cause franchises

to fail. Offering new levels of insight and experience refreshes the franchise and sustains consumer loyalty.[20]

The question of whether these Dell comics make a "valuable contribution" to our understanding of *Snow White* or whether they are redundant is debatable, but the comics certainly expand the film's story by adding to it. Stories like "The Seven Dwarfs and Dumbo" suggest that the world of Disney's films is interconnected, with characters from different movies able to encounter one another through mere coincidence. Media content from the 1940s was generally created using different technological means for different commercial needs, so the outright application of transmedia theory to these older comics isn't advisable but the prospective parallels remain intriguing. Jenkins describes how transmedia texts are often associated with "more ambitious and challenging works," while Carlos Alberto Scolari notes how the "textual dispersion" across multiple media characteristic of transmedia storytelling "is one of the most important sources of complexity in contemporary popular culture."[21]

The narrative extensions in stories like "The Seven Dwarfs and Dumbo" are not particularly complex, but they are still valuable objects of study given how rare such crossovers were in this era. Comics were a form that allowed film narratives and characters to be explored in new directions in this era, creating important precedents to later developments in transmedia storytelling. In a subsequent reflection on transmedia theory, Jenkins adds that "it is possible to find historical antecedents for transmedia" predating modern digital culture. "The options available to a transmedia producer today are different from those available some decades ago, but we can still point to historical antecedents which were experimenting with notions of world building," he says. Jenkins includes Walt Disney as one such transmedia producer given "his focus on transmedia branding" across a variety of forms, including comics.[22]

Disney didn't produce sequels to his animated feature films in this era, so the comics gave fans a way to "sustain" their interest in the studio's characters. A sequel called "Snow White Returns" was proposed as a possible short film but never emerged. The film would have incorporated some of the unused scenes with the dwarfs from *Snow White and the Seven Dwarfs* as the basis of the narrative in which the dwarfs receive a letter from Snow White informing them that she will soon be arriving for her "annual visit."[23]

Sketches were produced showing the full range of the story's events, but the new film never developed beyond these initial steps. The fact that the comics offer us the only sequels to the film makes their narrative extensions even more intriguing given how the studio explored the possibility of a new onscreen encounter between Snow White and the dwarfs.

Such world building is further seen in other stories featuring the dwarfs, such as "The Seven Dwarfs and Humpty Dumpty" from *Four Color* #227. Here, the giant from the 1947 short *Mickey and the Beanstalk* tries to eat Humpty's brother, Gumpty Dumpty. Doc and Dopey trick him into letting Gumpty go, with the giant realizing, "Uh-h-hh . . . just a minute! Since when is th' dwarf my friend? Always before they'd been my enemy!" This implies a backstory of previous encounters between the characters, in which various characters from different Disney films shared the same adventures. Another instance comes in 1943's *Four Color* #19—"Thumper Meets the Seven Dwarfs." This comic actually combined characters from three different Disney films—*Snow White and the Seven Dwarfs, Bambi,* and the Mickey Mouse short *The Brave Little Tailor,* with the giant (a different one from that in *Mickey and the Beanstalk*) returning from the last. Thumper leaves his family because he "had heard that the end of the world lay beyond the vast, green forest, so he had decided to try and find it." He falls down a hole and lands in the dwarfs' mine, and is then taken into their home as a guest.

Later in the story, Thumper is captured by the giant, who takes the rabbit home to his wife as a pet. Doc and Dopey rescue Thumper, nearly being eaten by the giant in the process as they hide in a blueberry pie. The journey home sees them encounter a few more close calls, but not before Thumper drinks from what turns out to be a wishing well. In addition to wishing that they were back at the dwarfs' home (saving them from death by drowning in a river whirlpool), Thumper wishes that his mother "had a house just like the dwarfs' right next door—then we could all be together!" The next morning he awakens to find his wish has come true, with his family standing next to their new home next door.[24]

The events of this story do not come into play in the 1944 story with Dumbo (in which the dwarfs bemoan their loneliness since Snow White left them, with Thumper's new home apparently no longer existing), which might imply the "redundancy" that Jenkins describes, given how there isn't an attempt at a strict narrative continuity. Yet the team-ups

and crossovers between characters from different films in these comics were precursors to more recent forays in which separate film and television characters met one another for the first time in comic books, such as 1990's *Aliens vs. Predator* (later a film series of its own) and 2012's *Star Trek: The Next Generation/Dr. Who.* Disney's efforts in the 1940s to extend cinematic narratives further in comic books shows the potential that the comics medium had for film studios to sustain interest in their products. In an era in which fans could not easily (let alone instantly) see their favorite films once they had left local theaters, comics offered a chance to savor familiar characters in new narratives while they awaited the studio's latest projects.

KID MOVIE KOMICS, CINEMA COMICS HERALD, AND THE GRAPHIC LITTLE THEATRE

By the late 1940s, *Walt Disney's Comics and Stories* was the most widely read comic book on newsstands. It sold thirty million copies per year, making it the fourth best-selling national magazine as of 1947.[25] By the early 1950s it had a circulation of more than three million copies per issue.[26] Other companies soon saw the potential in producing their own books featuring licensed animated characters. Comics featuring Bugs Bunny, Andy Panda, Tom and Jerry, Felix the Cat, Porky Pig, and Woody Woodpecker alternately appeared on newsstands throughout the 1940s in such Dell titles as *Four Color* and *New Funnies.* In some cases, comics even played a key role in characterization. The first issue of 1949's *Casper the Friendly Ghost* is the first instance in which the character is named. Casper had never been referred to by name in his two film appearances prior to his comics debut, 1945's *The Friendly Ghost* and 1948's *There's Good Boos Tonight.* The success of these two shorts led to a series of films throughout the 1950s, preceded by the 1949 comic in which he was first named.

Some publishers even sought to convince potential readers that their comics featured characters with their own film series, even if they had never actually appeared onscreen. Much like Ed Wheelan's *Minute Movies* strip of the 1920s, which presented faux-films in panel form, the term "movies" was regularly used by comics publishers to suggest the compatibility between film and comics and in turn sell more books to eager film

fans. As such, newsstands saw numerous titles well into the early 1950s that featured fake movie characters, including *Hollywood Comics* (1944), *Animated Movie-Tunes* (1945), *Movie Tunes Comics* (1946), *Kid Movie Komics* (1946), *Hollywood Funny Folks* (1950), and *Movie Town Animal Antics* (1950).

Much like *Fantastic Feature Films* did before them, the content in these books was faux-filmic, attempting to convince readers that characters like Nutsy Squirrel and the Raccoon Kids had their own animated film series. Publishers also often created mock-ups of possible new books or created potential covers in order to prevent other companies from using the titles, never actually producing the books themselves. Such titles included National's *Movie Cartoons, Movie Fables, Movie Gems, Screen Cartoons, Screen Comics, Screen Fables, Screen Funnies,* and *Screen Gems* in 1944. This interplay of terms actually goes both ways: Disney called 1928's *Plane Crazy* "A Walt Disney Comic" in its opening credits to suggest the humorous nature of the film. While there was little room for confusion about which medium that moviegoers and comic readers were experiencing in each case, the interchangeable use of terminology shows that many creators saw a connection between how movies and comics presented their imagery.[27]

These youth-oriented books were just part of the wide range of ways in which film-related content appeared in comics in the 1940s. Promotional comics continued throughout the decade. Some largely targeted children like *March of Comics* (given away by Sears and other stores) in the mid- to late 1940s, which featured the adventures of Roy Rogers, Gene Autry, Our Gang, Mickey Mouse, and others. Autry could also be found in giveaway comic books available from Pillsbury and Quaker. Other promotional comics featured films that were primarily intended for adults. Between 1941 and 1943, publisher B. W. Sangor created numerous comics as theater giveaways to advertise upcoming films. Each edition of *Cinema Comics Herald* was a mere four pages, combining art and photos to promote such films as *Bedtime Story* (1941), *Lady for a Night* (1942), *Reap the Wild Wind* (1942), *They All Kissed the Bride* (1942), and *Crash Dive* (1943). Only nine such editions were ever produced, but several Hollywood studios tried out the format, ranging from Universal and Columbia to larger studios like Paramount, RKO, and Twentieth Century–Fox, and even the Poverty Row stalwart Republic Pictures.[28]

In 1945, RKO tried a more ambitious approach to promote their Technicolor pirate picture *The Spanish Main* (1945). A one-page, six-panel comic strip was produced showcasing some of the film's highlights. It ran in 139 newspapers across the country: "Backed by the greatest national advertising campaign in RKO history . . . full color ads in newspapers totaling 66,244,618 in circulation!" boasted the studio. The color comic was thought to be an attention-grabbing way to sell the film's "Glorious Technicolor" spectacle. The first panel lists the film's title, main cast, and credits, while boldly announcing: "Soon you will attend your favorite theatre to sail away on the most stimulating screen experience in years! Life! Action! Romance! Adventure! Big in stars! Big in the things from which mighty motion pictures are made." The remaining five panels establish the main characters and the stars who play them, along with the basic story and central conflicts. The last panel reads: "Action-packed from beginning to end as thrill-follows-thrill in the most spectacular sea adventure ever filmed in the vivid realism of Technicolor—'The Spanish Main.'"

RKO regularly mentioned the strip in other promotional materials, signaling the importance of comics to selling the film. The *Hollywood Reporter* noted that the studio's efforts were a success, with the comic strip helping to sell both exhibitors and audiences on the film's merits: "On the wave of an all-embracing showmanship campaign, 'The Spanish Main' is rolling up impressive grosses in all engagements. Robert Mochrie, RKO Radio general sales manager, reports that in many cases it is not only breaking theatre records but it is playing in spots never before showing RKO product."[29]

While RKO's nationwide comic strip for *The Spanish Main* was a costly promotion and thus a rare event, a more frequent newspaper feature in one local market became one of the most prominent ways in which films were translated into comics in the 1940s. In 1941, the *Chicago Tribune* began a new feature called *Graphic Little Theater*. Every Sunday, readers were offered a condensed adaptation of a film currently playing in (or coming soon to) Chicago theaters. The story was told using publicity stills provided by film studios, much like Big Little Books did. But while the Big Little series, *Movie Comics, Walt Disney's Comics and Stories,* and the wide range of comic books based on animated film characters were produced with youth audiences in mind, *Graphic Little Theater* reached a wide age range in its readers. The photos were accompanied by text passages beneath explaining the plot,

arranged in sequences of what were typically nine to twelve panels. Unlike *Movie Comics*, the feature did not contain any editorial material explaining how or why the films were adapted, instead simply announcing the film's title and major stars. When Alfred Hitchcock's *Shadow of a Doubt* (1943) was adapted to the format, for instance, the feature headline read "Graphic Little Theater Presents Teresa Wright, Joseph Cotten in '*Shadow of a Doubt.*'" Later editions would provide head shots of the main actors with their character names, such as those in *Dick Tracy* (1945). That film was also identified along genre lines for readers, with the headline "Graphic Little Theater Presents a Mystery Drama, '*Dick Tracy.*'"

The use of text passages beneath the photos resembles the comics of the nineteenth and early twentieth century, which presented dialogue and narration in this manner before the use of word balloons and captions within the panels became commonplace. The panels were each numbered, also a common practice in early comics.[30] *Shadow of a Doubt* is recounted with such panels as: "1 / Charlie Newton (Teresa Wright) has invited her Uncle Charlie (Joseph Cotten), whom she adores but has never seen, to come to Santa Rosa to live. Uncle Charlie gets a royal welcome," as Cotten shakes hands with young actress Edna May Wonacott. The second panel shows an image of Wright and Cotten with a bank manager, accompanied by text stating: "2 / He seems a bit perturbed the next morning when they tell him two survey men are coming to photograph and interview them all in a search for the typical small town family. But he gayly goes to the bank with Charlie and deposits $10,000, his first step toward becoming a substantial Santa Rosa citizen."

Much as comics that tell a full story in one volume are called graphic novels, here was a new approach to film storytelling calling itself graphic theater. Just as graphic novels typically forgo the serialization of many comic strips and books in favor of narrative resolution, so too does *Graphic Little Theater* present a version (albeit truncated) of an entire film storyline. While many promotional comics of this era would forgo giving readers the film's ending, telling them that they had to visit their local theater to see how the story ends, *Graphic Little Theater* revealed all the major plot points of each film they adapted. In their version of *Shadow of a Doubt*, readers learn that Uncle Charlie is "wanted for the murder of three women," that he tries multiple times to kill his niece ("unsuccessfully attempting to trap her in a gas-filled garage," we learn), that he is killed while again trying to

murder young Charlie, and that she and her boyfriend will be married at the end.[31]

The film did not play Chicago theaters until nearly two months after readers were given this "graphic" version of the story, however. Newspaper advertisements proclaimed that *Shadow of a Doubt* was "guaranteed to be the most thrilling screen hit of the year! Positively no one will be seated during the last 20 minutes of the picture! Please do not reveal the plot!"[32] *Graphic Little Theater* revealed the plot of every film it adapted, of course, a practice that would not be allowed by film studios in the modern era in which the concept of "spoilers" denotes that our moviegoing experiences can be ruined if we know too much about a film's story in advance. But the studios at the time saw the publicity provided by the series as a way of giving readers a sampling of a story they might want to visit their local theater to see, rather than one from a competing studio. The format was obviously not intended to provide readers with an extensive summary of each film's story (one of the more unusual editions saw Universal's thirteen-chapter serial *The Adventures of Smilin' Jack* [1943] recounted in thirteen panels), but to give them an overview of the plot so as to entice them to the movie theater.

Graphic Little Theater ran until 1946, but the format returned in 1949 with a somewhat different approach called *Movie Plays in Pictures*. While it retained its predecessors' use of publicity stills and text passages, the new feature was a daily strip rather than a weekly one, serializing each film over several days. New to this version was a brief summary of the story in its first installment, reducing the film's plot to a single sentence. *She Wore a Yellow Ribbon* is described as "The United States' Cavalry's struggle to put down Indian uprisings in the exciting, early days of the west."[33] Similarly, *The Third Man* (1949) is described as a "Drama of life in brooding, fearful Vienna, a city of rackets in currency, drugs and human life."[34] Most films were presented over three days, requiring recaps of the previous installments, much as cliffhanger serials did, in the form of a short paragraph reminding readers of what came before.

Movie Plays in Pictures ended in 1954, perhaps a victim of the overall shift in how Hollywood films were marketed in the wake of new competition from television. But throughout much of the 1940s and early 1950s, Chicago filmgoers were given an advance look at many of the films that were coming soon to their local theaters. Both *Graphic Little Theater* and *Movie Plays*

in Pictures offered a regular dose of film imagery in comics form, reaching many readers who wouldn't ordinarily read comics and offering them Hollywood narratives in the form of sequential panels.

MOVIE STARS AND THE RETURN OF *MOVIE COMICS*

While many comics focused on adapting particular films, the second half of the 1940s saw an increasing number of comic books featuring popular film stars in new stories that went beyond their onscreen exploits. While many actors had appeared in short features like Bernard Bailey's *Stars on Parade*, few were given their own titles in years past. But once comic book publishers had established the market with superheroes like Superman and Captain Marvel, they soon turned to Hollywood to see which screen heroes could successfully anchor their own titles.

The relationship between how we experience film imagery when adapted into comics is in some ways similar to viewing comics characters onscreen. Comics based on films or starring famous actors recall the images of the original films just as we bring to mind the drawn image while watching a film adaptation. These drawn images are abstracted versions of actual people, while actors cast as live-action versions of drawn images are physical incarnations. Actors are substitutes for drawn characters onscreen, whereas drawn characters become replicas of actors on the page. In each case, the new version need not look exactly like the original to be considered appealing. An actor embodying Dick Tracy need only be of the right age range and physical build and wear the right costume elements to resemble the character. In the same way, a drawn image of Gene Autry doesn't need to look exactly like the actor so long as the same factors are in play. A drawn image of a cowboy on the range wearing a bandana around his neck and a white hat becomes Autry even if the artwork is not meant to approximate photorealism in the way that Bailey did in the 1930s. This is especially true when the book's cover features a photo of the movie star (increasingly common as the decade progressed), which is used to create a distinct relationship between the actor's filmic image and the drawn version found on the pages within. The reader in turn projects the photographic image onto the abstracted ones, allowing a drawing that might look like any number of screen cowboys to become Autry as they read the story.

Autry was one of the first film stars to receive his own ongoing book with 1941's *Gene Autry Comics*. Alongside his regular appearances in *Four Color*, the series featured the further adventures of Autry as he battled new villains and faced new threats: "Here is that hard-riding, fast-shooting adventurer, Gene Autry, in an exciting story of the western plains, where laws are made by grim-eyed men and enforced by blazing six guns," one issue begins.[35] What these hard and fast adventures lacked from his screen appearances, however, were musical numbers. Autry, known as "the singing cowboy" in Hollywood, didn't sing in his comics given how readers would have to make up their own music and rhythm to accompany any lyrics that might be presented. The comics medium must use visual signifiers to represent sound (hence the need for written onomatopoeic sound effects of the Bam! Pow! variety), making musical numbers impractical to re-create with any effectiveness. Autry's characterization was not necessarily different from his films given the lack of music, but the book's narratives adhered more strictly to western genre motifs than did his films, which used elements of the musical in addition to sometimes combining elements from different genres.[36]

Other movie cowboys were given their own series as well, including Hopalong Cassidy in 1943 along with Tom Mix and Roy Rogers in 1948.[37] Hopalong's first issue for Fawcett was even endorsed by the publisher's premier superhero—Captain Marvel. The cover features an offset image of Marvel wearing a cowboy hat, with the tagline, "Hopalong's my choice for rootin' tootin' wild west action." Here, the image of Captain Marvel in a cowboy hat is used as a way to sell any hesitant comics fans on the relevance of a film character making the transition to another medium. In this case, Hopalong's role as a comic book character is lent further authenticity through support from a comics character who had successfully made the leap to the big screen.

Other film genres also gained prominence on newsstands as the decade progressed. Numerous movie comedy teams received their own books, with their built-in appeal with younger audiences helping sales. The child stars of the *Our Gang* series appeared on newsstands from 1942 to 1949. Laurel and Hardy received their own comic book in 1948, followed by Abbott and Costello in 1949. The Three Stooges also saw their own book in 1949 (and again in 1953), as did Charlie McCarthy. Young female readers were courted with the series *Calling All Girls*, which often emphasized teen stars

like Shirley Temple, Mickey Rooney, and Elizabeth Taylor alongside vari-
ous romantic tales. *Sweet Sixteen Comics and Stories for Girls* offered the life
stories of stars like Ronald Reagan, Dana Andrews, and Robert Mitchum,
along with new movie-related characters like Dorothy Dare, "Queen of the
Hollywood Stunt Artists."

Stars like Tim Holt, Dick Powell, and Jimmy Durante appeared in *A1
Comics* in 1948 and 1949. The latter year also saw the arrival of *The Adventures
of Alan Ladd*, with one issue's cover boasting of how the book presented
"the World's top box-office star in the kind of he-man roles you like him
in!" The comic featured adaptations of such Ladd films as *Whispering
Smith* (1948) and *Chicago Deadline* (1949), but more regularly featured
new adventures like "Alan Ladd and the Beautiful Bodyguard," "Alan Ladd,
Stunt Man," "The Girl Who Bought a Movie Star," and "Alan Ladd—
Oil Rigger."

An even bigger he-man received his own comic book in 1949, with
the opening editorial of *John Wayne Adventure Comics* #1 telling how the
actor is "A Man's Man!" Another issue begins by telling readers how "big,
rugged John Wayne carries dynamite in his large fists and instant death
in each of his two guns," with this bravado used to set Wayne apart from
other Hollywood cowboys with their own series. Wayne appears as him-
self in the book ("Name is Wayne—John Wayne," he announces when
asked if he is new in the area),[38] drifting from town to town. Autry and
Rogers both used their own names in their films, so their print adven-
tures might be read as a mere continuation of their screen efforts. Since
Wayne plays different characters in each of his films, his appearances in
these comics might in turn be read the same way as Mickey Mouse's—
with Wayne traveling around such states as Montana and Wyoming
on horseback and finding adventure when he wasn't filming his latest
movie.

The series did not offer adaptations of his films, but instead featured new
stories in which Wayne regularly intervened in various murders and mys-
teries (often resolving things with his best "Sunday punch," as one character
describes it).[39] Some of his adventures were decidedly stranger than those
of his film westerns, such as when he is captured by a toga-clad man named
Nero who has re-created a Roman coliseum in a hidden valley. Wayne is
forced into a shootout with another man: "You talented killers are to be pit-
ted against one another as the Romans did, centuries ago—I would (sigh)

FIGURE 34. John Wayne appears as himself in the pages of *John Wayne Adventure Comics* #1 (Winter 1949).

prefer to see you using spear or sword—but you are not at home with these glorious weapons—I yearn for the days of chivalry—of man against man with the death penalty for the coward and weakling," bemoans Nero. When Wayne rigs the contest and attempts to escape, Nero sets "a band of hungry mountain lions" upon him, much as the Roman gladiators were beset by lions and tigers. Wayne and his combatant gun down the animals one

by one.[40] The book's western genre narratives occasionally veered into unusual territory rarely seen in Hollywood films, allowing comics readers to experience Wayne in stories in which he would never have been featured onscreen.

While the book's cover boasted the tagline "The Greatest Cowboy Star of Them All!" readers were occasionally offered a war tale in keeping with Wayne's popularity in such films as *Back to Bataan* (1945), *They Were Expendable* (1945), and *Sands of Iwo Jima* (1949). Issue fourteen uses an image from the *Sands of Iwo Jima* poster of Wayne charging with a bayonet, the publisher hoping to capture fans of Wayne's different film genre efforts. The issue begins with a story set during the Korean War entitled "Operation Peeping John," as our narrator tells us of how "the orders called for a mission loaded with the smell of death. The assignment sends Wayne behind enemy lines with orders to dig in under the noses of the enemy . . . and sweat out the mission of observation that makes him a . . . Peeping John!" The story ends with a nurse telling an injured Wayne that he should be discharged soon: "With the new regulations, most of the reservists will be getting out!" The final panel shows Wayne thinking to himself, "I hate to leave those boys back here in Korea—but I'll never forget them—even though it'll be good to get back on the range."[41]

This forced attempt at creating continuity between his western and war adventures furthers the book's illusion that Wayne's offscreen exploits were as thrilling as his cinematic ones. He is not referred to as a movie star in the comic, nor are any of his films directly invoked in the stories, but various characters nevertheless recognize him and are star-struck ("Why . . . why you're *John Wayne!*" says one sheriff, adding, "I thought you might be th' thief we're after. I didn't know it was *you*, Mr. Wayne").[42] The series therefore serves to bolster Wayne's larger-than-life persona as "The Duke," offering readers tales of derring-do that support his screen image.

Wayne was one of the biggest movie stars of the period, and the fact that he had his own comic demonstrates that such books were not just reserved for B-film stars and animated characters. Comics featuring movie stars helped to solidify the image or character type that actors constructed for themselves (or which their studios created for them). In the case of both Alan Ladd and John Wayne, their comics were used to position the actors as rugged heroes both onscreen and off, with the books boasting of their virility and manliness as a way of boosting their star power in a way similar

to that of other publicity outlets like fan magazines. In this case, however, narratives are used to sell the public on the potency of these movie stars, with such stories offering visual entertainment rather than prosaic journalism as a way for film fans to extend their enjoyment of their favorite screen stars.

While there were numerous series featuring a wide range of movie stars by the late 1940s, full-length movie adaptations in comic book form were still rare throughout the decade. *A-1 Comics* adapted *Joan of Arc* with Ingrid Bergman in 1949, but it was an isolated event for the series. A somewhat longer-running approach came in 1946 with a new series called *Movie Comics* from publisher Fiction House, which was of no relation to the 1939 series of the same name. Much like the original version, this one also offered adaptations of new movies currently in theaters or coming soon, offering a wide range of film genres: the crime release *Big Town* (1947) based on the radio series of the same name; comedies like *White Tie and Tails* (1946) with William Bendix, *Love Laughs at Andy Hardy* (1946), and *Merton of the Movies* (1946) with Red Skelton; plus the adventure film *Slave Girl* (1946). "World Premiere of Hollywood Highlights," the first issue's cover boasts, touting the fact that the book offered filmgoers an advance look at upcoming films.

Unlike the 1939 version, this *Movie Comics* series features strictly line art images, not the fumetti approach involving photographic imagery. As well, the 1946 version only featured one film adaptation per issue (except for the two films offered in #4). The remainder of each issue was filled with original movie-related material, such as Flicker Funnies (in which animals appear as film stars, directors, etc.), Johnny Danger of the Screenland Patrol ("Movie stars may be the stuff of dreams to you, but to me—Johnny Danger of Superba Studio's private police—they're a pain in the balcony," explains Johnny), Captain Stand-In (depicting the adventures of stuntman Buck Hoskins), and Mitzi of the Movies (featuring an aspiring actress named Mitzi Mason, "A home grown product of Hometown, U.S.A.").[43] Advertisements for the series announced: "New! Actual Screen Thrillers Presented in an Unusual Book! Don't Miss it!"[44]

In actuality, few of the Hollywood films adapted were thrillers, and the most "unusual" quality of the book was in how little of its content was based on actual movies. In most film-related comics, faux-filmic characters like Mitzi and the animals of Flicker Funnies were supporting elements used sparingly to accompany the main stories based on Hollywood films or stars.

FIGURE 35. Cover of the first issue of the 1946 *Movie Comics* series.

The film adaptations of *Movie Comics* are overwhelmed by a barrage of supporting characters, which may have frustrated readers given how the films themselves were not as high-profile as those adapted in the 1939 series (such as *Gunga Din, Son of Frankenstein,* and *Stagecoach*). In turn, the series lasted only four issues, as few comic books featuring simulated cinematic content met with long-term success in the 1940s. By the end of the decade, comics with popular western heroes, screen comedians, and animated characters proved consistently popular while most books offering simulated screen

content eventually lost favor. Comics fans craved further print adventures featuring their favorite film stars, which were plentiful on newsstands as the decade progressed.

Whether it was movie star comics, comics-based advertising campaigns for new films, or newspaper features like *Graphic Little Theatre* offering sneak peeks of upcoming movies in panel form, comics regularly re-created and repurposed film imagery throughout the 1940s. Some efforts were authorized by film studios as a form of marketing, while others came in the form of publishers attempting to cash in by suggesting a relationship between their books and Hollywood that didn't actually exist. Such titles offering counterfeit movie content usually didn't last long, as the demand for popular film characters and stars in comics form was increasingly filled by the end of the decade.

Comics allowed for narrative experimentation in ways not always permitted by the film industry, as seen in the dual roles played by Mickey Mouse and Donald Duck in comics and onscreen, Clark Kent sharing a knowing wink with his cinematic counterpart, or John Wayne battling mountain lions and a modern-day Nero. Many film-related comics of this period demonstrate a playful intertextual quality that foreshadow various modern texts considered to be examples of transmedia storytelling. From the adaptation of film narratives to the ways in which film characters and stars were extended into new adventures, the relationship between comics and film in the 1940s grew increasingly wide-ranging, with both industries gaining from the ways in which the two media came together.

5 · 1950s COMICS-TO-FILM AND TELEVISION ADAPTATIONS

Hollywood was in a state of flux by 1950. Attendance was in decline from its peak of 82.4 million viewers per week in 1946.[1] The U.S. Supreme Court handed down an antitrust ruling known as the Paramount Decree in 1948, forcing the major Hollywood studios to drastically change their business practices. New competition arose in the form of television, which would have a major impact on theater attendance rates as the decade progressed. The production of B-movies began to dwindle as the economic rationale for making them changed in the wake of the Paramount Decree. Among other restrictions, it became illegal for studios to continue a practice known as block-booking, in which they would demand that exhibitors buy their B-films in order to also get their A-films with big-name stars and higher production values. As a result, double bills gave way in many theaters to the showing of single films only. Hollywood also began making films with higher budgets in the 1950s, but offering fewer overall releases than in previous decades. As the industry adjusted to these changes, comics adaptations soon took on new forms.

Since comics adaptations had been closely aligned with B-filmmaking since the mid-1930s, comic books and strips were brought to film audiences in substantially different ways in the 1950s as the marketplace for low-budget

productions was reshuffled. Monogram Pictures renamed itself as Allied Artists Inc. in 1953, increasingly turning toward A-films while focusing on new genres like science fiction for many of their B-film efforts. Republic Pictures suffered, unable to reinvent itself. The studio became largely a distributor for other companies' films by mid-decade before folding in 1959. New companies emerged such as American International Pictures, but its focus on teenage audiences meant forgoing comic adaptations because of their longstanding association with serials and younger children. The early 1950s saw comics characters disappearing from movie screens in droves, although many would continue to entertain audiences at home through a growing number of television stations.

CHAPTERPLAYS AND B-FILM SERIES FADE

While serials and B-films based on comics characters had thrived at studios like Columbia, Universal, Monogram, and Republic throughout the 1940s, there was only one player from 1950 to 1955 still consistently making such adaptations—Sam Katzman. Through Katzman, Columbia remained the only studio to produce comics-based films on a somewhat regular basis into the mid-1950s. There were a handful of comics adaptations from other studios, but Columbia and Katzman became comics fans' best hope for big-screen versions of their four-color heroes, for better or for worse. Monogram's *Jiggs and Maggie* series, based on George McManus's newspaper strip *Bringing Up Father*, ended with 1950's *Jiggs and Maggie Out West*, while their *Joe Palooka* series came to an end in 1951 with *Joe Palooka in Triple Cross*. Republic did not acquire the rights to any further comics properties once their *Red Ryder* series ended in 1947. The company still produced serials, but turned more toward the western and jungle film genres (which allowed for the ample reuse of sets and stock footage). Universal had ceased making serials in 1946, hoping to position itself as a higher-class studio by dumping the chapterplays along with their long-running cycle of horror films.

Columbia continued producing serials until 1956, the last studio to do so. Among their final comics chapterplays were *Atom Man vs. Superman* (1950) and *Blackhawk* (1952), both produced by Katzman and starring Kirk Alyn. While the first *Superman* serial borrowed catchphrases from the radio series, the sequel went a step further by basing its script on the

memorable radio storyline "Superman vs. the Atom Man," which aired between October and December of 1945. The new serial changed much of the original narrative given how the original focus on a Nazi scientist was no longer as timely in 1950, but its use of atomic energy remained relevant as the cold war era began.[2]

Atom Man vs. Superman was touted as being "a *Bigger . . . Better . . .* brand new Columbia serial." With Lyle Talbot starring as Lex Luthor, the new film did offer something that few serials based on comic books contained—an existing villain from the source material rather than a newly created foe.[3] Captain America's arch-nemesis in his comic books was the Red Skull, Captain Marvel regularly faced the evil Dr. Sivana, while Batman fought a rogues gallery of villains including the Joker, Catwoman, the Penguin, and Two-Face. None of these villains appeared in the serials, however, despite the ease with which most could have been substituted in the script in place of the generic crime bosses of each film. Katzman had used a new villain named The Wizard in *Batman and Robin* (1948), who like so many serial villains had his face covered by a hood most of the time. Talbot (who played the heroic Commissioner Gordon for Katzman in *Batman and Robin*) donned a rubber cap to play the bald-headed Luthor. In contrast, the Joker and Two-Face would have required more elaborate makeup effects, while Catwoman and the Penguin necessitated special costumes and props. The characters could have been accommodated on a narrative level, but Katzman probably hesitated at the financial considerations involved in bringing the famous villains to the screen. Instead, he settled on a standard serial baddie for *Batman and Robin* who was indistinct from countless other cliffhanger foes, banking on his viewers coming to the theater to see the title heroes rather than any of the comic books' colorful villains who might have slightly stretched his razor-thin budget.

This strict adherence to formula was part of the serial format's undoing once television arrived. One review of Katzman's *Blackhawk* serial, based on the comic book from publisher Quality Comics about a group of dashing aviators battling foreign spies, noted how it was the latest release from his "assembly line."[4] *Blackhawk* is a fine example of the cliffhanger formula, and Alyn's performance capably distances itself from his role as Superman, but the film does not feature any new innovations. Not surprisingly, Katzman cut some corners in how he translated the book to the screen, using only a single aircraft where the comic had featured a fleet of planes.

In an unusual move, Katzman arranged an advance preview of the serial (which cliffhangers rarely received) complete with comment cards. The feedback confirmed the juvenile nature of the audience's interests, with one card stating, "Swell movie—no kissing."[5] By the time of *Blackhawk*'s release in 1952, however, children could see older serials on television, along with numerous youth-oriented TV programs of a wide range of genres. Comic books had thrived as source material for serial producers throughout the 1940s, but as the film industry went through various changes at the start of the new decade it was soon apparent that the market for film adaptations of comic book heroes was not what it once was.

Feature-length B-films based on comics did little better in the early 1950s. Several long-running series ended, while one new series never managed to sustain itself. The final *Blondie* effort, *Beware of Blondie*, was released by Columbia in 1950. The series was a remarkable mainstay at the studio for over ten years, with the same stars remaining throughout all twenty-eight films. *Blondie* creator Chic Young reportedly raised his price "heftily" for the strip's screen rights, prompting Columbia to go in a different direction.[6] The studio announced plans to release new films based on Frank King's *Gasoline Alley* comic strip and to re-release the first six *Blondie* films rather than produce new films in its *Blondie* series. *Variety* noted how the earlier films in the series had acquired "added exploitation prestige" by 1950, given how "practically all of [the] lot's current and recent star power—Rita Hayworth, Glenn Ford, Larry Parks, and Janet Blair—appeared in smaller roles in the films at one time or another."[7]

The *Gasoline Alley* films represented Columbia's last attempt at launching a new B-film series starring comic strip characters. In 1951, both *Gasoline Alley* and *Corky of Gasoline Alley* were released, with the studio waiting to see how they fared with moviegoers before committing to further entries.[8] While this new series failed to capture the same audiences that had sustained the *Blondie* films for over a decade, Columbia still had one ongoing B-film series in the early 1950s starring a familiar comics character. In 1948, Katzman began producing *Jungle Jim* films for the studio starring former *Tarzan* actor Johnny Weissmuller in the title role. Having just wrapped up his final appearance as the "lord of the jungle" in *Tarzan and the Mermaids* for Sol Lessor Productions, Weissmuller traded in his loincloth for khakis and a slouch hat to portray Jungle Jim in sixteen feature-length films

between 1948 and 1954 before then starring in a syndicated *Jungle Jim* television series the following year.

Katzman relied heavily on stock footage in his jungle adventures, often as a way of padding their running times. In reviewing the first film, *Jungle Jim* (1948), the *Hollywood Reporter* described how "the jungle and wild animal shots, excellent though they are, seem to be incorporated in a haphazard fashion instead of bearing a direct relationship to the plot."[9] *Valley of the Headhunters* (1953) was described as a "plodding adventure tale" with "routine" direction, while *Variety* wrote of *Savage Mutiny* (1953) that "Sam Katzman apparently gave it the once-over-lightly treatment in prepping."[10]

Despite being regularly savaged by the critics, the series served an economic purpose for Columbia in an era of declining B-film production, as the studio was one of the few to maintain a steady slate of B-films for the mostly rural and neighborhood theaters (along with drive-ins) that still offered double bills in the 1950s. Weissmuller was a recognizable star and Katzman's "assembly line" production methods kept these films profitable for Columbia throughout the first half of the decade: "Weismuller is a good name in the action market, and it is plain that he is not carrying too heavy a budget load. Film will get solid if not spectacular bookings," the 1948 review correctly predicted.[11]

As the growth in television audiences cut further into Hollywood's box office attendance numbers, B-film series like *Jungle Jim*, along with the cliff-hanger serials that had regularly served as the dominant live-action incarnations of four-color characters throughout the 1930s and 1940s, gave way to small-screen versions. *Jungle Jim* joined a roster of television shows based on comic books and strips, including *Dick Tracy, Flash Gordon, Terry and the Pirates, Joe Palooka, Superman,* and *Red Ryder,* all of which had formerly been serials or feature-length B-films. This shift in how audiences experienced comics characters onscreen in the 1950s demonstrates that despite how these adaptations were regularly limited to less acclaimed cinematic formats (B-films, serials, and animated shorts) throughout most of the Classical Hollywood era, comics-based imagery could flourish on small screens as well as large ones. But in a few cases, comics even thrived on big budgets and top stars, proving that the source material could support blockbuster films as well as B-films. While Katzman's efforts may not have received "spectacular" bookings, a handful of comics-based films did play in top theaters in the mid- to late 1950s.

PRINCE VALIANT, THE SAD SACK, AND LI'L ABNER: COMICS ADAPTATIONS AS A-FILMS

While comics adaptations were not A-film material throughout most of the Classical Hollywood era, a few notable films were produced with large budgets in the new era of widescreen epics. The biggest of these was 1954's *Prince Valiant* from Twentieth Century–Fox, which was among the earliest films released in the new CinemaScope format. Based on the Harold Foster comic strip about a Viking prince in the days of King Arthur, the film is a lavish effort with a wide range of period costumes, sets, and props. Given its sweeping scope and historical context, the comic strip simply could not have been adapted properly on a lower budget. At a cost of approximately three million dollars, the film's budget could have funded nearly twenty Republic serials, or upward of two dozen B-films (such as Columbia's *Blondie* and Monogram's *Dick Tracy* series). An acre-long lake was built on *Prince Valiant*'s Sherwood Forest set, while a castle built on the studio's back lot for $80,000 cost nearly as much as a single B-film at many studios.[12]

The film's budget was so large that it was known within the industry as a "super special," part of a move by Twentieth Century–Fox to spend a combined $20 million on seven films. "I don't believe," said the studio's production head Darryl F. Zanuck, "that any company in any single year ever has attempted to produce seven pictures of the cost and scope of these."[13] The film's trailer sells audiences on the epic scope of the film, proudly proclaiming: "Never before has adventure like this swept you into its exciting spell. Because only the magic cameras of Cinemascope and the marvels of stereophonic sound could recreate the dazzling magnificence of the court of King Arthur. The crash of lance against shield. The thunder of battleaxe against helmet. The knights. The deeds. The golden age of chivalry. And the epic story of a Viking prince who challenged a kingdom for the kiss of a beautiful princess."

Through such promotional rhetoric, *Prince Valiant* was sold on its technical merits more than its source material. The trailer boasts of how its all-star cast (including James Mason, Janet Leigh, Robert Wagner, Debra Paget, and Sterling Hayden), along with "A Cast of Thousands," are able to "Bring to life the Flaming Story of PRINCE VALIANT In Full Battle Array . . . In Full-Panoplied Spectacle . . . In the Full-Visioned Splendor of Cinemascope and the Wonder of Stereophonic Sound." The notion of bringing familiar

characters "to life" echoes the strategies of earlier comics adaptation, much as the opening credits show images from the strip (or at least stills in the style of Foster's artwork, which look newly painted for the film) as so many of the lower-budget efforts of previous decades do. Yet the film is aimed at a mass audience and not strictly a juvenile one—with the trailer heralding the strip as "the most Wondrous Adventure that thrilled millions of all ages."

The strip's historical setting in Arthurian England was one of the studio's biggest reasons for adapting *Prince Valiant* to the screen. "The colorful days of King Arthur, period in which Prince Valiant is limned, with knights and romances and battles on the field, lend a particularly colorful setting for spectacular action," reported *Variety*.[14] In a report chronicling the film's production, American Society of Cinematographers president Charles G. Clarke told of how "the soft light and gorgeous colourings" of the English countryside "are particularly beneficial for any process of colour photography. The magnificent landscapes fit into the CinemaScope screen proportions ideally. In the sense that New York is a city of verticals, Britain is a land of horizontals, and the latter condition is 'wide screen' at its ultimate best."[15] The report essentially defends the validity of the new widescreen process and its technical merits, such as how it will affect close-ups, different types of moving shots, and the relationship of camera to the set. Clarke admonishes those who resist it the same way that some resisted the move to sound filmmaking, using *Prince Valiant* as an example of the new types of films that will flourish under CinemaScope's widescreen process.

Reviews of the film were highly praiseworthy, without the sorts of qualifiers seen in accounts of prior comics adaptations from the past twenty years. The *Hollywood Reporter* called it "a glorious tale of adventure brought to the screen in a thrillingly swashbuckling style that will delight the huge following of Harold Foster's King Features comic strip and enthrall the young of all ages. Filled with romance, swirling swordplay and almost awesome battles, the combination of a ready-made audience and a beautifully produced spectacle makes this Robert L. Jacks production a sure boxoffice sensation."[16]

The film was the first feature-length comics adaptation to be released in Technicolor from Hollywood. Both the color format and widescreen Cinemascope process were particularly suited to the *Prince Valiant* strip. Colton Waugh wrote that Foster's work was "almost the ultimate in absorbing and realistic illustration," presenting an "authentic flavor" of the

historical events of Arthurian England in which "reality has supplanted sentimentalism."[17] Foster depicts epic scenes in *Prince Valiant*: fierce battles are fought between large armies; castles, bridges, and other massive architectural structures dominate the landscape; mountains, meadows, and mighty rivers serve as the settings for the strip's many voyages. The technical advances in color and widescreen cinematography aid in how the film is able to represent the intricate details presented in the strip, which would have suffered on a lower budget.

While some scenes might have easily been achieved using B-film production methods, others would have proved more difficult. One scene finds Valiant escaping from a prison cell and setting fire to the castle with the help of a large group of torch-bearing Vikings. Re-creating the scope of the scene's elaborate sets and costumes, numerous extras and elaborate pyrotechnics would have proven difficult in a B-film, yet there were some low-budget historical adventure films in this era such as Roger Corman's *Viking Women and the Sea Serpent* (1957). An escape scene like the one in *Prince Valiant* could have been staged by Corman, but rather than set fire to an $80,000 set the director might have used a makeshift dungeon or existing ruins for his location, forgoing any establishing shots of the entire castle ablaze in favor of more tightly framed interior shots of the daring escape through the dungeon's hallways.

Yet other scenes would surely have tested a B-film producer's financial limitations, such as the jousting tournament used to determine who will win the hand of Princess Aleta. This spectacular event is much more convincing on a large budget given the ability to present a wide range of characters, backdrops, props, and architecture to give a full sense of Camelot's majesty (the film's production budget lists the use of nearly 1,800 extras, for instance).[18] The use of horses and staged violence involving jousting lances would prove difficult to pull off without significant rehearsal and several trained stuntmen, luxuries not generally afforded to low-budget filmmaking in this era.

Prince Valiant's top-tier budget also allowed for the casting of several notable Hollywood stars. While the title role went to relative newcomer Robert Wagner, alternative casting choices considered for the lead included Burt Lancaster, Dirk Bogarde, Gene Kelly, Marlon Brando, Richard Burton, Richard Todd, Stewart Granger, Montgomery Clift, James Mason, Charlton Heston, Rory Calhoun, Peter Lawford, and Peter Graves. While Janet

FIGURE 36. An image of the jousting scene from *Prince Valiant* (Twentieth Century–Fox, 1954) demonstrates the elaborate production values of this big-budget adaptation.

Leigh played Aleta, other actresses considered for the part included Susan Hayward, Audrey Hepburn, Jean Simmons, Elizabeth Taylor, Ava Gardner, and Grace Kelly.[19] This list includes many of the decade's top stars, a scenario that might have seemed unfathomable for a comic strip adaptation just a few years earlier. While the source material may have drawn many fans to the theater, most viewers were primarily drawn to *Prince Valiant* to see Janet Leigh, James Mason, and Sterling Hayden put through the spectacular paces of a medieval period piece.

The same was true of Paramount's *The Sad Sack* (1957) starring Jerry Lewis, based on the newspaper strip by George Baker (and subsequent comic books from Harvey Publications). The film's opening credits use a font replicating how the title appears in the strip itself, but no images of the character are used. Instead, a photographic image of Lewis appears next to the film's title, a strategy also seen in trade advertising as well as the film's posters. Paramount sold exhibitors and audiences on the actor, not the character. *Motion Picture Daily* told of how "George Baker must have had Jerry Lewis in mind when he drew the original—for certainly the star and the role are identical."[20] Yet the source material was not the major draw of the film, unlike earlier adaptations of previous decades in which audiences went to see the onscreen adventures of their favorite comics characters.

Many reviews point out that audiences should enjoy the film *despite* how it handles its source material, specifically because of Lewis. *Variety* wrote: "It's the old army game, done over. But it's fun. Not any imaginative explorations. Relying on the type of zanyism with which Lewis is readily identified."[21] Colton Waugh wrote of how Baker's strip captured "the irony of life"

and represented "a cry of the injustice of life, of the fact that to the wolves go the rewards."[22] The satirical nature of the strip goes largely unexplored in the film, which caters to Lewis's star persona as a madcap underdog. The *New York Mirror* described how "very little of the pathos inherent in the comic strip, 'The Sad Sack,' is visible in the film. . . . Instead, the familiarly frantic antics of Lewis are substituted for the injustice usually meted out to the Army's favorite yardbird."[23]

Baker originally sold the film rights to Paramount in 1951, but the studio announced that casting difficulties had led to the project being "written off" by the end of 1953.[24] Both Alan Young and Red Buttons were attached to the film during that period, but once the project was abandoned Buttons "stole liberally" (according to Paramount story editor John Mock) from the script in a January 25, 1954, episode of *The Red Buttons Show*.[25] Buttons's alleged pilfering of the unproduced script did not stop producers Hal B. Wallis and Joseph H. Hazen from acquiring both it and the rights to the strip in 1956, arranging a distribution deal with Paramount that paid the studio $17,500—the same amount that Paramount had paid Baker in 1951.[26] Wallis

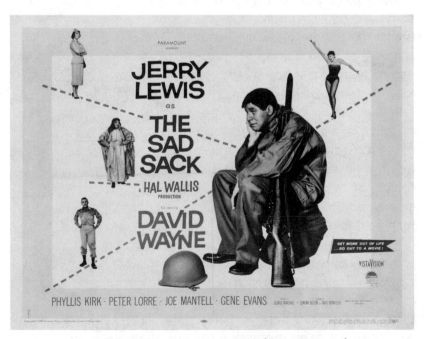

FIGURE 37. Lobby card for *The Sad Sack* (Paramount, 1957).

and Hazen originally planned to use the material for Dean Martin and Jerry Lewis while they were still a comedic duo. Story editor Paul Nathan told Wallis that the original script was "funny," but he noted that if the ending "gets wild or seems old fashioned, it will be a matter of your cuts . . . block comedy is there, even if it is a Hope & Crosby third act."[27] Much of the script, including the ending, was revised during preproduction to accommodate Lewis's frantic comedic style. When he and Martin split, the project became Lewis's second solo outing (after *The Delicate Delinquent* [1957]).

The Sad Sack was a box office hit for Paramount and tied for the twentieth highest-grossing film of 1957, earning $3.5 million.[28] Baker profited from the film's success as well, something that few of his peers did with the B-film adaptations of other comics. Baker's original deal with Paramount (and which Wallis and Hazen were required to assume) saw the creator paid an additional $17,500 once the film grossed 1.9 times its negative cost, plus additional incentives for even higher box-office grosses.[29]

With a budget of $1,225,000, *The Sad Sack* was not a "super special," but it was nearly ten times costlier than many B-films of the period. Even with its higher budget, there were concerns about the film's production values. Upon viewing the dailies of the desert sequence, Wallis was worried that the end product wasn't reflecting its A-film budget. "I feel we are getting very little production value from the set," he told director George Marshall. Wallis demanded that Marshall use "longer shots" in order to "get some production value from it and make full use of the set we built" and to "get some composition and atmosphere into the shots, so that you don't take two steps out of a shot at a gun and they are immediately in front of a tent."[30] Such issues might have been overlooked had it been a B-film adaptation, but with a bigger budget came a larger concern about a film's aesthetics, given how *The Sad Sack*'s appeal wasn't just about the source material and it characters, but for a well-rounded film comedy featuring a major Hollywood star.

At the same time Paramount was preparing their film version, Desilu Productions was simultaneously involved in preproduction efforts for a Sad Sack television series. Baker had retained the television rights to his strip, but offered to sell them to Paramount for $3,000 (he "turned down $500 offer and won't negotiate," Nathan told Wallis).[31] Desilu announced in July 1957 that the pilot would be shot the following month, and that Tom Ewell was being considered for the lead role following his success in

The Seven Year Itch (1955) and *The Girl Can't Help It* (1956). With character actor Arnold Stang also sought for a supporting role, the series seemed highly promising but (much as with Paramount's initial difficulties earlier in the decade) was postponed twice and then finally scrapped due to casting problems.[32]

Casting difficulties also seemed to play a role in a failed television series based on another strip that was adapted into a big-budget feature film in the 1950s—*Li'l Abner*. Created by Al Capp in 1934, the strip depicts the hillbilly residents of the mythical southern town of Dogpatch (including Li'l Abner Yokum, Mammy and Pappy Yokum, Daisy Mae Scragg, and Moonbeam McSwine) and their explorations of big city life. Media theorist Arthur Asa Berger describes the strip as an important piece of American satire, noting how Capp saw his characters as "broad burlesques"—comedic foils for satirizing society and politics.[33]

The strip's debut saw readers introduced to "the simple home of the Yokums, nestling high in the hills of the south. And there are no simpler hill billies in all them hills than Mammy and Pappy Yokum." Pappy gets frustrated by a letter he has just opened, exclaiming "Dawgone!—Ah can't read this letter on account ah can't read anyhow!" We are then introduced to Li'l Abner himself, "only 19 years old and six foot three in his stockinged feet—if he wore stockings." "Accordin' to the sun, it hain't supper time—but the way mah stummick feel it *must* be!" he says.[34] The strip served as a comedic way to satirize issues of class and culture in a way that the urban adventures of *Dick Tracy*, the international intrigue of *Terry and the Pirates* and *Tim Tyler's Luck,* and the interplanetary adventures of *Flash Gordon* and *Buck Rogers* did not.

ABC produced a pilot for a *Li'l Abner* television show in 1949, but the series was not picked up despite the involvement of both Capp and musical director Busby Berkeley. Producer Mort Millman struggled to cast the pilot, with *Variety* describing how the show represented the overall difficulties that television faced in adapting familiar characters to the new medium: "Because of the preconceived notions of viewers as to what the characters should look like, Millman at first attempted to find actors who would look as though they had stepped directly out of the Al Capp comic strip. He later decided, however, that it was more necessary that the actors have the subtler qualities of walking and talking like the cartoon characters, since the public has acquired a feeling for such things based on watching the strip for years."[35]

FIGURE 38. Lobby card for *Li'l Abner* (Paramount, 1959).

RKO had produced a feature film version of the strip in 1940 that was poorly received. Film historian Roy Kinnard notes how some of the actors wore "rubber facial appliances" to appear more like Capp's distinctive characters, making them "look like refugees from a horror movie."[36] The rubber noses, chins, and other prosthetic enhancements of the RKO film were perhaps more reserved than the rubber masks considered by the producers of the failed *Funny Page* in 1933, but the obvious artifice of the effect still drew attention to the inherent differences between drawn images and photographic ones. Film audiences were likely more familiar with the five animated shorts from Columbia in 1944: *Kickapoo Juice, Amoozin' but Confoozin,' A Pee-kool-yar Sit-chee-ay-shun, Porkuliar Piggy,* and *Sadie Hawkins Day.* These efforts proved that the strip could be readily adapted, but the way in which animation thrives on the distortion of physical forms (in turn surpassing the unnatural qualities of the live-action film's makeup effects) may have contributed to the "preconceived notions" of how Capp's characters should appear onscreen that complicated the television pilot's reception.

While the strip stalled on television in the 1950s, a Broadway musical stage play of *Li'l Abner* was produced in 1956 by Norman Panama and Melvin Frank (who had previously written *White Christmas* [1954] and *The Court Jester* [1955] together). The musical featured songs by Gene de Paul and lyrics by Johnny Mercer, who had previously teamed up two years earlier on *Seven Brides for Seven Brothers* (1954). In a press release issued during the film's production, Capp revealed that Panama and Frank were not the first who sought to transform the strip into a musical:

> "Lots of people have been wanting to make a movie of 'Li'l Abner,' but Panama and Frank were the first to really understand the property," Capp explains. "The first thing they understood was that nothing should be required of me. Alan Lerner and I discussed 'Abner' a few years ago. We had a lot of fun together but accomplished very little. Then he came up with something called 'My Fair Lady,' whatever happened to that?" Capp said the same sort of thing happened more than a dozen years ago when he sat down with John [*sic*] Logan and Oscar Hammerstein, both of whom wanted to make stage and movie versions of "Abner." "They're awfully bright fellows and had done good ideas," he admits. "But they were like Lerner in that they expected some sort of contribution from me. So nothing happened. Finally, Panama and Frank came along and said they'd do it, provided I keep out of their way. Being a lazy man at heart, I jumped at their offer."

Capp served as a consultant on both the musical and film versions—"I made a few suggestions, but that's as far as it went," he says.[37] The musical was financed by Paramount, which also paid Capp the remarkable sum of $3,000 for the screen rights.[38] In 1959, Paramount produced a feature film version of the musical, with Frank directing from a script by both himself and Panama that retained much of the original. The studio apparently put a great deal of faith into the creative pair, with the film going nearly $400,000 over its initial $995,000 budget.[39]

Li'l Abner was a big box-office draw, proving to be one of the most popular releases of the Christmas season.[40] Unlike *The Sad Sack*, the film did not rely on star power for its success, using character actors like Stubby Kaye and Julie Newmar in supporting roles. As a film "with topnotch production values but without outstanding boxoffice names," *Li'l Abner* was even looked at within the industry as the type of production that might break "the strongly entrenched position of the handful of star names."[41]

As Hollywood increasingly made fewer films (but with bigger budgets) as the decade progressed, exhibitors complained of a growing shortage of releases with which to satisfy audiences accustomed to a more frequent turnover of titles shown at their local theater. *Variety* described in 1959 how exhibitors "frequently charged that the alleged stranglehold these stars have on the industry has caused the product shortage because no one wants to make a picture without b.o. insurance and has hiked film rental charges because of the astronomical salaries paid these stars." In turn, many exhibitors gave films like *Li'l Abner* "an extra merchandising push" to show the major studios that "they need not wait to assemble a package that contains only the established box-office stars . . . [in] hope of getting more pictures on the market."[42]

Li'l Abner demonstrated that big-budget adaptations of comics could draw audiences not just by casting a well-known star but through the popularity of the source material and the strength of the filmmakers' adaptive approach. Together, the three feature-length A-film adaptations from this decade represent a range of approaches that were rarely if ever used previously. From the epic widescreen spectacle of *Prince Valiant* to the comedic star power of *The Sad Sack* to the Broadway flair of *Li'l Abner*, audiences encountered remarkably different versions of comics characters on theater screens from those offered by B-films and serials. The A-film adaptations of the 1950s featured exponentially bigger budgets, longer shooting schedules, and enhanced production values, and often some of the industry's best-known actors, composers, and other top talent. While comics did not ultimately dominate Hollywood in the 1950s as they would in later decades, these three films proved that comics-based source material was not merely the domain of low-budget productions, and that comics had the potential to thrive onscreen in a wider range of forms than they had since the beginning of the sound era of filmmaking.

FROM PANELS TO CHANNELS: TELECOMICS, DICK TRACY, AND FEARLESS FOSDICK

Although there were fewer overall films based on comics in the 1950s than in prior years, *Dick Tracy, Flash Gordon, Buck Rogers, Terry and the Pirates, Joe Palooka,* and *Red Ryder* were among those that made the transition to the small screen as the decade progressed. But before these stalwarts of the

funny pages were adapted for television, the new medium first presented comics in a unique manner. In 1947, as television began making its first major inroads with household audiences after years of experimentation, several companies offered a new product to stations that combined the static imagery of comic panels with the new possibilities for broadcasting sound and moving images. "The rush to package cartoon and comic strip programs for television this week threatened to turn into a stampede," *Billboard* reported in November 1947, "with five organizations readying funnies for video." The end result was known as telecomics, which presented television viewers with a series of images taken from comics panels with added audio. The images would "change about once per second" (although many were shorter or longer) and the audio could take the form of either "voices impersonating the characters dramatizing the action," or else simply "told by a narrator" using a steady voiceover. The resultant product was described as "a combination of comic strip and radio serial techniques" and ranged from five to twelve minutes (typically meant to accommodate advertising time and a fifteen-minute time slot).[43]

There were actually two different companies by the name of "Telecomics Inc." One was run by Jimmy Saphier, a Hollywood agent whose clients included Bob Hope. The other was run by Stephen Slesinger Productions, which maintained that it "had been protected both copywise and titlewise for at least a year" prior to the debut of Saphier's telecomics. While some of the strips used for these telecomics were newly created (including *Kid Champion* and *Jim Hardy, Ace Reporter*), others used longtime popular characters.

Several of the major newspaper syndicates shopped their comic strips to telecomics producers. Century Television Corporation optioned the rights to such strips as *Joe Palooka* and *Mutt and Jeff*. United Features shopped around the rights to *Nancy* and *Li'l Abner*, while the New York Daily News Syndicate sought to create series around such strips as *Little Orphan Annie*, *Gasoline Alley*, and *Harold Teen*. Slesinger's Telecomics Inc. was preparing a series based on King Features' *King of the Royal Mounted*, which actually retained the original word balloons of the original strips. They also offered stations the option of paying extra for voice talent to act out the dialogue, or a "silent" version at half the price that could be narrated by a "local announcer."[44]

Slesinger's *Telecomics* series became a syndicated program by 1949 and was optioned by 1950 by NBC, which changed it to *NBC Comics* and

launched new characters like Space Barton and Johnny and Mr. Do-Right. The program aired weekdays at 5:00 P.M., right before *Howdy Doody*.[45] While such creations remain little remembered, there was also a telecomic created from one of the most memorable comic strips of the 1940s, Will Eisner's *The Spirit*. In 1948, radio and television producer Alan R. Cartoun produced five telecomic installments based on Eisner's strip for syndication, hoping to attract enough interest for a regular series.[46] Cartoun even created advertising for his telecomics: "Hello, my name is The Spirit and I'm a famed fighter of crime. I'll bring my exciting new adventure program to your television station every Monday through Friday on this television station. So keep your eyes and ears open, boys and girls, for the new television series The Adventures of The Spirit!"[47] Another telecomics program was created for WNBT in New York out of *Classics Illustrated*, a series that adapted venerated literary works into comic book form.[48]

While the format was short-lived, there were numerous comic strips adapted to television in the early 1950s. Many of the strips that had been made into serials and feature-length B-films in the 1930s and 1940s were also turned into television series. "See Ya in TV, Say the Funny Papers," proclaimed one *Billboard* headline, as television producers showed a "lively interest" in bringing comic strip characters to the small screen. The article notes the "natural hazards of the comics-to-film conversion" but tells of how "the allure of a pre-sold title and pre-existing story material is hard to resist. When the comic strip is hot, TV is definitely interested." Such "hazards" are further explained as a need to preserve the "identity" of the source material in the adapted work, something that Columbia and Republic's serials often neglected:

> The difficulty in the comics-TV relationship has been in maintaining the identity of the original characters in the converted form. There is some feeling on both sides that this can be overcome to a great extent if the originator of the property would maintain co-production authority on the converted version, would exercise the right of rejection on casting and story, for instance, rather than merely sitting back and collecting royalties.
>
> Others feel that when you put a comic strip on film you just try your best and take your chances. They believe that everyone has his own idea of what a comic-strip character should look like in life size, and you just can't please everybody.[49]

The discourse here positions the seemingly uninterested creators who are only after the money to be had when their work is adapted versus the inherent difficulty in casting a human actor who embodies a drawn character. The latter aspect had long been problematic throughout previous decades of cinema, and would only persist into the modern era. Yet the idea of money-hungry creators looking for someone to create any old version of their strip onscreen is misleading given the interest that Chester Gould and especially Milton Caniff showed in the cinematic adaptations of their work. Most film producers sought to exclude creators from the adaptive process in previous decades rather than give them any substantial input. Given the new, still unproven storytelling possibilities inherent in the television medium, it appeared as if the industry was more open to collaboration than many Hollywood producers were (in keeping with how film studios often positioned their adaptations as the superior incarnation of a comic character, telling audiences that you can't truly know that character until you have seen him/her onscreen).

Two familiar comic strip heroes received their own programs in 1950, Buck Rogers and Dick Tracy. In each case, the way in which they were initially sold to stations reflects how new and untested the medium of television was at the time. Spurred by the success of both *Captain Video and His Video Rangers* (1949) and *Space Patrol* (1950), *Buck Rogers* ran from April 1950 until January 1951 on ABC, and underwent frequent recasting throughout its brief run. While a pilot for the show was filmed with Earl Hammond as Buck and Eva Marie Saint as Wilma Deering, neither was retained for the actual series. The title role was played by two different actors (with Kem Dibbs being replaced by Robert Pastene), while Lou Prentis took over the role of Deering. The fact that the final product contained a different cast from the pilot episode isn't unheard of in the television industry, but in this case demonstrates how it was the source material being sold rather than the cast.

Dick Tracy's television debut was on ABC in 1950. The show was later sold to various stations in syndication, with a twenty-one-minute promotional short created to market the series to potential sponsors. The promo featured clips from numerous episodes to showcase the wide range of characters and conflicts found in the series. "This film is a sample of what you will see when you buy the Dick Tracy series. It shows the many characters, tells a few of storylines and illustrates faithfully what you are buying," a narrator tells via voiceover. It begins as so many serial trailers did by listing the

strip's readership numbers: "There is *one* comic strip that has the greatest readership in the country. . . . There is *one* comic strip with which every child is familiar. . . . There is one comic strip with a readership of over 60% adults . . . and that is *Dick Tracy*." Clips from several episodes are presented, many of which feature steady violence, which the narrator frames in positive terms toward the end: "As usual, there is a story with a moral. Crime does not pay. In fact, this is a point that is repeated over and over again throughout the whole Dick Tracy series. Crime does not pay!"

As television gained ground with home audiences in the early 1950s, there was growing concern for the amount of violence to which viewers— especially younger ones—were exposed. But the producers of *Dick Tracy* deliberately toned down the violence in early episodes so as not to offend potential sponsors. "Kids watching the new Dick Tracy telefilm series are going to be sure the guy's a slow starter," noted *Variety*, describing how the series "has very little rough stuff" in its initial two episodes. "Vidpix were launched at a time when video networks were under fire for using too much blood-and-thunder stuff during the juve viewing hours so writer-producer-director P. K. Palmer made the first two as gentle as possible. By the time those had been canned, the heat was off. Third and fourth pix began to build up the Tracy of old, fifth contains two murders, a gun fight, and a fist fight and the sixth will open with a hanging."[50]

Serial producers frontloaded their chapterplays with as much action and intensity as possible, given how exhibitors booked these films after seeing only the first few chapters; television producers like Palmer, in contrast, had to be more conservative in their initial installments. Film exhibitors usually knew their customers and what they would respond to. Television audiences were a new breed entirely in the early 1950s, and the need to satisfy a sponsor to gain a broadcasting deal placed different demands on what to showcase early on.

The promotional short's concern for morality quickly transitions to fiscal matters as a line art image of Tracy's face appears: "Dick Tracy is programmed fifty-two weeks a year . . . / Dick Tracy will help *sell* merchandise," instructs the narrator. "The sponsor is entitled to exclusive showings of Dick Tracy on television, and the sponsor may utilize point of sale displays, newspaper advertising, package wrappers and billboards," he points out. "*Dick Tracy* is completely merchandised. There will be monthly newspapers with the Dick Tracy fan clubs containing adventure stories, secret codes,

puzzles and every gimmick children love," with sponsors able to put ads on the back page of the fan club newsletter. "This monthly newspaper will help build a loyal audience and move product." Comics played a different role for the television industry and its sponsors as compared to what they did for Hollywood. The presold nature of the strip became of added benefit to the show given the emphasis on selling merchandise and moving product.

The promotional short ends by briefly praising the series' production values: "Qualitatively, there is no finer film made than these Dick Tracys. They were shot on the Samuel Goldwyn sound stages, utilizing all the Samuel Goldwyn crews." But the final word again returns to the role of sponsorship: "Dick Tracy is not only an adjunct to good programming, but it will build a loyal, regular audience for its sponsors," the narrator concludes. Without a sponsor, most television series struggled in this period. *Variety* reported in 1949, for instance, how Palmer's *Dick Tracy* series would be "beamed only if sponsored," referring to the need for the show to attract a sponsor in order to be viable.[51]

Some of the show's production values are worth noting, such as the memorable opening credits. They begin with the sounds of a tommy gun firing and a police whistle shrilling, followed by Tracy running into the frame. He leans against a brick wall as he fires his own gun, before rushing toward the camera. As he moves into a close-up, he fires his pistol at the camera and, by doing so, the viewer. The titles roll over this footage, creating a very different beginning from the Dick Tracy serials and B-films of previous decades with their direct invocation of Gould's strip and its distinctive drawn imagery. The program's opening credits serve a similar function to that of the famous shot in Edwin S. Porter's *The Great Train Robbery* (1903) in which a bandit in medium close-up fires his gun directly at the audience. The shot could be inserted by exhibitors either at the beginning or the end of the film as a way of confronting the audience in a spectacular fashion with a simulated attack, placing them directly in the line of fire through a point-of-view shot in a way that had not been attempted before onscreen. By staging the scene with Tracy first at a distance before he charges the camera while firing his weapon, *Dick Tracy* sets itself up as a different viewing experience altogether from the numerous films that preceded it. Television is seemingly positioned here as a more involved medium than cinema in these opening credits, in which characters can seem to inhabit the viewer's personal space rather than having audiences remain distant observers of the

action onscreen. Even with a smaller screen, TV viewers are seemingly in the middle of the action in their living rooms, whereas filmgoers remain at a far-off distance from the screen in their theater chairs.

Unlike Republic's *Dick Tracy* serials and Monogram's feature films, the television show's opening credits forgo any of Gould's drawn imagery. Emphasizing the source material in the credits was part of Hollywood's ongoing effort in the 1930s and 1940s to sell film audiences on the pleasures of watching once-static images come to life, as static images of familiar characters soon become embodied by actors. Early television adaptations of comics typically did not contain images from the original strips and comic books, however. With the television industry selling its programs as an alternative to filmgoing, the new medium didn't always package its finished product in the same ways that films did. Many film versions used images from the source material as a way of stressing the fact that they were adaptations in a new (and supposedly greater) medium, whereby your favorite comics characters come to life on the big screen, seemingly larger than life. Television's smaller screen and domestic viewing context meant that the new medium could not aspire to the same degree of all-immersive spectacle (although the opening of *Tracy* tries in its own way); rather, it could sell viewers on the thrill of bringing the outside world and all its wonders into the home to experience vicariously. In this way, the opening sequence of the *Dick Tracy* show succeeds precisely because it does not attempt the same strategies as the earlier *Tracy* films and serials with their use of Gould's imagery. Tracy appears real from the very start of the program, and the way in which he confronts the viewer head-on during each episode's opening shootout plays to the strengths of the television medium while also distinguishing the show from Ralph Byrd's prior cinematic efforts.

The pleasures of television spectatorship are even directly invoked by Tracy himself at the end of one episode. As he and his sidekick Pat wrap up a case, the camera tracks in toward Tracy sitting at his desk: "Well now I think I could use a nice quiet evening at home. I think I'll call Tess and tell her tonight I'm gonna watch my television set!" he announces looking straight at the camera with a knowing gesture to all those watching on their own sets at home.

Dick Tracy ran for only one season on ABC but was picked up by Snader Productions in 1951 with new episodes produced for syndication. The series came to a premature end in 1952, however, when Byrd suffered a fatal heart

attack. The show earned strong ratings in most cities where it aired, and was noted to be the highest-ranked series "in the non-Western kiddie category."[52] Reruns of the show remained in syndication through 1955, further demonstrating its popularity.[53] Nevertheless, critics panned the series, with *Variety* stating how the strip's older fans might be "disappointed" and that while the production values were "technically competent" it used "few sets."[54]

Like many adventure series of the early 1950s, *Dick Tracy* was produced on a very low budget. The original episodes had a budget of $6,500 each in 1950, while those produced in 1952 cost $9,500.[55] Such amounts were still less than the cost of an average serial chapter (which had comparable running times) at Republic or Columbia. The serials faded from theaters as television began to offer viewers similar types of fare. Children were seen as the primary audience for western, crime, and sci-fi shows, which made up the bulk of the serials. Comics adaptations in turn made a natural shift between the two formats given how much of the low-budget production methods of B-filmmaking easily carried over into early television genre series.[56]

While the *Li'l Abner* television pilot failed to garner a series, one minor character from Capp's strip did receive his own show thanks to the enduring popularity of *Dick Tracy*. Fearless Fosdick, a parody of *Dick Tracy's* square-jawed detective, was an occasional character in the *Li'l Abner* strip. After the news that Byrd would play Tracy on television was announced in November 1949, plans for a series based on Fearless Fosdick emerged by March 1950 while preproduction for *Dick Tracy* was still under way. Produced by Films for Business, Inc., *Fearless Fosdick* used marionettes in place of actors or animation, and the show did not incorporate any of the *Li'l Abner* strip's characters and narratives. The series would not air until 1952 and lasted only one season on NBC.[57] While the use of marionettes in early 1950s television was not extensive, the success of *Howdy Doody* (which ran from 1947 to 1960) proved that puppets were a viable form of televised entertainment at the time.

In a 1950 trade advertisement, Films for Business, Inc., announced that it was "proud to have been selected to produce on film Al Capp's Fearless Fosdick comic strip through the medium of marionettes and puppets."[58] The use of the word *medium* is intriguing for the study of comics adaptations given how marionettes are a little-used but entirely feasible way to add motion to comics characters. While animated versions present audiences with what remains only an *image* of Superman, Popeye, and others,

marionettes transform an image into an *object* (a wooden puppet), which can give such characters a physical presence onscreen that animation lacks. This physicality is altogether different from that provided by human actors embodying a character, and may seem gimmicky and unsatisfying to some viewers. Yet the use of puppets nevertheless allows comics characters to both retain elements of abstraction (such as exaggerated anatomy and tiny black dots for eyeballs) that make their hand-drawn counterparts so compelling, while still acquiring a sense of physical depth and weight that is altogether different from the representations that animation can provide. Puppets, in other words, don't quite look or move like human beings, and yet they offer the chance to use photorealistic elements when filmed—sets and costumes are used along with real (albeit miniature) props like guns and vehicles. Such factors lend these productions a look that is altogether different from animation, given how the puppets inhabit the space before the camera's lens in the same manner that actors do.

Photography, however, "does not supply animation's imagery," as film theorist Tom Gunning notes.[59] The images in an animated film or program stem from numerous drawings that are then captured in succession by a camera. The images in shows like *Fearless Fosdick* arise from the process of cinematography, which captures the movements of the objects being filmed. In so doing, the use of marionettes in adapting the static imagery of the comics page offers viewers a unique combination of stasis and motion, given the ways in which an inanimate object like a puppet is granted life by a puppeteer. The still image of the comics page becomes in turn a still wooden object given the illusion of animation by the puppeteer's control of its strings. The result is not quite live-action because of the absence of a human body, but it is more akin to those films and programs starring actors than it is to animated efforts, since animation can alter the laws of physics with ease by drawing that which is impossible to photograph.

Comics scholar Scott Bukatman describes "cartoon physics" as creating an "alternative universe of unnatural laws" in animation, presenting viewers with "an alternative set of means by which bodies navigate space: momentum trumps inertia, gravity is a sometimes thing, solid matter often isn't."[60] Such laws do not apply to *Fearless Fosdick*'s marionettes, which navigate the three-dimensional space of a television studio set. The result looks both natural and unnatural at the same time—the characters are subject to the same temporal and spatial laws as human actors, but the wooden bodies

they inhabit are still anatomically abstracted much like Capp's drawings. Puppets are perhaps most memorable on television when used for the purposes of stop-motion animation (particularly in the Rankin-Bass television productions of the 1960s, such as *Rudolph the Red Nosed Reindeer*), but though they are rarely used today, the more I watch *Fearless Fosdick* the more I find puppets a compelling way to adapt comics. The technique might have made for some wonderful versions of *Popeye*, *Krazy Kat*, or even *Dick Tracy* and his rogues gallery.

COMICS ON TV (AND ON ICE)

Marionettes were later used for the cult-favorite television show *Thunderbirds* in 1965, featuring numerous science-fiction elements. While puppet versions of other sci-fi adventurers like Flash Gordon might have proven to be equally admired, the television version of Alex Raymond's space hero that did emerge in the 1950s isn't well remembered (despite some attempts at innovation on a low budget). In 1953, a *Flash Gordon* series debuted in syndication from producer Edward Gruskin. A co-production between the United States, France, and West Germany, numerous episodes were filmed in Berlin and Marseilles. The show's production values were considerably reduced from the Universal serials, given how those releases benefited from the reuse of the studio's various sets, props, and stock music. Gruskin's sets, costumes, and other design elements were not overly elaborate—the large bay windows of a spaceship clearly are made of plastic given the way they are rippled, for example. Still, the use of special effects is often quite capable, such as when various planets explode. The series relied more heavily on dialogue than did the serials, with its lower budget necessitating less action than in the Universal films. There is also a heavy reliance on close-up shots during dialogue scenes, which helps to conceal the lower production values.

To its credit, however, the *Flash Gordon* series was often much more concept-driven than the films, as in the episode "Deadline at Noon" in which Flash and his team must travel back to Earth in the 1960s to prevent an atomic explosion. The premise allows for comparisons between modern technology and that used in *Flash Gordon*'s future setting, as Dr. Zarkov muses: "It does seem ridiculous when you consider that in our century, a motor the size of my fist has more power than the gigantic steam-driven

turbines they use." There is also a relatively progressive exchange about the differences in gender roles between the two centuries, as Wilma Deering asks Zarkov what women were like in the 1960s. "Well, instead of filling their heads full of knowledge about astrophysics and atomic research and electronic phenomena like a certain young lady we know . . . ," he begins. Deering interrupts: "Yes, well, what did they do, sit at home and knit?" Zarkov answers, "Well, I wouldn't say that was all they did. But they certainly knew their way around a kitchen better than a laboratory."

While the series uses the speculative nature of the science-fiction genre for some interesting cultural observations, the time travel premise is largely enacted so that the producers could shoot in modern Berlin without needing to disguise the location. Episodes such as "Deadline at Noon" and "Race against Tomorrow" were shot extensively outdoors with little dialogue recorded on-site. Voiceover narration and the occasional use of post-production dubbing allowed Gruskin to use these locations in cost-effective ways, while also providing the show with a different narrative scope from other science-fiction shows like *Tom Corbett, Space Cadett* and *Captain Video*, which were recorded live and therefore largely limited to various studio sets. Gerald Duchovny notes how the "futuristic worlds and speculative nature" of the science-fiction genre "often challenged both the budgets and narrative constraints of the [television] medium."[61] *Flash Gordon* frequently found ways to work around these constraints, but the show remains overshadowed by the relatively more lavish Universal serials (particularly the first).

While most *Flash Gordon* fans may negatively compare the television series to the serials, the same cannot be said of *Terry and the Pirates*, given how its 1940 serial hardly resembled the famous strip at all. When no further *Terry* serials emerged, Douglas Fairbanks Jr. declared his intention to produce a feature film in 1946. By this point, creator Milton Caniff was readying himself to leave the strip in order to pursue new ideas, so he saw the act of selling the film rights to *Terry* as a healthy step in moving on. Fairbanks reportedly filmed screen tests for the lead roles, but the feature never materialized.[62] Instead, he went on to prepare a television series based on the strip that aired in 1952 and 1953. Caniff was much more positive about this effort than the serial adaptation: "They did a pretty good job," he said of the television series. "It was murder in those days . . . but they did a damn fine job."[63]

The series was shot at RKO studios and was sponsored by what the industry referred to as a "top-spending advertiser": Canada Dry Ginger Ale. The soft drink had previously been the sponsor of a program called *Super Circus*, at a cost of $4,500 per episode, but that jumped to $31,500 per episode for *Terry and the Pirates*.[64] Despite its large advertising push, *Terry* failed to last beyond one season, with Canada Dry choosing to sponsor a new *Annie Oakley* program in 1954 instead. One reviewer noted how the series would only "get by with action fans . . . on the strength of its identity with the comic strip of the same name." The series "smacks more of a potboiler than of a trailblazer in the adventure idiom," the reviewer stated, concluding that while children might enjoy the show, it "emerged as something of a disappointment for the devotees of the decisive comic strip aviation adventurer."[65] *Terry and the Pirates* remained in syndication in numerous television markets through 1955 and was promoted as a "fabulously successful, faithful reproduction of the beloved comic strip"—which it was in comparison to the earlier serial. Fairbanks contemplated producing new episodes once this syndication run had ended, but they never materialized.[66]

The mid-1950s saw numerous comic strips adapted to television, although none with any longevity. *The Joe Palooka Story* ran for one season, 1954–55. *Jungle Jim* (with Johnny Weismuller continuing his role from the B-film series) ran for one season in 1955–56. It was joined that year by *Sheena Queen of the Jungle*, the title character having been a regular feature in *Jumbo Comics* since its debut in 1938 as well as her own eponymous comic book. Starring newcomer Irish McCala, the series quickly led to plans for a feature film in CinemaScope and in color based on the show, but the picture was never made.[67] Instead, McCala's film career went in another direction as she starred in such horror and crime B-films as *She-Demons* (1958), *The Beat Generation* (1959), *Five Bold Women* (1960), and *Hands of a Stranger* (1962).

There were also several attempts at producing television series that ultimately went unsold. Failed pilots for a *Red Ryder* series were shot in 1951 and again in 1955, starring Jim Bannon and then Alan Lane, who had alternately starred in the title role in the Republic features of the 1940s. A pilot episode of *Mandrake the Magician* was made in 1954 but went nowhere. Other familiar comic strip characters were optioned for series that were never produced: the rights to *Little Orphan Annie* and *Gasoline Alley* were acquired in January 1952 by "newly formed Este Productions" with production supposedly set to begin in July, but nothing emerged.[68] One unsold

effort finally became a series a few years later, with a 1954 pilot leading to a regular *Blondie* series in 1957. Arthur Lake returned as Dagwood from the longstanding B-film series (although now almost twenty years older than when he originated the role) alongside Pamela Britton as Blondie. Britton had appeared in the 1954 pilot but not alongside Lake. Oddly enough, Dagwood was played in the pilot by Hal LeRoy, who had portrayed Harold Teen in the 1934 film much as Lake had in the 1928 silent version of that strip (teenage frivolity giving way to domestic routine in each case).

But while *Blondie* thrived with moviegoers for more than a decade, Chic Young's characters did not fare as well on television and lasted only one season. As *Variety* noted, "Translating a popular comic strip such as 'Blondie' into a tele-film series has its pitfalls," and the show "seems not to have missed nary a one." The review continues:

> What appears amusing and quaint about a family in comic strip form, the situation drawn in big, bald strokes to get the point across in a small panel of pictures, becomes outlandish when the same approach is adopted for a half-hour teleplay. Bumstead, played to the mugging, slap-happy hilt by Arthur Lake, hardly draws a laugh when he screams 'B-L-O-N-D-EEE' intermittently, despite the canned yocks. The tv adaptation . . . adds no new dimensions, either in wit or humor to the comic strip. Rather, over the 30-minute span, the comic strip humor is diluted, the clichéd lines and situations standing out like sore thumbs.[69]

Whereas Columbia's film series presented Blondie and Dagwood in some rather extravagant scenarios (such as disguising themselves as conga band members aboard a cruise ship in *Blondie Goes Latin* [1941], as well as seeing their dog Daisy kidnapped by gangsters in *Life with Blondie* [1945]), the show's relatively limited narrative scope saw the Bumstead family dealing with more modest hijinks, such as the rescue of a bird's nest from a job site owned by Mr. Dithers's construction company. Young's strip excelled in presenting self-contained gags rather than serialized exploits, while the longer running time of the Columbia feature films allowed for more narrative complexity than in the shorter television episodes. But perhaps the biggest factor is that by the time *Blondie* appeared on television, there were already numerous domestic sitcoms on the air. The Bumsteads were just another foible-filled family by the mid-1950s, and they couldn't compete with the popularity of the Ricardos, the Cleavers, the Kramdens, and the Nelsons.

As the decade progressed, it was also evident that comics adaptations were still perceived as being primarily for young audiences, despite how such shows often aired during prime time in many markets. This reputation was also partially sustained by some of the more inventive ways in which the public experienced comics characters beyond the pages of their favorite newspaper strips and comic books. In the fall of 1956, the Conrad Hilton hotel in Chicago offered patrons a new family-oriented form of spectacular entertainment—"Comics on Ice." In reviewing the first night of a three-month run, *Variety* noted how the 8 P.M. start time was "to encourage the family trade with the moppets." The publication also pointed out that, compared to other Hilton stage shows, the production was "a low-budgeter especially designed for the kids. To hold their interest, comic strip characters on skates are used." The somewhat patronizing rhetoric in the review echoes that often used in prior decades to describe the youth-oriented ways in which comics were translated into other forms:

> In fact, the main attraction in this show is the appearance of skaters costumed as familiar funnypaper characters, Little Orphan Annie, Dick Tracy, The Phantom, etc. Except for a flashily costumed "Phantom" African number, this show does not hew to the generally lush production values of many in the past, but nonetheless should prove entertaining for the kiddies.
>
> . . . Paul Gibben, who spoofs Little Orphan Annie, in costume, [opens] with some fair pratfallery and better bladework. Dennis Arnold & Marji then take over the ice as Prince Valiant and his lady. This duo looks good on the floor and gets off some pretty fancy bladework.
>
> The following "Phantom" number is rich in production values. . . . Number gets strong aud [*sic*] reaction. Paul Duke, as "Mandrake, the Magician," does some run-of-the-mill sleight-of-hand, topped by an impressive razor blade trick that should lead to bloodshed but doesn't. A Dick Tracy number, which rings in the Keystone Cops and has the sleuth searching for two "criminals" (John Melendez and Dick Maxfield) right under his nose gets a few yocks.
>
> Wrapup has the entire cast costumed out of the funnies in an okay finale. . . . Icery runs until Jan. 3 next.[70]

Producers, reporters, and audiences still saw comics as being primarily for kids. The success of the few feature films aimed at mass audiences like *Prince Valiant* and *The Sad Sack* did not carry over to television, which saw fewer and fewer shows based on comics as the decade wound down.

But despite the fact that few shows lasted for long, there were still two significant programs adapted from comic strips that debuted in the late 1950s, each on major networks. CBS offered viewers the adventures of *Dennis the Menace,* based on the strip by Hank Ketcham that began in 1951 (and owed much to Percy Crosby's *Skippy*). The network needed a replacement for *Leave It to Beaver* when that show moved to ABC, and *Dennis* offered viewers the same sorts of trouble-filled but ever-loveable shenanigans as young Theodore "Beaver" Cleaver enjoyed every Sunday night. Crosby's strip ended in 1945, but had *Skippy* endured it would have probably been as successful with television audiences as *Dennis the Menace.* Instead, Crosby's chronic alcoholism led to personal anguishes, a suicide attempt, and his subsequent admission to the psychiatric ward of Bellevue Hospital. Ironically, the sponsor of *Dennis the Menace* on CBS was Skippy Peanut Butter, a product that arose in the 1930s by appropriating imagery from the *Skippy* strip. Crosby had fought an ultimately unsuccessful trademark dispute with Best Foods, but the peanut butter brand proved resilient. Crosby remained institutionalized until his death in 1964, one year after *Dennis the Menace* wrapped up a successful four-season run on CBS.[71]

The other program to emerge in the late 1950s was *Steve Canyon,* based on Caniff's strip about a daring aviator. The show began in the fall of 1958 on NBC and enjoyed the cooperation of the U.S. Air Force (which provided unreleased footage of its "new developments in flight and missiles" that were showcased in the series as stock footage). In some cases, story ideas were built around particular pieces of footage, such as the testing of a B-58 Hustler supersonic bomber jet.

Steve Canyon was positioned from the start as being different from other series based on comic strips. *Variety* described how producers Mike Menshekoff and David Haft were "bucking a persistent trend," in that aside from *Adventures of Superman* "there hasn't been a series based on a cartoon strip that's ever made the grade—and the list is a long one ... ":

> They've analyzed the failures of the strips and have come to the conclusion that mistakes of the past have included the incorporation of all the characters and situations in the strips. This has been a mistake, they claim, because strip characters are actually caricatures which are acceptable in print but which audiences just won't react to in the flesh. Ditto on the strip storylines.
>
> What they've done, Menshekoff and Haft explain, is merely take the Steve Canyon name and identification and do an Air Force story.[72]

Steve Canyon represented a greater move away from any kind of narrative fidelity to the strip and its cast of characters than shows like *Dick Tracy* and *Terry and the Pirates* demonstrated. In this way, the show was like many comics-based serials (particularly from Republic) of prior decades, which used the basic premise and main character but little else from their source material. The show's producers sought a balance of genres in different episodes: "Apart from the scientific angles, they're juggling the scripts to include cloak and dagger, straight adventure, even comedy, to maintain a change of pace each week."[73]

The series ran for thirty-six episodes but failed to gain a second season like so many of its predecessors—a more puzzling outcome given the show's many strengths. *Steve Canyon* had high production values, with a $1.7 million budget among the highest of the time. It had a top sponsor in Chesterfield cigarettes. The series was shot on 35mm film, and directors included Arthur Hiller and Don Taylor. Scripts came from writers such as Ray Bradbury. The supporting cast saw a mix of character actors like Claude Akins, Russell Johnson, and Gavin MacLeod, as well as such future stars as Leonard Nimoy and Mary Tyler Moore. Of all the programs adapted from comics in the 1950s, *Steve Canyon* was by far the most adult-oriented.

Caniff described how the show was ultimately "hamstrung" by its involvement with the U.S. Air Force, which required the scripts and the finished episodes to be vetted for approval. The Air Force even demanded that one episode be pulled from its broadcast schedule because its content was too similar to "a current international situation," a move that irked potential sponsors and stations alike.

Caniff had hoped to revive the series in the early 1960s, changing it to a cliffhanger format. "It's the oldest trick in the world . . . but that's what I do every day in the strip. It will be the same technique."[74] The show was to still maintain its own unique storylines, but would more closely resemble the serial format that had been the staple of comics adaptations for years. The revival never happened, and (except for a menace named Dennis) comics generally faded from television screens as the 1960s began. But there was one program that ran for much of the 1950s that remains loved by its fans even to this day—despite its unhappy star and his tragic death.

ADVENTURES OF SUPERMAN, SUPERBOY, AND SUPERPUP

Superman was by far the most popular comics character on television in the 1950s. *Adventures of Superman* ran for six seasons, and might have continued longer were it not for the death of its star, George Reeves. Given how the character had previously thrived in film serials, in animated shorts, and on radio, it seemed a given that Superman would receive his own small-screen effort. The way in which *Adventures of Superman* arrived on television, however, was highly unconventional.

National Comics Publications sold Superman's television distribution rights to Flamingo Films in 1951 (in a thirty-one-year deal that also included the rights to the 1940s animated films).[75] But rather than shooting a traditional pilot episode with which to attract a sponsor, National took a different approach altogether and used a feature-length film to launch a television series. *Superman and the Mole Men* started shooting on July 30 that same year, with production lasting twelve days. Once the film had wrapped, filming immediately began on twenty-four episodes of *Adventures of Superman*. Historian Bruce Scivaly describes how the episodes were divided between two directors, Lee Sholem (who shot *Mole Men*) and Tommy Carr (who codirected the 1948 *Superman* serial). "Four shows were filmed every ten days. While one director was filming his shows, the other was prepping the next batch," says Scivaly. In less than two and a half months, both *Superman and the Mole Men* and the entire first season of *Adventures of Superman* were completed (with *Mole Men* also being split into two parts for television, bringing the total number of episodes to twenty-six) at a total cost of $400,000.[76]

Superman and the Mole Men was created first and foremost as a way to initiate a television series. Had a series not been picked up by a sponsor, the profits from the film would have subsidized the episodes' production costs. Sets, props, and costumes were also reused from the film, further reducing the cost of the television episodes. The film received solid reviews, with Reeves described as "effective in both roles" as Clark Kent and his alter-ego. *Variety*, with its customarily colorful rhetoric, noted how "Lee Sholem's direction keeps the Richard Fielding script moving at a clicko pace."[77] This minor praise would have come as a relief to National, given the stakes involved.

There even seems to have been efforts to keep Superman's role in the *Mole Men* film a secret while it was being shot. Modern productions often

do this: *Return of the Jedi* (1983) was filmed under the title "Blue Harvest," *Titanic* (1997) as "Planet Ice," *The Dark Knight* (2008) as "Rory's First Kiss," and *The Avengers* (2012) as "Group Hug." In this way, producers are able to deter both journalists and the public during production; with *Superman and the Mole Men*, the additional pressure of using the film to launch a television series likely contributed to the way in which it was disguised. The script's original title was "Nightmare," submitted to the MPAA for approval and used in shooting scripts and casting notices during production. A casting sheet also lists Reeves's role only as "Kent," rather than including the more familiar names of Clark Kent and Superman. Perhaps in part because of the sinister title, the MPAA listed the film under the category of "fantasy-horror" while reviewing the script, given how the Mole Men are a subterranean race "from the bowels of the earth."[78]

Like the film, the series was relatively well received by critics. In reviewing the pilot episode, *Billboard* predicted the show's success by drawing several comparisons with Superman's previous media incarnations: "The opening of each segment uses the same copy that the old radio series made famous ('Faster than a speeding bullet . . . it's a bird, a man [*sic*] etc.'), only here it's accompanied by visuals." They also noted how "the scripts are based on the same thrillers used in the other media, which present Superman as the irrepressible champion of the common man." Reeves is described as "the spitting image of the comic strip drawing of Clark Kent-Superman. He has the same wavy dark hair and square face. And he's hefty enough to look as if he can bend those bars."[79]

Another article stated that "George Reeves is widely regarded as the perfect embodiment of Superman in his paper manifestations."[80] The actor's physique and facial structure are compared here to the line art of the page in a way that once again suggests that a performer can successfully embody a comics character. But unlike the Hollywood rhetoric of prior decades, there is no implication here that the television series offered viewers a superior image of the Man of Steel. Rather, these reviews seem to advance the idea that television is capable of doing justice to the image of the character to which readers have long become accustomed in print. As a new medium in the 1950s, television did not have the same superiority complex toward other media that the film industry often revealed in its marketing. While comics were quickly relegated to lower-tier forms of cinema in the 1930s, television offered a wider spotlight for comics characters. Audiences that

may not have gone to weekly matinees to watch Superman survive a series of cliffhangers could now regularly follow his adventures during prime viewing hours at home.

Adventures of Superman began its syndicated run in 1952 in fifty-two television markets; by 1956 it was in 167 markets. The show's ratings were so strong that it regularly outdrew major network programs regardless of its time slot.[81] In 1955, the series began shooting in color, although most viewers still did not own color television sets. Clearly its producers believed that the show would continue to be successful in reruns for years to come into the 1960s, when it was (correctly) anticipated that color would replace black-and-white production.

Adventures of Superman was popular with adults as well as kids, with Flamingo Films pointing out how the "hefty adult audience" had them "seeking evening slotting whenever possible."[82] At the peak of the show's popularity, Reeves appeared in character on other programs such as *Funny Boners* in 1955 and *I Love Lucy* in 1957. A feature film was proposed for a spring 1956 release but never materialized. Historian Jake Rossen notes how two different scripts were commissioned "for potential feature films, Superman and the Ghost of Mystery Mountain and Superman and the Secret Planet," but that "there was little benefit in risking a box office flop" that might ultimately hurt the television show's ratings.[83]

There were actually five cinematic efforts after *Mole Men*, but they were all what I have described elsewhere as "Made-from-TV-Movies" in which various episodes of the television series were combined into the semblance of a connected narrative through the use of newly shot scenes.[84] In 1954, Twentieth Century–Fox released *Superman and the Jungle Devil*, *Superman Flies Again*, *Superman in Exile*, *Superman in Scotland Yard*, and *Superman's Peril* to theaters, with each film consisting of three episodes from the second season of *Adventures of Superman*. Had the first season of the show not ultimately been picked up by a sponsor, those episodes might have received a similar treatment as a way of recouping their costs.

Adventures of Superman ceased production at the end of its sixth season in November 1957, at which point the show was on hiatus while reruns aired. In August of that year, Reeves had begun a new business venture. Part of his contract required him to do personal appearances as the Man of Steel, which he didn't particularly enjoy. He often appeared at state fairs, and after doing enough of them he decided to mount his own personal tour—"The

Superman Show"—for which he was both producer and star. His television costar Noel Neill joined him as Lois Lane, along with such other acts as "Jose Natividad Dominguez Vacio and his group; the Maxwells; Kara Kiro's dancing dolls; Miss Lona and her pets; and Keeviet-the-Clown's Circus." Reeves took 70 percent of the gate receipts, beginning with the Colorado State Fair and with planned stops in Japan, France, England, Australia, and several Latin American countries where the show was popular. But "The Superman Show" was poorly received by fans and fairgoers. Journalist Larry Tye describes how the show's "low point was a stop in North Carolina where only three people showed up—a young boy and his parents."[85]

While Reeves struggled during the show's hiatus, it was announced in May 1959 that a new season was in preproduction with scripts being prepared.[86] They would never be filmed. A few weeks later, on June 17, George Reeves was found dead in his home. He had committed suicide (although suspicions of murder have persisted) by shooting himself in the head, and was found lying naked in his bed with a gun resting between his feet.[87] Episodes of the show continued to air in syndication well into the next decade, and international sales remained strong in 1959 as new episodes continued to be dubbed into Spanish for release in twenty-three countries.[88] Despite Reeves's death, his character was far too profitable to shelve *Adventures of Superman* entirely. The show had led to a "resurgence in Superman merchandise" for National,[89] so reruns continued unabated. Hundreds of companies had licensed the rights to make Superman-related products, from T-shirts, watches, and coloring books to lunch boxes, 3-D viewers, swim goggles, bathrobes, and rain capes (the last produced by the unfortunately named Adjust-a-Diaper Company).[90]

Watching bullets bounce off Reeves's chest took on new connotations after his death (actor Milton Frome has described how his son was harassed by other children after they watched Frome's character shoot Superman in an episode that aired the day Reeves died).[91] But at least there wasn't also an odd-looking dog running around in a Superman costume to further emphasize National's commitment to maintaining the Superman brand on television. As production of the final season of *Adventures of Superman* came to an end in 1957, producer Whitney Ellsworth concocted a pilot for a new Superman-inspired show aimed at young audiences: *The Adventures of Superpup*. The cast consisted entirely of actors with dwarfism wearing canine headpieces, with Billy Curtis (who was one of the *Mole Men*)

starring as both Superpup and his alter-ego Bark Bent. Perry White became Perry Bite, and Lois Lane became the equally alliterative Pamela Poodle.

The pilot was rejected by test audiences, potential sponsors, and National alike and soon abandoned.[92] Ellsworth was determined to reinvent the Superman brand on the small screen, however, and in February 1960 a "sequel" (although it was what we would now call a prequel) was announced in the form of *The Adventures of Superboy*. The Superboy character debuted in a 1944 issue of *More Fun Comics* before becoming a regular feature of *Adventure Comics* in 1946 and finally receiving his own title in 1949. *Variety* announced that the show would cover "the youthful days of [the] Superman character," and that Ellsworth was seeking an "athletically inclined actor who looks 15 or 16 years old." Twenty-six episodes were planned for a mid-April start.[93] The pilot even attracted a sponsor—General Mills' Wheaties—but was shelved when Kellogg's took offense to another cereal company's involvement, given how they were still sponsoring reruns of *Adventures of Superman*.[94]

The pilot itself is fairly strong, echoing *Adventures of Superman*'s opening but adding a longer account of Superboy's origins and his journey as an infant from Krypton to Earth. The exterior scenes of Smallville offer a visual change-of-pace from the urban settings of Metropolis, and the teenage-oriented subplots (such as how one of Clark's schoolmates is ashamed of his father's profession as a doorman) would have likely been well received by younger viewers. But the Boy of Steel was overpowered by the fact that the television marketplace could not support two Super-characters (be they man or boy or pup). While comics had thrived on television in the 1950s, at least in the sheer number of titles adapted, far fewer characters moved from page to screen in the decade that followed.

END OF AN ERA: COMICS FADE FROM THE SCREEN

While fewer comics-based programs were produced as the decade came to a close, there were even fewer comics-based films in the 1960s. With their move to the small screen, perhaps there was less motivation for Hollywood to keep adapting comics into movies unless there was a pressing reason (such as how *Prince Valiant*'s British landscapes lent themselves so well to the new CinemaScope format).

The decline in adapted versions had little effect on the creators of most of the source material used. While some like Al Capp were paid handsomely for the screen rights to their work, others received nothing. Superman's co-creators Jerry Siegel and Joe Shuster had signed away their rights to the character from the start before fighting a legal battle with National in the late 1940s. By the 1950s, however, both men were struggling. They tried launching a new comic book title together in 1947—*Funnyman*, about a prank-oriented crime fighter reminiscent of a heroic version of The Joker. Siegel and Shuster's contract with Magazine Enterprises gave them full control of the character and all licensing rights, and the two creators envisioned a newspaper strip, movies, merchandise, and all the other outcomes that Superman's success had provided National.[95] *Funnyman* flopped, however, lasting only six issues. A newspaper strip version was picked up by a few papers, only to be quickly dropped by the syndicate because the character was "too off-putting."[96] Shuster was on the edge of bankruptcy in 1952 (being unable to repay money borrowed from Capp's brother Jerome) and had resorted to drawing pornographic fetish art in between unemployment checks.[97]

As his creators suffered, Superman flourished on television. But aside from *Adventures of Superman* there were no long-running series based on comics in the 1950s. Many came and went, but only the Man of Steel (along with a small boy named Dennis) endured. Just as comic books themselves were an untested form in the 1930s that saw some trial and error, so too did television's early years see numerous experiments in format (from live to filmed programs, and with both actors and puppets), genre (with many shows carrying over from radio but requiring a more visually oriented approach), and audience demographics (with the boundaries between youth and adult viewers often becoming blurred).

Comics adaptations can be seen as part of the building process that television underwent in the 1950s. Given their success in B-films and serials, comics seemed like natural source material as television programming developed. But by the end of the decade, many of the most recognizable characters had come and gone from the small screen, just as they had from movie theaters. There seemed little reason to give comics characters a second try when their first efforts failed, even though creators like Milton Caniff often pursued new versions. It was the end of an era as the 1960s began. Superman lived on only in reruns, and there was no room for his youthful or canine embodiments. Comics fans would have to wait several years before seeing any more caped crusaders on television or movie screens.

6 · 1950s CINEMA, TELEVISION, AND COMICS

Screen to Page

Just as the film industry was grappling with how to deal with competition from television in the 1950s, so too were comic book publishers wondering how they should react to the new medium. There were over sixty million comic books on newsstands each month in 1950, but circulation had fallen to one-third of that number by mid-decade.[1] Comic book readers, like film audiences, now had a new alternative for consuming visual entertainment at home. Just like how television offered an alternative to the movies, the new medium also offered comic book readers the possibility of consuming visual entertainment at home. Comics historian Jean-Paul Gabilliet describes television as the biggest factor in the decline of comic book readership in this decade—"a gap between the two rival cultural practices was beginning to be established: one was moving toward a stunning expansion, the other toward a slow collapse."[2] This pattern was evident even as the decade began: in Gilbert Seldes's 1950 study *The Great Audience*, he notes how "children even stop buying comic books" when television is introduced to the home, "saying that television is comic books with moving pictures."[3]

The film industry saw a similar downturn, with attendance rates declining 45 percent between 1946 and 1955.[4] Hollywood responded with new technical innovations such as 3-D and widescreen formats like CinemaScope

and VistaVision, along with making big-budget blockbusters. The comics industry wasn't in a position to spend more money on individual titles, nor was a format change to a larger page size the answer given both the higher paper costs and the space limitations of newsstands. Instead, most publishers quickly embraced television, offering readers the further adventures of their favorite small-screen stars. At the same time, movie adaptations and extensions also grew rapidly within the comics industry, which increasingly turned to the content of other media at the same time the comic book itself came under attack by cultural critics.

PICTURE NEWS AND TELEVISION COMICS

With comic books regularly incorporating film imagery since the 1930s, it was natural that television content would also be adapted into comics. Television shows and stars were quickly licensed by comic book publishers. While Hollywood often approached television with disdain or hesitation, comics welcomed the chance to work with the new medium. Many comic books were actually centered on different media and technologies in the 1940s as a way of appealing to a wide range of reader interests, such as *Camera Comics*, which ran from 1944 to 1946. An editorial describes how the series was aimed at "camera fans," "photography hobbyists," and even the "would-be shutter bug who owns nothing but a box camera."[5] Along with schematic drawings of how to make an automatic timing switch for your camera, how to set up your own darkroom, and other technical concerns, *Camera Comics* featured adventure tales in which cameras played a prominent role in the action. The Grey Comet, a World War II flying ace, uses his "flying camera" to take surveillance photos of Nazi rocket bases: "His plane may not carry any guns, but the Nazis fear it as much as they do the bombers!" Other segments feature a young boy with the nickname Kid Click, who uses his trusty camera to foil the Nazis, intrepid "Woman Photographer" Linda Lens, whose "intelligence, daring, and beauty are all rolled up into one photographic minded person," and "ace newsreel cameraman" George Ferguson, who uses his camera "to shoot some live action pictures of a wild and wooly adventure!"[6]

While *Camera Comics* offered the fictional exploits of a newsreel photographer, another series offered an alternative to newsreels altogether. *Picture*

News ran for ten issues in 1946 and 1947, presenting readers with recent news events in comics form, such as atomic bomb testing, the heavyweight boxing match between Joe Louis and Billy Conn, and celebrity profiles of entertainers like Frank Sinatra, Benny Goodman, and Perry Como and baseball stars Joe DiMaggio and Jackie Robinson. *Picture News* declared itself a series that was "keeping up with exciting events that make the country talk" and told readers: "Remember, there is always something to think about behind the illustrated features in *Picture News*." The series emphasized its role in offering thoughtful commentary on current social issues, as with its prediction that Joe Louis would be victorious in his 1946 fight with Billy Conn ("This magazine admires Joe as a fighting, patriotic American who is a living lesson to the ignorant who proclaim that color dooms races to lasting inferiority"). *Picture News* fashioned itself as a sort of visual equivalent to magazine-format radio news programs like Edward R. Murrow's *Hear It Now* well before Murrow brought the format to television with *See It Now* in 1951.

The book even used the tagline "It's News, When Televised in *Picture News*,"[7] drawing an equivalent between the journalistic possibilities of comics and television while the latter was still on the cusp of becoming a more widely adopted medium. The series lasted only one year, but the way in which *Picture News* presented newsworthy subjects in comics form demonstrated the possibilities for the medium in handling nonfiction content.

In 1950, two short-lived series appeared that were aimed at young television fans—*Television Comics* and *Television Puppet Show*. Much like the comics of the mid-1940s that presented faux-animated-film characters like *Hollywood Comics* and *Kid Movie Komics*, these TV-related titles showcased characters that seemed like they had their own television program but really didn't. *Television Puppet Show* offered up a thinly veiled version of *Howdy Doody* in the form of Sparky Smith, a western-themed marionette (clad in a Davy Crocket–inspired outfit rather than Howdy's cowboy duds) who was joined by fellow puppets Spotty the Pup, Speedy Rabbit, and a Native American named Cheeta. The book clearly draws upon *Howdy Doody*'s popularity, seeking to convince children that there was room in their lives for two rootin' tootin' marionettes by using a generic description of its contents as the book's title rather than a character name (Howdy Doody is a puppet on television, hence *Television Puppet Show*).

Television Comics offers the exploits of a young boy named Willy Nilly as he gets into silly situations, with the book insinuating that he is a new TV

sensation. Each cover depicts a group of children gathered around a television set to watch Willy, with a tagline that reads "Featuring Willy Nilly / America's Newest Comic Sensation" above the book's title. The character name is also an obvious play on Howdy Doody, yet Willy is not a puppet but instead a real boy with a family (until the book's final issue, that is, when he was inexplicably turned into a marionette and the cover blurb was changed to "Featuring Willy Nilly, America's Wonder Puppet").[8]

FIGURE 39. *Television Comics* #7, 1950, features a *Howdy Doody*–inspired youngster.

Neither book lasted beyond a few issues, as it was clear that fans wanted to see actual television characters in their comics, not made-up ones. Between 1950 and 1960 there were numerous books devoted to some of the most popular programs. Children's shows were a favorite among younger readers, of course, with *Howdy Doody, Lassie,* and *Rin Tin Tin* all receiving their own titles. *The Mickey Mouse Club* had its own book in *Walt Disney's Mickey Mouse Club Magazine* (later retitled simply *Walt Disney's Magazine*). Adventure shows were represented in such comics as *Ramar of the Jungle* and *Captain Gallant of the Foreign Legion.* Science fiction shows like *Captain Video, Rocky Jones, Space Ranger, Tom Corbett,* and *Space Patrol* all received their own comic books, as did such crime programs as *77 Sunset Strip* and *Peter Gunn.*

The most popular sitcoms were also adapted into comic books, including *I Love Lucy* and *The Honeymooners.* Actor Jackie Gleason even proved popular enough in comics form to warrant his own title, simply called *Jackie Gleason.* *The Aldrich Family* was turned into *Henry Aldrich Comics,* comedian Milton Berle was given his own comic called *Uncle Milty,* while *The Phil Silvers Show* spawned two titles, *Sergeant Bilko* and *Sgt. Bilko's Pvt. Doberman.* *My Little Margie* topped them all, with three different titles appearing at different points throughout the decade. The *My Little Margie* comic book even outlived the series, lasting ten years compared with only four seasons for the show. The success of the main book, which debuted in 1954, led to *My Little Margie's Boyfriends* in 1958 and *My Little Margie's Fashions* in 1959.

Many of these comics use their first issues to recount the origin story of their main characters, something that the actual shows didn't always provide viewers. The first issue of *Rocky Jones, Space Ranger,* for instance, opens with a description of how young Mr. Jones found a discarded rocket suit as a boy, which he uses to fly into the stratosphere until he reaches Space Ranger Headquarters, run by the "United Worlds of the Solar System." There, he is recruited as a Space Ranger by the "Secretary of Space," eventually helping to win the "The Great Solar War" and becoming the commander of his own space ship.[9]

Similarly, the first issue of *Uncle Milty* shows how Milton Berle reached the top of his profession as "King of the Klowns." The opening narration asks, "Bet you never knew the really true story of how Uncle Milty became the great clown and comedian that he is . . . well here he is to tell you all

FIGURE 40. Milton Berle, in *Uncle Milty* #1 (December 1950), offers a tongue-in-cheek version of how he rose to fame.

about it and . . . every word of it is true. . . . mmm . . . well, almost every other word, anyhow!!" The story shows Berle recounting his humble origins to a group of young fans backstage after taping one of his shows. Sure enough, the tale is a wild one in which he was a struggling young comedian trying to get his first paid gig, only to be approached by "a funny looking little man" who takes him to Klownland to meet "King Komus, the King of Komedy." The king informs Milty that "no funnyman ever becomes famous until he has taken a trip to Klownland," and that he shall participate in an annual "kontest to see who shall ascend the throne of the king of Klownland." Naturally, Berle wins the "kontest," and upon returning to the real world (or, rather, regaining consciousness after apparently having been hit in the head by a revolving door) immediately lands his first paying job as a comedian.[10] Such origin stories (even if inspired by a head injury) further demonstrate the transmedia role that comics often played in developing a show's continuity. Readers could enjoy their favorite stars and characters anew in a different form, often learning more about how they rose to prominence than on the show itself.

Much as titles like *John Wayne Adventure Comics* and *The Adventures of Alan Ladd* offered readers the chance to bask in the adventures of their favorite Hollywood stars more regularly than they could onscreen, comic books offered television fans a way to extend their enjoyment of favorite shows. The phenomenon became so popular in the early 1950s that deals for the adapted versions of certain shows were being signed before any episodes were even produced. More than a month before shooting was set to begin on *Rocky Jones, Space Ranger*, an agreement for a comic book was reached with Whitman Publishing Company.[11] Comics and television seemed like natural allies as the decade began.

"IT'S SO REAL"—*TEE AND VEE CROSLEY IN TELEVISION LAND*

Not all TV-related comics offered readers their favorite television stars (or imitations thereof). Some books attempted to sell their readers on the vitality of the new medium—and of buying a particular brand of television set. Using comic books for promotional purposes was common throughout the 1950s, with children the common target. Even the American Dental

Association created a comic book to be distributed in schools "to encourage boys to plan a career in the molar world."[12] In 1951, appliance manufacturer Crosley Division and the Avco Manufacturing Corporation released the promotional comic book *Tee and Vee Crosley in Television Land Comics*, presumably as a way of getting children to badger their parents into buying Crosley TV sets. The book is a fascinating look into how television was marketed to the public in the early 1950s, given both the ways in which it was compared to other media and in how it uses fantasy scenarios to offer the promise of a fully immersive sensory experience within the comforts of the home.

The book begins with a rotund young lad named Butch calling out to a boy and a girl named Tee and Vee from beneath their bedroom window: "Hey! Tee and Vee! Come on over to my house and see our new Crosley television!"—with news of the arrival of a television set in the neighborhood apparently worthy of shouting in the street for all to hear. "Hurry up! The pictures on our Crosley are as clear as a movie," says Butch. Upon arriving at Butch's house, the young lad announces: "How's this for a big, clear picture? And the Crosley Unituner makes it as easy to tune as a radio."[13] Television's benefits are compared with two different media in terms of image quality and ease of use, positioning the new medium as a technological equal to both film and radio as far the public is concerned.

Afterward, Tee and Vee tell their parents about how "swell" it was to watch Butch's television set, and ask whether they might also get a Crosley television. As the children fall asleep and dream about their new television, Mr. and Mrs. Crosley decide that their household is also in need of a set. "Do you know, dear, I think we ought to get a television set. There are so many things we would enjoy besides the children's programs," Mrs. Crosley opines. "You're right! Put on your hat and we'll go visit that television dealer right now," announces Mr. Crosley. They abandon their sleeping children at home and rush off to the nearest dealer. The salesman recommends that the couple buy a Crosley brand set, of course: "It has everything—a big, clear picture—wide angle vision—a built in antenna—slide ruler tuning. And Crosley's Unituner is as easy to tune as a radio." Mrs. Crosley can't help but marvel at the unit's aesthetics: "It certainly is a beautiful piece of furniture!"[14] she exclaims. After arranging for their new set to be delivered the next day, Mr. Crosley reiterates the technical features and beautiful design of their new television as they head home to their unattended children.

FIGURE 41. Cover of 1951's *Tee and Vee Crosley in Television Land Comics* #1, a promotional effort used to sell Crosley televisions and other appliances.

Once the new set is delivered, Tee and Vee watch the adventures of a cowboy named Two-Gun Carson. "Gee, I wish Two-Gun Carson was right here in this room. I could tell him which way those outlaws went," exclaims Tee. The boy immediately falls asleep in his chair and begins to dream (as indicated by the formerly rigid lines of the book's panels now appearing wavy). Two-Gun Carson then speaks directly to the kids, reaching out into their living room from the confines of the screen: "Here I am Tee and Vee. If you know where they are heading, come along and show me!"

In the next panel Two-Gun leaps out of the television atop of his trusty steed. "Jump on my horse—I've got another horse waiting on the other side of Crosley's no-glare screen," he promises. Tee and Vee climb aboard and they all ride off into the television set. "Wow! In we go!" the kids shout as they enter into the titular Television Land.[15] By this point, the panel borders have become jagged lines meant to resemble lightning bolts (denoting the electricity through which the set's signals are transmitted). Just as the opening credits of the *Dick Tracy* series sought to create an immersive experience by having Tracy fire a gun directly at the viewer, so too does *Tee and Vee Crosley in Television Land Comics* position television as a more interactive medium than either movies or radio, whereby the actor onscreen can seemingly reach out into your living room. Television audiences are therefore thought to engage in a more active form of spectatorship than the passive spectators in a movie theater or those listening to the radio, as demonstrated by Two-Gun's ability to cross back and forth from Television Land into the viewer's home.

Tee helps Two-Gun find the outlaws thanks to his having spotted one of their hats perched on a cliff while watching the show: "I can see the smallest details on our Crosley T.V. screen. The picture is big and it never fades or blurs. Come on, they went this way!" Tee bellows, mixing promotional rhetoric with a call to action. The story continues to use the hard-sell approach after the bandits are caught: "Guess I better buy me a Crosley T.V, set, pronto!" says Two-Gun. "Good idea!" replies Tee. "Everyone who wants the best gets a Crosley T.V. My Pop says there's no finer T.V. at any price."[16]

The next day, the children watch a puppet show while Tee recounts the dream he had with Two-Gun Carson. "Gee! These puppets look so real on our Crosley screen. Wish we could go with them to Puppetland," Tee says wistfully. "Your wish is granted. Come along with me and visit all your friends in Puppetland," announces a puppet named Danny Dragon, who rolls out a flying carpet into the kids' living room to whisk them away. "I'm glad to see you have a Crosley T.V. set, with it's [*sic*] perma-clear picture, otherwise you might have missed me. Crosley's super power means no dim-out, and you're able to see me clearly for the entire life of the set. Let's go back through the Crosley television to Puppetland," Danny announces. Tee and Vee take a tour of Puppetland to see how the puppets are made and how their show is produced. At one point, the king of Puppetland commands a ballerina named Rosette to dance. "Yes, do," Vee says. "Our Mom

and Pop and all Television owners will enjoy that!" But rather than watch the dance being performed in front of her, Vee is more captivated by the Crosley TV nearby that is simultaneously broadcasting Rosette's movements. "It's so real," says an astonished Vee, confirming Danny Dragon's musings that Rosette's dancing must be "as clear on our Crosley T.V. as it is right here where it's being broadcast."[17]

Television has long been conceptualized as a "window to the world," allowing viewers to experience different visual phenomena in the comforts of their own home that they would otherwise need to leave the house to enjoy. Lynn Spigel, in her seminal book *Make Room for TV*, quotes an NBC director as stating in 1955 that "the viewer is inclined to accept it as his window to the world, as his reporter on what is happening now—simultaneously. The miracle of television is actually Man's ability to see at a distance while the event is still happening."[18] Such viewing pleasures are actively being sold by Crosley in their *Tee and Vee* comic book, but the notion that television can become a substitute for lived experience (a fear expressed in films like 1955's *All That Heaven Allows*) is clearly being sold as a benefit by the comic book, as young Vee chooses to watch the ballerina's performance on a screen rather than before her very eyes, joined by two other puppets who prefer the televised vantage point over the actual one.

The same holds true in an issue of *TV Teens*, which featured an *Archie*-inspired gang of all-American teenagers. One story tells of how a teen named Ozzie would rather stay home and watch an event on television than join his girlfriend Babs in person. The story opens with Ozzie and Babs discussing a new show being recorded in their town that night with their friends Jean and Dippy—a horror series entitled "I Married a Monster" starring Boris Karload (an amusing play on words reflecting the way in which Boris Karloff and the horror genre had become a staple of 1950s drive-in theaters, to which teenagers flocked by the car load). Ozzie describes how the broadcast is "a local tryout! If this one is a hit, it will be picked up nationally, I heard!" Babs is excited that Karload will be there in person, and she wants the gang to get tickets so that she can add his autograph to her collection. "Why do we need tickets!? We can watch it on TV! huh, Babs?" suggests Ozzie. Dippy volunteers himself and Ozzie to get Karload's autograph, which clearly frustrates Ozzie: "If you'd kept your big yap shut we could have watched this show on TV and not had to worry about getting an autograph!"[19] he spews at Dippy once they are alone.

The story suggests that a teenager would be more interested in spending an evening at home watching television (presumably with his parents, since most homes only had one set) than in going out with his friends. Another story finds Ozzie and Babs watching a baseball game on television, only to be asked by Babs's mother, "Why you kids aren't outside on such a beautiful day. . . . You should be out enjoying some sport *yourselves* instead of watching it on TV!" Ozzie, ever the couch potato, makes excuses as to why they should remain indoors. "I think you should get more regular exercise than twirling the TV dial!" says the mother, who suggests that they go fishing and practice with Babs's father's equipment. This leads to Ozzie accidentally tearing the curtains down as he demonstrates how to cast a line, followed by Babs ripping the dress right off of her mother while practicing herself. The punchline sees the mother grumbling, "When will I learn to keep my suggestions to myself?!" as the two teens continue watching the game on television.[20] Such comic books poke fun at parental concern over listless children who prefer to watch television rather than be active or social. At the same time, they reaffirm the pleasures of TV viewing for the younger readers of these comics, assuring them that their four-color peers are equally uninterested in the outside world. While Hollywood often warned audiences about the ill effects that television might have upon their lives, comic book publishers were keen to capitalize on the new medium's popularity, even as it contributed to an overall decline in comic book sales.

Meanwhile, back in *Televisionland*, Tee and Vee encounter a Martian named Captain Mars who takes them to the red planet and shows off its superior technology. The kids are shown a "walkie talkie wrist watch" similar to the one that Dick Tracy wears, a gun that shoots popcorn, and personal flying saucers with "automatic radar controls" that serve as the main form of transportation. Despite such advancements, the Martians still rely on a certain Earth-based company to provide their planet with a wide range of products. When Vee asks whether "the cute radio up there on the shelf" was made on Mars, the captain admits, "No we've tried, but we can't make radios as good as Crosley, so we use Crosley radios all over Mars! They get such clear reception and come in such beautiful colors, we have them in every room in all the homes!" The Martians also use Crosley garbage disposals in their kitchens, and of course have Crosley television sets in every home. "Our leading engineers couldn't improve on the Crosley garbage

disposal, television or Crosley radios, so we don't try anymore!" explains Captain Mars. "Golly, Capt. Mars, Crosley does make excellent products," replies Tee (who does not bother to ask about Crosley's interplanetary distribution network).[21]

Tee and Vee later visit Jack Frost Land and meet Mr. Jack Frost himself, who shows them the factory in which he manufactures freezers and refrigerators for Crosley ("Living up here in Jack Frost Land we know more about cold than anybody!"). Jack sells the children on the superiority of his appliances, gaining two future customers. "When I grow up I'm sure going to have a Crosley Shelvador refrigerator and a Crosley Shelvador freezer!" say Tee. "Me too!" echoes Vee. "Then I can buy food in quantities and save a lot of money and have more time to play with my dolls,"[22] she says, envisioning her future domestic life.

Finally, Tee and Vee make a stop in Mother Goose Land and give the little old lady who lived in a shoe a kitchen makeover with top-of-the-line Crosley appliances. They also reach out to their friends in Puppetland to help them with one other gift: "We knew your Crosley kitchen would save you so much time that you would be able to enjoy yourself more, so we brought you a Crosley T.V.," says Rosette. "This certainly is a surprise, folks, and I know every other mother of children would like to have a surprise like it. Thanks a lot, and the children thank you too . . . sniff . . . sniff," sobs the little old lady.[23] With television offered up as a beacon of domestic relaxation to a harried mother (who can now share moments of quality programming with her many children before they go to bed, rather than whipping them soundly as the nursery rhyme goes), *Tee and Vee Crosley in Television Land Comics* is an exercise in hard-sell advertising that sees television as not only a modern electronic convenience, but as something just as necessary to home and family life as the Crosley brand stove that cooks your meals and the Crosley Shelvador refrigerator that keeps your food fresh.

Other companies had their own television-inspired comics for promotional purposes, typically using popular children's shows as a way to advertise their wares. In 1950, Grape Nuts cereal offered a promotional *Hopalong Cassidy* comic book as a giveaway, while in 1951 there were several free *Hopalong* comics offered by Bond Bread. While *Hopalong* fans might have become loyal consumers of those products because of these regular giveaways, the promotional *Lassie* comic book sponsored by Red Heart Dog Food in 1949 was not repeated (the tie-in seemed to make

sense, but unlike other food products the final consumer could not read). Promotional books based on *Davy Crockett* and *Dennis the Menace* were more recurrent as the decade progressed. Just as comic books were used by movie exhibitors in the 1930s and 1940s as a way to entice patrons to the theater, comics were seen as a way to both sell sponsored products and draw more viewers to particular programs. But while many companies saw value in comic books for their marketing potential, there were many who saw the medium as a dangerous and corrupting influence on its young readers. This anti-comics groundswell would find its champion in the early 1950s in a psychologist named Fredric Wertham, whose work soon changed the comics industry.

SEDUCTION OF THE INNOCENT

Comics were not the first medium to become the subject of a moral panic. The film industry came under scrutiny in the early decades of the twentieth century, culminating in 1930 with Hollywood's adoption of the Motion Picture Production Code (commonly known as the Hays Code after Will H. Hays, president of the Motion Picture Producers and Distributors of America). Numerous reports were released in the 1920s and 1930s claiming that films had a damaging influence on young viewers; the most notable were the Payne Fund Studies. Francis Payne Bolton, a wealthy Republican politician, funded a series of studies into the effects of popular culture on children that were published in manuscript form, including Alice Mitchell's *Children and Movies* in 1929. In 1933, numerous additional studies were published: Herbert Blumer and Philip Hauser's *Movies, Delinquency, and Crime*; Wendell Dysinger and Christian Ruckmick's *The Emotional Responses of Children to the Motion Picture Situation*; Henry James Foreman's *Our Movie Made Children*; and Ruth Peterson and L. L. Thurstone's *Motion Pictures and the Social Attitudes of Children*. Other studies followed as the decade progressed, with Hollywood beginning to more strictly enforce the Hays Code by 1934.

In turn, academics and professionals offered a wide range of insights throughout the 1930s, 1940s, and 1950s into the effects that movies, radio, comic books, television, and other media were having on children. Not everyone saw harm in letting kids read comic books and watch movies,

with one professor even advocating for it. "Pix, Comics Don't Hurt Kids, Sez Prof; Need Diet of Films, Radio," *Variety* reported in 1947:

> No child ever learned anything bad from a film or a comic book alone, according to Dr. Clarence B. Allen, who, in his capacity as professor of education at Western Reserve Univ. is making a study today of the effect of films and radio on the modern child.
>
> "No child ever went wrong because of a radio program or a film," Dr. Allen said. "He had the tendency or the attitude beforehand, and the film merely gave him the technique to carry it out." Dr. Allen began his study to find out for himself how much films, radio programs and comic books really harm the growing child. In his 17 years as professor of education at Reserve he has spoken to thousands in PTA and other educational groups.
>
> Dr. Allen believes that children cannot grow up in America normally without an average diet of movies and radio programs. "If a child gets nightmares from overdramatic radio programs, or becomes morbid from certain movies, then such things are bad for him. But if there is no apparent reaction on the part of the child, then parents should not try to over-protect him by keeping him away from these amusements.
>
> "Some parents try to pre-digest all such entertainment for their children. But life doesn't treat the child that way. The poor manners, bad language, intoxication, can't be avoided in real life. The child must learn to live with such things and judge them in his own mind."[24]

Dr. Allen's perspective was quickly overshadowed by that of Dr. Fredric Wertham, a leading psychiatrist who had worked at Johns Hopkins Hospital, Bellevue, and Queens Hospital Center. In 1948, Wertham presented research at a symposium hosted by the Association for the Advancement of Psychotherapy entitled "The Psychopathology of Comic Books," which led to a *Time* magazine article on the event and Wertham's work.[25] Comics historian Bradford W. Wright describes how Wertham took the position that "comic books did not 'automatically' cause delinquency in children, but clinical studies demonstrated that 'comic book reading was a distinct influencing factor in the case of every single delinquent or disturbed child' that he had studied. He insisted that comic books also contributed to the particular brutality that juvenile crimes had begun to assume," and also "warned of the sexual threat posed by comic

books" given how publishers "made a 'deliberate attempt to emphasize sexual characteristics.'"[26]

Wertham also published an article in 1948 entitled "The Comics . . . Very Funny!" in the *Saturday Review of Literature* that brought even more attention to his research. The article, which was soon reprinted in *Reader's Digest*, begins with a series of anecdotes about violent acts committed by his young patients, all of whom read comic books: "What is the common denominator of all this?" asks Wertham. "Is it the 'natural aggression' of little boys? Is it the manifestation of the sex instinct? Is it the release of natural tendencies of the imitation of unnatural ones? The common denominator is comic books," he concludes.[27]

This concern for the "imitation" of immoral behavior echoes that already faced by Hollywood in the Payne Fund Studies and elsewhere, yet Wertham did not go so far as to blame all media for the bad behavior of the children he encountered. In fact, Wertham saw varying levels of influence among different media—"What is said of one medium may be totally untrue of another," he wrote in his 1954 book *Seduction of the Innocent*: "In our studies we found marked differences between the media in their effect on children. The passivity is greatest in reading comic books, perhaps a little less with television, if only because often other people are present in the audience. In both, the entertainment flows over the child. Passivity is least in going to movies, where others are always present."[28]

This distinction between passive and active audiences would be upended by Marshall McLuhan ten years later in *Understanding Media*, in which he designated movies as a "hot" medium in which a single sense is emphasized and less participation is required. Comic books, on the other hand, are considered to be a "cool" medium, which according to McLuhan requires more participation on the reader's behalf (given the individual roles played by panels, captions, word balloons, and drawn images in creating meaning).[29] A different sensory experience is therefore created when the content of movies are adapted into comic books, one which McLuhan sees as more participatory. Wertham did not see such adaptations as bringing any more value to comic books, describing how "different media are not mutually exclusive. Some of them blend very well; when they blend with comic books it is always in their worse aspects. There are radio comic books, TV comic books, and movie comic books."[30] He goes on to note how "comic books have been in competition with the other media not only with regard to money but with regard to children's minds as well. I have not found, as many would have us believe, that the good influence of legitimate

media makes comic books better. . . . On the contrary, comic books make the other media worse."[31]

Wertham's influence was felt in the increasing number of calls for legislation surrounding the content of comic books. In 1952, Justice Martin Frank of the New York Supreme Court decried, "By the immortals . . . literature has been called the highest form of human expression and the greatest of all sources of refined pleasure. The growth and popularity of this new and malignant form, contrived as it is of lurid illustrations and language untouched by the essentials of grammar, good taste, and careful vocabulary, makes a dreary prospect indeed, for the art of American letters. What an unsavory dish set before prosperity."[32] That same year, a bill was introduced in the New York Legislature "to examine and license every comic book" in order to prevent the sale of those which are "obscene, lewd, lascivious, filthy, indecent, immoral or disgusting, or is of such a character as to tend to incite minors to violent or depraved or immoral acts."[33]

In 1954, the Senate Subcommittee on Juvenile Delinquency held three days of hearings to investigate the comic book industry. Comics historian Amy Kiste Nyberg describes how "when it was all over, the comic book industry closed ranks and adopted a self-regulatory code" that endured into the early twenty-first century.[34] The code that they adopted was inspired by the Hays Code, something that the U.S Senate particularly recommended. *Variety* reported on how "the Sub-Committee of the U.S. Senate Judiciary Committee, which is investigating juvenile delinquency, is looking to the film industry for some guidance. Senate group wants to cite the effectiveness of Hollywood's Production Code in urging comic book and humor mag publishers use some restraint in what they market . . . and likely will call on some film production officials. Already some film execs have been contacted in NY."[35]

On August 17, 1954, a meeting was held in New York in which "thirty-eight publishers, engravers, printers, and distributors attended," representing such publishers as National Comics, Archie Comics, and Toby Press. "Taking their cue from what had proved successful for the film industry," writes Nyberg, "the comic book industry sought a 'czar' with the proper credentials to administer their new code."[36] The search was announced on August 21, with *Variety* reporting on the desire of comic book publishers to "appoint a 'Czar' to censor their publications," and noting that the salary "will be around $40,000, which industryites [*sic*] feel will eliminate the possibility of payolas for favorable handling of material. Position would be patterned after Hollywood's Production Code Administration and the baseball 'czar.'"[37]

In turn, the Comics Code Authority was born, with the code itself consisting "of forty-one specific regulations,"[38] mostly aimed at curtailing the more lurid elements found in horror and crime comics. Later that same year, Robert E. Lee, the head of the Federal Communications Commission (FCC), "warned the broadcasting industry that something must be done about the 'ill-conceived programs being put on the air,'" noting how he believed that the television industry "would be well advised to put their house in order before someone does it for them." Specifically, he pointed to the way in which comic book publishers had recently appointed a "czar" to get their own house in order.[39] Just as the comic book industry turned to the Hays Code as inspiration for their self-censorship initiative, the television industry was being pushed by the FCC to follow the lead of comic book publishers in reconsidering the content they provide to audiences.

While the formal means obviously vary in how each different medium presents its visual content (be it "ill-conceived" or otherwise), similar approaches were either undertaken or advocated in regulating cinematic, television, and comic book content, with the Hays Code seen as being equally applicable as a general model to both TV and comics in the 1950s. Nyberg describes how those who drafted up the comics code "relied heavily on the Hays film code," and that "a side-by-side comparison" of the two "shows that the comics code was organized along the same lines as the film code, and much of the language of the film code was incorporated into the comics code."[40] Crime and horror comic books were the most affected by the Comics Code Authority, while titles adapting Hollywood films saw little change. Since the stories featured in such comics as *Movie Classics, Movie Love*, and *Fawcett Movie Comics* were all drawn from existing films, their narratives had already passed the moral rigors of the Hays Code. Despite Wertham's belief that comic books with cinematic source material "make the other [medium] worse," movie-related comics thrived throughout the 1950s.

MOVIE LOVE, MOTION PICTURE COMICS, AND DELL FOUR COLOR

While series like *Movie Comics* from Fiction House, Inc., were short-lived in the 1940s, the following decade saw a boom in such titles. From 1949 to 1952, *Fawcett Movie Comics* appeared on newsstands alongside

that publisher's popular superhero titles like *Whiz Comics, Captain Marvel Adventures,* and *Captain Marvel, Jr.* With twenty issues published during its run, *Fawcett Movie Comics* achieved a relative longevity that the 1939 and 1946 versions of *Movie Comics* did not. *Movie Love* also enjoyed a three-year run between 1950 and 1953, as did Fawcett's *Motion Picture Comics.* Fawcett Comics would have likely continued to publish movie-related titles throughout the decade if not for its demise altogether because of a lawsuit by National Periodicals (in which it was "ruled that Captain Marvel was an infringement on Superman's copyright").[41]

Motion Picture Comics offered readers adaptations of western films almost exclusively, with issues based on such B-westerns as Republic's *Frisco Tornado* (1950) and *Rough Riders of Durango* (1951) alternately appearing on newsstands with print versions of A-films like MGM's *Red Badge of Courage* (1951). The one exception to the western films adapted in *Motion Picture Comics* was also an A-film, the science-fiction effort *When Worlds Collide* (1951). While the special effects of a big-budget Hollywood sci-fi effort might have been more difficult to re-create in comic form than the sagebrush sagas of most Republic westerns, the *Motion Picture Comics* adaptation of *When Worlds Collide* smartly forgoes the use of a multi-panel layout (usually between five to nine panels per page) at times and instead uses larger panels to re-create the film's most exciting moments. Two-thirds of particular pages are devoted to the first glimpse of a gigantic spaceship being built and to an erupting volcano. Another page contains only two-panels, one depicting a giant tidal wave ("Vast tidal waves smash inshore as the oceans are torn from their beds!") and the other showing the effects of devastating earthquakes ("Shock after shock rends the tortured earth!").[42]

While *Motion Picture Comics* emphasized action with its choice of western and science-fiction films, *Movie Love* represented a wider range of genres. The first issue offered readers a double bill of the romantic drama *Mrs. Mike* (1949) starring Dick Powell and Evelyn Keyes along with Mickey Rooney in the racecar drama *The Big Wheel* (1949). Issue seven featured the musical *Let's Dance* (1950) with Fred Astaire and Betty Hutton, plus Eve Arden and Howard Da Silva in the comedy *Three Husbands* (1950). The sea-faring mystery *Pandora and the Flying Dutchman* (1951) starring James Mason and Ava Gardner was featured in issue eleven, along with the sunken treasure adventure *Crosswinds* (1951) starring John Payne and Rhonda Fleming. Issue twelve featured the Dean Martin and Jerry Lewis comedy

FIGURE 42. Cover of *Motion Picture Comics* #110 (May 1952).

That's My Boy (1951) and the war drama *Submarine Command* (1951) star-
ring William Holden. *Movie Love*'s covers frequently featured a publicity
still of the lead male and female actors in a warm embrace (Martin and
Lewis simply smile at the reader), but while "Love" may have been empha-
sized in the title, the film choices were hardly restricted to romantic fare.

Although a variety of genres were used within the pages of *Movie Love*,
the ways in which the musical is brought into a comic book is a compelling

example of how the formal qualities of the comics medium demand changes in the content of a film when adapted into a series of panels. The *Movie Love* version of *Let's Dance* contains little reference to singing or dancing in its actual narrative, largely rendering the film a straight romantic drama on the page. The opening image of the issue is a full-page drawing (known as a "splash page" in the industry, meant to grab the attention of potential

FIGURE 43. *Movie Love* #7 (February 1951), featuring Fred Astaire and Betty Hutton in *Let's Dance* (1950).

buyers) of Astaire and Hutton framed by a circular spotlight. The two are clearly in the middle of a dance routine for an audience, with each in mid-step on what appears to be a stage and Hutton holding onto Astaire's arm. The film tells the story of how two former United Service Organization (USO) entertainers meet again years after World War II, with the second page of the comic showing us a silhouetted image of Astaire and Hutton dancing "at a fighter base somewhere in England" in 1944.[43] The pair appear to be in the middle of a dance number for a large group of troops, but we only get this single image of the USO performance, an extreme long shot positioning the reader at the back of a large crowd.

The film's song-and-dance numbers are the primary spectacle offered in *Let's Dance* (and in the musical genre as a whole). Comics, however, are only able to convey sound through onomatopoetic means and to portray static images of a body in the midst of rhythmic motion rather than moving images, hence the difficulty in adapting a film's musical numbers. *Let's Dance* contains a famous scene, entirely cut from the adaptation, in which Astaire dances with a coat rack as well as underneath, on top of, and even inside a grand piano. Also cut was the film's western-themed dance number in which Hutton and Astaire (each wearing fake mustaches) cavort before a saloon full of uninterested cowboys, with numerous pratfalls. The comic book instead provides readers with a melodramatic tale of a custody dispute over Hutton's son. The story's final page again offers an image of Astaire and Hutton dancing in the spotlight, but the lack of the film's major musical numbers demonstrates once more how certain temporal qualities of cinema (in which music and rhythmic dancing must unfold over a certain duration of time) are often incompatible with the medium of comics.

Similarly, issue fourteen of *Movie Love* features an adaptation of the beloved musical *Singin' in the Rain* (1952). The story's opening splash page shows Gene Kelly and Debbie Reynolds about to embrace, along with the famous image of Kelly holding onto his umbrella while he stands atop the base of a lamppost. The actual dance number in which this moment occurs is nowhere to be found in the comic book, however. Nor are "Make 'Em Laugh," "Good Mornin'," or any other songs featured in the film. Rather, *Singin' in the Rain* becomes a serious melodrama about Hollywood's transition to sound filmmaking in which the film's comedic moments are either removed or lose their humor amid the inertia. While still an enjoyable story in its own right, Kelly and Reynolds's budding love is expressed not through song but through captions like "And so day follows day—with Kathy and

Don seeing more and more of each other . . . with Kathy and Don falling evermore deeply in love . . ."

Aside from the opening image, this adaptation of *Singin' in the Rain* contains no singing and no rain, shifting the reader's generic expectations entirely. Those who purchased the book before seeing the film might be surprised to discover that it is actually a musical, while those who had already seen the film might wonder why Kelly's rhythmic steps are not on display. With challenges similar to those faced by producers such as Sam Katzman

FIGURE 44. *Movie Love* #14 (April 1952), featuring a nonmusical adaptation of *Singin' in the Rain* (1952).

in re-creating the fantastic imagery of superhero comic books onscreen, comic book versions of films may be more or less successful depending on the genre being adapted and how well static and moving images represent particular subjects.

By far the most popular comic books based on films were from Dell Publishing Company, which had presented the adventures of numerous Disney characters and movie cowboys like Roy Rogers and Gene Autry throughout the 1940s in the pages of *Four Color.* Jean-Paul Gabilliet describes Dell as "the industry's unchallenged leader in sales thanks to its titles for preadolescents" during the 1950s, and the expansion of TV-related books in the decade's first half only added to the company's success.[44] By 1954, "roughly one third of the comic books sold in the United States carried the Dell label, and the percentage rose" as the decade progressed.[45] The average Dell comic sold between 750,000 and 800,000 copies, with the "slogan 'Dell Comics Are Good Comics' appearing at the bottom of the first page" of each issue that year (in response to the controversy surrounding horror, crime, and other comic book genres that Dell did not publish).[46] Not only were adaptations highly profitable for Dell, they were also seen as a more honorable type of comic book than those which the Comics Code Authority was brought about to suppress.

In the mid-1950s, Dell expanded their cinematic adaptations to include recent feature films from a range of studios. In 1954, *Variety* reported on the growing trend of film-based comic books, detailing their mode of production:

> Building of want-to-see smallfry interest in particular pictures is being effectively accomplished via tieups with comic book publishers. Yarns based on upcoming films are finding their way into the moppet literature. The film companies provide the comic book publisher with the shooting script of a film. The publisher's staff provides the cartoon drawings and the story thread for the comic strip balloons. The books are then marketed via the regular channels and are sold at the customary price of 10¢. The film company receives a color cover and inside black and white pictures with ample credits for the picture. The rights to the yarn and the shooting script are furnished to the publishers at no cost. The print order for each book varies from 600,000 to 1,000,000, but it's estimated that the books receive even wider distribution since there is an active exchange system of these books

among children. The publishers are careful in their story selection, avoiding blood and thunder material and selecting only wholesome stories with adventure or historical backgrounds. . . . Theatres occasionally take part in the tieup by purchasing a number of copies for free distribution to their Saturday matinee trade.[47]

A 1958 article further describes how along with "being sold in lobbies of theaters in advance of playdate and during picture's run," the comic books are distributed to "magazine racks in drug stores, book shops, supermarkets and other high traffic locations. Ordinarily, the movie tie-in comic book is released a month before film makes its appearance, and has [a] 90-day life span."[48] Disney's live-action efforts were at the forefront of these new books, with *Treasure Island* (1950) and *20,000 Leagues Under the Sea* (1954) receiving their own comics. Warner Bros. was particularly active in licensing their films, seeing the value in how comic books could promote upcoming releases. Historian Michael Barrier describes a 1958 meeting between Western Printing Company (which owned Dell) and "three executives of Warner Bros., one each representing the studio's cartoons, theatrical motion pictures, and television series" in which "each executive outlined production plans for the forthcoming season's releases—twenty cartoons, four western series, and about three dozen feature films, all of them potential grist for Western's mill."[49]

Dell worked closely with film studios to ensure that their adaptations were published at the same time as a given movie's release. In a letter dated October 12, 1959, editor Chase Craig wrote to publicist Marty Weiser about an upcoming comic book based on the upcoming Twentieth Century–Fox film *A Dog of Flanders* (1960), expressing concern over the exact release date. "You have notified us that *A Dog of Flanders* will release nationally in June 1960, 'with limited viewing in key cities sometime before the national June release,'" wrote Craig. "Could you give us more definite information as to the number of cities involved in the limited viewings; also, the phrase 'sometime before June' gives a rather large latitude," he continued. While comic books were released nationally, the staggered release patterns of Hollywood films in this era complicated the logistics of publishing a movie-based title. "There have been a number of stories in the trade papers, stating that the picture is for Christmas release; these stories, you inform me are incorrect. If we are to tie-in the comic book with release of picture, it is vital

that we be informed as to release dates," Craig asserted.[50] While a comic book based on a television series would seem current on newsstands for as long as the show remained on the air, a film-related title had a more limited shelf life given that movie theaters saw a much faster turnover in content than TV stations.

Dell's film and television adaptations were considered to be high-profile assignments given the popularity of the source material. "If you mentioned to someone that you were doing *Car 54*, it was an impressive thing," said artist Tony Tallarico of his work on Dell's adaptation of the series *Car 54, Where Are You?*[51] Creators would typically watch the show they were assigned to adapt, and often got to see the films before starting work on the books. But if there was a strong inclination against adapting a given film, then Dell might forgo licensing that title. Tallarico recalled attending several screenings with Helen Meyer, vice president of Dell Publishing and the head of its comics line. "If I didn't think something was appropriate, I would say so. One film . . . they wanted to license it, and I said, 'Gee, I wouldn't license it if I was doing it.' She didn't license it," said Tallarico.[52]

Artists were given publicity material from the studio to use as a reference for their work, in order to ensure some semblance of continuity between the costumes, sets, props, and other materials used in the film and the way they were depicted in the comic. While artists would not always draw close likenesses of a film's actors, there was generally an effort to match the physique, hairstyle, and facial structure of lead performers so that readers would identify their favorite stars when they picked up the book on a newsstand. Such identification was aided by the use of photo covers depicting the stars and/or a major scene from the film.

Publicity stills were also typically used on the inside front cover, either as a single image or in a sequence. Dell frequently offered potential readers a summary of the film's plot told through multiple photos with captions as a way of hooking them on the narrative so that they would buy the book. The adaptation of *The Searchers* (1956), for instance, contains seven stills with the following captions spread across them: "Ethan Edwards's homecoming / is spoiled by an Indian raid. / His young niece disappears, / and a desperate search . . . / leads to the Comanche camp . . . / where he must face . . . / the challenge of his life!"[53] Similarly, *Spartacus* (1960) is recapped through captions across five photographic panels: "At a Roman gladiator school, Spartacus, a Thracian slave, learns to be a savage fighter. / Under

his leadership, the slaves turn on their Roman masters, destroy the school, and escape. / Molding themselves into a mighty army, they win battle after battle as they march toward the sea . . . / . . . and liberty, while in trembling Rome, the fearful Senators debate ways to stop them. / Just as the slaves reach freedom, they find themselves facing the armies of Crassus and Pompey."[54] These concise summaries, along with images of John Wayne and Kirk Douglas in several riveting situations, provide compelling reasons to buy each issue. The summaries also do not tell how the film ends,

FIGURE 45. Dell's *Four Color* #709, 1956, featuring an adaptation of *The Searchers* (1956).

tantalizing readers with just enough of the story to make them want to buy the book if they have not yet seen the film.

While previous decades had seen a mix of line art and photographic covers, movie comics in the 1950s primarily used photos on the front of each book. Each book typically contained a photo cover of the film's main star. Some covers were painted, "sometimes in oils or acrylics, usually in gouache," says Michael Barrier, which lent them what he calls a sense of "prestige."[55] Certain painted covers also contained a small inset image from the film, such as *Voyage to the Bottom of the Sea* (1961). While most of the photos from movies and television programs were provided by the studios, some were taken specifically for Dell—further demonstrating its clout in the marketplace. Barrier notes how both Roy Rogers and Gene Autry posed for exclusive photos shot by Western staffers Kellogg Adams and Polly Harrison. Autry's photos were taken at his ranch in Newhall, California, where his films and television program were made, while a shoot was held in the desert for *The Adventures of Rin Tin Tin* with the show's stars Lee Aakers and the canine hero himself.[56]

Some artists would even photograph their television screen when doing TV-based titles as a way of gaining more reference material. Tallarico describes how fellow artist Angelo Torres taught him "how to photograph pictures from the television, because there's a trick to it. It was a great help" to have the extra images, he says. Not every publisher was as committed to ensuring that an adaptation was as faithful as possible to the source material, however. Tallarico notes how when he worked for Charlton Comics there was room for artists to deviate from the scripts they were given in terms of how they drew the events in the film's narrative. Charlton, he says, wasn't overly concerned with the way an artist's final layouts looked "so long as they could print them."[57]

Dell's film adaptations were the industry's leaders in both sales and quality. While books like the 1939 and 1946 versions of *Movie Comics* could not sustain their readership, Dell had become a trusted brand among comics fans by the 1950s, and the way in which they had already been giving readers the print adventures of their favorite animated characters created a more natural transition into publishing other cinematic adaptations. The fact that their television-based comics were all best sellers made it an easy decision for Dell to expand their film-related offerings as well. Comic books were too new as a format in 1939 for a series like *Movie Comics* to last. The comic book industry was still establishing itself in the late 1930s and experimenting with

formats and genres, and the question of which publishers would endure and which would fly by night was still being determined. A decade later, the industry had already gone through its initial growing pains and was in a better position for publishers like Dell to maintain strong working relationships with Hollywood studios. A 1953 *Variety* advertisement sums up how Dell "gives Hollywood *a powerful friend!*" through their line of comic books. "There's only one way to measure what Dell means to Hollywood," the ad proclaims. "*Go down to your nearest newsstand!*"[58]

MORE MOVIE STARS: FROM BOB HOPE TO HOPALONG CASSIDY

There were many good reasons for movie studios to collaborate with the comics industry, given the marketing potential for their films. Movie stars had an additional incentive beyond the boost to their fan base. *Billboard* reported in a July 1950 article entitled "Comic Book Rap Ain't Funny" that comic books "have been bringing in plenty of royalties to top-name film, radio and TV actors," who typically received around 5 percent from the sale of a book that features their likeness. "The average deal calls for a substantial advance, plus one-eighth to a quarter of a cent per copy, approximately five percent of the gross sale. However, the percentage can be as high as 10 or as low as 1 depending on the name involved. Cash-wise, this means plenty, since the average successful comic book sells 500,000 copies per issue, and toppers like Howdy Doody and the Walt Disney series sell in the millions."[59]

Billboard also noted that a given show's popularity did not necessarily correspond to a particular sales level, as "air ratings apparently have nothing to do with sales appeal on the stands." It quotes one "veteran comic book publisher" as stating that "comedy is harder to put over than slam bang adventure stuff, which explains why *Mr. District Attorney* is one of the all-time best sellers while *Ozzie and Harriet* fizzled out after the first issue."[60] Even a minor star like Buster Crabbe had two of his own comic books—the first ran for twelve issues between 1951 and 1953 and the second from 1953 to 1954, a period in which his B-film career was winding down. With his B-westerns and science-fiction serials regularly appearing on television in the early 1950s, Crabbe's adventurous star-persona worked well in panel form (the first issue begins with a biography of the former Olympic athlete,

concluding, "Unlike most actors, Buster Crabbe *is* actually *every bit* the *he-man* he portrays in his movie roles! His superb physique, and extraordinary strength, was acquired by *living* the part, not by *acting* it!").[61] Crabbe's comic books even helped reignite his career long enough for him to land the lead role in the TV series *Captain Gallant of the Foreign Legion* in 1955.

While some comedians' comic books struggled to find an audience, others excelled. When the only superheroes left at National Comics by the mid-1950s were Superman and Batman, the publisher turned to some of Hollywood's leading funny men to save the day.

In 1950, *The Adventures of Bob Hope* was launched to great success, with the series lasting eighteen years. Hope even devoted an entire radio broadcast to the book's debut in April of that year.[62] Advertisements stressed the multi-genre appeal of the series: "No matter what you like, you're bound to like *The Adventures of Bob Hope* . . . the sensational new magazine that's filled with fast-action, adventure, mystery, beautiful gals—and rip-roaring laughter with America's favorite funnyman on stage, screen, radio, and television!"[63] It was followed in 1952 by *The Adventures of Dean Martin and Jerry Lewis*, which became *The Adventures of Jerry Lewis* in 1957 once the pair split. Lewis's solo title was so popular that it lasted until 1971, with cameos along the way by Hope himself, The Beatles, Superman, Batman, The Flash, and Wonder Woman.

But superheroes were not a major emphasis at National in the early to mid-1950s. While Superman and Batman endured, other heroes like The Flash and Green Lantern had disappeared from newsstands. Many would be reinvented starting in the late 1950s, but for most of the decade it was film- and television-based comics that kept National going. The publisher used the tagline "The Line of Stars" in several ads to promote their range of titles.[64] Many of these luminaries were actual movie stars like Hope and Martin and Lewis, while others were titles based on popular television programs like *A Date with Judy*, *Big Town*, *Gang Busters*, and *Mr. District Attorney*. Hopalong Cassidy soon joined the line of stars when his title ended at Fawcett in the wake of its demise. By 1958, National was specializing in screen comedians, with Hope, Lewis, Jackie Gleason, and Phil Silvers all in their own books, marketed as "The Kings of Comedy!" within the pages of *Batman* and *Superman*.[65]

Superheroes were overshadowed by film and television stars for most of the decade, with adaptations increasingly proving to be a profitable (and

FIGURE 46. Advertisement for *The Adventures of Dean Martin and Jerry Lewis* and *The Adventures of Bob Hope.*

uncontroversial) way for publishers to connect with readers. The actors themselves had no creative input into their titles but reaped the benefit of additional media exposure along with the royalties received for the use of their name and likeness. Even those without their own titles could see appearances in books like *Famous Stars,* which chronicled how various actors got their start in Hollywood. The first issue features the story "How Shelly Winters Made the Grade," showing the actress knocking on a wooden doorframe for good luck before shooing a scene. "But it was only a few years back that Miss Winters was knocking on studio doors, without

the slightest encouragement," a caption tells us. "(Sigh!) I've got plenty to offer, but no one seems to be interested! Well—I'll keep banging away, and if I bang loud enough, and long enough, they may notice me!" says Winters as she knocks on the door of the fictional Majestic Studios.[66] This rags-to-riches biography is used in support of her lead role in *Winchester '73* (1950) alongside Jimmy Stewart, with the issue's cover featuring a publicity photo from the film of the two stars in mid-embrace.

Others featured in the pages of *Famous Stars* include Ava Gardner (who, we are told, rose to fame "through Hollywood's strangest screen test!"),[67] Bing Crosby, Judy Garland, Robert Mitchum ("A strictly natural guy, Bob Mitchum made one sacred vow to himself... that he would never let success go to his head ... in other words, that he will never 'Go Hollywood!'"),[68] Elizabeth Taylor, Betty Grable, Janet Leigh, Gary Cooper, and Gene Kelly ("He carried his heart in his shoes!" his biography begins).[69]

Animated stars continued to sell strongly throughout the decade, with Disney's roster of titles expanding to include *Chip 'n' Dale* in 1955. *Terrytoons* characters like Mighty Mouse, Heckle and Jekyll, and Gandy Goose were featured in the pages of both *Terry-Toons Comics* and *Paul Terry's Comics*. Heckle and Jekyll received a solo title in 1952, while Mighty Mouse had two books in the 1950s (*Mighty Mouse* and *Adventures of Mighty Mouse*). Casper the Friendly Ghost also had two comic books (an eponymous title as a well as *Casper's Ghostland*), in addition to making frequent appearances in *Harvey Comic Hits* and *Harvey Hits*. Paramount characters Herman and Katnip, Baby Huey, and Buzzy the Crow were featured in *Paramount Animated Comics*, followed by *Baby Huey, the Baby Giant*. *Looney Tunes* characters like Bugs Bunny, Tweety and Sylvester, Daffy Duck, and Porky Pig were regularly featured in the pages of *Four Color*, with all later receiving their own titles.

Comic books became an increasingly important source of revenue for animators in the 1950s given the recent changes in film exhibition. Walter Lantz, creator of Woody Woodpecker, expressed concern over how the decline of the double bill and the rise of longer blockbuster films meant that "considerable revenue is being lost from the houses which are bypassing the cartoons in order to speed up the turnover." However, a "certain percentage of the revenue lost from the decrease in bookings is made up from the merchandise licensing and comic book business."[70]

By far the most popular film genre to carry over into comic books was the western. With cowboy heroes like Gene Autry, Roy Rogers, and

Hopalong Cassidy continuing their adventures on television, comic books made them true multimedia stars. By 1952, *Roy Rogers Comics* was selling 1.6 million copies per issue for Dell.[71] Bill Boyd, who played Hopalong Cassidy, was so popular that he received his own title in *Bill Boyd Western* from 1950 to 1952, which appeared alongside the long-running *Hopalong Cassidy* comic book. Many other movie and television cowboys received their own books as well, including such titles as *Rocky Lane Western; Tim Holt Comics; Tim McCoy; Rod Cameron Western; Jimmy Wakely; Bob Colt; Johnny Mack Brown; Lash Larue Western; Whip Wilson; Wild Bill Elliott; Buck Jones; Bob Steele Western; Durango Kid* (based on the series of films starring Charles Starrett); *Rex Allen Comics; Monte Hale Western; Ken Maynard Western;* and *Tex Ritter Western.* While western titles flourished throughout the decade, they were particularly popular between 1950 and 1952, before the FCC lifted its freeze on new television stations. Eager western fans who couldn't yet see their favorite cowboys at home could still enjoy their further adventures in comic book form.

There were also general titles like *Dell Giant Western Roundup* offering stories with Gene Autry, Roy Rogers, Johnny Mack Brown, Rex Allen, and Bill Elliott. *Western Hero* featured Tom Mix, Hopalong Cassidy, Gabby Hayes, Monte Hall, and Tex Ritter, while *Crack Western* saw Randolph Scott and Tim Holt on its covers. *Six Gun Heroes* also saw a range of western film and television stars, while *Prize Comics Western* contained adaptations of such films as *Canadian Pacific* (1949), *Streets of Laredo* (1949), and *Roughshod* (1949). *Cowboy Western Comics* also featured adaptations of films like *Rio Grande* (1950) and *Winchester '73* (1950), along with stories about famous historical or folklore figures such as Buffalo Bill and Paul Bunyan.

Some comic books were based on particular television shows, such as *Flying A's Range Rider.* In 1956 and 1958 *Steve Donovan, Western Marshall* was featured in issues of Dell's *Four Color,* while the book based on *The Cisco Kid* ran from 1950 to 1958, two years longer than the show itself. Many sidekicks got their own titles too, including *Andy Devine Western* and *Gabby Hayes Western.* Such books were not limited to male characters, either, with Dale Evans receiving two titles that spanned more than a decade—*Dale Evans Comics* (running from 1948 to 1952) and *Queen of the West, Dale Evans* (1953 to 1959). Her books were sold on the strength of their exciting narratives as well as the star's beauty: "Action! Excitement! Glamor! Here's another thrill-packed issue of the great comics magazine starring the 'Queen of

the Westerns' in the sort of lickety-split fast-action stories that have made Dale and her magazine top favorites with you, you, and YOU!" one ad proclaims.[72] The genre was so popular that even the best-known horses in Hollywood were getting their own books, such as *Rocky Lane's Black Jack*. Gene Autry's horse Champion had his own book between 1951 and 1955, while *Roy Rogers' Trigger* sold over 890,000 copies in 1952 (outselling many non-equine actors).[73]

As crime and horror comics came under fire in the early years of the decade, and as superhero titles dwindled to only a handful of top heroes, movie-based books became a dominant presence on newsstands in the 1950s. They were regularly among the industry's best-selling titles at a time when comic books faced close scrutiny of their content from public officials as well as an overall decline in sales. Comic books were a way for established stars like Bob Hope and Jerry Lewis to build a stronger cross-media brand (with both also regularly appearing on television throughout the decade), and allowed fading heroes like Buster Crabbe to market their continuing vitality. Western comics proved so popular that cowboy stars even appeared in their own titles long after their death. *Tom Mix Western*, featuring the adventures of the silent film star who died in 1940, enjoyed success with readers from 1948 to 1953.[74] While comic books based on animated characters might have been less satisfying for some readers than watching them move onscreen (Barrier sees most as "shallow and uninteresting on the page"),[75] these titles aided creators like Lantz at a time when the sales of animated shorts were suffering. Just as comics proved to be good business for Hollywood, movie-based comics served the comics industry well into the 1950s as various genres were in the midst of reinvention.

ROMANCING HOLLYWOOD: FROM STARLET O'HARA TO BURT LANCASTER'S LOVE LESSONS

Western comics were also popular enough to sustain several romance-oriented titles in the 1950s, many of which used movie stars as tie-ins with recent releases. *Romances of the West, Real West Romances,* and *Western Hearts* featured Hollywood stars like Yvonne De Carlo, Audie Murphy, Ray Milland, Hedy Lamarr, Fred MacMurray, Irene Dunne, and Randolph Scott on their covers in conjunction with such films as *Calamity Jane and Sam*

Bass (1949), *Copper Canyon* (1950), *Never a Dull Moment* (1950), and *Santa Fe* (1951). The use of comics to promote new films also extended throughout the decade to traditional romance titles, a genre that was as closely aligned with Hollywood as the western within the comic book industry.

Romance comics flourished in the late 1940s. Comic book historian Mike Benton describes how there were ninety-nine romance titles on the market by 1949. "Romance comics became the fastest growing comic-book genre of all time," says Benton, and they were soon "merging with and replacing other genres of comics."[76] Numerous romance comics featured Hollywood stars on their covers as way of enticing potential readers. Rita Hayworth, Jimmy Stewart, Elizabeth Taylor, Fred Astaire, Jane Russell, and Robert Mitchum appeared on the front of books like *Enchanting Love, Great Lover Romances, Love Letters, Intimate Love*, and *Pictorial Love Stories*. Some titles offered biographies of the cover stars, such as *Personal Love*. The inside front cover of that series was dedicated to a brief life story of such actors as Farley Granger, Glenn Ford, Esther Williams, and Loretta Young—referred to as either "Our Cover Girl" or "Our Cover Boy."

Other titles offered more unusual approaches. *Lovers' Lane* had a column called "The Stars Tell" in which movie stars answer advice questions from readers: "Send in three to five questions on any problem you would like answered, plus the name of any movie star whose opinions you respect. This page is yours, and the answers lie in the hands of the stars!" When asked about the qualities that an "ideal woman" should have, Burt Lancaster (who was twice divorced) told readers that he's "not a guy to demand perfection in a woman. All she must have is charm, poise, intelligence, an understanding nature, a sense of humor and an appreciation of nice things. Looks are not too important—just as long as she's pretty and has a swell figure."[77] Another issue saw Peggy Cummins (star of *Gun Crazy* [1950]) offer sage advice for male readers on how to behave on a first date, including the following: "Talk slowly and coherently, and don't swear. Swearing is a sign of poor upbringing, not of sophistication," and "If you want to kiss her on this first date, don't act like a sorehead if she turns you down; be gracious about it."[78]

Cummins could also be found in the first issue of *Hollywood Film Stories*, which adapted *Gun Crazy*. The cover promised "Full-Length Foto Previews of Big Movie Romances," while listing the movie stars featured within its pages rather than the films being adapted. Despite the cover's emphasis on romance, the issue adapts several film noir efforts, including Nicholas Ray's

Born to Be Bad (1950), Anthony Mann's *Side Street* (1949), and Joseph H. Lewis's *Gun Crazy* (here called by its alternate title *Deadly Is the Female*). The series used a fumetti approach to its imagery, but unlike the 1939 *Movie Comics* series, *Hollywood Film Stories* did not alter the publicity stills with additional artwork. Instead, the series used the studio photographs in the same manner that *Graphic Little Theatre* did in newspapers. Just as that strip did, each story contained numbered passages of text recounting the film's narrative (but with the addition of word balloons for dialogue, something not found in *Graphic Little Theatre*). While crime films were prominent in *Hollywood Film Stories*, the romantic elements were played up as much as possible. The ending of their *Gun Crazy* adaptation, for instance, includes the caption "Here was the payoff to their wasted criminal existence. Wasted was all their love and youth and dreams!"[79]

Other romance comics forewent adapting actual films, and some simply used publicity stills without any reference to the actual films beyond the cover image. A 1951 issue of *New Romances* features Richard Baseheart and Barbara Bel Geddes posing together to promote *Fourteen Hours* (1951), but the film is not mentioned within the issue. With its story of a man threatening suicide by standing on a window ledge for fourteen hours, the film noir thriller would have seemed out of place amid the dating advice (a column called "Date Bait" offers tips on how to make a man notice you) and tales of wayward romances (a woman drives her husband away by preferring to overclean her house rather than to make love to him; a woman ignores her wedding vows in a "frenzied effort to win the love of the man next door!").[80]

Numerous titles used Hollywood only as the setting for the fictional exploits of aspiring starlets, playing into readers' fantasies of one day being discovered by a casting agent themselves. In *Movies about the Movies: Hollywood Reflected*, Christopher Ames describes how "one of the first truisms about Hollywood is that it is not a place but a state of mind." He sees films about the film industry (such as *What Price Hollywood?* [1932], *The Bad and the Beautiful* [1950], and *The Player* [1992]) as a way "to study the myths that are fostered and debunked when Hollywood depicts Hollywood."[81] These myths are also explored within the pages of such comic books as *Hollywood Diary, Hollywood Confessions, Hollywood Secrets,* and *Dr. Anthony King, Hollywood Love Doctor,* all of which use Hollywood as the backdrop for romantic tales in which young women fall in love with famous leading men, become overnight stars, and learn valuable life lessons about the

FIGURE 47. *Hollywood Film Stories* #1 (April 1950) featuring *Gun Crazy* (aka *Deadly Is the Female*, 1950).

fickle nature of show business. While male-oriented comics like *John Wayne Adventures* and *The Adventures of Alan Ladd* depict the supposed offscreen exploits of famous stars when they aren't making movies, the Hollywood-oriented romance comics of the 1950s offered female readers an imaginary look at life in Tinseltown (full of both happiness and heartache). The escapism of *John Wayne Adventures* comes in the form of a retreat from the studio sets, while the pleasures promised by *Hollywood Diary* and *Hollywood Confessions* stems from a close interrogation of the seemingly glamorous lives led by movie stars as they work within the major studios.

The cover to the first issue of *Hollywood Diary*, for instance, proclaims: "Beautiful woman flock to moviedom's capital. . . . Now read their tales of love, frustration and heartbreak as told in their own intimate style." The first story begins with an image of a woman's diary, in which she writes: "When I came to Hollywood, a young magazine writer on her first assignment, my eyes were still full of stardust! I was an impressionable girl, realizing her dream!"[82] While the series offered only fictional movie stars, the covers teased at the possibility of becoming the real thing with captions like "Daring excerpts from the love affairs of future stars!"[83] Similarly, *Hollywood Secrets* presented tales of budding starlets as they negotiate their new career and their love life. An aspiring actress named Diane tells us in the first issue: "I stood where any girl would give her last breath to stand, before the cameras of Hollywood's top studio . . . on the threshold of stardom! My future, and the future of Paul Dennis, the man I loved, hung in the balance!"[84] The allure of Hollywood is also sold within the pages of *Dr. Anthony King, Hollywood Love Doctor*, in which a fictional psychiatrist tells of how he "deal[s] with *true* facts, the human emotions, that terrifying, strange force which plays such an important role in the glamorous, romantic, mysterious world of Movieland."[85]

Other series depict Hollywood in a negative light, such as *True Life Secrets* with its story of how Cupid tries to make a better man out of fictional movie star Robert Tyler. Cupid tells readers that Hollywood is one of the worst places on earth: "Here I am again, folks," says Cupid, "and of all the places to be, I have to turn up in Hollywood! Ordinarily I take care of nice kids who will be happy with each other but Hollywood is my beat too— and it's more trouble than the rest of the world put together!"[86] The darker side of Hollywood is also seen in the first issue of *Hollywood Confessions*, in which a young woman named Rita sees the film industry as her path to

fame and fortune but soon finds out "that show business is not the glamor-
ous nether-world one reads about in magazines." Told by one casting agent
that she is "too inexperienced," she encounters another who promises her
work in return for (implied) sexual favors: "Sure, honey, sure. . . . You be
good to me—and I'll be good to you!"[87]

As she struggles to find work, Rita takes work dancing as a chorus
girl in disreputable venues: "My first job in show business . . . a 'hula'
dancer in a side show in Coney Island. . . . Then came a series of two-bit,

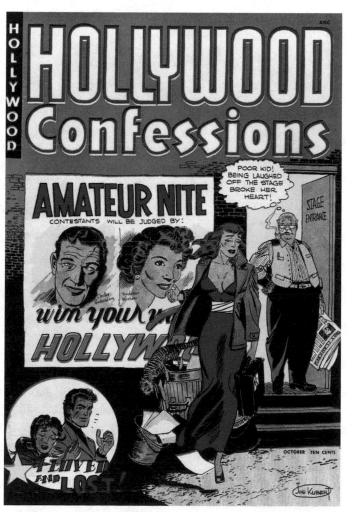

FIGURE 48. Cover of *Hollywood Confessions* #1 (October 1949).

fly-by-night shows . . . leering, sweating faces, broken down dressing-rooms, and . . . loneliness." When she finally does land a screen test, the studio lot is described in terms of its artifice: "A movie set is a world within a world . . . giant flood-lights give the effect of suns shining in the void, as the cameras purr, recording the scenes with its mechanical eye."[88]

The story ends by upholding traditional 1950s gender roles, as Rita reconnects with her old boyfriend Sam after failing to land an acting job. "Being a wife is a career in itself! It may not be as glamorous as acting . . . ," he says. She abandons her dream of stardom, telling Sam, "My selfish interest in success almost destroyed me! . . . *You're* my career now, Sam! My career—my life . . . my everything!"[89] Romance comics of this era generally reflected the cultural norms of the time regarding marriage, with women playing a subservient role as housewives. *Hollywood Confessions* cautions against the perils of becoming an actress, instructing female readers that they will be happier playing a starring role in their husbands' lives instead.

In addition to titles that offered a rotating stock of characters, other comics featured fictional starlets in ongoing title roles—but combined romance and humor together much like *Archie* does. The covers for *Starlet O'Hara* announce that the book contains "Her Romantic Adventures in Movieland." Starlet and her roommate Fritzi arrive in Hollywood expecting to be discovered, but they end up working in the mail room for the fictional Miracle Studios (the front gates of which read, "If it's a Good Picture, it's a Miracle").[90] Similarly, a young socialite named Hedy De Vine seeks stardom in *Hedy of Hollywood*, but here the emphasis was also on comedy rather than melodramatic tales of loss and heartache (the cover regularly boasted "52 Big Pages of Hollywood Humor!"). In *Miss Beverly Hills of Hollywood* we find a young Miss Hills as she navigates her fledgling acting career while meeting numerous movie stars along the way. The first issue costarred Alan Ladd, while future issues saw her meet Fred Astaire, Eve Arden, Betty Hutton, and Bob Hope. While the series lasted only nine issues, Miss Hills was also featured in backup stories within the pages of *The Adventures of Bob Hope* for several issues.

All three of these comedic starlets spoof the film industry and the legions of fans who seek to break into Hollywood. They offer, however, far more affirmation for those dreaming of their big break than the frequent cautionary tales found in romance books like *Hollywood Confessions*, which urge their female readers to embrace domestic life and seek fulfilment in serving their husband. Each comic book genre represented Hollywood differently

FIGURE 49. Advertisement for *Miss Beverly Hills of Hollywood* #1.

in the 1950s, depending on its narrative needs. Comedic titles used the major studios as a backdrop for lighthearted misadventures, romantic books used the film industry as fodder for melodramatic tales of woe, and westerns allowed rugged movie stars to flex their masculine vigor in a more natural setting while helping others in need.

Movies and television shows were prominent aspects of the comic book industry throughout the decade. Gabilliet notes that the leading comic book genres in the latter half of the decade "were the funny animal titles, humor, TV, western, and romance comics; in intermediary position

were teen comics, fantasy, detective, and war titles; the least represented genres were adventure, superheroes, science fiction, and newspaper comics reprints."[91] Most funny animal books stemmed from animated films, and the majority of western titles featured movie and television cowboys. Numerous romance and humor titles were centered on Hollywood. In turn, movies and television were well represented in all of the top comic book genres of the period. "Most of the Dell characters," for instance, "originated elsewhere, in other media, and were adapted to comic books," writes Barrier.[92] With Dell selling more copies than any other publisher, film and television characters and actors dominated newsstands during a time of change for the comic book industry. With horror and crime books having succumbed to the moral concerns of cultural critics and public officials, and superhero comics still waiting for their eventual resurgence, comic book publishers sustained themselves by turning to other media for characters, stories, and settings to which the public would respond. Dell sold readers on the idea that their line of books were "Good Comics"; for the comic book industry, adapting movies and television programs was clearly good business in the 1950s.

CONCLUSION

The 1960s and Beyond

Movies and comics have been allied since the beginning of narrative cinema. Movies (and later, television programs) about comics characters have had a steady screen presence throughout the twentieth century, with the 1930s through 1950s representing a peak period. At the same time, film fans could also experience cinematic content in panel form through numerous comic books and strips. As each medium evolved, it drew upon and adapted the other's content and characters, first during the silent film era in live-action and animated shorts and then in feature films. As B-movies, serials, and comic books increasingly became entwined in the 1930s and 1940s, film audiences continued to enjoy live-action adaptations along with numerous animated shorts starring popular comics characters. While comics adaptations were not as prolific in movie theaters in the 1950s, an abundant amount of television programs was based on comic books and strips throughout the decade.

As the 1960s began, comics characters had largely faded from both television screens and movie theaters. Hollywood tried a few more adaptations of comic strip characters like *Dondi* (1961) and *Modesty Blaise* (1966), but the results were uninspired. While reruns of *Adventures of Superman* continued across the country, new efforts at adapting popular characters were stifled. In addition to the failed attempts at bringing *Superboy* and *Superpup* to television, there was also a prolonged effort to bring a popular newspaper

strip hero to the small screen. In 1957, Flamingo Films entered into a distri-
bution agreement with Panther Productions for twenty-six color episodes
of a new television series based on Lee Falk's comic strip *The Phantom*. The
contract outlined how the production values of the show would "be sub-
stantially the same quality of the film series entitled 'Superman' currently
being distributed by [Flamingo]." Panther failed to deliver the episodes,
and those that were produced did not live up to the "minimum standards"
set by Flamingo.[1] New agreements were struck in 1960, and again in 1962,
but the series never emerged.

While a less-polished aesthetic might have been passable in the first half
of the 1950s, it was no longer acceptable as the medium developed. With
comics making the shift from serials and B-films to television, the produc-
tion values of those cinematic forms often carried over as well. As more
stations emerged and audiences increased, bigger sponsors saw the need
to advertise on television. In turn, budgets often mounted and the overall
production quality of individual programs rose. Comics adaptations had
thrived for decades on screens both large and small as low-budget produc-
tions, but they would not endure once television emerged out of its infancy.
As the western genre began to dominate the ratings with such shows as
Gunsmoke, Bonanza, Rawhide, Maverick, Wanted: Dead or Alive, and *Have
Gun Will Travel,* comics heroes were soon forgotten by television audiences
in the early 1960s (aside from the *Superman* reruns, of course, in which
George Reeves lived on for his fans).

It wasn't only superheroes who were disappearing—a certain red-haired
teenager from Riverdale also struggled to maintain a steady television pres-
ence. In March 1959, production company Ted Lloyds Inc. acquired the
rights to make a pilot for a series to be called "The Adventures of Archie
Andrews," with plans to use the comic book and newspaper strip "to find
a 'real life' teenager to play the title role" rather than an established actor.[2]
These plans fell through, and in 1962 a pilot was made for ABC called
Life with Archie featuring more familiar faces like Frank Bank and Cheryl
Holdridge. But the sponsor seemed to think that the actors were perhaps
too familiar, since both had costarred on *Leave It to Beaver* (with Bank for-
ever known to viewers as the unfortunately named Lumpy). A 1964 effort
followed with John Simpson as the new Archie, followed by television
specials in 1976 and 1978 (*Archie* and *The Archie Situation Comedy Musical
Variety Show,* respectively), but the Riverdale gang only seemed able to

sustain itself on the small screen in animated form with *The Archie Show* (1969) and *Archie's Funhouse* (1970).[3]

A pilot was also made in 1967 for a new *L'il Abner* series, but it too failed to be picked up. The most enduring series based on a comic strip to emerge in the 1960s is one that remains little remembered: *Hazel*, adapted from Ted Key's single-panel work for the *Saturday Evening Post* about a spunky maid named Hazel Burke. The show ran for five seasons from 1961 to 1966. More famous today is *The Addams Family*, based on Charles Addams's single-panel *New Yorker* strip, which ran from 1964 to 1966 and spawned two Hollywood films in 1991 and 1993.

While *Hazel* and *The Addams Family* stemmed from esteemed magazines, the decade's most infamous television show hailed from the pages of DC Comics. From 1966 to 1968, *Batman* delighted children and adult viewers alike with its campy take on the Caped Crusader, even leading to a feature film from Twentieth Century–Fox (1966's *Batman: The Movie*). But some saw *Batman's* success as a sign that television was pandering to the lowest common denominator. In a July 1966 article entitled "TV—Camp or Class? Two Trends on a Collision Course," *Backstage* speculated as to the effects that comics-based (and radio-based) programs would have on the television industry:

> Will Willy Shakespeare be able to defeat the Green Hornet? What will Williams' Glass Menagerie look like after the Batmobile crashes through it? Can Arthur Miller mystify Dick Tracy? Tune in your tv set this fall and get the impending answers to the battle of camp vs. culture. The networks have embarked on a 'class' movement with David Susskind as the high and mighty mogul. His Talent Associates (which did 'Death of a Salesman') is heading toward a banner year with the firm producing at least 14 major productions for next season including an original Richard Rodgers musical—'Saturday Night Around the World,' 'Othello,' 'Dial M for Murder,' etc. However this apparent movement towards 'class' is complicated by another powerful trend: the increasing number of 'camp' shows. The success of 'Batman' on ABC has resulted in such absorbing creations as 'The Green Hornet' and 'Dick Tracy' with Bill Dozier as the leader of the clan. Every time the culture crowd announces a 'Sunday Night at the Theatre,' 'ABC Stage '67' or a CBS Playhouse, the camp crowd comes up with a Flash Gordon, Buck Rogers or Marvel Comics. 'Biff! Bang! Zop!' are the sounds likely to be heard next season as these two antagonists clash head-on.[4]

Whereas comics-based programs had used little of the actual imagery from their source material, Batman reveled in it throughout the show's opening credits and in the extensive use of onomatopoeic words presented in large type during fight scenes such as "Biff!!!," "Kapow!," "Zzonk!," "Zamm!," "Qunckkk," "Z-Zwap!" and "Thwack!" (among many others), which were meant to resemble the equivalent of comic book sound effects as they appear on the page.[5] The overt nature of the show's comic book origins, along with its explicitly campy tone, made Batman a target for cultural critics who feared for the future of the television medium and its ability to sustain shows based on literary sources with a higher pedigree than that of DC Comics. Comics-based programs of the 1950s were largely geared toward children, even though many adults tuned in as well. Unlike those programs, Batman "segment[ed] its audience by age via its blended genre codes," writes comics scholar Matt Yockey. He argues that the show offered older viewers "a nostalgic version of childhood remediated via the mass culture parody of a signifier of that childhood."[6]

The series clearly had a different intent in the use of its source material from previous film and television adaptations of comics. While enormously popular, the show's success also meant that audiences would have a hard time taking superheroes seriously onscreen for some time to come. It wasn't until the mid-1970s with Wonder Woman (1975) and The Incredible Hulk (1978) television series and the Superman (1978) feature film that comics heroes could be seen as more than campy crusaders again, although that cycle of films and programs itself declined by the early 1980s.

While comic adaptations of films and television programs continued to be produced by publishers like Dell and their competitors, remaining popular through much of the 1960s, the comic book marketplace underwent a significant shift as the decade began. The overall number of titles being published had been steadily declining since its peak in 1952. That year, notes comics historian Jean-Paul Gabilliet, "3161 comic books were published for an overall circulation around 1 billion. . . . By the 1960s the trend leveled off around 1500 yearly releases."[7] He argues that while television offered new competition for the comics industry, the rising birth rates of the baby boom era should have compensated enough to reduce the sharp decline in readership.

As publishers were faced with decisions about which titles to cut and how to better attract new readers while keeping existing ones, some tried to breathe new life into old trends.

Superheroes quickly experienced newfound popularity as National Periodical Publications reinvented many of their older heroes in the late 1950s, including The Flash, Green Lantern, and The Atom. The new versions of these characters were then teamed up with Superman, Batman, Wonder Woman, and Aquaman in the Justice League of America. This later became known within comics culture as the rise of the Silver Age of comics, following the Golden Age of the late 1930s and 1940s.

Soon after the start of the Silver Age, Marvel Comics emerged as a new player in the superhero comic marketplace. The success of their first superhero title, *The Fantastic Four*, in 1961 led to the debut of new heroes over the next three years, like Spider-Man, the Hulk, Thor, the X-Men, Iron Man, and Daredevil, while older characters like Captain America and the Sub-Mariner were brought back. By mid-decade, Marvel was actively licensing their characters to television animators. In 1966, a series called *Marvel Super Heroes* offered audiences Captain America, Iron Man, the Hulk, Thor, and the Sub-Mariner, with each episode consisting of three adventures with a particular hero. *Marvel Super Heroes* was distributed by Krantz Films, Inc., which also put out the first animated *Spider-Man* series in 1967. It was also reported that Krantz had acquired the rights to adapt several comic book titles from DC as animated programs—*The Atom, Sea Devils, Metamorpho,* and *Mystery in Space*.[8] The series never surfaced, but numerous other animated programs did in the late 1960s including those starring Batman, Superman, Aquaman, and The Fantastic Four.

The animation style of *Marvel Super Heroes* was much different from that used to bring other comics characters to the screen, however. Through a process called Xerography, comic book panels by the original artists were used as the basis of each episode. A 1966 issue of *Broadcasting* describes how "literally, by virtue of Xerography, five super heroes from the Marvel Comics Group are coming to television. They are coming, via syndication, just the way they appear in the comic books, same stories, same artwork, same coloring. It's said to be the first time that an animation process has attempted to show comics as they originally appeared, except with limited motion." The xerographic approach is described as being more "realistic instead of the traditional cartoon approach of translating the comics to the television screen." Robert Lawrence, executive producer of the series, asked, "Why change anything?" Marvel's artists, he says, "are great art directors, great cameramen. They have a tremendous feel for continuity, for action. Their work gives the impression of movement."

FIGURE 50. Trade advertisement for the 1966 *Marvel Super-Heroes* animated television series (*Broadcasting*, June 27, 1966).

Xerography involves using Xerox machines to photocopy comics on to film stock, "thus bypassing the tedious human process and insuring more than a reasonable facsimile," the article continues. In defense of the way in which the Xerographic technique is "somewhat limited" in how it can animate characters, Lawrence offered an explanation that attempts to promote the vital quality of the comics medium (while sidestepping the economic rationale for avoiding hand-drawn animation): "We don't want to fully animate because then the figures on the screen become cartoony, or caricatures. Actually, the human movement cannot be animated. What we do is force people to use their minds to fill in the gaps."[9]

The latter notion has long been held as one of the strengths of the comics medium in that readers must actively intuit connections across and within panels. While Lawrence is clearly trying to sell his show the best way he can, the idea of offering "more than a reasonable facsimile" harkens back to the question of authenticity that has been so central to the reception of adaptations. With images from one medium altered for reuse in another (an approach similar in its intent to the fumetti style used in the 1939 *Movie Comics* series), the Xerographic process in *Marvel Super Heroes* allows for media content to retain part of its original qualities while crossing formal boundaries. While the printed words of novels become fundamentally transformed into visual images when adapted to film or television, here the drawings of Jack Kirby, Don Heck, and others from the pages of such books as *Captain America* and *The Incredible Hulk* remain relatively intact as they are given the illusion of motion. Rather than serve as the basis for an animator's reinterpretation or an actor's embodiment, the drawings used in *Marvel Super Heroes* remain recognizable as comic book content.

Adaptations are often judged by how well the content of another medium is transformed by the new one, while still retaining largely indefinable qualities like the "essence" of the original work. Comic books like *Movie Comics* and television programs like *Marvel Super Heroes* that repurpose the actual content of another medium are usually thought of as quaint novelties, but in some ways they retain more of their source material than do other adaptations. When we seek new versions of familiar stories and characters in different media forms, we usually do not expect to see the actual presence of those stories and their imagery from their original incarnation. But from *Movie Comics, Graphic Little Theatre,* and *Hollywood Film Stories* to the ways that 1930s serials regularly used comics panels to introduce each chapter, to

the use of comics imagery in the opening credits of 1940s and 1950s serials and features, to the actual comics panels (and sound-effect inspired graphics) present in 1960s programs like *Marvel Super Heroes* and *Batman*, the ways in which movies and television adapted comics (and vice-versa) regularly involved repurposing the original source material while still retaining actual elements.

At the same time that comics fans enjoyed an increasing number of animated television programs based on comic books in the 1960s and 1970s, adaptations of film and television programs continued to be published in comic book form. By the late 1970s, Marvel Comics was offering adaptations of popular Hollywood blockbusters in the pages of *Marvel Super Special*, while presenting the further adventures of Luke Skywalker in an ongoing *Star Wars* series. Other films and programs saw their narratives extended further in such comics series as *Star Trek, Battlestar Galactica, The Further Adventures of Indiana Jones, The Terminator, Aliens,* and *Predator* in the 1970s, 1980s, and 1990s.

As the evolution of publishers like DC and Marvel Comics saw them acquired by media conglomerates such as TimeWarner and Disney, the intersections of comics with other media became subject to new corporate concerns in the twenty-first century. Along with the rise of blockbuster superhero films has come an increasing need to make comic books a forum for prequels to specific films, as well as to more closely align characterization and visual design between film and print versions of popular characters. Recent years have also seen the proliferation of such direct-to-video animated films as *Planet Hulk, Batman: The Dark Knight Returns, Justice League: The New Frontier,* and *All Star Superman*, providing fan-oriented and faithful adaptations of popular comic book series and storylines. The superhero genre remains popular and profitable in modern Hollywood, which in turn affects media outlets such as comic book publishers with which many Hollywood studios have corporate relationships.

As I compare the ways in which my children today can experience comics characters in different media with what was available when I was their age, I struggle to imagine growing up in an era in which Spider-Man and Iron Man have always been Hollywood fixtures, let alone lesser-known print characters like Ant-Man and the Guardians of the Galaxy. Movies were more often adapted into comics than the other way around when I was young, and if I couldn't convince my parents to let me see *Blade Runner*

(1982), *Conan the Barbarian* (1982), or other films that I was probably still a bit too young for, I could always find the Marvel Comics version instead. The modern explosion of comic book movies is the result of a different media landscape from the one I grew up in; now I ask my children whether they want to watch *The Flash* or *Supergirl* on television (they're still too young for *Gotham* and *Daredevil*), or if they'd rather watch one of the *Iron Man* or *Captain America* sequels on DVD. But the idea that comics characters have never been more prevalent in Hollywood is a fallacy. Screen stars were commonly found in comics panels throughout the Classical Hollywood era, and comics characters were regularly transported from the page to the screen. Comics and cinema have always been allies. When my grandfather was a boy, he read movie-related comics and watched comics-based films. I expect my grandchildren will continue to do the same in the decades ahead.

NOTES

INTRODUCTION

1. Ian Gordon's *Film and Comic Books* (Jackson: University Press of Mississippi, 2007), for instance, while a valuable work, offers numerous essays on mostly contemporary case studies, such as *X-Men*, *Spider-Man*, and *Ghost World*. Even more common are non-academic books containing little industrial or aesthetic analysis (although many have their own virtues), such as David Hughes's *Comic Book Movies* (London: Virgin Books, 2008), Liam Burke's *Superhero Films* (Harpenden, UK: Oldcastle Books, Pocket Essentials, 2008), Gina Misiroglu's *The Superhero Book: The Ultimate Encyclopedia of Comic Book Icons and Hollywood Heroes* (Canton, MI: Visible Ink Press, 2012), and Roz Kaveny's *Superheroes!: Capes and Crusaders in Comics and Film* (London: I. B. Tauris, 2008).

2. An 1897 Edison film depicts a dancing Yellow Kid from *Hogan's Alley*, but the short appears to have been shot during a public event rather than having been staged for the camera as was the case with later adaptations. In 1900, another Katzenjammer Kids film appeared, *The Katzenjammer Kids Have a Love Affair.*

3. Jared Gardner, *Projections: Comics and the History of Twenty-First Century Storytelling* (Redwood City, CA: Stanford University Press, 2012), 181.

4. Charles Musser, *Before the Nickelodeon* (Berkeley: University of California Press, 1991), 267. The series also contained a short entitled *R. F. Outcault Making a Sketch of Buster and Tige* in which the strip's creator is filmed drawing his characters.

5. See Denis Gifford's *Books and Plays in Films, 1896–1915* (Jefferson, NC: McFarland, 1991) for a list of comic strips adapted to film in this era.

6. See Donald Crafton's *Before Mickey: The Animated Film, 1898–1928* (Chicago: University of Chicago Press, 1982) and Giannalberto Bendazzi's *Cartoons: One Hundred Years of Cinema Animation* (Bloomington: Indiana University Press, 1994) for more on the early history of animated films based on comics strips.

7. Gifford, *Books and Plays in Films*, 48, 56.

8. See James Chapman's *British Comics: A Cultural History* (London: Reaktion Books, 2011) for the early history of British comics, as well as the online exhibition "'Wonderfully Vulgar': British Comics, 1873–1939" (http://www.wonderfullyvulgar .de/index.html). The latter contains a fascinating section on the parallels between comics and cinema in this period.

9. Denis Gifford, *The Comic Art of Charlie Chaplin* (London: Hawk Books, 1989), 14.

10. Ibid., 115.

11. Graham King and Ron Saxby, *The Wonderful World of Film Fun, 1920–1962* (London: Clarke's New Press, 1985), 16.

12. Ibid., 10.

13. Ian Gordon, Mark Jancovich, and Matthew P. McAllister, eds., *Film and Comic Books* (Jackson: University Press of Mississippi, 2007); Liam Burke, *The Comic Book Film Adaptation: Exploring Modern Hollywood's Leading Genre* (Jackson: University Press of Mississippi, 2015).

14. Greg M. Smith, "It Ain't Easy Studying Comics," *Cinema Journal* 50, no. 3 (Spring 2011): 110–111.

15. Quoted in Anthony Slide, *The Historical Dictionary of the American Film* (Metuchen, NJ: Scarecrow Press, 2001), 92. The quote comes from the July 1927 issue of *Hi-Hat* magazine.

16. See, for instance, Will Brooker, *Batman Unmasked: Analyzing a Cultural Icon* (New York: Continuum, 2000); Sasha Torres, "The Caped Crusader of Camp: Pop, Camp, and the Batman Television Series," in *Camp: Queer Aesthetics and the Performing Subject*, ed. Fabio Cleto (Ann Arbor: University of Michigan Press, 1999); Matt Yockey, *Batman* (Detroit: Wayne State University Press, 2014).

17. Paul Young, *The Cinema Dreams Its Rivals: Media Fantasy Films from Radio to the Internet* (Minneapolis: University of Minnesota Press, 2006), xxii.

18. Michelle Hilmes, *Hollywood and Broadcasting* (Champaign: University of Illinois Press, 1990); Jane Stokes, *On Screen Rivals: Cinema and Television in the United States and Britain* (Basingstoke: Palgrave, 2000); Christopher Anderson, *Hollywood TV: The Studio System in the Fifties* (Austin: University of Texas Press, 1994).

19. Stokes, *On Screen Rivals*, 3. In turn, the comics adapting films and television programs covered here relate to several modern theoretical concepts examining how different media handle the content of other media. In *Remediation: Understanding New Media*, J. David Bolter and Richard Grusin examine the ways in which digital media repurpose existing media forms. "Media are continually commenting on, reproducing and replacing each other, and this process is integral to media. Media need each other in order to function as media at all," they argue. "The goal of remediation is to refashion or rehabilitate other media," with titles like *Film Fun*, *Movie Classics*, *Motion Picture Comics*, and *Television Comics* serving as prime examples of this refashioning process (*Remediation: Understanding New Media* [Cambridge, MA: MIT Press, 1999], 55–56). Such comics also fit the definition of a "paratext," as outlined in Jonathan Gray's *Show Sold Separately: Promos, Spoilers, and Other Media Paratexts* (New York: New York University Press, 2010), even though he does not cover the Classical Hollywood era specifically. Citing such examples as licensed comic books, video games, toy lines, and role-playing games based on popular films and shows, Gray demonstrates how paratexts can "continue to give us information, ways of looking at the film or show, and frames for understanding it or engaging with it. Their work is never over, and their effects on what the film or show is—on what it means to its audiences—are continued" (10–11). Movie- and television-related comics therefore give us new ways of engaging with their associated films and programs, with readers bringing their experiences with

a film or television narrative or actor in printed form with them when they engage with that story or star onscreen. Another useful perspective is found in Carlos Scolari, Paolo Bertetti, and Matthew Freeman's *Transmedia Archeology: Storytelling in the Borderlines of Science Fiction, Comics and Pulp Magazines* (New York: Palgrave Macmillan, 2014). They note that "while the concept of transmedia storytelling has become mostly synonymous with recent digital transformations in a contemporary setting—often associated with new formats such as the webseries, for example, where interaction is at its most pronounced—it is equally important to re-examine and synthesize more traditional media while tracing the relations between older storytelling practices and seemingly newer strategies of transmedia. This approach allows for a clearer grasp of transmedia as a trans-historical practice of media production that bridges these older and newer practices together" (7–8).

20. Rich Johnston, "Marvel Movies—More as Brands, Less as Film—Official," *Bleeding Cool*, October 4, 2010, http://www.bleedingcool.com/2010/10/04/marvel-movies-more-as-brands-and-less-as-films/.

21. See Ian Gordon, *Comic Strips and Consumer Culture, 1890–1945* (Washington, DC: Smithsonian Institution Press, 2002), for a full account of Buster Brown's film adaptations and overall merchandizing.

22. Quoted in Hubert H. Crawford, *Crawford's Encyclopedia of Comic Books* (Middle Village, NY: Jonathan David, 1978), ix.

23. Margaret Farrand Thorp, *America at the Movies* (New Haven, CT: Yale University Press, 1939), 27.

24. Quoted in David Bordwell, Janet Staiger, and Kristin Thompson, *The Classical Hollywood Cinema: Film Style and Mode of Production to 1960* (New York: Columbia University Press, 1985), xiii. The quote comes from a 1964 television interview Ford conducted with the BBC (415).

CHAPTER 1. 1930S COMICS-TO-FILM ADAPTATIONS

1. Thomas Doherty, *Pre-Code Hollywood* (New York: Columbia University Press, 1999), 34.

2. Scott Eyman, *The Speed of Sound* (New York: Simon and Schuster, 1997), 377.

3. "Par after Young Cooper, Has 4-Yr. Roach Contract," *Variety*, April 29, 1931, 11.

4. Paramount Production Records, 189.f-1—Skippy, Margaret Herrick Library (MHL).

5. Audrey Chamberlin Scrapbooks, no. 12, 16, MHL.

6. Ibid., 17.

7. Letter from Jason S. Joy to B. P. Schulberg, January 28, 1931, MPAA Files, MHL.

8. Kristin Thompson and David Bordwell, *Film History: An Introduction*, 3rd ed. (New York: McGraw-Hill, 2010), 307.

9. MPAA report from James B. M. Fisher, March 23, 1931, MHL.

10. "Review: Skippy," *Billboard*, April 11, 1931, 20.

11. Audrey Chamberlin scrapbooks, no. 12, 17, MHL.

12. Quoted in John Harington, *Film and/as Literature* (New York: Prentice-Hall, 1977), 212.

13. *Skippy* Pressbook, 1931–1932, Paramount Pictures Press Sheets, 2–4, MHL.

14. Ibid.

15. See for instance, Scott Bukatman, "Sculpture, Stasis, the Comics, and Hellboy," *Critical Inquiry* 40, no. 3 (Spring 2014): 104–117.

16. *Skippy* Pressbook, 15.

17. This marketing strategy also signals Hollywood's need to reiterate to 1930s film audiences how vital and alive sound filmmaking was on the whole. Robert Spadoni argues that "the coming of sound stirred up sensations of the strangeness and ghostliness of cinema, sensations that characterized some perceptions of the medium during its first years. The introduction of sound resensitized viewers to the artificial nature of cinema," he says, which explains why the horror genre and its strange imagery flourished in the early 1930s (*Uncanny Bodies: The Coming of Sound Film and the Origins of the Horror Genre* [Berkeley: University of California Press, 2007], 121).

18. Paramount Production Records, 193.f-1—*Sooky*, MHL.

19. Letter from Joy to Schulberg, September 24, 1931, MPAA Files; Letter from Schulberg to Joy, September 25, 1931; MPAA report, June 6, 1932, MHL.

20. Advertisement, *Film Daily*, December 14, 1931, 3–6.

21. "Believe Kid Pictures Are Washed Up; Await 'Sooky' as the Final Indicator," *Variety*, December 15, 1931, 15.

22. "Think Sooky a Week Early in Pitt—$20,000," *Variety*, December 22, 1931, 8; "Sooky Nice, a 9 Days $25,000," *Variety*, December 22, 1931, 8; "'Hyde' $11,500 and 'Peach' $24,00 K.C.," *Variety*, January 5, 1932, 5.

23. Sam Mintz, who wrote the screenplay for *Sooky*, also wrote a treatment for a film based on Harold Gray's *Little Orphan Annie* newspaper strip. Mintz's version went largely unused, with RKO's eventual script containing only a few general similarities. One scene that was thankfully omitted would have seen Annie and another orphan performing a blackface routine in order to evade detection by authorities, which Mintz intended as part of "a series of incidents in the spirit of the cartoons" whereby she and her friend (plus faithful dog Sandy) are "alone in the world, seeking to make their living" (Treatment, Little Orphan Annie, Sam Mintz, Victor Heerman Collection, MHL).

24. Letter from Ned E. Depinet, RKO Pictures, October 18, 1932, to Jason S. Joy, MPAA; MPAA Production Code Administration Records, MHL.

25. "Two Pictures," *New York Times*, December 26, 1932, 26.

26. "Brooklyn Dizzy with Fancy Biz; Par $55,000," *Variety*, January 3, 1933, 10.

27. George Schaffer, "Writer Busy on Movie for Orphan Annie," *Chicago Tribune*, May 26, 1932, 20.

28. "May Do Second 'Orphan Annie' in 3 Yrs.," *Variety*, December 4, 1934, 4.

29. MPAA Production Code Administration Records, John V. Wilson MPAA report, October 8, 1932, MHL.

30. "Par Will Film Orphan Annie," *Variety*, April 4, 1938, 2.

31. Letter from A. M. Botsford to Russell Holman, June 15, 1938, Paramount Pictures Press Sheets, MHL.

32. "Review: Little Orphan Annie," *Variety*, November 25, 1938, 3.

33. *Little Orphan Annie* Pressbook, 1938, MHL.

34. Ibid.

35. See Richard DeCordova, "Child-rearing Advice and the Moral Regulation of Children's Movie-Going," *Quarterly Review of Film and Video* 15, no. 4 (1995): 99–109, for more on the state of youth films in the 1930s.

36. *Little Orphan Annie* Pressbook.

37. *Skippy* Pressbook, 1.

38. "Advertisement," *Film Daily*, January 19, 1937, 6; "Advertisement," *Independent Exhibitors Film Bulletin*, February 23, 1937, 12.

39. Peter Bart, "Pixar under Gun as Mouse Chases Tales," *Variety*, June 28, 2010, 4.

40. Bruce Smith, *The History of Little Orphan Annie* (New York: Ballantine, 1982), 44–45.

41. "Le Roy for 'Teen,'" *Variety*, November 21, 1933, 24.

42. "'Wild West' U's 1st Serial; Comics Hit Plug Hurdles," *Variety*, January 14, 1937, 6. In 1937, Universal found that "Exploitation is proving a headache" with their serials based on certain King Features Syndicate strips (*Radio Patrol*, *Tim Tyler's Luck*, and *Flash Gordon's Trip to Mars*), "since papers in competition with those showing the comics will not go for plugs."

43. "Warners Seek to Outwit Editors," *Variety*, January 12, 1934, 2.

44. "From the Box-Office Point of View: Harold Teen," *Billboard*, March 3, 1934, 21. Modern Hollywood's need for presold audiences also extends to the record number of sequels and remakes being produced. In 2011 there were a then-record twenty-seven sequels produced. Between 2006 and 2010, 57 percent of all Hollywood films were either adaptations, remakes, or sequels—and in 2010, this was true of 60 percent of all films. Jason Dietz, "Are Original Movies Really Better Than Derivative Works?," *Metacritic*, April 21, 2011, http://www.metacritic.com/feature/movie-sequels-remakes-and-adaptations.

45. "Review: Harold Teen," *Variety*, February 15, 1934, 7.

46. One Baltimore theater felt that *Harold Teen* was "not the sort of booking this deluxer's sophisticated following favors," while Warner Bros. pulled it from the prestigious downtown Hollywood Theatre in New York after it only earned two thousand dollars in three days. "Bal'more Peppy; Hepburn Sock $18,000, 'Trouble' and Spitalny Same, Sturdy," *Variety*, April 10, 1934, 9; "Warners Yanking Out 'Harold Teen,'" *Variety*, May 26, 1934, 2.

47. "L.A. Populated by Disappointments; Wonder Bar Best of All, $30,000; Ben Bernie Band at Paramount at Par, $14,500," *Variety*, March 20, 1934, 8.

48. Michael Barrier describes how the Fleisher's contract with King Features Syndicate allowed for a "test cartoon," hence Popeye's debut was actually part of the Betty Boop series. *Hollywood Cartoons: American Animation in Its Golden Age* (Oxford: Oxford University Press, 1999), 183.

49. "Advertisement: Popeye," *Variety*, September 26, 1933, 26. See also Stefan Kanfer, *Serious Business: The Art and Commerce of Animation in America* (New York: Scribner, 1997), 96.

50. "Cartoon Figures in Musical," *Film Daily*, August 15, 1933, 4; "Literati: Novelty Deal," *Variety*, June 27, 1933, 63. King Features Syndicate was owned by the Hearst Corporation

and syndicated newspaper columns, comics strips, and other print features to thousands of newspapers around the world.

51. Ralph Wilk, "A Little from 'Lots,'" *Film Daily*, August 11, 1933, 7.

52. "Hollywood: 'Funny Page' Tuff," *Variety*, August 15, 1933, 27; "Burke in Stripper," *Variety*, September 18, 1933, 3; "Femmes Needed in 'Funny Page,'" *Variety*, September 27, 1933, 1.

53. "Par's 'Funny Page' New Film Cartoon Feature," *Variety*, August 19, 1933, 2; "Funny Faces, Mom!," *Variety*, September 26, 1933, 7.

54. Paramount Pictures 1933–1934 Pressbook, Richard Merkin Collection, MHL.

55. "Chatter: Broadway," *Variety*, October 31, 1933, 60; "Fifty Comics in Search of a Pic," *Variety*, September 30, 1933, 1.

56. "Actor Shortage," *Film Daily*, October 11, 1933, 2; Wilk, "A Little from 'Lots,'" *Film Daily*, September 11, 1933, 7.

57. Guy Barefoot, "Who Watched That Masked Man? Hollywood's Serial Audiences in the 1930s," *Historical Journal of Film, Radio, and Television* 31, no. 2 (June 2011): 179, 183.

58. Blair Davis, "Singing Sci-Fi Cowboys: Gene Autry and Genre Amalgamation in *The Phantom Empire* (1935)," *Historical Journal of Film, Radio, and Television* 33, no. 4 (2013): 552–575.

59. "Literati: Newspaper vs. Air Serials," *Variety*, April 3, 1934, 58.

60. "Tailspin Tommy Up for U's Pic," *Variety*, February 9, 1934, 6.

61. Barefoot, "Who Watched That Masked Man?," 174.

62. "'Tailspin Tommy' to Be Shown at Bud's Party," *Chicago Defender*, November 16, 1935, 17.

63. Imelda Whelehan, "Adaptations: The Contemporary Dilemmas," in *Adaptations: From Text to Screen, Screen to Text*, ed. Deborah Cartmell and Imelda Whelehan (London: Routledge, 1999), 3–4.

64. Thierry Groensteen, *The System of Comics*, trans. Bart Beaty and Nick Nguyen (Jackson: University Press of Mississippi, 2007), 26.

65. "Tailspin Tommy Has No Tommy for Start," *Variety*, July 1, 1935, 19.

66. "English's End Book," *Variety*, January 14, 1937, 6.

67. In actuality, the graphic itself is moved to the left in front of a static camera, creating the effect of camera movement.

68. This process is very similar to a modern process of reading comics digitally (such as through an iPad app), using a process such as "Guided View" in which the panels of a comic are presented one at a time instead of showing an entire page at once. See, for instance, Chris D'Lando, "Creating Comics the Comixology Way," *Bleeding Cool*, July 22, 2013, http://www.bleedingcool.com/2013/07/22/creating-comics-the-comixology-way/.

69. The 1950s saw the success of Eagle Lion's *Destination Moon* and Lippert Productions' *Rocketship X-M* launch a cycle of sci-fi films in Hollywood.

70. William H. Young and Nancy Young, *The Great Depression in America: A Cultural Encyclopedia*, vol. 1 (Westport, CT: Greenwood, 2007), 177.

71. "Chatter: Hollywood," *Variety*, January 22, 1935, 61; "U Lacks Giants, Tarzan for 'Flash' Serial," *Variety*, December 30, 1935, 30.

72. Jon Tuska, *The Vanishing Legion: A History of Mascot Pictures 1927–1935* (Jefferson, NC: McFarland, 1982), 160.

73. Roy Kinnard, "The Flash Gordon Serials," *Films in Review* 39, no. 4 (April 1988): 198.

74. Barefoot, "Who Watched That Masked Man?," 171.

75. Roy Kinnard et al., *The Flash Gordon Serials, 1936–1940* (Jefferson, NC: McFarland, 2008), 168, 174.

76. "Review: Flash Gordon's Trip to Mars," *Variety*, February 16, 1938, 17.

77. "Screen News Here and in Hollywood," *New York Times*, November 2, 1938, 27; "U Releases Mars War Picture," *Variety*, November 2, 1938, 1; 14.

78. George E. Phair, "Retakes," *Variety*, November 3, 1938, 2. Phair regularly wrote such poems for the column.

79. Alta Durant, "Gab," *Variety*, December 20, 1939, 3.

80. George E. Phair, "Retakes," *Variety*, November 24, 1939, 2.

81. Ron Goulart, "Introduction: Rogers, Ray Guns, and Science Fiction," in *Buck Rogers in the 25th Century—The Complete Newspaper Dailies*, vol. 1, *1929–1930* (Neshannok, PA: Hermes Press, 2009), 7.

82. "Inside Stuff—Radio," *Variety*, June 27, 1933, 38.

83. 18.f-151 Buck Rogers files, MGM Reader's report, MHL.

84. *The 'Pop-Up' Buck Rogers in A Dangerous Mission* (New York: Blue Ribbon Press, 1934).

85. 18.f-149 Buck Rogers Correspondences, 1935, MHL.

86. John Furthman papers, MHL.

87. "Universal to Make Four Serials on 1940 Sked," *Variety*, January 3, 1939, 8; "Last U Serial for '39 Sked Readied; 4 in Frying Pan," *Variety*, November 13, 1939, 3.

88. Kinnard et al., *The Flash Gordon Serials*, 169.

89. "Creator of 'Buck Rogers' Shows 'Em How It's Done," *Variety*, April 19, 1939, 49.

90. Goulart, "Introduction: Rogers, Ray Guns, and Science Fiction," 15.

91. "Fire Damages U Set," *Variety*, September 15, 1937, 5; "Strange Faces That 'Star' in the Movies!," *Lodi News-Sentinel*, June 18, 1937, 4.

92. Umberto Eco, *The Mysterious Flame of Queen Loana*, trans. Geoffrey Brock (Orlando, FL: Harcourt, 2005), 443.

93. Ibid., 242.

94. Tom DeHaven, "Heart of Gould: The Progress of Plainclothes Tracy," *Comic Art*, no. 9 (Fall 2007): 32.

95. Max Allan Collins, "Shoot First," in *The Complete Chester Gould's Dick Tracy*, vol. 2 (San Diego: IDW Publishing, 2007), n.p.

96. Advertisement, *Film Daily*, June 14, 1935, 3.

97. Michael H. Price, "In Which Dick Tracy Storms Hollywood," in *The Complete Chester Gould's Dick Tracy*, vol. 4 (San Diego: IDW Publishing, 2008), n.p.

98. "Purvis in G-Man Role in Levine's 'Dick Tracy,'" *Variety*, June 23, 1936, 19. Purvis would not go on to a film acting career, but he did star in the 1940s radio series *Top Secrets of the FBI*. He also owned and operated South Carolina radio station WOLS and was among the first to apply for a television station license in Augusta, Georgia,

following the end of the 1952 freeze on new applications ("WOR," *Variety*, December 17, 1947, 40; "Purvis Planning Bid for Augusta, GA., TV'er," *Variety*, April 2, 1952, 46).

99. DeHaven, "Heart of Gould," 39.

100. Frank S. Nugent, "Review: The Crime Nobody Saw," *New York Times*, April 5, 1937, http://movies.nytimes.com/movie/review?res=9D05E2D6153EE03ABC4D53DFB26 6838C629EDE.

101. "Review: Dick Tracy," *Independent Exhibitors Film Bulletin*, March 13, 1937, 8.

102. Gary Johnson, "Dick Tracy," *Images*, vol. 4, http://www.imagesjournal.com /issue04/infocus/dicktracy.htm.

103. See Guerric Debona's *Film Adaptation in the Hollywood Studio Era* (Urbana: University of Illinois Press, 2010) for discussion of how fidelity was approached in the 1930s and 1940s.

104. Charles M. Schulz, "Foreword," in *The Comic Stripped American*, by Arthur Asa Berger (New York: Walker and Company, 1973), xiii.

105. Quoted in Price, "In Which Dick Tracy Storms Hollywood," n.p.

106. Charlotte Chandler, *I Fellini* (New York: Cooper Square Press, 2001), 242.

107. "'Secret Agent X-9' for Films," *Film Daily*, October 5, 1935, 2.

108. "Reynolds, Stone Set for 'Tailspin' Series," *Variety*, November 28, 1938, 11; "Tailspin Tommy Pair Set by Malvern," *Variety*, June 24, 1939, 4; "Advertisement," *Variety*, July 17, 1939, 8; "Review: Sky Patrol," *Variety*, September 15, 1939, 3.

109. "Hollywood Inside," *Variety*, February 9, 1939, 2.

110. "Tailspin Tommy Encore," *Variety*, February 8, 1939, 7. The *Sky Pirate* title was subsequently changed to *Mystery Plane*.

111. Blondie herself was recast with Pamela Britton for the 1957 television show, but Singleton went on to do the voice of Jane Jetson in 1962 for the Hanna-Barbera cartoon series *The Jetsons*.

112. "Review: Blondie," *Variety*, October 29, 1938, 3.

113. "Hollywood Inside," *Variety*, December 28, 1939, 2.

114. "Program Reviews: Blondie," *Billboard*, July 22, 1939, 8.

115. "Hollywood Inside," *Variety*, May 29, 1939, 2.

CHAPTER 2. 1930S CINEMA AND COMICS

1. Ian Gordon, *Comic Strips and Consumer Culture, 1890–1945* (Washington, DC: Smithsonian Institution Press, 1998), 85.

2. Pierre Couperie, Maurice C. Horn, et al., *A History of the Comic Strip* (New York: Crown Publishers, 1968), 57.

3. Robert C. Harvey, *The Art of the Funnies: An Aesthetic History* (Jackson: University Press of Mississippi, 1994), 11.

4. Will Eisner, *Comics and Sequential Art* (New York: Norton, 2008), 2.

5. Arthur Asa Berger, *The Comic-Stripped American* (New York: Walker & Co., 1973), 78.

6. Michael Barrier, *The Animated Man: A Life of Walt Disney* (Berkeley: University of California Press, 2008), 57.

7. David Gerstein, "Starting the Strip," in *Walt Disney's Mickey Mouse: Race to Death Valley* (Seattle: Fantagraphics, 2011), 227. Some sources claim that Iwerks was first approached by King Features, while Disney recalled in 1956 that he was approached by the syndicate at the very same time he was preparing a test version of the strip for future sale. See also Neal Gabler, *Walt Disney: The Triumph of the American Imagination* (New York: Random House, 2006), 141.

8. Gerstein, 227–229.

9. Ibid., 253.

10. See Tom Brown, *Breaking the Fourth Wall: Direct Address in the Cinema* (Edinburgh: Edinburgh University Press, 2012), for the history of this technique in cinema. Brown describes how the dancers in 1930s Busby Berkely musicals regularly look at the camera and in turn the audience (64), but his major case studies of actors speaking to the audiences directly demonstrate how this technique increases sharply after the 1950s. The use of extensive point-of-view shots was sporadic throughout the 1930s and 1940, marked by the uniqueness of Robert Montgomery's *Lady in the Lake* (1946), which is filmed entirely from the main character's perspective.

11. Thomas Andrae, "Of Mouse & Man," in *Walt Disney's Mickey Mouse: Race to Death Valley*, 13. While Gottfredson was first told that his work on the strip would only be temporary, the job seemed to suit him. By September he was regularly writing and drawing the strip, and remained on it until 1975.

12. "Interview of Walt Disney by Cecil B. DeMille," in *Walt Disney: Conversations*, ed. Kathy Merlock Jackson (Jackson: University Press of Mississippi, 2006) 13.

13. Brian Cronin, *Was Superman a Spy? and Other Comic Book Legends Revealed* (New York: Plume, 2009), 200. The 1921 Harold Lloyd film *Never Weaken* also contains a thwarted suicide gag.

14. David R. Smith, "The Man Who Drew the Mouse: An Interview with Floyd Gottfredson," in *Walt Disney's Mickey Mouse in Color* (New York: Pantheon, 1988) 107.

15. Quoted in *Walt Disney's Mickey Mouse in Color*, 6.

16. Smith, "The Man Who Drew the Mouse," 108.

17. Barrier, *The Animated Man*, 84.

18. Gabler, *Walt Disney*, 141.

19. "Along the Rialto," *Film Daily*, December 11, 1931, 12.

20. Margaret Farrand Thorp, *America at the Movies* (New Haven, CT: Yale University Press, 1939), 22.

21. Mike Benton, *The Comic Book in America: An Illustrated History* (Dallas: Taylor Publishing, 1989), 14.

22. Leonard S. Marcus, *Golden Legacy* (New York: Golden Books, 2007), 10.

23. James A. Findlay, *Big Little Books: The Whitman Publishing Company's Golden Age, 1932–1938* (Fort Lauderdale, FL: Bienes Center for the Literary Arts, 2002), 5.

24. Susan R. Gannon describes the format, rather cynically, in an analysis of Big Little Books' adaptation of *Little Women*: "The book draws on the film for its imagery. Indeed, its cover, featuring the faces of the four sisters, looks very much like the sort of tinted lobby card films [sic] of the period used for advertising purposes, as if to underscore

how the book functions as a souvenir of the film. Certainly the text comes across as a thin and inadequate plot summary that offers a reader little more than an excuse for looking at the pictures and reliving the experience of seeing the film." Gannon, "Getting Cozy with a Classic: Visualizing *Little Women* (1868–1995)," in *Little Women and the Feminist Imagination: Criticism, Controversy, Personal Essays*, ed. Janice M. Alberghene and Beverly Lyon Clark (New York: Routledge, 1999), 127. Gannon's argument about the role that the book played for film audiences is somewhat unclear, but the idea that Big Little Books served as "souvenirs" and allowed readers to "relive" the cinematic experience ties in strongly with my analysis in this chapter of how *Movie Comics* declared its intention to serve this very purpose for filmgoers in 1939.

25. "In disdainful response to the Saalfeld challenge" of the Little Big Books series, the Big Little series was renamed "Better Little Books" in 1938 (Marcus, *Golden Legacy*, 10).

26. For more information on Whitman and their Big Little Books in the 1940s, see Francis J. Molson, "Films, Funnies, and Fighting the War: Whitman's Children's Books in the 1940s," *Journal of Popular Culture* 17, no. 4 (Spring 1985): 147–154.

27. For a brief description of the book see Robert M. Overstreet, *The Overstreet Comic Book Price Guide*, 38th ed. (New York: Random House, 2008), 392.

28. Robert C. Harvey, *The Art of the Comic Book: An Aesthetic History* (Jackson: University Press of Mississippi, 1996), 17. In 1922, George McManus (creator of the strip *Bringing Up Father*) published twelve issues of *Comic Monthly*, which was the first comic to receive monthly distribution on newsstands. While featuring such popular characters as Barney Google and Tillie the Toiler, the series was not popular enough to sustain itself. For more on the early history of comic books in the 1930s, see Benton, *The Comic Book in America*, and Paul Lopes, *Demanding Respect: The Evolution of the American Comic Book* (Philadelphia: Temple University Press, 2009).

29. "Another Cartoon Mag Try," *Variety*, June 19, 1934, 72.

30. Sean Howe, *Marvel Comics: The Untold Story* (New York: HarperCollins, 2012), 11. *Famous Funnies* also featured the lesser-known strip *Ollie of the Movies* by Julian Ollendorf, about a fictitious film heroine. Ollendorf had previously created the educationally oriented *Sketchographs* series of animated film shorts in the 1920s. Like Gottfredson's transition from animator to writer/artist of the *Mickey Mouse* strip, Ollendorf's background in film animation also led him to try his hand at comics.

31. Anthony Slide, *Inside the Hollywood Fan Magazine: A History of Star Makers, Fabricators, and Gossip Mongers* (Jackson: University Press of Mississippi, 2010), 112.

32. *Famous Funnies* #1 (July 1934): 65.

33. Harvey, *The Art of the Comic Book*, 17. *New Fun* was replaced by *More Fun Comics* after six issues, but it too struggled. The original comic strips presented therein were ones that had gone unsold to various syndicates.

34. "Review: Police Car 17," *Photoplay*, January 1934, 110.

35. See Ken Quattro, "Bernard Bailey: The Early Years," *Alter Ego*, no. 109 (May 2012): 5–6.

36. *Feature Funnies* #7 (April 1938): 17.

37. *Wow, What a Magazine!* #1 (July 1936): 38.

38. *Jumbo Comics* #7 (April 1939): 9.

39. Thorp, *America at the Movies*, 74.

40. See Michelle Hilmes, *Hollywood and Broadcasting* (Champaign: University of Illinois Press, 1999), for a compelling account of how the film and radio industries did business with one another in this era. For specific examples of the tensions between the two, see also "Shepard Prohibits Free Movie Plugs," *Broadcasting*, September 15, 1938, 20; "Complete Film-Radio Divorce Unlikely from Recent Action," *Broadcasting*, March 1, 1939, 48.

41. See for instance Norman O. Keim, *Our Movie Houses: A History of Film and Cinematic Innovation in Central New York* (Syracuse, NY: Syracuse University Press, 2008), 61.

42. Roy Thomas, "A New Phenomenon," *Golden Age Marvel Comics Omnibus*, vol. 1 (New York: Marvel Comics, 2009), 25. The more prevalent account is that *Motion Picture Funnies Weekly* came first, followed by Marvel Comics #1. Bill Everett apparently approached Martin Goodwin with his Sub-Mariner character after *Motion Picture Funnies Weekly* did not proceed beyond the first issue, and the box that once read "Continued Next Week" now appears blank in Marvel Comics #1 on the eighth of what became twelve pages (see Brian Cronin, "Comic Book Urban Legends Revealed," no. 92, March 1, 2007, http://goodcomics.comicbookresources.com/2007/03/01/comic-book-urban-legends-revealed-92/). It seems unlikely that Everett would have cut the story down for inclusion in *Motion Picture Funnies Weekly* given its prominence in that book as the lead tale. Writer Warren Reece is adamant that *Marvel Comics* #1 came first, however, based on oral accounts of the book's history by two men who recall owning the book as children before also receiving a free copy of *Motion Picture Funnies Weekly*. "The evidence that MPFW #1 was an inexpensive black-and-white *reprint compilation*, made as a sample for the purpose of solicitation to theater managers, and not to patrons, with its contents never able to be copyrighted since they were already copyrighted by the publishers for whom they had previously been produced, is overwhelming" (Warren Reece, "With the Fathers of Our Heroes," *Alter Ego*, no. 108 [April 2012]: 30–31). The back-cover ad from *Motion Picture Funnies Weekly* #1 states, of course, that its contents are "brand NEW" and "original comics from cover to cover." The truth of this claim remains a comic book legend.

43. Ronin Ro, *Tales to Astonish: Jack Kirby, Stan Lee, and the American Comic Book Revolution* (New York: Bloomsbury, 2004), 7–8. Ro does not provide any specific sources in his book (providing only a list of interviewees in his acknowledgments), making this account even harder to verify.

44. "Carr and Jackman Preparing 'The Lost Atlantis,'" *Variety*, November 4, 1938; "Busch Scripts 'Atlantis,'" *Variety*, January 4, 1939, 23; 6; Jack Jungmayer, "Film Production Trends," *Variety*, January 4, 1939, 8.

45. Ro, *Tales to Astonish*, 8.

46. Jared Gardner, *Projections: Comics and the History of Twenty-First-Century Storytelling* (Stanford, CA: Stanford University Press, 2012) 65.

47. Jean-Paul Gabilliet, *Of Comics and Men: A Cultural History of American Comic Books*, trans. Bart Beaty and Nick Nyugen (Jackson: University Press of Mississippi, 2010),

18; Gerard Jones, *Men of Tomorrow: Geeks, Gangsters, and the Birth of the Comic Book* (New York: Basic Books, 2004), 164, 223. Jones notes how when Gaines approached Donenfeld "for distribution and financing, Harry had one condition: that he take Jack Leibowitz as his partner." Leibowitz had been Donenfeld's business manager and he was instrumental in the success of what became DC Comics. See also Roy Thomas, *The All-Star Companion* (Raleigh, NC: Two Morrows, 2004), 14.

48. Tino Balio, *Grand Design: Hollywood as a Modern Business Enterprise, 1930–1939* (Berkeley: University of California Press, 1993), 13, 27–28.

49. *Movie Comics* #3 (June 1939): 1; *Movie Comics* #5 (August 1939): 1.

50. Letter from James H. Walsh to Marty Weiser, May 16, 1950, 22.f-686—Lippert miscellaneous, 1949–1959, MHL.

51. Balio, *Grand Design*, 20, 29.

52. See, for instance, John Fiske's overview of Shannon and Weaver's model of communication, in *Introduction to Communication Studies* (New York: Routledge, 2013), 6.

53. Edmund Carpenter, "The New Languages," in *Communication in History*, ed. Paul Heyer and David Crowley, 6th ed. (Toronto: Pearson, 2010), 250–251.

54. Thierry Groensteen, *The System of Comics*, trans. Bart Beaty and Nick Nguyen (Jackson: University Press of Mississippi, 2007), 62–63.

55. *Movie Comics* #3, 65.

56. See Bruce Robertson, *Ruth Harriet Louise and Hollywood Glamour Photography* (Berkeley: University of California Press, 2002); Mark A Vieira, *Hurrell's Hollywood Portraits: The Chapman Collection* (New York: Harry N. Abrams, 1997).

57. Paul Levitz, *The Golden Age of DC Comics* (Los Angeles: Taschen, 2013), 31.

58. Jim Amash, "I Didn't Want to Know [What Other Companies Were Doing]: Veteran Coloring Guru Jack Adler on Three Decades at DC," *Alter Ego*, no. 56 (February 2006): 24.

59. Levitz, *The Golden Age of DC Comics*, 85.

60. Ivan Brunetti, *Cartooning: Philosophy and Practice* (New Haven, CT: Yale University Press, 2011), 21.

61. David Kunzle, *The History of the Comic Strip: The Nineteenth Century* (Berkeley: University of California Press, 1990), 351, 365.

62. "Craven of FCC Vague as to When Practical Television Will Arrive," *Variety*, April 19, 1939, 6; "RKO Cans First Televish Film, 'Gunga Din,' from H'D," *Variety*, February 17, 1939, 1–2. See also Eric Smooden, "Motion Pictures and Television, 1930–1945: A Pre-History of the Relations between the Two Media," *Journal of the University Film and Video Association* 34, no. 3 (Summer 1982): 3–8; David Pierce, "'Senile Celluloid': Independent Exhibitors, the Major Studios, and the Fight over Feature Films on Television, 1939–1956," *Film History* 10, no. 2 (1998): 141–164.

63. See Thorp, *America at the Movies*, 170–171, on reissues in the 1930s. While equipment such as 8mm and 16mm projectors were commercially available during the 1930s and 1940s, viewing Hollywood films in the home remained a rarity until television's debut. See, for instance, Haidee Wasson, "Suitcase Cinema," *Cinema Journal* 51, no. 2 (Winter 2012): 148–152; Sheila Chalke, "Early Home Cinema: The Origins of Alternative Spectatorship," *Convergence* 13, no. 3 (August 2007): 223–230.

64. *Movie Comics* #1, 1; *Movie Comics* #1.

65. *Movie Comics* #6 (September-October 1939): 51.

66. Other films to receive Sunday strips include *Bambi* (1942), *Cinderella* (1950), and *Alice in Wonderland* (1951). *Song of the South* (1946) led to the ongoing comic strip *Uncle Remus and His Tales of Brer Rabbit*, which ran until 1972, while *Lady and the Tramp* (1955) spawned the comic strip *Scamp*, which lasted until 1988.

CHAPTER 3. 1940S COMICS-TO-FILM ADAPTATIONS

1. George Bluestone, *Novels into Films* (Baltimore: Johns Hopkins University Press, 1957), 5.

2. James Naremore, ed., *Film Adaptation* (New Brunswick, NJ: Rutgers University Press), 6.

3. Bluestone, *Novels into Films*, 3.

4. Ibid., 5.

5. Will Brooker, "Batman: One Life, Many Faces," in *Adaptations: From Text to Screen, Screen to Text*, ed. Deborah Cartmell and Imelda Whelehan (London: Routledge, 1999), 197.

6. Les Daniels, *Superman: The Complete History* (San Francisco: Chronicle, 2004), 41.

7. "Superman Cartoons, Pal Models Are New Par Shorts," *Variety*, September 10, 1940, 4.

8. "Superman Deal with Rep. Carries Right to Cancel," *Film Daily*, April 29, 1940, 11.

9. "Republic May Drop 'Superman' Serial Permanently," *Variety*, August 16, 1940, 6.

10. "First Par 'Superman Short' Ready by X-mas," *Variety*, September 4, 1940, 7; "Republic Demands $50,000 in Superman Balm Action," *Film Daily*, June 27, 1941, 2.

11. "To Film Radio Series," *Broadcasting*, September 15, 1940, 42.

12. "Fleischer Will Make Superman for Par," *Variety*, September 3, 1940, 5.

13. Quoted in Daniels, *Superman: The Complete History*, 58.

14. Michael Barrier, *Hollywood Cartoons: American Animation in Its Golden Age* (New York: Oxford University Press, 1999), 304. Barrier lists the budget at "as much as fifty thousand dollars."

15. "First Par 'Superman Short' Ready by X-mas."

16. Advertisement, *Film Daily*, June 10, 1942, 3.

17. "Offer 'Superman' Trailer as Outright Exhib. Buy," *Film Daily*, October 31, 1941, 10.

18. *Action Comics* #1 (June 1938): 1.

19. *Superman* #1 (July 1938): 1. For further analysis of Superman's cross-media presence in the 1940s, see Matthew Freeman's article "Up, Up, and Across: Superman, the Second World War, and the Historical Development of Transmedia Storytelling," *Historical Journal of Film, Radio and Television* 35, no. 2 (2015): 215–239.

20. Giannalberto Bendazzi, *Cartoons: One Hundred Years of Cinema Animation* (Bloomington: Indiana University Press, 1994), 184.

21. Noell K. Wolfgram Evans, *Animators of Film and Television: Nineteen Artists, Writers, Producers, and Others* (Jefferson, NC: McFarland, 2011), 54–55.

22. Bruce Scivaly, *Superman on Film, Radio, Television, and Broadway* (Jefferson, NC: McFarland, 2007), 25–26.

23. Bob Moak, "H'wd Eyes Serial Cycle," *Variety*, November 6, 1940, 21, 23.

24. Colton Waugh, *The Comics* (1947; rpt., Jackson: University Press of Mississippi, 1991), 344.

25. "Rep. Buys 'Captain Marvel,'" *Film Daily*, October 4, 1940, 11; "Program Notes from the Studios," *Showmen's Trade Review*, December 28, 1940, 18.

26. Jack Mathis, *Valley of the Cliffhangers* (Northbrook, IL: Jack Mathis Advertising, 1975), 171–172.

27. "'Marvel' Campaign Continues Unabated," *Showmen's Trade Review*, October 4, 1941, 26.

28. "Exhibitors to Again Benefit from Republic-Fawcett Tieup," *Showmen's Trade Review*, May 2, 1942, 22; "Exhibitor-Newsdealer Cooperation Spurring Juvenile Interest in 'Spy Smasher' Serial," *Showmen's Trade Review*, July 4, 1942, 26.

29. Chipp Kidd and Geoff Spear, *Shazam: The Golden Age of the World's Mightiest Mortal* (New York: Abrams Comicarts, 2010), n.p.

30. For National, the character was a little too "familiar" for their liking, leading to a lawsuit against Fawcett for infringing on Superman's likeness, character traits, and super powers. In turn, Republic was also sued for their part in bringing the character to film audiences. See Scivaly, *Superman on Film, Radio, Television, and Broadway*, 31, and "Superman Piracy Charged in Suit against Rep," *Variety*, September 10, 1941, 8. In light of such legal action, Republic decided not to pursue their option to produce a sequel to the *Captain Marvel* serial, which would have otherwise been produced— Republic was "willing but hesitant" to make the follow-up effort (Mathis, *Valley of the Cliffhangers*, 172).

31. See Guy Barefoot, "Who Watched That Masked Man? Hollywood's Serial Audiences in the 1930s," *Historical Journal of Film, Radio and Television* 31, no. 2 (June 2011): 167–190, for a full delineation of serial audiences in this era.

32. See Patrick Parsons, "Batman and His Audience: The Dialectic of Culture," in *The Many Lives of the Batman: Critical Approaches to a Superhero and His Media*, ed. Roberta E. Pearson and William Uricchio (New York: Routledge, 1991), 69, which quotes a 1953 study by Ruth Morris Bakwin ("Psychological Aspects of Pediatrics: The Comics," *Journal of Pediatrics* [1953]: 633).

33. Jan Alan Henderson, "Republic's Special Effects Wizards: The Lydeckers," *Cult Movies*, no. 13 (1995): 46–47.

34. "Short Subject Reviews," *Showmen's Trade Review*, March 8, 1941, 26.

35. "Short Subject Reviews," *Motion Picture Daily*, March 4, 1941, 7.

36. Advertisement, *Motion Picture Daily*, April 17, 1942, n.p.

37. Will Brooker, *Batman Unmasked: Analyzing a Cultural Icon* (New York: Continuum, 2001), 81.

38. Ibid., 36.

39. Advertisement, *World's Finest Comics* (Winter 1944): n.p.

40. Advertisement, *Film Daily*, July 12, 1943, 9.

41. Joe Desris, "A History of the 1940s Batman Newspaper Strip Part 1," in *Batman: The Dailies, 1943–1946* (New York: Sterling Publishing, 2007), 3–4.

42. Brooker, *Batman Unmasked*, 89.

43. Brian Cronin, "Comic Book Urban Legends Revealed," *Comic Book Resources*, no. 8, July 21, 2005, http://goodcomics.comicbookresources.com/2005/07/21/comic-book-urban-legends-revealed-8/.

44. Paul Levitz, *The Golden Age of DC Comics* (Los Angeles: Taschen, 2012), 165. There was also an affinity between comic book narratives and chapter-play storytelling, as Republic hired former Fawcett editor Lynn Perkins to write the script for the 1945 serial *The Purple Monster Strikes* ("Short Shorts," *Variety*, January 11, 1945, 7).

45. Bob Kane and Tom Andrae, *Batman and Me* (Forestville, CA: Eclipse Books, 1989), 127; "Short Subject Reviews: Batman," *Showmen's Trade Review*, July 31, 1943, 37.

46. Brooker, *Batman Unmasked*, 85–87.

47. *Captain America Comics* #1 (1940): 5.

48. Richard M. Hurst, *Republic Studios: Beyond Poverty Row and the Majors* (Metuchen, NJ: Scarecrow Press, 2007), 121.

49. Mathis, *Valley of the Cliffhangers*, 255.

50. Hurst, *Republic Studios*, 125.

51. Ibid., 130.

52. Manny Farber, "Comic Strips," in *Arguing Comics: Literary Masters in a Popular Medium*, ed. Jeet Heer and Kent Worcester (Jackson: University Press of Mississippi, 2004), 88–90.

53. Ibid., 93.

54. Robert C. Harvey, *Meanwhile… A Biography of Milton Caniff* (Seattle: Fantagraphics Books, 2007), 325.

55. Ibid., 330.

56. Ibid., 329.

57. Ibid.

58. "'Don Winslow' Serial Using 'In the Navy' Sets," *Variety*, August 13, 1941, 29; "Cliffhangers Would Woo Adult Film Fans with Maturer Plots," *Variety*, September 9, 1942, 7.

59. "Review: Don Winslow of the Navy," *Variety*, November 5, 1941, 24.

60. "Get More Steady Patrons by Selling Grown-Ups on Serials," *Showmen's Trade Review*, November 1, 1941, 37.

61. "Serial Gets Six Day Premiere on Navy Day," *Showmen's Trade Review*, November 1, 1941, 40; "'Don Winslow' Serial Using 'In the Navy' Sets," *Variety*, August 13, 1941, 29; Chris Costello and Raymond Strait, *Lou's On First: The Tragic Life of Hollywood's Greatest Clown Warmly Recounted by His Youngest Child* (New York: Macmillan, 1982), 62.

62. "Hollywood Inside," *Variety*, November 23, 1941, 2.

63. "Short Subject Reviews: The Phantom," *Showmen's Trade Review*, January 1, 1944, 45.

64. Pressbook: *Adventures of Red Ryder*, Janus Barfoed Collection, 11-OS.f-5496.f-4175, MHL.

65. "Producers Stress Originals to Lure Shopping Public," *Variety*, August 18, 1948, 3.

66. Rob Edelman, "Vintage '40s and '50s Film Serials Were Smashes before TV Did 'Em In," *Variety*, July 7, 1987, 29. This account has never been confirmed elsewhere, and in a personal correspondence with Jake Rossen, author of *Superman vs. Hollywood* (Chicago: Chicago Review Press, 2008), he noted how he suspects the report may have been related to the 1946 *Superman* radio spoof starring Bob Hope on *Command Performance*, November 10, 1946.

67. Edelman, "Vintage '40s and '50s Film Serials," 29.

68. Larry Tye, *Superman: The High-Flying History of America's Most Enduring Hero* (New York: Random House, 2012), 99.

69. Scivally, *Superman on Film, Radio, Television and Broadway*, 36.

70. Edelman, "Vintage '40s and '50s Film Serials," 29.

71. "Hail the Forgotten Man!," *Variety*, October 18, 1948, 2.

72. Scott Bukatman, "Why I Hate Superhero Films," *Cinema Journal* 50, no. 3 (Spring 2011): 118–120, 122.

73. Gloria Brent, "Meet 'Tillie the Toiler,'" *Hollywood* 30, no. 6 (June 1941): 54.

74. "Dick Tracy Clippings," 4.f-56, MHL.

75. "Amateur Night," *Variety*, February 15, 1945, 3.

76. "Review: Dick Tracy Meets Gruesome," *Hollywood Reporter*, September 26, 1947; MPAA Production Code Administration Records, MHL.

77. "'Dick Tracy' Swell Start; 'Strange Voyage' Novelty," *Hollywood Reporter*, December 13 1945, 3.

78. "Tracy vs. Cueball Nifty; 'Rogue' Light But Smooth," *Hollywood Reporter*, November 8, 1946; MPAA Production Code Administration Records, MHL.

79. Chester Gould, "Dick Tracy's Creator Sees Him in the Flesh!," *Chicago Tribune*, March 21, 1946, 28.

80. "Red Ryder Series Ends with 'Cripple Creek' at Rep," *Variety*, March 14, 1957, 51.

81. Advertisement, *Variety*, June 25, 1947, 28–29.

82. Seymour Chatman, *Story and Discourse: Narrative Structure in Fiction and Film* (Ithaca, NY: Cornell University Press, 1978), 30.

CHAPTER 4. 1940S CINEMA AND COMICS

1. Advertisement, *World's Finest Comics* #42 (September-October 1949): 45.

2. Advertisement, *Wonderworld Comics* 1, #12 (1940): inside front cover.

3. Jerry Siegel and Joe Shuster, "Superman: Matinee Idol," *The Superman Chronicles*, vol. 10 (New York: DC Comics, 2012), 138–150.

4. Jan Holmberg, "Ideals of Immersion in Early Cinema," *Cinémas: Journal of Film Studies* 14, no. 1 (2003): 131–132.

5. Siegel and Shuster, "Superman: Matinee Idol," 139–141, 149.

6. Hedda Hopper, "Myths Stars Believe about Themselves," *Modern Screen* 39, no. 2 (July 1949): 34, 36.

7. "Black Magic on Mars," *Superman* #62 (January-February 1950): 2–4.

8. Charles Acland, *Swift Viewing: The Popular Life of Subliminal Influence* (Durham, NC: Duke University Press, 2012), 7.

9. Ibid., 11.

10. Ibid., 7.

11. Ibid., 11.

12. Thomas Andrae, "Of Mouse and the Man: Floyd Gottfredson and the Mickey Mouse Continuities," in *Walt Disney's Mickey Mouse in Color* (New York: Pantheon Books, 1988), 9.

13. *Four Color* #13 (1941), reprinted in *Disney's Four Color Adventures*, vol. 1 (Los Angeles: Boom! Studios, 2011), 123–124.

14. Floyd Gottfredson notes how this reformatting was also common when the *Mickey Mouse* comic strip was used for comic books. Western Printing "had to change the format so that the panels would fit in the magazines. Sometimes they'd have to crop off some of the drawing, and sometimes they'd have to add something to it—with the result that there are some pretty weird-looking hands and feet and things of this kind in the comic books through the years. For a long time, King Features was sending the originals directly to Western, and then Western would cut them up and reshape them and revamp the format, to fit the comic magazine and the comic books." David R. Smith, "The Man Who Drew the Mouse: An Interview with Floyd Gottfredson," in *Walt Disney's Mickey Mouse in Color* (New York: Pantheon Books, 1988), 111.

15. See Michael Sporn Animation, Inc., http://www.michaelspornanimation.com/splog/?p=3297.

16. Michael Barrier, *Hollywood Cartoons: American Animation in Its Golden Age* (New York: Oxford University Press, 1999), 129.

17. "Donald Duck and the Seven Dwarfs," in *Walt Disney's Comics and Stories* #43 (1944), reprinted in *Walt Disney's Comics and Stories*, no. 523 (Prescott, AZ: Gladstone Publishing Ltd., October 1987), n.p.

18. "Walt Disney's The Seven Dwarfs and Dumbo," in *Disney Comics, The Classics Collection* (New York: Disney Editions, 2006), 45–56.

19. Henry Jenkins, *Convergence Culture: Where Old and New Media Collide* (New York: New York University Press, 2006), 21.

20. Ibid., 98.

21. Ibid.; Carlos Alberto Scolari, "Transmedia Storytelling: Implicit Consumers, Narrative Worlds, and Branding in Contemporary Media Production," *International Journal of Communication* 3 (2009): 587. For more industry-based perspectives on transmedia storytelling practices, see also Tom Dowd et al., *Storytelling across Worlds: Transmedia for Creatives and Producers* (Waltham, MA: Focal Press, 2013), and Andrea Phillips, *A Creator's Guide to Transmedia Storytelling* (New York: McGraw-Hill, 2012).

22. Henry Jenkins, "Transmedia 202: Further Reflections," August 1, 2011, http://henryjenkins.org/2011/08/defining_transmedia_further_re.html.

23. See *Snow White* Diamond edition DVD, Snow White Returns featurette.

24. "Thumper Meets the Seven Dwarfs," *Four Color* #19 (1943): 3–66.

25. Frank Nugent, "That Million Dollar Mouse," *New York Times Magazine*, September 21, 1947, 22, 60.

26. Jean-Paul Gabilliet, *Of Comics and Men: A Cultural History of American Comic Books*, trans. Bart Beaty and Nick Nguyen (Jackson: University Press of Mississippi, 2010), 40.

27. This compatibility extends to how Walt Disney Studios used comics in the 1970s and 1980s to help train their animators. Carson Van Osten of Disney's Comic Strip Department used comic strip imagery to teach young artists about such concepts as how to stage their characters and the best ways to convey action (Frank Thomas and Ollie Johnson, *The Illusion of Life: Disney Animation* [New York: Hyperion, 1981], 214).

28. Michael Vance, "'Something . . . ?': A Study of Comics Pioneer Richard E. Hughes," *Alter Ego* 3, no. 112 (August 2012): 50. The other films featured were *Mr. Bug Goes to Town* (1941), *Thunder Birds* (1942), *Arabian Nights* (1942), and *Bombardie* (1943). Only those editions published between 1941 and 1942 contained photos. Those from 1943 contained only line art (Robert M. Overstreet, *The Overstreet Comic Book Price Guide*, 38th ed. [New York: Random House, 2008], 298).

29. Paul Henreid Papers, Scrapbook #7, MHL.

30. See David Kunzle, *History of the Comic Strip: The Nineteenth Century* (Berkeley: University of California Press, 1990), for more on the use of text passages in this era.

31. "Graphic Little Theater," *Chicago Tribune*, January 10, 1943, G6.

32. Advertisement, *Chicago Tribune*, March 8, 1943, 16.

33. "Movie Plays in Pictures," *Chicago Tribune*, October 13, 1949, D11.

34. "Movie Plays in Pictures," *Chicago Tribune*, February 6, 1950, B1.

35. *Four Color* #57 (1944): 1.

36. See Blair Davis, "Singing Sci-Fi Cowboys: Gene Autry and Genre Amalgamation in *The Phantom Empire* (1935)," *Historical Journal of Film, Radio, and Television* 33, no. 4 (2013): 552–575.

37. See Maurice Horn, *Comics of the American West* (New York: Winchester Press, 1977), for more on western comic books of this period.

38. *John Wayne Adventure Comics* #1 (1949): 1, 4; *John Wayne Adventure Comics* #3 (1950): 3.

39. *John Wayne Adventure Comics* #1 (1949): 4.

40. Ibid., 29–32.

41. *John Wayne Adventure Comics* #14 (1952): 3, 10.

42. Ibid., 21.

43. *Movie Comics* #1 (December 1946).

44. Advertisement, *Movie Comics* (New York: Fiction House, February 1947), 1.

CHAPTER 5. 1950S COMICS-TO-FILM AND TELEVISION ADAPTATIONS

1. Peter Lev, *The Fifties: Transforming the Screen, 1950–1959* (Berkeley: University of California Press, 2003), 7. As Lev notes, this number was provided by the Theatre Owners of America, while the U.S. Census Bureau lists a possibly less accurate number of 90 million filmgoers per week in 1946.

2. See *The Superman Radio Scripts*, Vol. 1: *Superman vs. the Atom Man* (New York: Watson-Guptill Publications, 2001).

3. Rob Edelman, "Vintage 40s & 50s Film Serials Were Smashes before TV Did 'Em In," *Variety*, July 8, 1987, 46.

4. Review: "Blackhawk," *Variety*, August 13, 1952, 6.

5. "The Children's Hour," *Variety*, June 12, 1952, 3.

6. "You Can Eat Your Way into, Not out of, 'Alley' Role," *Variety*, September 7, 1959, 6.

7. "Col Discontinuing 'Blondie,'" *Variety*, June 20, 1950, 8.

8. "You Can Eat Your Way into, Not out of, 'Alley' Role."

9. Review: "Jungle Jim," *Hollywood Reporter*, December 16, 1948, MPAA Production Code Administration Records, Production no. 934, MHL.

10. Review: "Valley of the Headhunters," *Variety*, July 29, 1953, 18; Review: "Savage Mutiny," *Variety*, January 21, 1953, 18.

11. Review: "Jungle Jim," *Hollywood Reporter*, December 16, 1948, MPAA Production Code Administration Records, Production no. 934, MHL.

12. "Chatter," *Variety*, July 13, 1953, 8; Army Archerd, "Just for Variety," *Variety*, August 28, 1953, 2.

13. "$20,000,000 in 7 20th Color Pix," *Variety*, January 5, 1953, 1.

14. "Metro Skeds 'Julius Caesar,' 'Prince Valiant,' in Continuing Cycle of Spectacle Pix," *Variety*, April 28, 1952, 3. The film was originally optioned by MGM, but the rights were picked up by Fox in the fall of 1952. MGM was already producing *Ivanhoe* (1953) and *Julius Caesar* (1953) and probably wanted to avoid having too many historical epics on its release slate.

15. Charles G. Clarke, "Cinemascope Filming in Britain," Charles G. Clarke Collection, MHL.

16. "Review: Prince Valiant," *Hollywood Reporter*, April 2, 1954, MHL.

17. Colton Waugh, *The Comics* (1947; rpt., Jackson: University Press of Mississippi, 1991), 244–245.

18. William Gordon Collection, Folder 232, MHL.

19. Ibid.

20. "Review: The Sad Sack," *Motion Picture Daily*, October 21, 1957, 3.

21. "Review: The Sad Sack," *Variety*, October 23, 1957, 6.

22. Waugh, *The Comics*, 312–314.

23. "Lewis a Frantic 'Sad Sack,'" *New York Mirror*, November 28, 1957, Hal Wallis Papers, 106.f-1104, MHL.

24. "The Sad Sack—Production Reports," MHL; letter from Y. F. Freeman to James H. Richardson, July 2, 1954, MHL. Republic's budgets remained comparable in this decade to those of its B-films from the 1940s, while American International Pictures' B-films typically cost around $125,000 each.

25. Letter from John Mock to Russell Holman, January 29, 1954, MHL.

26. Hal Wallis Papers, File no. 106.f-1104, MHL.

27. Letter from Paul Nathan to Hal Wallis, October 19, 1956, Hal Wallis Papers, File no. 106.f-1104, MHL.

28. "Top Grossers of 1957," *Variety*, January 8, 1958, 30.

29. Letter from Paul Nathan to Hall Wallis and Joseph Hazen, July 16, 1956, Hal Wallis Papers, File no. 106.f-1104, MHL. Nathan describes how the contract states that "Baker is also to be paid an additional $25,000 when the picture grosses 2½ times the negative cost. Baker is to be paid an additional $30,000 when the picture grosses 3 times the negative cost." Nathan suggested to Wallis and Hazen that they try to negotiate with Baker "for a flat deal" rather than a percentage-based one.

30. Letter from Hal Wallis to George Marshall, April 30, 1957, Hal Wallis Papers, File no. 106.f-1104, MHL.

31. Letter from Paul Nathan to Hal Wallis, May 6, 1957. Hal Wallis Papers, File no. 106.f-1104, MHL.

32. "Tom Ewell Tagged to Do 'Sad Sack,'" *Variety*, July 15, 1957, 15.

33. Arthur Asa Berger, *Li'l Abner: A Study in American Satire* (New York: Twayne Publishers, 1970), 51–52.

34. Al Capp, *Li'l Abner, Vol 1: Dailies 1934–1935* (Princeton, WI: Kitchen Sink Press, 1988), 13.

35. "Inside Television," *Variety*, August 24, 1949, 41.

36. Roy Kinnard, *The Comics Come Alive: A Guide to Comic-Strip Characters in Live-Action Productions* (Metuchen, NJ: Scarecrow Press, 1991), 126.

37. Press release, June 25, 1959, Paramount Pictures Production Records, Li'l Abner Press Releases, 1959–1960, File no. 127.f-8, MHL.

38. Sam Zolotow, "Musical Based on 'Li'l Abner,'" *New York Times*, May 17, 1955, 32; A. H. Weiler, "By Way of Report," *New York Times*, October 2, 1955, X7.

39. The film's final budget was $1,376,000. Paramount Pictures Production Records, MHL. The budget also assumed that Panama and Frank would make available "a portion of the wardrobe used in the show."

40. "'Abner' Good 11G Philly; 'Pillow' 9G," *Variety*, December 23, 1959, 8; "'Abner' Sturdy $10,000, Mpls. Ace," *Variety*, December 23, 1959, 8; "'Abner' Robust 12G, Denver; 'Hound' 7 ½ G," *Variety*, December 23, 1959, 8.

41. "Producers Too Star-Dazzled: Exhibs Teaching Trade Lesson," *Variety*, December 9, 1959, 3.

42. Ibid.

43. "Comic Strips in Stampede to Tele Fold," *Billboard*, November 22, 1947, 3, 15, 17.

44. Ibid.

45. Stuart Fischer, *Kids TV: The First Twenty-Five Years* (New York: Open Road Media, 2014), n.p; "Outlook at Networks," *Broadcasting*, August 28, 1950, 68; Jerry Beck, *Animation Art* (London: Flame Tree, 2004), 162.

46. "Animated Version on TV Is Made of 'The Spirit,'" *Broadcasting*, November 8, 1948, 71.

47. Audio recordings from *The Adventures of the Spirit* are available in the Will Eisner collection at the Billy Ireland Library at Ohio State University.

48. "WNBT's Rights to Classics for 'Seeing' TV Show," *Variety*, November 14, 1951, 30. The series began that night with an adaptation of Robert Louis Stevenson's *Treasure Island*.

49. Gene Plotnik, "See Ya in TV, Say the Funny Papers," *Billboard*, May 22, 1954, 1.

50. "Inside Television," *Variety*, September 27, 1950, 40.

51. "Ralph Byrd Essays Dick Tracy on TV," *Variety*, November 15, 1949, 5.

52. "Tracy Leads Non-Westerns, Charts Reveal," *Billboard*, September 20, 1952, 12.

53. "Year More for 'Tracy,' Then to Retirement," *Billboard*, July 3, 1954, 8.

54. "Review: Dick Tracy," *Variety*, October 25, 1950, 29.

55. "Snader Junks $50,000 Worth of Telepix," *Variety*, September 10, 1951, 10.

56. See Blair Davis, "Made-from-TV Movies: Turning 1950s Television into Films," *Historical Journal of Film, Radio, and Television* 29, no. 2 (June 2009): 197–218.

57. "Ralph Byrd Essays Dick Tracy on TV," *Variety*, November 15, 1949, 5; "Capp's 'Fearless Fosdick' Set for Video Series," *Variety*, March 29, 1950, 49.

58. Advertisement, *Business Screen Magazine* 11, no. 7 (1950): 17.

59. Tom Gunning, "Animating the Instant: The Secret Symmetry between Animation and Photography," in *Animating Film Theory*, ed. Karen Beckman (Durham, NC: Duke University Press, 2014), 37.

60. Scott Bukatman, "Some Observations Pertaining to Cartoon Physics; or, The Cartoon Cat in the Machine," in *Animating Film Theory*, 302–303.

61. Gerald Duchovnay, "From Big Screen to Small Box: Adapting Science Fiction Film for Television," in *The Essential Science Fiction Television Reader*, ed. J. P. Telotte (Lexington: University Press of Kentucky, 2008), 67.

62. "Fairbanks Sets Tests for 'Pirates,'" *Variety*, June 28, 1946, 14.

63. Robert C. Harvey, *Meanwhile . . . A Biography of Milton Caniff* (Seattle: Fantagraphics Books, 2007), 499.

64. "Canada Dry Inks $3,000,000 Deal to Bankroll 'Terry and the Pirates' Series," *Variety*, August 27, 1952, 25; "Canada Dry Buys 'Terry'; To Drop 'Super Circus,'" *Billboard*, August 30, 1952, 13.

65. "Telepix Reviews: Terry and the Pirates," *Variety*, December 3, 1952, 20.

66. "'Terry' Syndication in Non-Canada Dry Areas," *Variety*, February 18, 1953, 24; "Advertisement," *Billboard*, November 7, 1953, 12; Dave Kaufman, "On All Channels," *Variety*, December 14, 1954, 8.

67. "Closed Circuit," *Broadcasting-Telecasting*, October 17, 1955, 5.

68. "Comic Strip Pix by TeleScreen," *Billboard*, February 2, 1952, 7.

69. "Review: Blondie," *Variety*, January 16, 1957, 31.

70. "Night Club Reviews: Conrad Hilton, Chi," *Variety*, October 3, 1956, 76.

71. Jerry Robinson, *Skippy and Percy Crosby* (Austin: Holt, Rinehart and Winston, 1978) 103; 135. Crosby was transferred to a New York facility after being checked into Bellevue. He was diagnosed with paranoid schizophrenia, although many say unrightfully so. See http://www.skippy.com for an account of Crosby's life from the perspective of his estate.

72. "'Steve Canyon' Will Bear to Public U.S. Air Force's Scientific Hoopla," *Variety*, July 30, 1958, 26.

73. Ibid.

74. "'Steve Canyon' to Get New Format," *Variety*, May 25, 1960, 28.

75. "Flamingo Gets 31 Year Excl. to 'Superman,'" *Billboard*, May 19, 1951, 6. The rights were later reacquired by National.

76. Bruce Scivaly, *Superman on Film, Radio, Television, and Broadway* (Jefferson, NC: McFarland, 2007), 49; Gary Grossman, *Superman: Serial to Cereal* (New York: Popular Library, 1977), 113.

77. "Review: Superman and the Mole Men," *Variety*, December 12, 1951, 6.

78. MPAA Production Code Administration Records, Production Files: Superman and The Mole Men, MHL.

79. "TV-Film Reviews: Superman," *Billboard*, November 1, 1952, 14.

80. Plotnik, "See Ya in TV, Say the Funny Papers," 1.

81. "Superman Telepix 6 Yr. Tab: $3,000,000," *Variety*, October 21, 1956, 31; "A&A Tops Berle, 'Superman' Passes Godfrey in L.A. as Syndicated Vidpix OutPull Web Show in Major Keys," *Variety*, January 13, 1954, 25.

82. Plotnik, "See Ya in TV, Say the Funny Papers," 8.

83. "Entry of Major Studios into TV Doesn't Faze 'Superman' Producer," *Variety*, October 12, 1955, 44; Jake Rossen, *Superman vs. Hollywood* (Chicago: Chicago Review Press, 2008), 34.

84. See chapter 5 of Blair Davis, *The Battle for the Bs: 1950s Hollywood and the Rebirth of Low-Budget Cinema* (New Brunswick, NJ: Rutgers University Press, 2012).

85. "Set 'Superman Show' for Fair, O'Seas Dates," *Variety*, August 21, 1957, 51; Larry Tye, *Superman: The High-Flying History of America's Most Enduing Hero* (New York: Random House, 2012), 152.

86. "Ellsworth Readies Eighth Year of 'Superman,'" *Variety*, May 13, 1959, 12.

87. See Tye, *Superman: The High-Flying History of America's Most Enduing Hero*, 151–157, for a thorough account of Reeves's death.

88. "'Superman' Latino Sales," *Variety*, January 21, 1959, 32.

89. Plotnik, "See Ya in TV, Say the Funny Papers," 8.

90. "Series Returns Superman Products to Field," *Billboard*, April 10, 1954, 7.

91. Grossman, *Superman, Serial to Cereal*, 102–103.

92. Scivaly, *Superman on Film, Television, and Radio*, 62–63.

93. "'Superboy' Series on Ellsworth's Sked; Looking for Lead," *Variety*, February 2, 1960, 14; "'Superman' Sequel," *Variety*, February 10, 1960, 31.

94. Scivaly, *Superman on Film, Television, and Radio*, 64.

95. Gerard Jones, *Men of Tomorrow: Geeks, Gangsters, and the Birth of the Comic Book* (New York: Basic Books, 2004), 243–251.

96. Ibid., 251.

97. Rich Johnston, "Joe Shuster, Penniliess in 1952," *Bleeding Cool*, March 22, 2013, http://www.bleedingcool.com/2013/03/22/joe-shuster-penniless-in-1952/. This article contains a copy of a letter sent from Shuster's lawyer to Jerome Capp stating that Shuster was "presently unemployed" and that "he has no assets." See also Craig Yoe, *Secret Identity: The Fetish Art of Joe Shuster* (New York: Harry N. Abrams, 2009). Most of the artwork features imagery of bondage and discipline, spanking, whips, lingerie, and female nudity.

CHAPTER 6. 1950S CINEMA, TELEVISION, AND COMICS

1. Susan B. Neuman, *Literacy in the Television Age: The Myth of the TV Effect* (Norwood, NJ: Ablex Publishing, 1995), 30.

2. Jean-Paul Gabilliet, *Of Comics and Men: A Cultural History of American Comic Books*, trans. Bart Beaty and Nick Nyugen (Jackson: University Press of Mississippi, 2010), 201.

3. Gilbert Seldes, *The Great Audience* (New York: Viking Press, 1950), 214.

4. U.S. Senate, Select Committee on Small Business, *Motion Picture Distribution Trade Practices—1956: Problems of Independent Motion-Picture Exhibitors* (Washington, DC: Government Printing Office, July 27, 1956), 24.

5. *Camera Comics* #1 (October 1944): 1, 22.

6. Ibid., 29.

7. *Picture News* #6 (June 1946): 1.

8. *Television Comics* #8 (November 1950).

9. *Space Adventures Presents Rocky Jones* #15 (March 1955): 1–5.

10. *Uncle Milty* #1 (December 1950): 1–13.

11. "On the Air Waves," *Variety*, December 19, 1951, 8. Although the comic book never emerged from Whitman (Rocky Jones was featured in several issues of Charlton's *Space Adventures* in 1955), there were several Rocky Jones coloring books from Whitman.

12. "Literati: Comics Cultural Impact," *Variety*, April 18, 1956, 89.

13. *Tee and Vee Crosley in Television Land Comics* (Cincinnati: Crosley Division, Avco Manufacturing Corporation), 1951, 3.

14. Ibid., 4.

15. Ibid., 5–6.

16. Ibid., 8.

17. Ibid., 10, 14.

18. Lynn Spigel, *Make Room for TV* (Chicago: University of Chicago Press, 1992), 99. Joanne Martin's book *Television: Window to the World* (New York: Rosen Publishing Group, 2003) is another example of how this concept is used in conceptualizing the medium.

19. *TV Teens* #5 (1954): 3–4.

20. Ibid., 22–26.

21. *Tee and Vee*, 19, 21.

22. Ibid., 28; 31. The shameless promotion of Crosley's wide range of products continues as Tee and Vee meet Mother Goose, who shrinks them down small enough to enter Mother Goose Land by waving her magic wand and uttering the phrase "Ippity Osley! The best is a Crosley." They soon meet several familiar nursery rhyme characters, each of which are excited about the many fine products available from Crosley. "Why is Jack jumping over the candlestick?" asks Tee. "Oh, his mother just got a new Crosley water heater today and Jack's afraid he's going to get into hot water," replies Mother Goose. After being startled by a loud "Honk," Mother Goose reassures the children that it's only "Little Boy Blue letting people know that he's awake to the many

advantages of Crosley appliances" by blowing his horn. "Mother Goose, does everyone in Mother Goose Land have appliances like Little Boy Blue?" asks Tee. Mother Goose tells him that, sadly, "Some are still putting up with old fashioned inconvenience," upon which they are knocked over by a tumbling Jack, Jill, and their pail of water after having been sent out by their mother. "Well—tell your mother to get a Crosley kitchen with a Crosley electric water heater in it, and you kids won't be falling down the hill all the time." Finally, they meet the old woman who lives in a shoe, who cooks a fine array of food for her many children in "one of those new Crosley ranges with the divided cook top" (32–35). Clearly, the comic book seeks to use its youthful readers to sell their parents on the merits of Crosley brand appliances and electronics, just as Jack and Jill are urged to ask their own parents to buy an electric water heater in order to prevent their constant hill-related injuries.

23. Ibid., 43.

24. "Pix, Comics Don't Hurt Kids, Sez Prof; Need Diet of Films, Radio," *Variety*, February 26, 1947, 1, 62.

25. Bradford M. Wright, *Comic Book Nation: The Transformation of Youth Culture in America* (Baltimore: Johns Hopkins University Press, 2001), 92–93.

26. Ibid., 94–95.

27. Fredric Wertham, "The Comics . . . Very Funny!," *Saturday Review of Literature*, May 29, 1948, 6.

28. Fredric Wertham, *Seduction of the Innocent* (New York: Rinehart & Co., 1954), 355.

29. Marshall McLuhan, *Understanding Media* (1964; rpt., London: Routledge, 1965), 22–25.

30. Wertham, *Seduction of the Innocent*, 356.

31. Ibid., 359.

32. "Literati: Court Deplores Comic Book Rise," *Variety*, May 7, 1952, 61.

33. "Literati: Comic Book Legislation," *Variety*, March 5, 1952, 76.

34. Amy Kiste Nyberg, *Seal of Approval: The History of the Comics Code* (Jackson: University Press of Mississippi, 1998), 51. Marvel Comics abandoned the comics code in 2001; DC Comics dropped out in 2011 followed quickly by the only remaining hold-out, Archie Comics.

35. "Hollywood Inside," *Variety*, September 30, 1954, 4.

36. Nyberg, *Seal of Approval*, 109–110.

37. "Literati: Comic Books' 'Czar,'" *Variety*, August 25, 1954, 61.

38. Nyberg, *Seal of Approval*, 112.

39. "B'casters Better Do Something about Ill-Conceived Shows: Lee," *Variety*, November 17, 1954, 30.

40. Nyberg, *Seal of Approval*, 112.

41. Gerard Jones, *Men of Tomorrow: Geeks, Gangsters, and the Birth of the Comic Book* (New York: Basic Books, 2004), 262.

42. *Motion Picture Comics*, vol. 19, #110 (May 1952): 14, 18–19.

43. *Movie Love* #14 (April 1952): 1–2.

44. Gabilliet, *Of Comics and Me*, 49.

45. Michael Barrier, *Funnybooks: The Improbable Glories of the Best American Comic Books* (Berkeley: University of California Press, 2015), 9, 313.

46. Ibid., 313.

47. "Comic Books Bait B.O. for Tots," *Variety*, August 18, 1954, 3.

48. "A Film 'Still' Big Sell on Paperbacks," *Variety*, March 5, 1958, 7.

49. Barrier, *Funnybooks*, 300.

50. Letter from Chase Craig to Marty Weiser, October 12, 1959, Marty Weiss Papers, MHL.

51. Jim Amash, "I Absolutely Love What I'm Doing! Interview with Artist Tony Tallarico," *Alter Ego*, no. 109 (May 2012): 43.

52. Ibid., 40.

53. *Four Color* #709 (1956): inside front cover.

54. *Four Color* #1139 (1956): inside front cover.

55. Barrier, *Funnybooks*, 298–300.

56. Ibid., 298.

57. Amash, "I Absolutely Love What I'm Doing!," 43.

58. Advertisement, *Variety*, December 11, 1953, 9.

59. June Bundy, "Comic Book Rap Ain't Funny," *Billboard*, July 8, 1950, 1.

60. Ibid., 8. The news that Ozzie and Harriet's comic book "fizzled" is surprising, given this from *Variety*: "Sales reports on 'The Adventures of Ozzie and Harriet' comic book, put out by National Comics last August, reveal the radio pair's book is now third on the nation's list of best sellers in the cartoon category. Featuring Ozzie, Harriet, their sons David and Ricky, and the family dog, Nick, the book is holding top place in retail sales in New York City, Newark, N.J., Philadelphia, Chicago, Seattle and San Francisco." "Hollywood Inside," *Variety*, November 8, 1949, 2. The series ran for five issues.

61. *Buster Crabbe* #1 (November 1951): inside front cover.

62. Ibid., 8.

63. Advertisement, *World's Finest Comics*, vol. 1, #47 (August 1950): 73.

64. Advertisement, *World's Finest Comics*, vol. 1, #65 (July 1953): 51.

65. Advertisement, *World's Finest Comics*, vol. 1, #92 (February 1958): 6.

66. *Famous Stars* #1 (November-December 1950): 1.

67. Ibid., 18.

68. *Famous Stars* #4 (May-June 1952): 9.

69. *Famous Stars* #6 (Spring 1952): 1.

70. "Love, But Starve, Cartoons," *Variety*, October 31, 1956, 15.

71. Sheilah Graham, "Just for Variety," *Variety*, September 25, 1952, 2.

72. Advertisement, *World's Finest Comics*, vol. 1, #52 (June 1951): 23.

73. Graham, "Just for Variety," 2. Even a cowboy host who introduced films on television had his own book in 1950, *Sherriff Bob Dixon's Chuck Wagon*.

74. "Tom Mix, dead ten years, has emerged as one of the top sellers in the comic book league," *Variety* noted. Mike Connolly, "Just for Variety," *Variety*, December 22, 1950, 4.

75. Barrier, *Funnybooks*, 81.

76. Mike Benton, *The Comic Book in America: An Illustrated History* (Dallas: Taylor Publishing, 1989), 46.

77. *Lovers' Lane*, vol. 1, #2 (December 1949): 11.

78. *Lovers' Lane*, vol. 1, #7 (February 1950): 24. This issue also offers a contest called "Who's Your Prince Charming?" in which readers must choose from six male movie stars (John Wayne, Victor Mature, John Lund, Alan Ladd, Macdonald Carey, and Robert Ryan) and say why in fifty words or fewer (11).

79. *Hollywood Film Stories* #1 (April 1950): 36.

80. *New Romances* #6 (July 1951): 23.

81. Christopher Ames, *Movies about the Movies: Hollywood Reflected* (Lexington: University Press of Kentucky, 1997), 1–2.

82. *Hollywood Diary* #1 (December 1949): 1.

83. *Hollywood Diary* #2 (February 1950): front cover.

84. *Hollywood Secrets* #1 (November 1949): 1.

85. Dr. Anthony King, *Hollywood Love Doctor* #1 (1952): 1.

86. *True Life Secrets*, vol. 1, #1 (March-April 1951): 1.

87. *Hollywood Confessions*, vol. 1, #1 (October 1949): 2.

88. Ibid., 5–6.

89. Ibid., 8, 11.

90. *Starlet O'Hara* #2 (March 1949): 1.

91. Gabilliet, *Of Comics and Men*, 49.

92. Barrier, *Funnybooks*, 51.

CONCLUSION: THE 1960S AND BEYOND

1. Agreement By and Between Panther Productions, Inc. and Flamingo Films, Inc., April 1957, Kit Parker Collection, f.364, MHL.

2. "Ted Lloyd on Prowl for Teenage 'Archie,'" *Variety*, March 25, 1959, 34.

3. Vincent Terrace, *Encyclopedia of Television Pilots, 1937–2012* (Jefferson, NC: McFarland, 2013), 211; Terrace, *Encyclopedia of Television Shows, 1925–2010*, 2nd ed. (Jefferson, NC: McFarland, 2008), 54.

4. "TV—Camp or Class?," *Backstage*, July 8, 1966, 1.

5. All are actual "words" (though made up) used during the show. See http://www.66batmania.com/trivia/batfight_words.php.

6. Matt Yockey, *Batman* (Detroit: Wayne State University Press, 2014), 4–5.

7. Jean-Paul Gabilliet, *Of Comics and Men: A Cultural History of American Comic Books*, trans. Bart Beaty and Nick Nyugen (Jackson: University Press of Mississippi, 2010), 46.

8. "Krantz Digging in Comics Field," *Variety*, March 9, 1966, 35.

9. "'Super-Heroes' on the Way," *Broadcasting*, August 29, 1966, 68. For analysis of how *Marvel Super Heroes* compares with the modern phenomenon of motion comics, see Drew Morton, "The Unfortunates: Towards a History and Definition of the Motion Comic," *Journal of Graphic Novels and Comics* 6, no. 4 (2015): 347–366.

SELECT BIBLIOGRAPHY

Acland, Charles. *Swift Viewing: The Popular Life of Subliminal Influence.* Durham, NC: Duke University Press, 2012.

Amash, Jim. "I Absolutely Love What I'm Doing! Interview with Artist Tony Tallarico." *Alter Ego,* no. 109 (May 2012): 37–48.

———. "I Didn't Want to Know [What Other Companies Were Doing]: Veteran Coloring Guru Jack Adler on Three Decades at DC." *Alter Ego,* no. 56 (February 2006): 30–36.

Ames, Christopher. *Movies about the Movies: Hollywood Reflected.* Lexington: University Press of Kentucky, 1997.

Balio, Tino. *Grand Design: Hollywood as a Modern Business Enterprise, 1930–1939.* Berkeley: University of California Press, 1993.

Barefoot, Guy. "Who Watched That Masked Man? Hollywood's Serial Audiences in the 1930s." *Historical Journal of Film, Radio, and Television* 31, no. 2 (2011): 167–190.

Barrier, Michael. *The Animated Man: A Life of Walt Disney.* Berkeley: University of California Press, 2008.

———. *Funnybooks: The Improbable Glories of the Best American Comic Books.* Berkeley: University of California Press, 2015.

———. *Hollywood Cartoons: American Animation in Its Golden Age.* Oxford: Oxford University Press, 1999.

Bendazzi, Giannalberto. *Cartoons: One Hundred Years of Cinema Animation.* Bloomington: Indiana University Press, 1994.

Benton, Mike. *The Comic Book in America: An Illustrated History.* Dallas: Taylor Publishing, 1989.

Berger, Arthur Asa. *The Comic Stripped American.* New York: Walker and Company, 1973.

Bluestone, George. *Novels into Films.* Berkeley: University of California Press, 1957.

Bolter, J. David, and Richard Grusin. *Remediation: Understanding New Media.* Cambridge, MA: MIT Press, 1999.

Brooker, Will. "Batman: One Life, Many Faces." In *Adaptations: From Text to Screen, Screen to Text,* edited by Deborah Cartmell and Imelda Whelehan, 185–198. London: Routledge, 1999.

———. *Batman Unmasked: Analyzing a Cultural Icon.* New York: Continuum, 2000.

Brown, Tom. *Breaking the Fourth Wall: Direct Address in the Cinema.* Edinburgh: Edinburgh University Press, 2012.

Brunetti, Ivan. *Cartooning: Philosophy and Practice.* New Haven, CT: Yale University Press, 2011.

Bukatman, Scott. "Sculpture, Stasis, the Comics, and Hellboy." *Critical Inquiry* 40, no. 3 (Spring 2014): 104–117.

———. "Some Observations Pertaining to Cartoon Physics; or, The Cartoon Cat in the Machine." In *Animating Film Theory*, edited by Karen Beckman, 301–316. Durham, NC: Duke University Press, 2014.

———. "Why I Hate Superhero Films." *Cinema Journal* 50, no. 3 (Spring 2011): 118–122.

Burke, Liam. *The Comic Book Film Adaptation: Exploring Modern Hollywood's Leading Genre*. Jackson: University Press of Mississippi, 2015.

Carpenter, Edmund. "The New Languages." In *Communication in History*, edited by Paul Heyer and David Crowley, 6th ed., 250–252. Toronto: Pearson, 2010.

Chalke, Sheila. "Early Home Cinema: The Origins of Alternative Spectatorship." *Convergence* 13, no. 3 (August 2007): 223–230.

Chapman, James. *British Comics: A Cultural History*. London: Reaktion Books, 2011.

Chatman, Seymour. *Story and Discourse: Narrative Structure in Fiction and Film*. Ithaca, NY: Cornell University Press, 1978.

Couperie, Pierre, and Maurice C. Horn. *A History of the Comic Strip*. New York: Crown Publishers, 1968.

Crafton, Donald. *Before Mickey: The Animated Film, 1898–1928*. Chicago: University of Chicago Press, 1982.

Crawford, Hubert H. *Crawford's Encyclopedia of Comic Books*. Middle Village, NY: Jonathan David, 1978.

Cronin, Brian. *Was Superman a Spy? and Other Comic Book Legends Revealed*. New York: Plume, 2009.

Daniels, Les. *Superman: The Complete History*. San Francisco: Chronicle, 2004.

Davis, Blair. *The Battle for the Bs: 1950s Hollywood and the Rebirth of Low-Budget Cinema*. New Brunswick, NJ: Rutgers University Press, 2012.

———. "Made-from-TV Movies: Turning 1950s Television into Films." *Historical Journal of Film, Radio, and Television* 29, no. 2 (2009): 197–218.

———. "Singing Sci-Fi Cowboys: Gene Autry and Genre Amalgamation in *The Phantom Empire* (1935)." *Historical Journal of Film, Radio, and Television* 33, no. 4 (2013): 552–575.

Debona, Guerric. *Film Adaptation in the Hollywood Studio Era*. Urbana: University of Illinois Press, 2010.

DeCordova, Richard. "Child-Rearing Advice and the Moral Regulation of Children's Movie-Going." *Quarterly Review of Film and Video* 15, no. 4 (1995): 99–109.

Doherty, Thomas. *Pre-Code Hollywood*. New York: Columbia University Press, 1999.

Duchovnay, Gerald. "From Big Screen to Small Box: Adapting Science Fiction Film for Television." In *The Essential Science Fiction Television Reader*, edited by J. P. Telotte. Lexington: University Press of Kentucky, 2008.

Eisner, Will. *Comics and Sequential Art*. 1985. Reprint, New York: Norton, 2008.

Evans, Noell K. Wolfgram. *Animators of Film and Television: Nineteen Artists, Writers, Producers, and Others*. Jefferson, NC: McFarland, 2011.

Eyman, Scott. *The Speed of Sound*. New York: Simon and Schuster, 1997.

Farber, Manny. "Comic Strips." In *Arguing Comics: Literary Masters in a Popular Medium*, edited by Jeet Heer and Kent Worcester. Jackson: University Press of Mississippi, 2004.

Findlay, James A. *Big Little Books: The Whitman Publishing Company's Golden Age, 1932–1938.* Fort Lauderdale, FL: Bienes Center for the Literary Arts, 2002.

Freeman, Matthew. "Up, Up, and Across: Superman, the Second World War, and the Historical Development of Transmedia Storytelling." *Historical Journal of Film, Radio, and Television* 35, no. 2 (2015): 215–239.

Gabilliet, Jean-Paul. *Of Comics and Men: A Cultural History of American Comic Books.* Translated by Bart Beaty and Nick Nyugen. Jackson: University Press of Mississippi, 2010.

Gabler, Neal. *Walt Disney: The Triumph of the American Imagination.* New York: Random House, 2006.

Gardner, Jared. *Projections: Comics and the History of Twenty-First-Century Storytelling.* Redwood City, CA: Stanford University Press, 2012.

Gifford, Denis. *Books and Plays in Films, 1896–1915.* Jefferson, NC: McFarland, 1991.

———. *The Comic Art of Charlie Chaplin.* London: Hawk Books, 1989.

Gordon, Ian. *Comic Strips and Consumer Culture, 1890–1945.* Washington, DC: Smithsonian Institution Press, 2002.

Gordon, Ian, Mark Jancovich, and Matthew P. McAllister, eds. *Film and Comic Books.* Jackson: University Press of Mississippi, 2007.

Gray, Jonathan. *Show Sold Separately: Promos, Spoilers, and Other Media Paratexts.* New York: New York University Press, 2010.

Groensteen, Thierry. *The System of Comics.* Translated by Bart Beaty and Nick Nguyen. Jackson: University Press of Mississippi, 2007.

Grossman, Gary. *Superman: Serial to Cereal.* New York: Popular Library, 1977.

Gunning, Tom. "Animating the Instant: The Secret Symmetry between Animation and Photography." In *Animating Film Theory,* edited by Karen Beckman, 37–53. Durham, NC: Duke University Press.

Harington, John. *Film and/as Literature.* New York: Prentice-Hall, 1977.

Harvey, Robert C. *The Art of the Comic Book: An Aesthetic History.* Jackson: University Press of Mississippi, 1996.

———. *The Art of the Funnies: An Aesthetic History.* Jackson: University Press of Mississippi, 1994.

———. *Meanwhile . . . A Biography of Milton Caniff.* Seattle: Fantagraphics Books, 2007.

Hilmes, Michelle. *Hollywood and Broadcasting.* Champaign: University of Illinois Press, 1999.

Holmberg, Jan. "Ideals of Immersion in Early Cinema." *Cinémas: Journal of Film Studies* 14, no. 1 (2003): 129–147.

Horn, Maurice. *Comics of the American West.* New York: Winchester Press, 1977.

Howe, Sean. *Marvel Comics: The Untold Story.* New York: HarperCollins, 2012.

Hurst, Richard M. *Republic Studios: Beyond Poverty Row and the Majors.* Metuchen, NJ: Scarecrow Press, 2007.

Jackson, Kathy Merlock, ed. *Walt Disney: Conversations.* Jackson: University Press of Mississippi, 2006.

Jenkins, Henry. *Convergence Culture: Where Old and New Media Collide.* New York: New York University Press, 2006.

Jones, Gerard. *Men of Tomorrow: Geeks, Gangsters, and the Birth of the Comic Book*. New York: Basic Books, 2004.

Kane, Bob, and Tom Andrae. *Batman and Me*. Forestville, CA: Eclipse Books, 1989.

Kanfer, Stefan. *Serious Business: The Art and Commerce of Animation in America*. New York: Scribner, 1997.

Keim, Norman O. *Our Movie Houses: A History of Film and Cinematic Innovation in Central New York*. Syracuse, NY: Syracuse University Press, 2008.

Kidd, Chipp, and Geoff Spear. *Shazam: The Golden Age of the World's Mightiest Mortal*. New York: Abrams Comicarts, 2010.

King, Graham, and Ron Saxby. *The Wonderful World of Film Fun, 1920–1962*. London: Clarke's New Press, 1985.

Kinnard, Roy. *The Comics Come Alive: A Guide to Comic-Strip Characters in Live-Action Productions*. Metuchen, NJ: Scarecrow Press, 1991.

Kinnard, Roy, Tony Crnkovich, and R. J. Vitone. *The Flash Gordon Serials, 1936–1940*. Jefferson, NC: McFarland, 2008.

Kunzle, David. *The History of the Comic Strip: The Nineteenth Century*. Berkeley: University of California Press, 1990.

Lev, Peter. *The Fifties: Transforming the Screen, 1950–1959*. Berkeley: University of California Press, 2003.

Levitz, Paul. *The Golden Age of DC Comics*. Los Angeles: Taschen, 2013.

Lopes, Paul. *Demanding Respect: The Evolution of the American Comic Book*. Philadelphia: Temple University Press, 2009.

Marcus, Leonard S. *Golden Legacy*. New York: Golden Books, 2007.

Martin, Joanne. *Television: Window to the World*. New York: Rosen Publishing Group, 2003.

Mathis, Jack. *Valley of the Cliffhangers*. Northbrook, IL: Jack Mathis Advertising, 1975.

McLuhan, Marshall *Understanding Media*. 1964. Reprint, London: Routledge, 1965.

Molson, Francis J. "Films, Funnies, and Fighting the War: Whitman's Children's Books in the 1940s." *Journal of Popular Culture* 17, no. 4 (Spring 1985): 147–154.

Morton, Drew. "The Unfortunates: Towards a History and Definition of the Motion Comic." *Journal of Graphic Novels and Comics* 6, no. 4 (2015): 347–366.

Musser, Charles. *Before the Nickelodeon*. Berkeley: University of California Press, 1991.

Naremore, James, ed. *Film Adaptation*. New Brunswick, NJ: Rutgers University Press, 2000.

Neuman, Susan B. *Literacy in the Television Age: The Myth of the TV Effect*. Norwood, NJ: Ablex Publishing, 1995.

Nyberg, Amy Kiste. *Seal of Approval: The History of the Comics Code*. Jackson: University Press of Mississippi, 1998.

Parsons, Patrick. "Batman and His Audience: The Dialectic of Culture." In *The Many Lives of the Batman: Critical Approaches to a Superhero and his Media*, edited by Roberta E. Pearson and William Uricchio. New York: Routledge, 1991.

Pierce, David. "'Senile Celluloid': Independent Exhibitors, the Major Studios, and the Fight Over Feature Films on Television, 1939–1956." *Film History* 10, no. 2 (1998): 141–164.

Quattro, Ken. "Bernard Bailey: The Early Years." *Alter Ego*, no. 109 (May 2012): 3–16.

Ro, Ronin. *Tales to Astonish: Jack Kirby, Stan Lee, and the American Comic Book Revolution.* New York: Bloomsbury, 2004.

Robertson, Bruce. *Ruth Harriet Louise and Hollywood Glamour Photography.* Berkeley: University of California Press, 2002.

Robinson, Jerry. *Skippy and Percy Crosby.* Austin, TX: Holt, Rinehart and Winston, 1978.

Rossen, Jake. *Superman vs. Hollywood.* Chicago: Chicago Review Press, 2008.

Scivaly, Bruce. *Superman on Film, Radio, Television, and Broadway.* Jefferson, NC: McFarland, 2007.

Scolari, Carlos Alberto. "Transmedia Storytelling: Implicit Consumers, Narrative Worlds, and Branding in Contemporary Media Production." *International Journal of Communication* 3 (2009): 586–606.

Scolari, Carlos Alberto, Paolo Bertetti, and Matthew Freeman. *Transmedia Archeology: Storytelling in the Borderlines of Science Fiction, Comics, and Pulp Magazines.* New York: Palgrave Macmillan, 2014.

Seldes, Gilbert. *The Great Audience.* New York: Viking Press, 1950.

Slide, Anthony. *Inside the Hollywood Fan Magazine: A History of Star Makers, Fabricators, and Gossip Mongers.* Jackson: University Press of Mississippi, 2010.

Smith, Bruce. *The History of Little Orphan Annie.* New York: Ballantine, 1982.

Smith, Greg M. "It Ain't Easy Studying Comics." *Cinema Journal* 50, no. 3 (Spring 2011): 110–112.

Smooden, Eric. "Motion Pictures and Television, 1930–1945: A Pre-History of the Relations between the Two Media." *Journal of the University Film and Video Association* 34, no. 3 (Summer 1982): 3–8.

Spadoni, Robert. *Uncanny Bodies: The Coming of Sound Film and the Origins of the Horror Genre.* Berkeley: University of California Press, 2007.

Spigel, Lynn. *Make Room for TV.* Chicago: University of Chicago Press, 1992.

Stokes, Jane. *On Screen Rivals: Cinema and Television in the United States and Britain.* Basingstoke: Palgrave, 2000.

The Superman Radio Scripts. Vol. 1, *Superman vs. the Atom Man.* New York: Watson-Guptill Publications, 2001.

Thomas, Frank, and Ollie Johnson. *The Illusion of Life: Disney Animation.* New York: Hyperion, 1981.

Thorp, Margaret Farrand. *America at the Movies.* New Haven, CT: Yale University Press, 1939.

Tuska, Jon. *The Vanishing Legion: A History of Mascot Pictures 1927–1935.* Jefferson, NC: McFarland, 1982.

Tye, Larry. *Superman: The High-Flying History of America's Most Enduring Hero.* New York: Random House, 2012.

U.S. Senate, Select Committee on Small Business. *Motion Picture Distribution Trade Practices—1956: Problems of Independent Motion-Picture Exhibitors.* Washington, DC: Government Printing Office, July 27, 1956.

Vance, Michael. "'Something . . . ?': A Study of Comics Pioneer Richard E. Hughes." *Alter Ego*, no. 112 (August 2012): 46–54.

Vieira, Mark A. *Hurrell's Hollywood Portraits: The Chapman Collection*. New York: Harry N. Abrams, 1997.

Wasson, Haidee. "Suitcase Cinema." *Cinema Journal* 51, no. 2 (Winter 2012): 148–152.

Waugh, Colton. *The Comics*. 1947. Reprint, Jackson: University Press of Mississippi, 1991.

Wertham, Fredric. "The Comics . . . Very Funny!" *Saturday Review of Literature*, May 29, 1948, 6–10.

———. *Seduction of the Innocent*. New York: Rinehart & Co., 1954.

Whelehan, Imelda. "Adaptations: The Contemporary Dilemmas." In *Adaptations: From Text to Screen, Screen to Text*, edited by Deborah Cartmell and Imelda Whelehan. London: Routledge, 1999.

Wright, Bradford M. *Comic Book Nation: The Transformation of Youth Culture in America*. Baltimore: Johns Hopkins University Press, 2001.

Yockey, Matt. *Batman*. Detroit: Wayne State University Press, 2014.

Yoe, Craig. *Secret Identity: The Fetish Art of Joe Shuster*. New York: Harry N. Abrams, 2009.

Young, Paul. *The Cinema Dreams Its Rivals: Media Fantasy Films from Radio to the Internet*. Minneapolis: University of Minnesota Press, 2006.

INDEX

ABOUT THE AUTHOR

BLAIR DAVIS is an assistant professor of Media and Cinema Studies in the College of Communication at DePaul University in Chicago. He is the author of *The Battle for the Bs: 1950s Hollywood and the Rebirth of Low-Budget Cinema* and coeditor of *Rashomon Effects: Kurosawa, Rashomon, and Their Legacies*. His articles and essays have been featured in the *Historical Journal of Film, Radio, and Television* and the *Canadian Journal of Film Studies*, as well as in such anthologies as *Reel Food: Essays on Film and Food; Horror Film: Creating and Marketing Fear; American Horror Film: The Genre at the Turn of the Millennium; Recovering 1940s Horror Cinema: Traces of a Lost Decade;* and *The Blacker the Ink: African Americans and Comic Books, Graphic Novels, and Sequential Art.* He is the co-chair of the Comics Studies Scholarly Interest Group with the Society for Cinema and Media Studies and the editor of an "In Focus" section for a 2017 issue of *Cinema Journal* on the graphic novel *Watchmen*.